COLOR MANAGEMENT & QUALITY OUTPUT

Titles in *The Digital Imaging Masters Series*:

Power, Speed & Automation with Adobe Photoshop
by Geoff Scott and Jeff Tranberry

Color Management & Quality Output: Working with Color from Camera to Display to Print
by Tom P. Ashe

Camera & Craft (coming in 2014)
by Jodi Steen, Andy Batt and Candace Dobro

Praise for the series:

Sounds like as close to a dream team as one could get without having to resort to spiritual means. I mean if you could get Ansel Adams to do a section on black and white and landscape-great, but that would require a séance. For the talent living, this is a dream team.

—Robert Barnett, QBToo (formerly PC-Review Online)

We loved our old Time/Life series of photography books. Time for an update. This series could become iconic.

—Anne Pfeiffer, Instructor

I think that Katrin Eismann's skill in curriculum development is reflected in the approach. I like the approach a lot; I would find it to be a valuable resource and would expect to turn to the texts often for advice.

—Mark Lewis, SUNY Empire State College

I think there is a good balance of technical vs. creative.

—Carol Tipping, FRPS EFIAP

I think many of the books on the market are software driven, whereas this series is developed to support the photography industry. There is a world of difference between explaining a feature of a software package and explaining how to get an important photography task accomplished through a software tool.

—Douglas Barkey, The Art Institute of Pittsburgh

The School of Visual Arts Master of Professional Studies in Digital Photography is an intensive one-year degree program that is offered as an on-campus/summer residency or an online/summer residency program that seamlessly blends the most current technical and aesthetic aspects of contemporary photographic image-making. The program meets the needs of professional photographers and photographic educators who want to advance their skills in digital image capture, image processing and high-quality output to remain competitive in a variety of image-making and related fields. Graduates work as commercial, fashion, fine-art, and editorial photographers; retouchers; studio managers; and higher education staff and faculty.

—Masters in Digital Photography Program Information
http://www.sva.edu/digitalphoto
Contact: mpsphoto@sva.edu

COLOR MANAGEMENT & QUALITY OUTPUT

WORKING WITH COLOR FROM CAMERA TO DISPLAY TO PRINT

Tom P. Ashe

SERIES EDITOR KATRIN EISMANN

Focal Press
Taylor & Francis Group

NEW YORK AND LONDON

First published 2014
by Focal Press
70 Blanchard Road, Suite 402, Burlington, MA 01803

Published in the UK
by Focal Press
2 Park Square, Milton Park, Abingdon, Oxon OX14 4RN

Focal Press is an imprint of the Taylor & Francis Group, an informa business

Series Editor: Katrin Eismann
Managing Editor: Candace Dobro

Library of Congress Cataloging in Publication Data
Ashe, Tom.
 Color management & quality output: mastering color from camera to display to print/Tom Ashe.
 pages cm.—(Digital imaging masters series)
 Includes bibliographical references.
 1. Color photography—Quality control. 2. Photography—Digital techniques. I. Title. II.
 Title: Color management and quality output.
 TR510.A79 2013
 778.6—dc23 2013018650

ISBN: 978-0-240-82111-5 (pbk)
ISBN: 978-0-240-82136-8 (ebk)

Typeset in Trade Gothic, Helvetica Neue and Optima
By Florence Production Ltd, Stoodleigh, Devon, UK
Printed in China by 1010

Bound to Create

You are a creator.

Whatever your form of expression — photography, filmmaking, animation, games, audio, media communication, web design, or theatre — you simply want to create without limitation. Bound by nothing except your own creativity and determination.

Focal Press can help.

For over 75 years Focal has published books that support your creative goals. Our founder, Andor Kraszna-Krausz, established Focal in 1938 so you could have access to leading-edge expert knowledge, techniques, and tools that allow you to create without constraint. We strive to create exceptional, engaging, and practical content that helps you master your passion.

Focal Press and you.

Bound to create.

We'd love to hear how we've helped
you create. Share your experience:
www.focalpress.com/boundtocreate

 Focal Press
Taylor & Francis Group

This book is dedicated to my Mom,
who has been a great inspiration and support to me,
and to my Pop, whom I miss very much.

Contents

Section 2 Digital Printmaking & Output

Foreword

Opposites Attract

For photography enthusiasts in the late 1980s, Rochester, New York was an exciting place to be. Eastman Kodak dominated the downtown skyline and celebrated what it meant to be a successful photographer: technically adept and creatively courageous. Visual Studies Workshop and the George Eastman House offered direct access to photo-related artifacts, immense collections of prints and artists who defined the history of photography. Bemoaning Rochester's weather was a citywide pastime, but for photo students at the Rochester Institute of Technology (RIT), the harder the weather blew, the more time we had to experiment in the photo studios or make additional prints in the many darkrooms that lined the long hallways.

Tom Ashe and I attended RIT at the same time, and we even lived in the same off-campus dorm. Tom was part of the technically oriented "Imaging and Photography Technology" program (which was referred to as "Tech Photo"), and I was going my own way in the more conceptual Fine Art program. The shared darkrooms and elective classes allowed separate photo departments to overlap. One day, I was experimenting in the color darkroom by printing through translucent plastic leaves and blossoms, and the "techies" were working on an important report for Glenn Miller's Color Science class. As I tossed plastic leaves onto expired color paper, the Tech Photo guys were being exceedingly thorough, and they checked and rechecked their measurements before meticulously entering them into a precisely labeled grid. When I asked them why they were being so careful (most likely using a less professional word), I was told, "we're not allowed to erase anything, and if we do, we'll have to start the entire report over." As my prints tumbled out of the color processor, the techies admired the abstract magentas and cyans that the green leaves and red petals had created—and I wondered why they couldn't use an eraser.

A lot has changed in the field of photography since the days of writing reports with a #2 pencil and waiting for color prints to fall into an eager student's hands. The transition from analogue silver-based processes to a digital workflow and practice is complete, and as a result, an astounding level of control—and array of tools—is available to photographers and artists. Along with that control comes responsibility, and by understanding how those tools work we are freer than ever before to concentrate on our ideas and create stronger images.

As the late Bruce Fraser said, "Color Management is push-button easy . . . as long as you know which *one* of the 600 buttons to push." Tom Ashe not only knows which button to push, but more importantly he knows why and how to share his passion—with us non-techies—for the art and science of color. Tom is a gifted, generous, patient, and dedicated teacher who both understands and can explain how color works in our minds, monitors, computers, and printers. I have personally seen Tom explain the complex with good humor, tremendous grace, and great clarity to many students. Without fail, Tom's students progress to see, understand and apply what they have learned. And they make the best prints that are produced at the School of Visual Arts, where we both teach and work in the Masters of Professional Studies in Digital Photography department.

With this book, you are fortunate to become one of Tom's students. Take the time to study the material and practice what he shares. If you do, then your understanding of color will deepen and the quality of your prints will improve exponentially. Class is in session.

Katrin Eismann
Series Editor, April 2013

Acknowledgments

In view of the intended nature and design of this book project and the many years I have been researching and learning about these topics, many people and organizations have been involved along the way. This book could not have been produced without their contributions of knowledge, time, advice, resources, and talent. My sincerest thanks go out to the following people:

Katrin Eismann, Chair of the Master of Professional Studies in Digital Photography program at the School of Visual Arts, recommended me for the opportunity to write this book. She has given me the opportunity to teach and learn more about color management and digital output, made it possible for me to have the bandwidth to be able to produce this book, and inspires me with her passion for photography, professionalism, and generosity every day.

My family—for their patience and encouragement during the long process of producing this book, especially my mom, Madeleine Ashe; my late dad, Thomas G. Ashe; my stepmom, Kathryn (Missy) Ashe; my brothers, Matthew, Patrick, Gregory, and Andrew; my nieces, Hannah and Adrienne (who are in many of the pictures in the book); and my boyfriend, Aaron Dai.

My teachers, colleagues, and students at Rochester Institute of Technology and RMIT University, especially: Glenn Miller, Frank Cost, Andy Davidhazy, Bill DuBois, Russ Kraus, Ivan Latanision, Therese Mulligan, and Doug Rea—all from RIT—and Les Walkling, John Storey, Rose La Fontaine, Gale Spring, Czesia Markiewicz, Fran van Riemsdyk, Gordon Pickard, Tomas Gislason, Greg Humphries, Megan McPherson, and Phred Petersen—from RMIT.

My colleagues and students at School of Visual Arts, who have given me opportunities, challenged me and helped me build my understanding and improve the ways I teach and present these topics, especially: Stephen Frailey, David Rhodes, Bill Armstrong, Bill Hunt, Susan Arthur Whitson, Joseph Sinnott, Bina Altera, Todd Carroll, Scott Geffert, John Delaney, Greg Gorman, Chris Murphy, Ben Bobkoff, Ben Gest, Allen Furbeck, Marko Kovacevic, and the late William L. Broecker and Matt Wilson.

Traditional Fine Art Printmakers and Printmaking Organizations: Peter Lancaster, Geoffrey Ricardo, Kim Westcot, Danny Moynihan, Bill Young, Louise Tomlinson, Martin King, all from the Australian Print Workshop; Neil Wallace, from Melbourne Etching Supplies; Naomi Florence, from the Print Council of Australia; and Lesley Harding, from the Victorian Arts Centre.

Digital Fine Art Printmakers: Jonathan Singer, Singer Editions; R. Mac Holbert, Nash Editions; Randall Green, Muse[x] Imaging; Jack Duganne, Duganne Ateliers; David Meldrum and Daryl Snowdon, The Cart Shed; Bill Hart, Tasmanian School of Art; and Jon Cone and Larry Danque, Cone Editions. Also, Albert Fung, Laumont Photographics; Andre Ribuoli, Ribuoli Digital; and Hong W. (Aaron) Chan, Authentic Vision.

Colleagues in the Color Management, Photographic, and Digital Output industries: Greg Gresock, Brian Welch, Thomas Gentry, Chris Heinz, Joe LaBarca, Lisa Markel, Kerry Mitchell, Gale Radley, Michael Shea, and John Stoia—all from Eastman Kodak Company; Steve Rankin, George Adam, Amy Mora, Leo Mora, Tom Orino, Brian Ashe, Ray Cheydleur, James Vogh, and Liz Quinlisk—from Monaco Systems/X-Rite, Incorporated; Jan Lederman, Mark Rezzonico, Cliff Hausner, Jan Ervin, Garry Montalbano, Dan Cirillo, Bill Gratton, and Brenda Hipsher—from The MAC Group/X-Rite Photo Marketing; James Abbott, Hewlett Packard; Eddie Murphy and Dan Steinhardt, Epson America; Daniel M. Weiss, Calumet Photographic; Jodie Steen, 127

Productions; Sarah Coleman, Dr. Franziska Frey, Neal Rantoul, Andrew Rodney, Jeff Schewe, Henry Wilhelm, and the late Bruce Fraser.

Photograph conservators: Hanako Murata, Tania Passafiume, and Martin Jürgens.

The following artists and photographers for making the book richer by allowing the use of their work: Andy Batt, Alan Bekhuis, Daniel Bolliger, Barbara Broder, Julie Brown, Allison Candage, Simon Chantasirivisal, Azhar A. Chougle, Desiree M. DiMuro, Candace Dobro, John Donich, Katrin Eismann, Christopher Ernst, Allen Furbeck, Giovanna Grueiro, Tara Lyn Johnson, Kevin Keith, Jonathan Lewis, Felix Nam Hoon Kim, Hyun Suh Kim, Jungmin Kim, Nayoung Kim, Young Hoon Kim, Christopher T. Kirk, Chong Uk Koh, Jamey Lord, Dhruv Malhotra, Alexandre Nunes, Charles Putnins, Jonas Racine, Brittany K. Reyna, A. Priscilla Ruiz, Christopher Sellas, and Adam A. Wolpinsky.

Additional help, support, and inspiration: José Alfaro, Sylvie Martin, Heida Olafsdottir, Laura O'Neill, Lucien Samaha, Therese Gietler, Eme Guitron, Cynthia Spence, Don Donofrio, and Allison Candage.

The team at Focal Press for their persistence, support, and chocolate, including: Stacey Walker, Cara St. Hilaire, Kimberly Duncan-Mooney, Alison Duncan, Emma Elder, Nikky Twyman, Faith McDonald and Michael Solomons.

I would like to further thank Madeleine Ashe, Denise Deshaies, Phred Petersen, John Story, Fran van Riemsdyk, and especially Allen Furbeck, Aaron Dai, John Donich, and the amazing Candace Dobro, for their invaluable help in refining this book from the original thesis report and online classes to the form it takes now.

INTRODUCTION

Welcome to *Color Management & Quality Output*! First, I want to give a brief introduction to my background, especially in terms of how it connects to this book, and then I'll review the goals and structure of the book.

I'm originally from the Boston area and started taking pictures at the age of ten. This led to photography classes throughout high school. Next, I attended the Rochester Institute of Technology (RIT) in Rochester, New York, where I ended up in Andy Davidhazy's Imaging and Photography Technology program. I proudly refer to "Tech Photo" as the geekier side of photography at RIT. While I was there, two topics of specific interest for me were Color Reproduction and the emergence of Digital Imaging and Photoshop. Participation in the second and third editions of Doug Rea's *ESPRIT (Electronic Still Photography at RIT)* class and publication—and a summer position in the research labs at Polaroid—had a big impact on me.

After RIT and a year working on satellite and aerial imaging systems, I returned to Rochester to work for Eastman Kodak Company. In the last three and a half of my eight years there, I worked as a systems development engineer for Kodak Professional. It was at Kodak that I was introduced to color management tools that improved color from scanners, digital cameras and all types of digital output—including inkjet, dye-sublimation, and true photographic output on film and paper. I was very fortunate, because I got to play with some fantastic toys.

In May of 1998, while I was still at Kodak, the George Eastman House's International Museum of Photography in Rochester had its first exhibition of digital inkjet prints. The exhibition was somewhat controversial at the time, since the prints were not made from light-sensitive materials, and some people felt they were "not really photographs." Of course, it's a quaint argument at this point. All the prints from this exhibition, which was curated by Therese Mulligan, came from the same place: Nash Editions.

Nash Editions was the first fine-art digital printmaking studio. It was started in 1990 by Graham Nash—photographer and member of the band Crosby, Stills and Nash—and Mac Holbert, his road manager/business partner.

The day after the exhibition opened, there was a panel discussion with photographers, printmakers (including Nash and Holbert) and other artists at RIT. The discussion concerned influences on digital printmaking, what was working well with digital technology and what was not. One topic that kept coming up was the frustration that stemmed from the differences between what an artist saw on his or her monitor and what came off the (typically Iris) inkjet printers.

Two things struck me most about this panel discussion at the time: The fact that digital printmaking at that point was influenced not only by photography, but also by the more collaborative traditions of fine art lithography, etching, and silk-screen printing, and also that the problems those printmakers and artists were having could be helped by the color management technology I was using at Kodak.

At the same time I was inspired by the Nash Editions exhibition and panel discussion, I was going through an early-life crisis. Knowing I didn't want to continue being an engineer (even though I enjoyed many aspects of it), I was looking for a change. Specifically, I was looking for opportunities to get my Masters degree, to get some experience teaching, and to go abroad. I ended up finding all three.

I was fortunate enough to get a scholarship to earn my Masters degree in photography at RMIT University in Melbourne, Australia—which also required teaching classes in digital photography. My master's thesis project, "Collaboration and Color Management in Fine Art Digital Printmaking," was inspired by that exhibition at the George Eastman House and panel discussion at RIT.

As part of the research, I interviewed digital printmakers and color experts in Australia and the United States about the tools and techniques they were using. One software company that kept getting mentioned was Monaco Systems. After two years in Australia, I completed my Masters degree, returned to Boston, and went to work for Monaco Systems (later purchased by X-Rite) for a little over a year.

FIGURE I.1 Flight DJ1293, Melbourne to Cairns, approaching the Great Barrier Reef, Queensland, Australia, 2011.
Credit: Photograph by the author

Next, I started to consult and teach color management around the country, which I still do for clients like the MAC Group (Mamiya America Corporation), X-Rite Photo Marketing, MIT, Northeastern University, Yale University, Andrew Eccles, and AdoramaPix.

In 2003, I moved to New York City and started teaching at the School of Visual Arts (SVA) in their BFA Photography program. Soon after, I created a course in Digital Printmaking and Color Management, which I'm still teaching. Then, in 2007, I was asked by Katrin Eismann (the series editor of the *Digital Imaging Masters Series*) to be the Associate Chair of the Master of Professional Studies in Digital Photography program at SVA, which she chairs. We were fortunate to have Chris Murphy, co-author of *Real World Color Management*, teaching our Color Management & Output course for the first few years of the program. I ended up creating an online version of this course and later took over teaching it, when Chris moved to Colorado. This book is largely based on my Masters thesis project and the evolution of the courses at SVA.

As you can guess from my background, I love this stuff. I firmly believe in the power of photography, art, digital prints, and the importance of color management in helping to bring our photographic vision to the page and screen—as accurately and efficiently as possible.

How many of you have had the same problem that those artists and photographers were having back in 1998—of matching your monitor to your prints? If we've made prints from digital files, most of us have had the same frustrating problem. It might be the reason you've picked up this book.

What happens when our prints and monitor don't match? We end up wasting time, ink, paper, and money, while we make iteration after iteration and adjustment after adjustment to get the image close to what we originally saw on the monitor. The goals of this book are to help you avoid this frustration, to help you to gain control over this process, and to give you the ability to produce excellent digital output.

The book is divided into two sections: Color and Color Management, and Digital Printmaking and Output.

In Section 1, we will start by reviewing the basics of how color is produced and reproduced. Specifically, this section will address the way color works in our monitors, image-processing software (Adobe Photoshop and Lightroom), and prints. You'll gain the fundamental knowledge you'll need to control the factors involved in creating, reproducing, correcting, and viewing your images. We will also discuss how to evaluate the technical quality of your images and prints, so that we can identify any defects and communicate well with others. This will help us troubleshoot and solve the inevitable problems that will arise. Towards the end of Section 1, we will thoroughly cover the tools and techniques available to us in color managing all of our devices—monitors, projectors, scanners, digital cameras, and printer/paper combinations—to give us as much accuracy and consistency from these devices as possible.

In Section 2, we will cover the different types of digital output, especially inkjet, photographic, and CMYK printing. The goal is for you to have a feel for their various benefits and detriments—and the techniques for getting the best results possible from them, whether a service provider or you are doing the printing yourself. We will also discuss the issues involved with preparing your images for output to screens for your website or iPad. Finally, we will review how to best resize and sharpen your images before output—and how to edition, document, label, and finish your prints, so they'll last for generations, or even centuries, to come.

Each chapter includes resources and exploration activities and exercises for you to further your understanding of each topic and build your skills. Hopefully this will be an opportunity for you to learn, explore, experiment, refine, and—in the end—make excellent quality prints and output.

One

COLOR &
COLOR VISION

Visual, mental and spiritual phenomena are multiply interrelated in the realm of color and the color arts.[1]
—Johannes Itten

Colors are the children of light, and light is their mother. Light, that first phenomenon of the world, reveals to us the spirit and living soul of the world through colors.[2]
—Johannes Itten

If we are going to make the best quality photographs and prints, we need to start by understanding the basics of color. Johannes Itten—the Bauhaus artist, author, educator, and color theorist in the early 20th century—saw color as a seriously complicated and deep topic and art as one of the many disciplines investigating it. Some of these other disciplines include: the physicist, who studies the nature of light, the electromagnetic spectrum, and the measurement of color; the chemist who looks at colorants, such as pigments and dyes, for their ability to produce different colors and reduce their tendency to fade over time; the physiologist, ophthalmologist, and neurologist that investigate the physical response of the eye and the brain (and their components) to color; and the psychologist, who delves into the influence of color on our perceptions, emotions, and behaviors. Itten was also saying the artist – whose interest is in the visual, aesthetic effect and symbolic nature of color and color combinations – is a natural entity, where many of these concerns intersect.

Color gives form and life to our images, and it also has the power to give mood and meaning. Since color is such a pivotal component of a visual artist's work, it's important that we, as photographers, have an understanding of how color *works*.

In this chapter we will explore the three basic components needed for color to exist: light, object, and observer. Our discussion of light will include the nature of different light sources and how these different light sources will impact the colors we see. Then we will examine how the object—depending on its characteristics—either absorbs or reflects portions of the light energy. Finally we will look at the influence we, as observers, and the combination of our eyes and brain, produce and impact the color perceived.

Light

So, not surprisingly, it all starts with light. Color, as well as photography, is not possible without light. Physicists define light as radiation consisting of packets of energy, traveling as electromagnetic waves. And Christiaan Huygens, the 17th-century mathematician and physicist, postulated that white light, or daylight, is composed of different wavelengths of light. He did this by separating sunlight into its components using a prism (as shown in Figure 1.2). Newton divided his spectrum into seven colors—red, orange, yellow, green, blue, indigo, and violet—which, when recombined again, resulted in white light. (Note that this recombination is an *additive* process, a subject that will come up again in Chapter 2.)

This visible spectrum (the part of the spectrum we can detect and see), which goes from wavelengths of approximately 380 to 730 nanometers, is a small part of the electromagnetic spectrum, which consists of radiation ranging from radio waves to gamma rays. Most of the light that enters our eyes is white light from sunlight or artificial light sources, like tungsten or fluorescent. While the spectrum is often divided into seven or six colors, it can just as easily be divided into *fewer* components. If we group the colors together at each end of the spectrum and in the middle, then white light can be more simply described as being made up of three major components: blue, green, and red. This corresponds roughly to the sensitivity of the detectors in our eyes that allow us to perceive color. Depending on the source

FIGURE 1.1 Eyjafjallajökull, Iceland, 2011.
Credit: Photograph by the author

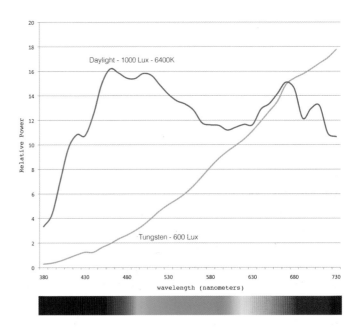

FIGURE 1.3 Spectral energy of daylight and tungsten white light sources. The light sources are measured with a device called a spectral radiometer for their radiance and different wavelengths to produce the data in this graph.
Credit: Illustration by the author

FIGURE 1.2 White light is separated through a prism into the visible spectrum, which is a small part of the electromagnetic spectrum.
Credit: Illustration by the author

of the white light, the red, green, and blue components will be present in different amounts, as seen in the spectral power distribution curves for daylight and tungsten light sources in Figure 1.3. They can combine to create warm light sources such as tungsten lamps (which have a high red component), or cool ones (like daylight in open shade), which have a higher blue component.

This varying blend of spectrum components in different white light sources is called *color temperature*, and is described in Kelvin (K). Just so you know, unlike temperature measurements in degrees Celsius or Fahrenheit, Kelvin units are not described as degrees and do not use the degree symbol. Figure 1.4 shows that tungsten lamps have a color temperature of approximately 3200 K, while the overcast

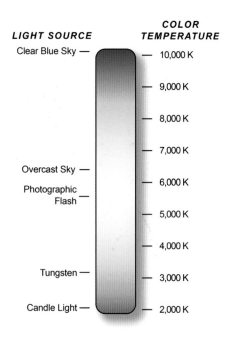

FIGURE 1.4 Color temperature of different continuous light sources.
Credit: Illustration by the author

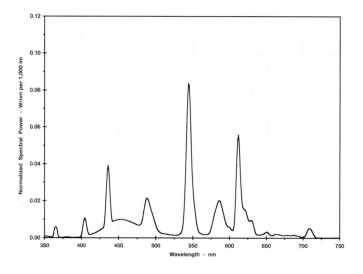

FIGURE 1.5 Spectral output of non-continuous fluorescent light sources.
Credit: Illustration by the author

The Temperature of Light Sources

The temperature of light sources is derived from something called the black body radiation experiment. A black body is an idealized physical structure that starts to radiate light when heat energy is applied to it. When heated to 727 degrees Celsius (1000 K) the black body starts to radiate or glow a dark red. As you heat it more, it glows a brighter red and at 3200 Kelvin glows orange amber. With more and more heat the black body glows yellow, then white, and finally blue at the higher temperatures. Does this make sense that higher temperatures would result in a cooler color? Maybe it would if you picture the flame of a candle. Where is the flame hottest? It's hottest closer to the wick. What color is the part of the flame that is close to the wick? It's blue. As you go away from the wick, the color goes from blue to white to possibly yellow, orange, or red, if it has been cooled by something like water.

daylight is approximately 6500 K and clear blue sky is around 10,000 K or 12,000 K. Also notice in Figure 1.4 that 5500K is photographic daylight. This means that 5500 K is the color temperature of most photographic strobe and electronic flash light sources. Correspondingly, 5500 K is the color temperature digital cameras are balanced for when they are set to daylight or flash.

Continuous versus Non-continuous Light Sources

One thing all the light sources in Figure 1.3 have in common is that they are continuous light sources. This means that daylight, photographic

strobes, or tungsten light sources each emit energy at all of the wavelengths in the visible spectrum. Non-continuous light sources like fluorescent or sodium vapor, on the other hand, are spikier in nature, as seen in Figure 1.5. This spiky nature is the result of the fact that fluorescent lights are made of gases that glow or fluoresce at certain wavelengths when excited by electricity. They glow at some of these wavelengths, but not at others, in the visible spectrum. You've most probably seen some manufacturers advertising full-spectrum fluorescent bulbs. How are these different? More gases are added to the full-spectrum bulb to make them emit energy in additional wavelengths, which can make the light more pleasing visually.

Whether the light source is daylight, tungsten, or fluorescent, the important thing for us to remember is that the light source is a critical factor in the colors that we can perceive with our visual system or record with a digital camera. Since the light source is first, it affects everything else. The colors of an object, like a print, will be limited by the energy of the light source that illuminates it.

FIGURE 1.6 Green hedges absorbing and reflecting different wavelengths of daylight. Credit: Illustration and photograph by the author

The Object or Stimulus

As we just discussed, light coming to us directly from a source has its own color properties, but on our path towards the existence of color there are three possible options for this light source. First, the light-source rays could go directly to the eye. If this light source has color, like neon lights, the energy has a *selective emission* at different wavelengths of light. Another possibility is that the light source could be modified by traveling *through* an object, such as a filter or colored glass, which results in the *selective transmission* of different wavelengths of the light. Or, more commonly, the light source could be modified by reflecting off an object, which results in *selective reflection* at different wavelengths of light.

An object illuminated by white light can either *absorb* or *reflect* the red, green and blue components of this white light, depending on the colorants in the object. A black object will absorb most or all of the light, while a white object will reflect most or all of the light. As Figure 1.6 shows, the green leaves of a hedge absorb most of the

red and blue components of the white light, and reflect some of the green. However, because the hedge is not a *pure* green, it absorbs some of the green and reflects small portions of the red and blue components of light.

Once again, an object will do one of two things with the different wavelengths of light energy presented to it. It will either absorb it or reflect it.

As mentioned before, the amount of each component wavelength in a light source is called its *spectral power distribution* (which I will generally refer to as a *spectral distribution*), and if we graph those amounts, we produce a *spectral power distribution curve*, as we saw in Figures 1.3 and 1.5. If we graph the spectral distribution of the light that is reflected from an object, we get a *spectral power reflectance curve* (or, more generally, a *spectral reflectance curve*). Figure 1.7 shows spectral reflectance curves for differently colored objects. In these diagrams, where the curve is close to 0, the object is absorbing more light energy at that wavelength. Where the curve is closer to 100%, it is *reflecting* more light energy at that wavelength.

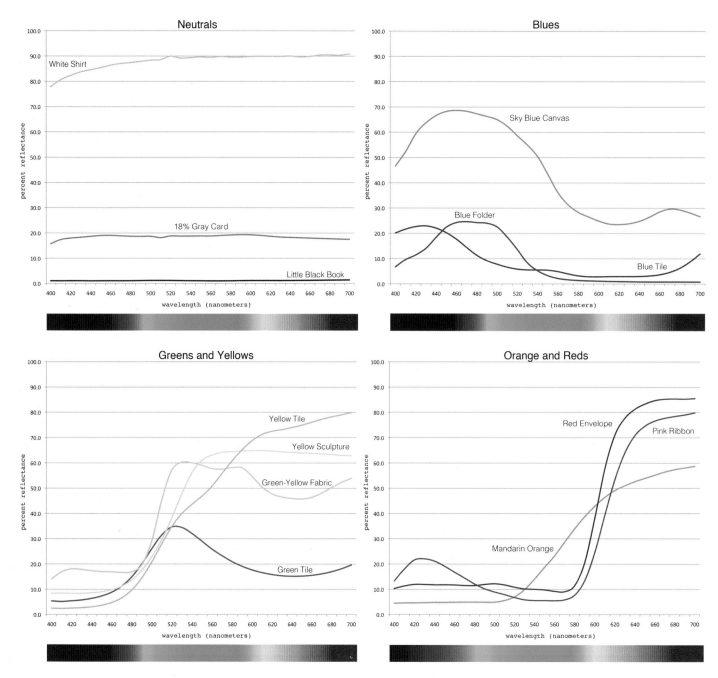

FIGURE 1.7 Spectral reflectance of different color objects.
Credit: Illustration by the author

Let's look more closely at these spectral reflectance curves for the different colors in Figure 1.7. In the graph in the upper left-hand corner, three neutral objects were measured: a white shirt, an 18% gray card, and a little black book. The white shirt reflects most, approximately 89%, of the light energy at all wavelengths of the spectrum, while the little black book absorbs most of the light energy, reflecting only about 1% of the light energy across the spectrum. The 18% gray card, which can be used for determining exposure with a reflected light meter, reflects, not surprisingly, about 18 percent of the light. What all the neutrals have in common is that they reflect almost equal amounts of energy at all the visible wavelengths.

Next, let's review the spectral reflectance curves for the blue objects in the upper right-hand corner of Figure 1.7. What we see in all three blue curves is that the highest or peak reflectance is in the blue part of the spectrum—in other words, wavelengths from approximately 400–500 nanometers. The fact that these objects reflect more blue energy and absorb more green and red energy is what makes them *blue*. We can also see that both the blue folder and the blue tile are relatively darker colors, so less of the light is being reflected and more of the light is being absorbed. On the other hand, the sky-blue canvas is lighter and reflects a greater percentage of the light energy in all three parts of the spectrum.

In the green and yellow spectral reflectance curves in the lower left, the green tile has its highest or peak reflectance in the green part of the spectrum (wavelengths from approximately 500–600 nanometers) and absorbs more or reflects less of the blue and red parts of the spectrum, which is part of what makes it *green*. The yellow tile and the yellow sculpture absorb more blue energy, while reflecting more energy in the green and red sections of the spectrum, which is part of what makes them *yellow*. As you can see, the yellow-green ribbon is somewhere in the middle. It is absorbing most blue energy, while reflecting green wavelengths and the red wavelengths, but it is not reflecting the red wavelengths as strongly as the two yellows.

Finally, let's look at the orange and red spectral reflectance curves in the lower right. The red envelope has its highest or peak reflectance in the red part of the spectrum (wavelengths from approximately 600–700 nanometers) and absorbs more or reflects less

of the blue and green sections of the spectrum, which is part of what makes it *red*. Notice that the mandarin orange, like the red envelope, reflects red wavelengths, but it also reflects some green wavelengths, but not as much as a yellow. Like the red envelope, the pink-magenta ribbon reflects lots of red wavelengths and absorbs the green wavelengths, but unlike the red object, it also reflects some blue wavelengths.

The different amount of light energy objects absorb or reflect at different wavelengths, as I've said above, is only part of what makes them the color they will be in the end. There is one more ingredient needed for the color to exist: us, the observer.

The Observer

The human observer is by far the most complicated piece of the color experience puzzle. We have a big impact on how color is perceived and experienced.

Using Figures 1.8 and 1.9, let's start by understanding what's happening at the eye and in the retina. When some wavelengths of light energy reflect off an object, these light rays are refracted by the *cornea* (the transparent protective layer of the eye), through to the opening or *pupil* (the black part of our eyes), which is modulated by the *iris* (the part of our eyes with color that opens and closes depending on the amount of light in the scene). The light is, additionally, focused by the *lens*, whose shape and ability to focus on objects at various distances is controlled by the *ciliary muscle*. When working properly, the lens and ciliary muscle focus the reflected light on the *fovea*, a point on the back of the eye or retina. If the lens and ciliary muscles are not working properly, we require corrective lenses to see well and in focus.

Light falling on the retina (Figure 1.9) results in a complex stream of chemical and electrical reactions and signals. The light-sensitive tissue of the retina is made up of different photoreceptor and nerve cells. The *ganglion photoreceptor cells* are important for reflexive responses to bright daylight and are the connection to the optical nerve. Signals go back and forth along the *bipolar* and horizontal

Human Eye Anatomy

FIGURE 1.8 Anatomy of the human eye.
Credit: Illustration by Alila Sao Mai

Cells and Photoreceptors of the Retina

FIGURE 1.9 Cells and photoreceptors of the retina.
Credit: Illustration by Alex Luengo

nerve cells from the ganglion cells and the two other photoreceptors, the rods and cones. The *rods* and *cones* are nourished by the typically dark pigment cells in the outside layer of the retina. The pigment cells help supply vitamin A and help control light in the eye.

The *rods* are active in dim light and allow us to see in low-light situations. In brighter light, the rods have too much signal and do not contribute to visual perception. The *cones* are responsible for our perception of color, but are only sensitive under brighter illumination. (This is the reason we have trouble detecting color in low-level illumination.) There are three types of cones, each having a unique spectral sensitivity resulting from the presence of different photo-sensitive pigments. The maximum sensitivities of the three cones are in the yellow-orange (long wavelength), the green (middle wavelength),

and the blue-violet (short wavelength) parts of the spectrum (Figure 1.10).

Depending on the wavelengths of light reflecting off of the object and into our eyes, the three different cones will be triggered with more or less signal. As an example, a yellow object reflects energy centered on yellow wavelengths (between about 550 and 600 nanometers). As you can see in Figure 1.10, both the middle and long wavelength cones are sensitive to these wavelengths, while the short wavelength cone is not. When these cones are triggered in the proper amounts, the brain eventually translates the input as yellow.

There is a great deal of image processing that occurs, even before the nerve impulses and signals from the different cones leave the eye to travel through the *optic nerve* to the *visual cortex* in the

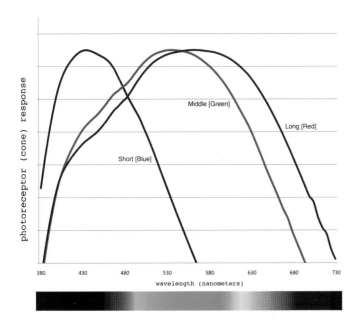

FIGURE 1.10 Spectral response of the short, middle, and long wavelength cones. Credit: Illustration by the author

back of the brain. Along the way, there are several more places where processing occurs, but it is only when the signals reach the visual cortex that the bulk of the processing happens. From there, even further processing occurs in the higher areas of the brain. Along the way, all sorts of perceptual and cognitive adjustments are made, which help us to both see and *understand* what we are seeing.

For us as photographers, this means we need to understand a complex circumstance: there are many things that can affect how each person will perceive colors differently. The colors we see are influenced by our age, physical state, mental state and the substances we put into our bodies. Not surprisingly, if we are sick, sleepy, stressed out, stoned, happy, or sad, we will perceive *everything* differently. We need to keep in mind that our employees, service providers, clients, or the viewers of our exhibition prints might see color differently than we do.

Color blindness and Color Deficiency

How differently might others perceive the colors in our images and prints? Remember that, as far as our ability to see colors is concerned, we are also influenced by our sex. Who perceives color differences better, men or women? It doesn't surprise most people that the answer is women. As part of this, color blindness is much more common for males than females: 8% of men are color blind, as opposed to 0.4% of women. That is a big difference!

Color blindness and color deficiency stem mainly from genetic origins and affect us if we are missing cones, have defective cones, or, in some cases, possess a smaller number of one type of cone. Figure 1.11 shows a simulation of different types of colorblindness as compared with normal color vision. The most common form of color blindness is red-green color blindness. This results from either a missing or defective middle-wavelength cone and is called *deuteranopia*, or a missing or defective long-wavelength cone, which is called *protanopia*. It is much less common to be missing only your short-wavelength cones, which results in a blue-green color blindness called *tritanopia*. If you are missing two cones, your vision is monochromatic, which is very rare. Finally, if a person is missing or has non-functional cones and only has rods, the result is monochromatic vision in low-light and daylight blindness.

Testing Color Vision

Because of the many psychological, physiological, and neurological variables within our visual system—even among those of us with "normal" color vision—there are subtle variations in the way we perceive color. The *Farnsworth Munsell Hue Test*, as shown in Figure 1.13, is a way for us to test our ability to discern subtle variations in hue. In the test, we take a set of 85 randomly ordered color tiles and place them in order as best as possible within approximately eight minutes.

Figure 1.14 shows the results of three of my students when they took the Farnsworth Munsell Hue Test on the first day of class. When tiles are out of order to a greater degree, the graph shows marks

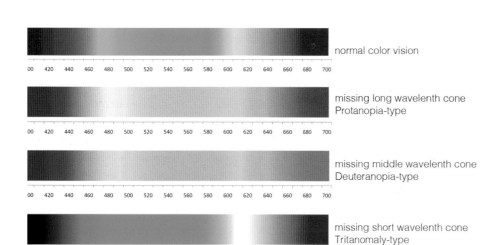

normal color vision

00 420 440 460 480 500 520 540 560 580 600 620 640 660 680 700

missing long wavelenth cone
Protanopia-type

00 420 440 460 480 500 520 540 560 580 600 620 640 660 680 700

missing middle wavelenth cone
Deuteranopia-type

00 420 440 460 480 500 520 540 560 580 600 620 640 660 680 700

missing short wavelength cone
Tritanomaly-type

00 420 440 460 480 500 520 540 560 580 600 620 640 660 680 700

FIGURE 1.11 *(left)* Simulation of a spectrum as seen by viewers with normal color vision and three types of color blindness.
Credit: Illustration by the author, inspired by Margaret Livingstone, 2002 (see Resources at the end of the chapter).

FIGURE 1.12 *(below)* Portrait of Remy on the left. On the right is a view from Adobe Photoshop that simulates Protanopia-type color blindness from missing or damaged long-wavelength cones.
Credit: Photograph by the author

FIGURE 1.13 *(facing page, top left)* Fadi Asmar taking the Farnsworth Munsell Hue Test under 5000 K viewing booth.
Credit: Photograph by the author

FIGURE 1.14 *(facing page, bottom)* Graphs generated in X-Rite's Farnsworth-Munsell 100 Hue Test Scoring Software.
Credit: Photograph by the author

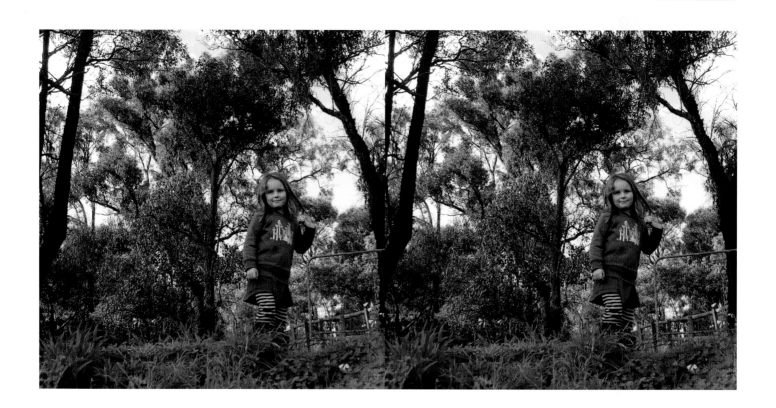

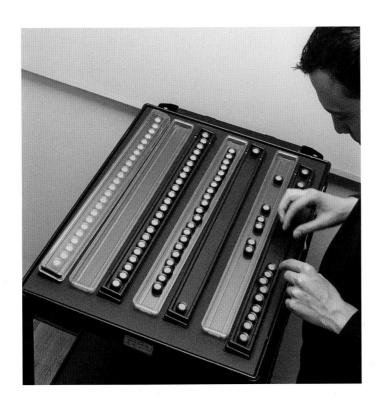

Did you know Adobe Photoshop allows us to simulate both forms of red-green color blindness? To display this simulation with your images, go to the menu bar. Select **View > Proof Setup >** and either **Protanopia-type** or **Deuteranopia-type** at the bottom. Figure 1.12 shows the change in an environmental portrait when Photoshop is simulating protanopia-type color blindness. Notice in the simulation on the right, not surprisingly, Remy's red skirt is now hard to distinguish from the color of the grass in the foreground. This tool is most useful for graphic designers, but it is also a good reminder to the rest of us that we all see things a little bit differently.

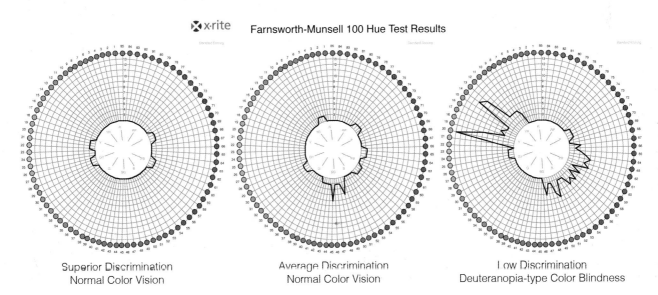

x-rite Farnsworth-Munsell 100 Hue Test Results

Superior Discrimination
Normal Color Vision

Average Discrimination
Normal Color Vision

Low Discrimination
Deuteranopia-type Color Blindness

farther from the center. A test with no mistakes, or perfectly ordered, has a circle in the center with no marks extended from it and would be described as indicative of normal color vision of "superior discrimination." Although not perfect, the student on the left also showed superior color discrimination with only four minor mistakes. The center graph shows the results of a test from a student with "average color discrimination." The last graph on the right shows the results of a student who is red-green color blind.

Metamerism and Metameric Failure

At this point we've looked at all three of the factors needed for us to perceive a color: light, object, and the observer. The light source illuminates the object. The object absorbs or reflects different parts of this light energy. And finally the reflected light enters our eyes and is detected by the cones and interpreted by the brain to tell us what color we are seeing. Now that we've got that straight, we need to look at an important visual phenomenon we've all experienced—and which is important to us as photographers—known as *metamerism*.

Most of us have experienced metamerism with clothing. You've gone shopping for a black shirt and pants. (Yes, I live in New York City.) The blacks of two articles of clothing look the same in the fluorescent lights at the store, but when you look at them at home under incandescent tungsten light or outside in daylight, the shirt is a blue-black and the pants are a warm-black.

When two objects have different spectral distributions—like the blue tile and the blue folder in Figure 1.7, or the shirt and pants above—but still appear to be the same color under some light sources, this phenomenon is known as metamerism. The objects or stimuli that show this are called *metameric pairs* or *metamers*.[3] Why do two colors that are not the same match under some circumstances and not others? Metamerism is (at least in part) caused by the nature of our trichromatic color vision. In other words, the fact that we have only three cones limits our ability to always see that two colors are different.

Why is metamerism important to us as photographers? Because it allows us to reproduce most of the colors of the world, using mixtures of only three or four colors, on monitors and prints. In these types of output we are able to construct *combinations of light and ink and paper*, which are metameric pairs to the colors of the world. We accept the image and the world as a match, or at least as a good representation. In other words, photography and digital imaging could not work without metamerism. It's not a flawless system, as anyone with a sensitive eye for color can see, but it's remarkably successful nonetheless.

When two colors that do match under one light source shift greatly and no longer match under another light source (and you expect them to match), that is properly referred to as a lack of metamerism, or *metameric failure*. In photography, we expect that the color print will keep a reasonably close relationship to the colors of the world, regardless of the white light source used to view the print. However, there have been issues with metameric failure in digital printmaking. One severe example was the ink-set and paper combinations for Epson's original pigment-based inkjet printer, the 2000P, which produced a green/magenta color shift under different lighting conditions. As we said, what we would hope for in this situation is to have the print look similar under the different lights, but in the case of the prints from the Epson 2000P, the prints appeared severely different when viewed from one light source to another. This situation is a good example of a lack of metamerism or metameric failure.

That being said, all prints will vary subtly from one light source to another, so when we evaluate our prints it will always be best to evaluate them under the same lights that will be used in the gallery to later display them or by our clients to review them. As we said at the beginning: the light source matters.

Conclusion

As photographers who want consistent and accurate color in our images, we must be aware of all three factors that are required for color to exist: light, the object, and the observer. Since all three affect the final color or colors that are perceived in our output, the trick for us as photographers is to learn to control and adjust these factors. That's what we will start to look at in the next chapter: color measurement and management.

Resources

Animation showing the human visual system:

http://www.sumanasinc.com/webcontent/animations/content/visualpathways.html

Information on the spectral responses of our eyes:

http://www.telescope-optics.net/eye_spectral_response.htm

Gregory, Richard, *Eye, and Brain, the Psychology of Seeing*, 5th edition, Princeton University Press, Princeton, NJ, 1997.

Hubel, David, *Eye Brain and Vision*, 2nd edition, chapter 3, "The Eye," W. H. Freeman & Co., New York, 1995. Available online at: http://hubel.med.harvard.edu/b8.htm

Hunt, R. W. G., *Measuring Colour*, Ellis Horwood Ltd, Chichester, England, 1987.

Itten, Johannes, *The Art of Color*, Van Nostrand Reinhold Co., New York, 1961, pp. 16–17.

Livingstone, Margaret, *Vision and Art: The Biology of Seeing*, Harry N. Abrams, New York, 2002. ISBN: 0810904063.

Sacks, Oliver, "The Case of the Colorblind Painter," in *An Anthropologist on Mars: Seven Paradoxical Tales*, Vintage, New York, 1996.

Wyszecki, Gunther, & Stiles, W. S., *Color Science, Concepts and Methods, Quantitative Data and Formulae*, 2nd edition, John Wiley and Sons, New York, 1982. (Very thorough and dense, with lots of math. Only for the committed or the fearless.)

Notes

1. Itten, Johannes, *The Art of Color*, Van Nostrand Reinhold Co., New York, 1961, pp. 16–17.

2. Itten, p. 13.

3. Wyszecki, Gunther, & Stiles, W. S., *Color Science, Concepts and Methods, Quantitative Data and Formulae*, 2nd edition, John Wiley and Sons, New York, 1982, p. 184.

Two

COLOR MEASUREMENT, REPRODUCTION & MANAGEMENT

Now that we have an understanding of what a color is, in this chapter we will examine how colors are described, measured, reproduced, and managed. First we will look at the limits of describing a color with language. Then we will review an influential model used for organizing colors created by Albert Munsell. This will lead to a review of the standards and devices used for measuring color that give us objective and repeatable numbers to define colors. After that, we will investigate how we photographers reproduce the colors of the world on our displays and prints, and explore the limitations of those systems. Finally, we will examine the color management techniques used to reproduce colors as accurately and consistently as possible.

FIGURE 2.2 Sample Colors.
Credit: Illustration by the author

Describing and Remembering Color

Imagine attempting to get a specific paint color to match the current color of the walls in your bedroom—without a sample. This would be very difficult for many reasons. Of course, as we discussed in the previous chapter, we know that the color of the walls will depend on the light source we view them under and our physical ability to see the colors accurately. We also have the limitations of our language and memory to consider.

How do we describe colors we have seen to others? How would you describe the colors of the sunset in Figure 2.1? To give someone the general feeling, we would be able to say, "It was a vibrant orange-red." To be slightly more poetic, we might add, "as if the sky were on fire." This might be good, but would this be enough for the person receiving the description, let alone the person making the description, to duplicate the colors? What if it were a week, month, or year later? Would we remember those colors accurately?

As with the sunset, if we were asked to describe or compare the two colors in Figure 2.2, we might start by saying, "One is blue and the other is red." Next, we might describe the blue as lighter and the red as darker, but not very dark in tone. Finally, we could point out that the blue is very muted, subdued, or desaturated, while the red is saturated, vibrant, rich, and colorful. We might even be more specific and name them as pale blue and geranium red.

But would you be able to pick the specific blue out a group of the 30 somewhat similar colors found in Figure 2.3?

Munsell Color System

As long as artists have been trying to depict the colors of the world, whether on canvas with paint or on paper with words, there has been a struggle to describe those hues, shades, and tints as accurately as possible. In the late nineteenth century, painter and educator Albert Munsell (seen in Figure 2.4) wanted to find a better way to describe and organize color that didn't depend on the vagaries of language alone.

During the 18th and 19th centuries, Munsell and others determined that the three basic attributes we use to describe color were hue, brightness, and saturation.

Hue

Hue is the property of color, which describes its dominant wave-length(s), and differentiates it from other colors, such as red, yellow, green, blue, etc. Neutrals such as black, white, and gray do not have a hue.

FIGURE 2.1 Sunset, Brooklyn, 2009.
Credit: Photograph by the author

FIGURE 2.3 Can you pick the blue from Figure 2.2? The answer is at the end of the chapter.

Credit: Illustration by the author

FIGURE 2.4 Albert Munsell, image restored by Douglas Corbin while a graduate student at the Munsell Color Sciences Laboratory at the Rochester Institute of Technology in 1998.
Credit: Photo-restoration by Douglas Corbin

Value

Brightness, or *value*, is the attribute of a visual sensation, which describes an area as exhibiting more or less light. In addition to brightness and value, you'll also hear the term "lightness" and "tone" (although the latter term can lead to confusion, since some people use it to mean other things, such as "hue").

Chroma

Saturation, or *chroma* (sometimes called colorfulness), is the attribute that describes a color exhibiting more or less of its hue, as a departure from neutral; it is a description of how intense the color is.

In the color system Munsell created in 1905 and published in 1915, as seen in Figure 2.5, he used hue, value, and chroma to describe the attributes of color, and then organized his system around these three basic dimensions. The important fact is that Munsell used these three basic dimensions of color in his system, so let's make sure you understand the differences as well as possible.

As you can see in Figure 2.6, the Munsell system has all the hues forming a circle around the neutral value center or core. The primary hues in his system are red, yellow, green, blue, and purple; the intermediate hues are yellow-red, green-yellow, blue-green, purple-blue, and red-purple. Figure 2.7 shows us the other two dimensions in the Munsell color space: value and chroma for a specific hue, yellow-red. In this Munsell Chart, you can see that value is the

Munsell colour space

FIGURE 2.5 Munsell Color System, three-dimensional view.
Credit: Illustration by the publisher, inspired by part of the New Munsell® Student Colour Set.

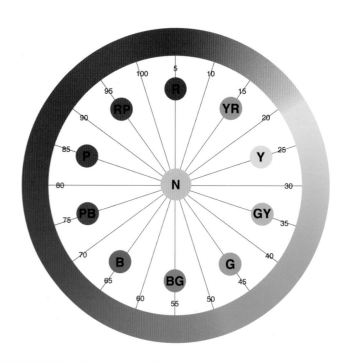

FIGURE 2.6 Hue Circle of the Munsell Color Space.
Credit: Illustration by the author, inspired by part of the New Munsell® Student Colour Set.

y-axis. The lower values (darker colors closer to black) are at the bottom of the configuration, while higher values (lighter and closer to white) are at the top. All the colors on any row have the same value or brightness. The neutral value core of the Munsell Color Space—which goes from black, through gray, and up to white—runs down the left-hand side of the Munsell Chart in Figure 2.7. The colors then radiate out to the right, gaining chroma or saturation the further they are from the neutral center. Hopefully, you can see that each column in the Munsell Chart has the same chroma or saturation.

Once again, this is important because Munsell's system, which is still in use, has had a big influence on the color models we use

for measuring colors. Although we don't use the Munsell system's numbers, we still use those three basic dimensions of color. HSV (hue, saturation, value,) HSL (hue, saturation, lightness), and HVC (hue, value, chroma) are three-dimensional color models and systems that are used for describing colors based on these attributes. Maybe you've already seen that Adobe uses HSB (hue, saturation, brightness) in the Color Picker in Photoshop, as shown in Figure 2.8. In this model, hue is described as "an angle around the center." Lightness or brightness increases from 0% at black to 100% closer to white, and, as expected, saturation increases from 0% for pure neutral to 100% for the most saturated and vibrant colors.

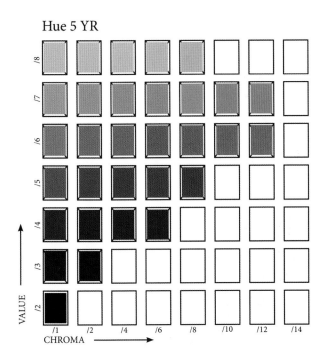

FIGURE 2.7 Simulated Munsell Value/Chroma Chart for red-yellow hue.
Credit: Illustration by the author, inspired by part of the New Munsell® Student Color Set

FIGURE 2.8 HSB (hue, saturation, brightness) display in Adobe Photoshop's Color Picker.
Credit: Photograph by the author

Color Measurement and Color Models

Munsell's system of organizing color is very important, but it still doesn't allow for objective measurements of all colors. Why is this important? If you want to manufacture a car or fabric in more than one country, but want the resulting color to be the same, then you need to be able to measure the resulting colors to confirm that the manufacturing processes are working. If you want the colors on an advertisement from a printing press to match the colors of your product, then you need to be able to tell the printer what color they are aiming to produce.

Defining the standards for measuring and communication colors has been the goal and reason for the Commission Internationale de l'Eclairage *(the International Commission on Illumination)*, or *CIE*. The CIE is the body responsible for standards in photometry and *colorimetry*, or the measurements of light and color, respectively. In order for the CIE to produce a system for measuring color, standards had to be established to describe three things: illuminants or light sources, measurement geometry, and the average human observer's color vision.

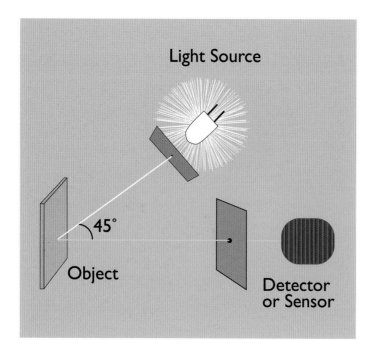

FIGURE 2.9 Color-measurement geometry.
Credit: Illustration by the author

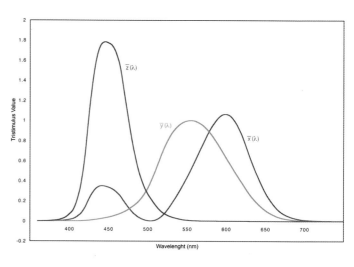

FIGURE 2.10 CIE 1931 Standard Observer.
Credit: Illustration by the author

- *CIE Standard Illuminants* or light sources include: D50, D55, D65, A, and F1 through F12. D50, D55 and D65 are daylight 5000, 5500 and 6500 Kelvin illuminants, respectively. CIE Standard Illuminant A is a tungsten light source. As you might guess, F1 through F12 are different standard fluorescent light sources.
- *Measurement geometry* is the angle at which the incident light falls on the measured object and is reflected to the viewer. In the example in Figure 2.9, the measurement geometry is 45 degrees.
- In 1931, the CIE established the *standard observer*, the average human observer's responses to different wavelengths of light viewed under a certain light source and at a certain angle—by testing fewer than 20 men. Based on the standard observer, the

CIE produced the CIE XYZ tristimulus (three responses of the three cones in our eyes) values and a model for measuring color stimuli (see Figure 2.10). For the first time, we finally had some real numbers that were based on measurements!

CIE-xy Chromaticity Diagram

To plot colors similarly to the HCV (hue, chroma, value) model of Munsell, the CIE developed the CIE-xy Chromaticity Diagram. In this model, as Figure 2.11 shows, all possible visible colors are contained in a horseshoe-shaped area. Wavelengths (from 380 to 720 nm) loop around the outside of the shape and are connected by the purple boundary. Colors closer to the edge are more saturated, and the neutrals, including light-source white points, are located in the lower

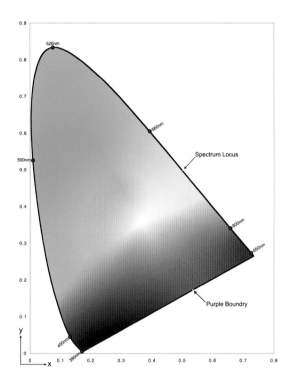

FIGURE 2.11 CIE 1931 XY Chromaticity Diagram.
Credit: Illustration by the author

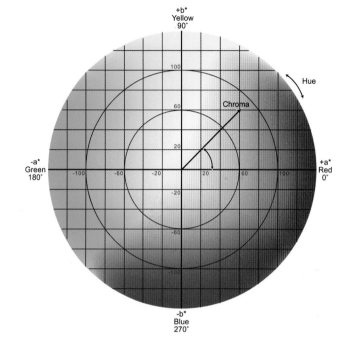

FIGURE 2.12 CIE LAB Color Space.
Credit: Illustration by the author

center. Not shown in this two-dimensional diagram is the third dimension, luminance, which runs from white to black (down into, behind, and back from the page). In its three-dimensional form, this diagram is referred to as the CIE xyY color space and is derived from the CIE XYZ color space tristimulus values. One problem with both of these color spaces is that distances between colors do not correspond to perceived color differences.

CIE-LAB

In 1976, the CIE adopted an additional three-dimensional color model, called CIE-LAB, in which the distances *do* correspond to perceived color differences, and is likewise derived from CIE xyY. In this model, 'L' is lightness (0 = black and 100 = white), 'a' is the red-green component (positive 'a' is red and a negative 'a' is green), and 'b' is the yellow-blue component (positive 'b' is yellow and a negative 'b' is blue). Neutrals are again in the center and have 'a' and 'b' values equal to zero. Figure 2.12 shows that colors have more chroma (or saturation) further away from the center. Changes in hue depend on the angle around the axis, which is called the hue angle.

The good thing for us about CIE-LAB is that the values are much more intuitive to understand than some of these other color spaces, like CIE-xy. We can read the numbers and know what color they represent. For example, hopefully it is easy to see that a perfectly

neutral middle gray would have a value of L = 50, a = 0, and b = 0. Take a look at Figure 2.23 to see some other examples of CIE-LAB values for three different colors.

It will be useful for you to work at understanding the *Lab* (i.e., CIE-LAB) numbers for two reasons: Lab is used under the hood with ICC profiles, as we will discuss in Chapter 6, and Lab values are used in Photoshop.

Color Measurement Devices

In photography and printing, the three main devices we use for measuring color on monitors and printed output are *densitometers*, *colorimeters*, and *spectrophotometers*.

Densitometers

Densitometers measure density and come in many types, including transmission and reflection. Density is the opposite, or *inverse*, of the transmission or reflection. If an object transmits or reflects all light, its density is *zero*. The higher the density, the more light that the object absorbs, and the darker it is. Density is described in logarithmic units, and every 0.3 units of density absorb one "stop" or half the light, since the Log of 2 is approximately 0.3.

Transmission densitometers are used to measure the light-stopping (or absorbing) ability of translucent or transparent objects such as photographic film and display materials. Reflection densitometers are used to measure the light-absorbing ability of reflective objects like the dye, pigment, ink, and paper combinations in prints, proofs, and press sheets. You will often see the maximum density (or d-max) of an ink-and-paper combination reported as a number like 2.25. *Once again: the higher the density, the more light that is absorbed, and the darker it is.*

Color densitometers, like the one in Figure 2.13, measure the light-absorbing ability of objects or ink-and-paper combinations while filtering the light source though three different filters: red, green, and blue. The result is three density measurements, or percent-ink

FIGURE 2.13 X-Rite eXact Densitometer measuring a press sheet. Credit: Photograph, © X-Rite, Incorporated

measurements, one for each of the three components of white light and the amount of cyan, magenta, yellow, and black ink. By measuring the amount of red light absorbed, we can find the cyan density or the percent of cyan ink. By measuring the amount of green light absorbed, the densitometer is able to produce the magenta density or the percent of magenta ink. Finally, by measuring the amount of blue light absorbed, the densitometer is able to produce the yellow density or the percent of yellow ink. These measurements are mainly used in quality control on printing presses and in systems that proof or simulate printing presses.

What the measurements from densitometers do *not* tell us is how the color of the object will be *perceived* by normal color vision under specific light sources. *Densitometry only tells us about the light absorption of the object.*

Colorimeters

Colorimeters, on the other hand, *do* tell us about the color perceived. Depending on the type of colorimeter, it will measure transmitted,

FIGURE 2.14 Blue-green color with Lab values of L= 50, a=-20, b=-18.

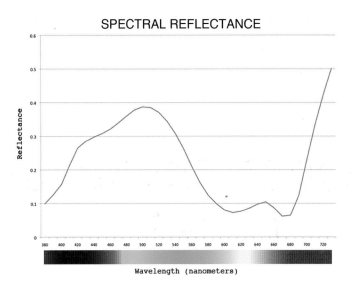

FIGURE 2.15 Spectrophotometry of color in Figure 2.14.
Credit: Illustration by the author

reflected, or *emissive* light though three to seven filters that are designed to match the human visual response. These measurements (along with CIE standard observer data and information about the light source, if applicable) are used to calculate the CIE XYZ tri-stimulus and/or CIE-LAB values. *We mainly use colorimeters to measure the emissive light and colors from monitors and displays.* You will see many examples of different colorimeters in the next chapter.

Spectrophotometers

Spectrophotometers also have the ability to tell us about the color perceived. Depending on the type of spectrophotometer, they measure transmitted, reflected, or emitted light from an object (or stimuli) at many different wavelengths. The original light source, or emitted light, is divided trough a

Colorimetry versus Spectrophotometry

Let's hammer home the difference between these two types of color measurement. *Colorimetry*, which we get from colorimeters or spectrophotometers, is the distillation of the color information down to how the color is perceived in three dimensions, as in the CIE XYZ or Lab color spaces. On the other hand, *Spectrophotometry*, which we can only get from a spectrophotometer, is the measurement of reflectance at around 30 different wavelengths in the visible spectrum, as we saw in Figure 2.15. Once again, you can get colorimetry from spectrophotometry, but not the other way around.

prism (or diffraction grating) to produce measurements throughout the visible spectrum. Typically, the measurements are made in increments of *ten nanometers* and result in thirty reflectance, transmittance, or emittance values from 400 to 700 nanometers.

As an example, the color in Figure 2.14 would result in the graphed spectrophotometric measurements in Figure 2.15. From this data, both densitometric and colorimetric values can be calculated. Spectrophotometers, which measure the spectral radiance or colors from emissive stimuli like monitors, are called *spectroradiometers*.

Additive and Subtractive Color Reproduction

Now that we know more about how color is measured, we need to discuss how color is reproduced. First, we need to make a distinction between the colors we see in the real world and the colors that are reproduced on our digital images. Our monitors and prints can only simulate or reproduce the colors of the world. One of the reasons we have trouble making the images from our monitor and the printer match is because they reproduce color in two very different ways: our monitors use the *additive mixing* of light, and our prints use the *subtractive mixing* of dyes, inks, and pigments.

Additive Color Mixing Theory

We use the additive color mixing of light to produce the colors shown by our displays. Additive color mixing works because of our tristimulus visual system, in other words, because we have three cones in our eyes that detect color. Based on the experiments and theories of the 19th-century physicist James Clerk Maxwell, and others, we know that as long as we stimulate all three (short-wavelength, middle-wavelength, and long-wavelength) cones in our eye with a high enough level of energy, we will perceive that we are seeing white light. Figure 2.16 shows the mixing of three lights: red, green, and blue. As you can

FIGURE 2.16 Additive color mixing with red, green, and blue light, along with red, green, and blue code values. White is in the center and is the combination of 255-red, 255-green, and 255-blue.
Credit: Illustration by the author

see, when all three lights are combined in the center, they produce white. The absence of all three lights results in black.

In terms of 8-bit RGB code values, in Figure 2.16 we see 0-red, 0-green, and 0-blue as black. 255-red, 255-green, and 255-blue are overlapping to produce white. The levels of all three can be varied to produce different colors. The absence of one color, and the combination of the other two, produces its complementary color. 255-red and 255-green makes yellow (the complement of blue), red and blue make magenta (the complement of green), and 255-green and 255-blue make cyan (the complement of red).

Maxwell's Triangle

Maxwell's Triangle in Figure 2.17 is a useful in understanding the three additive primaries: red, green, and blue, as well as their complements: cyan, magenta, and yellow. *What do we mean when we say that red and cyan are complementary colors?* Let's start by getting even more basic. What do we mean by complementary? When we describe two people in a relationship as complementary, we mean that they complete each other (think the line from the 1996 film *Jerry Maguire*). One partner is a good cook, while the other isn't. The other partner is good at fixing things around the house, while the other isn't. With respect to color we mean that red and cyan are complementary because they complete each other, too. This is because, together, red and cyan lights can reproduce white light. Why? Since, as we said above, green and blue light make cyan, the combination of red and cyan light is the same as combining red, green, and blue, which as we have seen reproduce white light.

Subtractive Color Mixing Theory

We use the subtractive mixing to produce the colors shown by our prints. Figure 2.18 simulates the subtractive color model by showing the mixing of three subtractive primaries (cyan, magenta, and yellow) as filters with light coming from behind. In this model, when cyan, magenta, and yellow colorants—such as dyes and pigments—are combined in full strength, they produce black. The absence of all three leaves the white of paper or clear film, depending on the substrate used to print onto. As before, the levels of all three can be varied to produce many different colors. The absence of one colorant and the combination of the other two produce its *complementary color*:

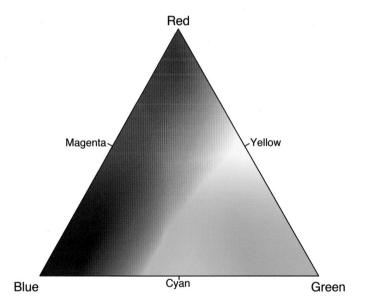
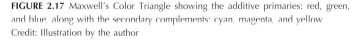

FIGURE 2.17 Maxwell's Color Triangle showing the additive primaries: red, green, and blue, along with the secondary complements: cyan, magenta, and yellow
Credit: Illustration by the author

FIGURE 2.18 Subtractive color mixing with cyan, magenta, and yellow filters.
Credit: Illustration by the author

yellow and magenta make red, yellow and cyan make green, and magenta and cyan make blue.

Why do we use cyan, magenta, and yellow inks and dyes in our prints—and not red, green, and blue inks? This is what we mean when we say our prints use *subtractive* color mixing. In subtractive mixing we start with white and go towards black, the opposite of additive color mixing with light. As we have discussed, white light is made up of three portions of the visible spectrum: red, green, and blue. As Figure 2.19 shows, the cyan in our prints absorbs, or subtracts, one-third of the visible spectrum, specifically its complement (the red part), and transmits the other two-thirds of the spectrum, blue and green (the parts that make it up). The same is true of magenta and yellow inks: they absorb only one-third of the spectrum (their complements) and transmit the other two-thirds. In the subtractive mixing we use in our prints, red, green, and blue inks would each absorb two-thirds of the spectrum and transmit only one-third. This is a problem, because if you mixed any two additive primary inks, let's say green and red (also seen in Figure 2.19), you would get black, since all the light would be absorbed. Red, green, and blue, as subtractive inks, are too greedy! (That being said, some inkjet printer manufacturers are adding red, green, blue, and orange inks to some of their printers to help increase color gamut on the print. They are, but they are not replacing cyan, magenta, and yellow, which are still doing most of the color reproduction work.)

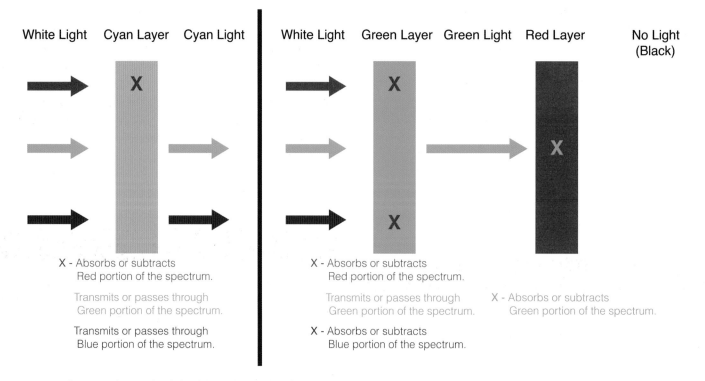

FIGURE 2.19 Subtractive color: (1) white light (and its red, green, and blue components) going through a cyan layer, which absorbs red and transmits green and blue and (2) white light through a green layer, which absorbs red and blue and transmits green, and then a red layer that absorbs the green leaving nothing left but black. Credit: Illustration by the author

What about the K in CMYK?

As we've just seen, according to subtractive color theory we should be able to produce a full range of colors with just three colorants: cyan, magenta, and yellow. And, in fact, in photographic color prints (C-prints) there are just three emulsion layers with varying densities of cyan, magenta, and yellow dye (CMY). So why, in graphic arts printing and in most inkjet printmaking, do we talk about CMYK? On the printing press and in our inkjet printers, the images are created with cyan, magenta, yellow, *and black* inks in the form of halftone dots. The K stands for *black*. Why use a K and not B? It comes down to the fact that, if we used B, there could be confusion between blue and black. Why is it there to begin with? Black ink is added because of impurities in the cyan, magenta, and yellow inks, which do not give a true black from the combination of full CMY inks alone. Typically we end up with a muddy brown or green, so we add the black ink to insure a true black.

There are also other benefits to having black ink. Using one ink for black is useful for printing text. When printing on a printing press, it is very difficult to keep all the inks in register (in exact position one over the other). I'm sure you've seen this in newspapers or magazines. Misregistration is especially noticeable in fine line details, such as text, where the text can become blurry and difficult to read. The black ink can also help save money when printing neutrals. Instead of using three inks to produce grays or neutrals, you only need one. When printing many copies, these savings can add up.

Color Gamut Mismatch

The fact that the monitors and prints reproduce or display colors in such different ways (additive versus subtractive) causes some of the major frustrations in maintaining accurate color in digital printmaking. The monitor does not match the print; the print does not match the monitor. This is partially because both systems produce colors that the other cannot reproduce. These colors are said to be "out of gamut." Color gamut is defined as *the set or range of colors that can be seen*

or produced by a particular device or process. Colors that are beyond this range are said to be out of gamut.

The chromaticity diagram in Figure 2.20 shows a comparison between the color gamut of a specific CRT monitor and CMYK printing on two different paper stocks. The uncoated paper print produces the smallest gamut. This makes sense, since it would be like printing on plain paper as opposed to coated inkjet paper. You don't get the same dynamic range or saturated colors as you would on the coated paper. Even the coated paper cannot produce all the colors of the monitor, and the monitor cannot display all the colors that can be produced in the coated paper. Perfect reproduction doesn't work in either direction! Don't get too discouraged. None of this is new.

Photography has never worked perfectly. Photographs, even photographic slides/transparencies/chromes (with all their gamut and dynamic range), have never been able to reproduce all the colors of the world. Photographs have always produced a rendering we accept as a representation of the colors of the world. One of the challenges of digital color management is to help deal with these mismatches in color gamut that result from the differences in the additive and subtractive color systems. Will any of the color management tools we talk about completely solve this problem? The answer is NO. These are the physical limitations of the processes. What color management *will* help us do is get as close as possible—within the limits of our equipment and materials.

Color Management

The general term for any technology that predictably brings the color of an artist's vision to the printed page is color management. The artist may be a commercial or a fine artist. The technology may be old or new.

Pantone Swatchbook

One older technology that uses pre-printed swatches is the Pantone Color Matching System. In this elegant system, an art director or

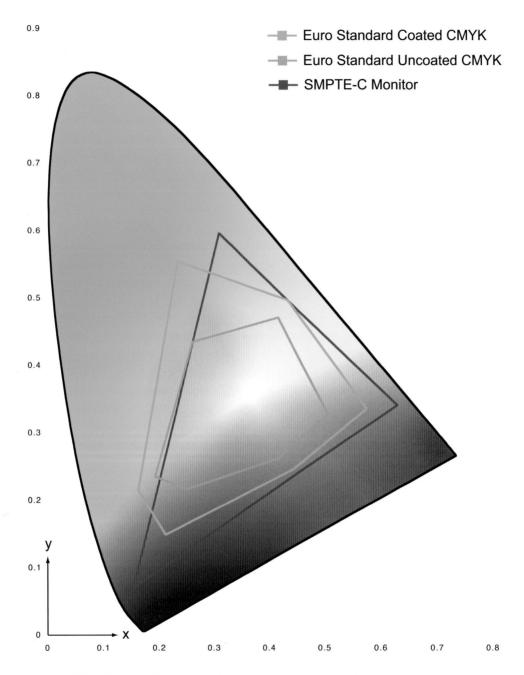

FIGURE 2.20 Gamut comparison of a CRT monitor and printing press output on a coated paper and an uncoated paper.
Credit: Illustration by the author

FIGURE 2.21 Pantone Swatchbook System.

graphic designer selects a color from the appropriate sample book (one is shown in Figure 2.21), for coated or uncoated paper, depending on the surface the piece will be printed on. This way, the choice of color being presented to the client is limited to the gamut (or range of colors) that is possible for that ink and paper combination to produce. This sets reasonable expectations for everybody involved.

The next step is to communicate to the printer (the person putting ink to paper) the Pantone color that has been selected. The Pantone color number tells the printer the ink formulation or recipe: how much cyan, magenta, yellow, and black ink needed to produce the color on that paper type. Those two steps—limiting the choices to colors that can be reproduced, and giving the formula to produce that color make this color management system very effective.

Similarly, fine art printmakers have produced samples of ink combinations on the paper to be used to help artists in planning and visualizing the final printed piece. These communication tools help the artist and the printer to devise realistic expectations and to produce the expected results more efficiently.

The same is true of digital color management tools, which consists of any hardware, software, or methodology to control and adjust color in an imaging system with the goal of getting accurate consistent color—or, at least, as close to accurate as possible.

Closed-Loop Color Management Systems

As with other technologies used in printmaking, color management also has its roots in the commercial world. Before "desktop" printing, "managing" color was the responsibility of the scanner operator, a professional who was (and is) highly trained in commercial printing and fine art reproduction. Typically for the scanner operator, managing color for high-quality reproduction meant rendering the larger color gamut and dynamic range of photographic transparencies to fit into the smaller gamut and dynamic range of the printing press (ink-and-paper combination). Usually, this was done in a closed-loop system, meaning that scanning was done to work on one specific printing press. Most early digital color management systems were also closed-loop in nature: one scanner to one printer.

Some photographers might still work this way today. If their monitor or display doesn't match the image coming off the printer, they might adjust the monitor's color, contrast, and brightness controls until it matches what was coming off the printer. But this closed-loop color system has problems: it's much too fragile. The combination may work for this display and printer/paper and not for anything else. If you send the image to another printer, perhaps at a lab, then the resulting print won't look right. If you send the image to someone else's monitor, like a relative or a client, it won't look right. If you send the image to the same printer, but on a different paper, it won't look right. The closed-loop system is just too fragile.

Open & ICC-Based Digital Color Management

The advent of desktop publishing brought about the need for more control and flexibility in color management, since images could be input from many different scanners or digital cameras, viewed on a variety of monitors, and output in many ways. The system needs to be more open. To use a musical analogy, we have gone from a one-man band to an orchestra; we now need a conductor if we are to produce beautiful music.

The challenge for digital color management is to understand the differing ways that devices produce color and enable consistent, accurate color throughout the production process—from scanners and digital cameras to monitors, and, finally, on printers and printing presses. As we have said, the main goal for our open digital color management is accuracy and consistency through all our devices. So, how do we get there?

Characterization, or profiling, on the other hand, is a description of the *color capabilities or limits of a device or process*. In other words, the characterization is the color gamut or the range of colors that the device or process can see, display, or produce once the device is in the calibrated state.

This characterization takes the form of an *ICC Profile*. What does the ICC part stand for? In 1992 a group of computer, digital equipment, and media manufacturers (Microsoft, Apple, Fuji, Kodak, and others) founded the International Color Consortium (ICC) to develop the standards that would allow for a more open system for maintaining consistency and managing color. In other words, they wanted all of their different devices to be able to talk to one another and get as close a match as possible.

The profile the ICC developed is a standard format for the characterization of digital devices and processes. Dawn Walner of Sun Microsystems described the ICC profile as a file containing "text descriptions of specific devices and their settings along with numeric data describing how to transform the color values that are to be displayed or printed on the device."

Inside the ICC System

What's going on inside an ICC profile? And how do ICC profiles for different devices work together? To describe the whole thing in a very technical way we could say, "The numerical part of the profile includes *matrices* and *lookup tables (LUTs)* that a *color management module* (*CMM*, another important standard developed by the ICC) uses to convert that device's colors to a common color space, defined by the ICC and called the *profile connection space* (PCS), and back to a device color space."

Let's unpack the definitions and then process the different parts of this statement. First let's look at the inside of an ICC profile. Figure 22.2 shows a matrix in an ICC profile for my display. A matrix (plural "matrices") is a rectangular arrangement of a mathematical expression, which for our purposes is used to transform colors from a device space like red, green, blue (RGB) to a device-independent color space like CIE XYZ. A lookup table, like the one we see in Figure 2.23, is an actual table of values—instead of being a mathematical formula—in which the device-space values have corresponding values in the device-independent color space, in this case, CIE-LAB.

Calibration versus Profiling

Regardless of which device we are working with, color management always has two stages: *calibration*, and *characterization* or *profiling*. Calibration means bringing any device to an *optimal repeatable state*. The optimal part of calibration is putting the device in its best condition first, such as making sure your print is working properly and you are using the optimal ink level for the type of paper you are using. The repeatable part of the calibration means that this optimal condition is something you want to maintain over time. This brings consistency to the device and the process.

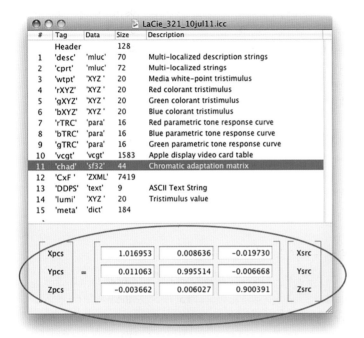

FIGURE 2.22 Matrix from a display ICC profile.

The color management module, or CMM, is a calculator that performs the transformation from one color space into the other. It doesn't necessarily have a big impact on the results.

Profile Connection Space (PCS)

The profile connection space or PCS, shown at the center of Figure 2.24, is the device-independent component of the ICC's vision that allows for the flexibility and open architecture we said was desirable in a color management system. Currently the two profile connection spaces are CIE-LAB and CIE XYZ. What is nice about colors in these two spaces is that they are agreed-upon standards and that everyone accepts the actual exact colors represented by the values. That is not the case in device spaces like RGB or CMYK.

Figure 2.24 shows how the profiles and the PCS work together in the ICC architecture. As an example, let's start at the top with an image that has been scanned in RGB and then transform the image

INPUT Profile (Device Space→Lab)						OUTPUT Profile (Lab→Device Space)					
Red	Green	Blue	L	a	b	L	a	b	Red	Green	Blue
229	229	234	91	1	-3	91	1	-3	220	230	233
75	123	64	46	-39	26	46	-39	26	66	150	50
137	61	110	41	46	-9	41	46	-9	150	50	110

FIGURE 2.23 Example of Lookup Tables from ICC profiles.

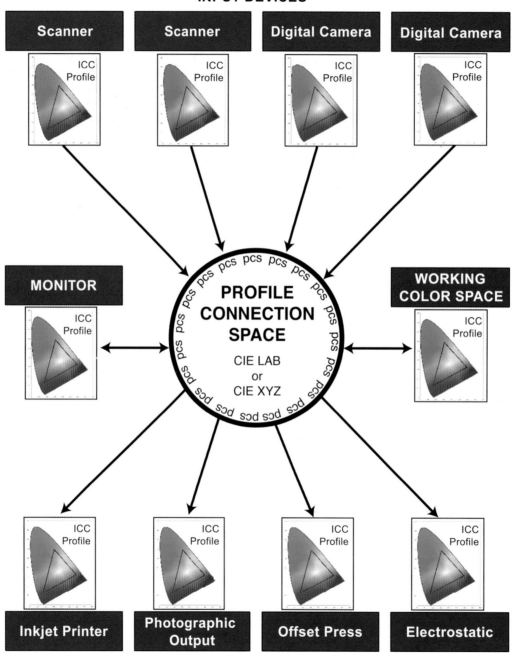

to get a match on an RGB inkjet printer. The scanner input ICC profile tells us what the RGB numbers from the scanner mean. The scanner profile has a lookup table, like the one on the right side of Figure 2.23. As you can see, the second row of this input profile's lookup table says that the combination 75-Red, 123-Green, and 64-Blue from the scanner actually means the specific green color in CIE-LAB is 46-L, -39-a, 26-b. If we then want to get this same exact green on a printed inkjet output, the lookup table on the right for the output profile says the RGB values would need to be adjusted to 66-Red, 150-Green, and 50-Blue. The output ICC profile tells us about how the device reproduces color and helps us understand what RGB or CMYK values will be needed to get the closest match possible.

Another way to think of the profile connection space in the ICC architecture is as the common language used by a translator. All of the devices in Figure 2.24—scanners, digital cameras, monitor, and printers—speak a different language of color and they do not speak each other's languages. Even if many of them speak in RGB, the RGB from one device does not mean the same color as it would from or on another device. The ICC profiles acts as a translators into and out of the common language (PCS).

EXPLORATIONS

If you have Adobe Photoshop, explore the **Color Picker** (Figure 2.25), which you can find at the bottom of the toolbar. Open an image and sample many colors from the image. Review the three dimensions of color Munsell discussed: hue, value, and chroma. Start to understand the values in RGB, CMYK, and Lab. Click on the **Color Libraries** to see a version of the Pantone system's colors.

FIGURE 2.25 Color Picker from Adobe Photoshop.

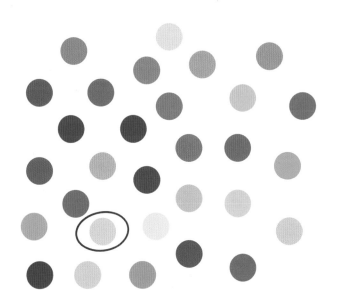

FIGURE 2.26 Answer for the question in Figure 2.3. Were you able to pick the blue from Figure 2.2?
Credit: Illustration by the author

FIGURE 2.24 *(facing page)* ICC Architecture with device color profiles and Profile Connection Space (PCS) in the center.
Credit: Illustration by the author

Conclusion

Hopefully you have seen that the common thread in everything we have discussed in this chapter has been about improving communication, specifically how we communicate about color. Albert Munsell did this first by organizing color in a logical three-dimensional model. Then the CIE created ways of putting exact numbers that describe specific colors into the XYZ and Lab color spaces. The colorimeters and spectrophotometers we discussed are able to objectively measure the colors of the world—as well as the colors of our monitors and prints—much more consistently and accurately than we would be able to detect with our visual system or describe with our limited language. Finally, color management systems, like the ones from Pantone or the ICC, help us to control, as much as possible, the reproduction of colors.

Now that some of the overall components of ICC-based color management architecture have been discussed, we will, over the next few chapters, look at some of the practical issues of how to use color management in photography and digital printmaking. Specifically, we will review the tools and procedures used to color manage displays, digital cameras, and printers.

Resources

Munsell Color Division of X-Rite
 http://munsell.com/
The New Munsell® Student Color Set, ISBN: 1563672006.

Giorgianni, Edward J. & Madden, Thomas E., *Digital Color Management Encoding Solutions*, Addison-Wesley, Reading, MA, 1988.

Hunt, R. W. G., *Measuring Colour*, Ellis Horwood Ltd, Chichester, England, 1987.

Walner, Dawn, *Building ICC Profiles—The Mechanics and Engineering* [PDF], 2000. Retrieved 2009 from http://www.color.org/iccprofiles.html.

©Ana Priscilla Ruiz
crimsonh.co@gmail.com
cell: 818 859 8991

©Chong Uk Koh

© Nayoungkim

© Dhruv Malhotra

© YOUNGHOON KIM

* TEST IMAGE

PRINT INFORMATION
Paper :

© Giovanna Grueiro

Three

EVALUATING IMAGE QUALITY, PRINT QUALITY & TEST PAGES

Before we start looking at how to calibrate and profile displays, scanners, digital cameras, and printers in the next few chapters, we first need to build our skills at analyzing and testing image and print quality. In this chapter we will start looking at our images and prints for the inevitable problems they might have and opportunities for improving them. We need to need to be able to both detect and communicate about the different aspects of image quality, so that you have the critical eye and the necessary vocabulary to make the best prints possible. After discussing the importance of the evaluation lighting, we will review the main terms to use when analyzing different aspects of image and print quality. Then we will look at the elements needed for an effective test page, like those in Figure 3.1, which will be an important tool for making sure our equipment and color management systems are working as well as they can.

Evaluation Lighting

Images and prints, like all objects, will vary in perceived colors and tones under different light sources. So we must take the evaluation lighting into account when viewing an image or print.

Display ICC profiles are built with the assumption that the image on the screen is being viewed under a light source with a specific color temperature and intensity combination recommended by the International Standards Organization—5000 K and 60 lux—which is a relatively subdued lighting condition.

Output profiles, on the other hand, are built with the assumption that the print is being viewed under a light source with a specific color temperature and intensity combination, 5000 K and 2000 lux. These are the conditions that most standard viewing booths attempt to create, and that is why they're excellent for print evaluation. In the graphic arts industry in the United States, controlled viewing booths with these conditions are used for customers and printing professionals to review contract proofs, get agreement on color, and signing off on contract proofs, before printing very expensive commercial printing jobs.

In fine art applications, there are some good arguments that the light source you should evaluate your prints under should be the same

FIGURE 3.2 Solux print lighting in MPS Digital Photography department at the School of Visual Arts, New York, NY.
Credit: Photograph by the author

light source they will be illuminated under when they are exhibited. Viewing booth conditions won't typically be the same as the viewing conditions in a gallery. More typically they will be tungsten lights with a color temperature around 3200–4100 K. The Solux bulbs and light fixtures in Figure 3.2 use 3700 K. Of course, one limit to our ability to evaluate the print under the exhibition lighting is the fact that you

FIGURE 3.1 Test pages created by School of Visual Arts photography students. From the top left: Chong Uk Koh, Ana Priscilla Ruiz, Christopher Borrok (partial page), Christopher T. Kirk; second row: Nayoung Kim, Dhruv Malhotra (partial page), Tara Lynn Johnson; third row: Azhar Chougle, Giovanna Grueiro (partial page), Young Hoon Kim, Christopher Patrick Ernst.

might not know what this lighting will be, or if the print is exhibited in a room with a window or mixed lighting, the viewing conditions could be continually changing and impossible to duplicate.

One temptation will be to view the print under the same lighting we're using for our computer display and compare the two. The problem with this is that, as we said before, the ISO standard viewing condition for a display is much dimmer than it is for print, and it is much too dim a lighting condition to evaluate print quality. Our print will always look too dark when viewed in subdued lighting.

All this being said, we must keep the evaluation lighting in mind when we evaluate our images on screen and as prints and come up with some strategy. How are you going to illuminate your prints to evaluate their quality?

Analyzing Print and Image Quality

Let's say you have an image on the screen and in print form. If everything has gone well, the image should match (as closely as possible) in both. But how do you judge and communicate the quality of the print to describe if there are any problems with the image or print? We need to build our technical language to help us communicate better as we are evaluating the quality of our images and prints. The aspects of image quality we will be looking at are neutrality and color balance, lightness and darkness, contrast, saturation, details, tonal quality and smoothness of gradations, and color rendering and reproduction.

Neutrality & Color Balance

If an image or print has an overall unwanted color, we say it has a colorcast, or that the color balance is off. If the image or print does not have a colorcast, it's described as being neutral. Colorcasts or color balance shifts are typically described by the predominant hue that is seen and the strength of that color. Traditionally, in photographic

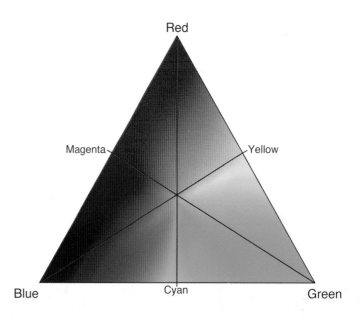

FIGURE 3.3 Maxwell's Triangle, highlighting the axes of typical colorcasts: red-cyan, green-magenta, and blue-yellow.
Credit: Illustration by the author

color printing, the three main axes of color balance correspond with the three complementary pairs found on Maxwell's triangle: red and cyan, green and magenta, and blue and yellow, as seen in Figure 3.3. For example, if a print is too blue, we want to move the color balance away from blue and towards yellow.

When evaluating whether a print has a colorcast, it helps to evaluate an image that contains neutrals (whites or grays) or near neutrals, like a skin tone. In Figures 3.4, 3.5, and 3.6, we are using a completely neutral grayscale image. In each of the three figures, the middle image is the same and has no colorcast. From left to right, Figure 3.4 shows the image with a strong red cast, then a slightly weaker red cast, the neutral version, then with a cyan cast, and finally with a stronger cyan cast. Figure 3.5 shows the image with a strong green cast, then a slightly weaker green cast, the neutral version, then with a magenta cast, and finally with a stronger magenta cast.

FIGURE 3.4 Colorcasts/color balance on a grayscale image along the red-cyan axis. From left to right: strong red cast, moderate red cast, slight red cast, neutral image in the center, slight cyan cast, moderate cyan cast, and strong cyan cast.
Credit: Photograph by the author

FIGURE 3.5 Colorcasts/color balance on a grayscale image along the green-magenta axis. From left to right: strong green cast, moderate green cast, slight green cast, neutral image in the center, slight magenta cast, moderate magenta cast, and strong magenta cast.
Credit: Photograph by the author

FIGURE 3.6 Colorcasts/color balance on a grayscale image along the blue-yellow axis. From left to right: strong blue cast, moderate blue cast, slight blue cast, neutral image in the center, slight yellow cast, moderate yellow cast, and strong yellow cast.
Credit: Photograph by the author

Figure 3.6 shows the image with a strong blue cast, then a slightly weaker blue cast; next is the neutral version of the image, then one with a yellow cast, and finally with a stronger yellow cast. It's possible for colorcasts to be different at different tonal levels within the image. The term to describe this characteristic or defect is *crossed curves*, which is a term from film-based color printing. An example of crossed curves would be a print with green shadows (dark areas) and magenta highlights (light areas). A colorcast can also be limited to part of an image or scene within an image, and would be corrected with selective color masking.

By the way, you'll be seeing this image of the rock formation a few times more. Just in case you are wondering, I took it on Kangaroo Island in South Australia.

Lightness and Darkness

There are many ways to describe a print that looks too dark or too light overall. A print that is too dark can be described as *too low in value, too heavy* (as in having *too much density)*, or, from a film-based photographic printer's perspective, it could be called *overexposed*. Conversely, a print that is too light could be described as being *too high in overall value, having too little density,* or as being *an underexposed print.* Although we are not producing darkroom prints, the traditional darkroom terms are deeply rooted in our language for describing print quality. Since an inkjet print does not receive an exposure, the fact that it is light could be the result of overexposure of the image or sensor, but not underexposure of the print. The brightness of an image is a description of the overall tone of the print or image, or portion of the print or image. It's possible to describe a print (or elements of a print) as being too dark, heavy, having too much ink lain down, or too much density, like the image on the right in Figure 3.7. Or, it's possible to describe the print (or portion of the print) as being too light or as having too little density, as with the image in the left in Figure 3.7.

Contrast

Figure 3.8 shows the same image with three different amounts of contrast. To better understand the difference we first need to understand the range of tones within our images. The possible tones in an image can be divided into three types: light tones or highlights, the middle value tones or mid-tones, and the dark tones or shadows. You also might encounter people in the graphic arts world who add two more tonal ranges. They would describe the tones between highlight and mid-tones as the quartertones and the tones between the shadows to mid-tones as the three-quarter tones. So, in order, the tonal ranges of the print from darkest to lightest are: shadows, three-quarter tones, mid-tones, quartertones, and highlights. For the most part, we will discuss our images and prints just using shadows, mid-tones, and highlights, as shown in Figure 3.9.

The contrast of the image is described as "the transition of tones from dark to light or from the shadows to the highlights." An image or print described as being *low in contrast* does not have a large range of tones. It has less of a tonal difference between the dark parts of the print and the lighter parts of the print, as with the left image in Figure 3.8. As you can see, this low-contrast image has less snap or depth and could be described as flat or dull. With a *high contrast* images, on the other hand, the tonal difference between the highlights and shadows are more extreme, and there are fewer mid-tones, as with the version on the right in Figure 3.8. The negative side effect of high-contrast imagery can be a loss of detail in the highlights and/or shadows. If a print or image has *normal contrast*, it means there's more of a balance of tones in highlights, mid-tones, and shadows, as with the center image in Figure 3.8.

Saturation

As we discussed in the last chapter, the saturation of a color is based on how pure the main hue of the color is. The purer the hue, the more saturated the color. On the other hand, the closer the color is to neutral, the less saturated or more desaturated that color is said to be. It is important for us to be able to determine if the colors of our images

FIGURE 3.7 Differences in lightness and darkness. From left to right: light version of image, original image, and dark version of image.
Credit: Photograph by the author

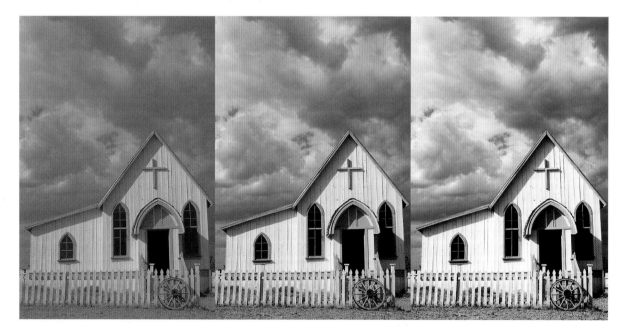

FIGURE 3.8 Differences in contrast. From left to right: a low contrast version of the image, the original image, and a high contrast version of image.
Credit: Photograph by the author

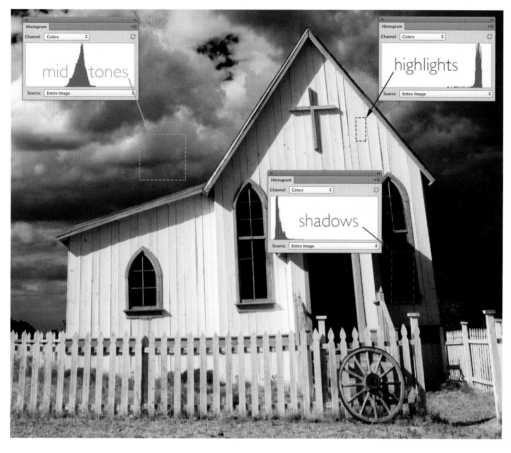

FIGURE 3.9 Labled image showing the shadows, midtones, and highlights, along with the corresponding histogram for each selected area shown.
Credit: Photograph by the author

or prints are possibly too saturated or too de-saturated. Too much or too little saturation will be especially noticeable in skin tones, as seen in Figure 3.10. I'm sure you've seen this before: a certain level of saturation can help an image have more punch, vibrancy, and life, but too much (or too little) saturation can make an image look artificial. As with lightness and contrast, there are no absolute rules about how much saturation should be rendered in your images and prints, but you should be able to see when you have more or less saturation in different parts of your image than you want.

Highlight, Shadow, and Color Details

After looking overall, there are many parts of the print to evaluate specifically for detail. Look at the dark areas for *shadow detail*. Look in the light areas for *highlight detail*. The loss of detail in these areas of the image can be called *clipping*, and more specifically *highlight clipping* for loss of details in the light areas and *shadow clipping* for loss of detail in the shadows. Check saturated colors to see if details are missing. Often the remedies for problems in these areas are

FIGURE 3.10 Differences in saturation. From left to right: a low saturation version of the image, the original image, and a high saturation version of the image.
Credit: Photograph, © Brittany K. Reyna

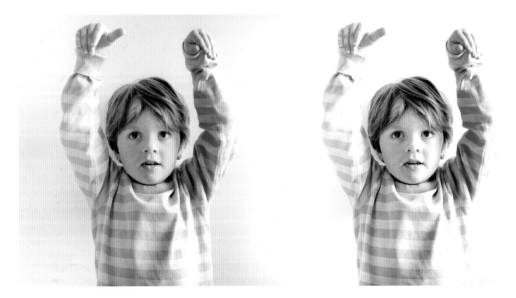

FIGURE 3.11 Highlight detail. The version of the image on the right shows a lack of highlight detail, which is found in the version on the left.
Credit: Photograph, © Christopher Borrrok (borrok.com)

FIGURE 3.12 Shadow detail. The version of the image on the right shows a lack of shadow detail, which is found in the version on the left.
Credit: Photograph by the author

FIGURE 3.13 Saturated color with detail. The version of the image on the right shows a lack of detail in the saturated red fabric, which is found in the version on the left.
Credit: Photograph, © Giovanna Grueiro (giovannagrueiro.com)

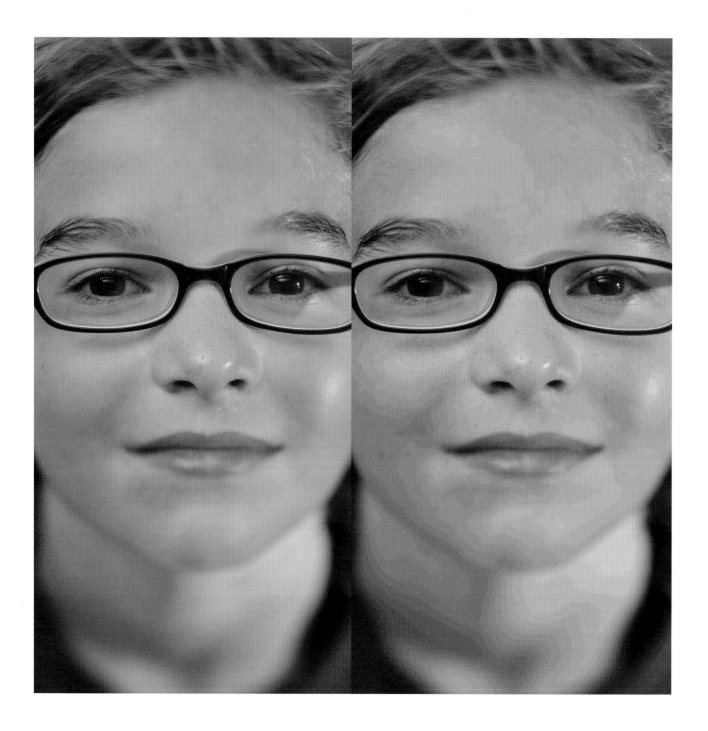

FIGURE 3.14 Posterization. The version of the portrait of Adrienne on the right shows a lack of tonal quality resulting in breaks in what should be smooth transitions or gradations. This defect is called posterization, which is not present in the original version on the left.
Credit: Photograph by the author

described in darkroom printing terms, such as: *burn-in the highlights* (to darken and possibly bring out detail) or *dodge or open up the shadows* (to lighten the dark areas and possibly bring out detail). When evaluating image or print quality, it's important to monitor the amount of detail that's been maintained in different portions and aspects of the image. Figure 3.11 shows the loss of highlight detail in the right-hand image from the original image on the left. Then, Figure 3.12 shows the loss of shadow detail on the right from the original image on the left. Finally, Figure 3.13 shows the loss of color detail, especially in the orange, and somewhat in the red towel, on the right compared with the original image on the left.

Tonal Quality and Smoothness of Gradations

Part of the tonal quality of a digital image or print is found in the ability to render smooth gradations or transitions in tones and colors without breaks in the transition. When we see breaks in transitions that should be smooth, we call this defect *posterization*. In Figure 3.14, the image on the right shows posterization in my niece's face and neck, especially in the transitions from shadow to highlight. You will get a similar artifact from too much compression when saving a JPEG file. In this case, the presence of posterization is described as "JPEG artifacts."

Color Rendering and Reproduction

Look at colors you know in the print, such as the blue of the sky or green of the grass, to see how they are rendered and reproduced. While other elements of the image could be well balanced for neutrality, the sky could appear too purple or magenta, as seen in Figure 3.15. As we already discussed, remember that there are no absolute rules of right and wrong in printing. The optimal appearance of a final print depends on many factors, including subject matter and the aesthetic and artistic goals of the photographer. So when we evaluate our prints and the prints of other photographers, we should take this into mind. The translation of colors from input, through to the display and the print or color rendering, can result in shifts in hue, tone, and saturation from what is expected. In the example in Figure 3.15, the blue of the sky has shifted in hue, and is more magenta than expected. These shifts are especially important to watch for in memory and product colors when evaluating image and print quality, since our viewers will have expectations of their appearance.

Creating a Test Page

Now that we have discussed how to evaluate our images, this seems like a good point to discuss creating a test page that will help us to utilize these skills. Each semester I have students create test pages to help test their color management workflow. You can see the results of what the students have produced over the years in Figure 3.1.

The test page gives you a meaningful reference tool to help evaluate the quality of printers, papers, monitors, ICC profiles, ICC profiling packages, and service providers. By having a standard test page that you consistently use to test quality (instead of using different images every time), you'll be able to detect subtle—and not so subtle—differences, benefits, and flaws, both more effectively and more efficiently. By using your own images as often as possible, the target will be more meaningful, and also more useful for evaluating quality differences that impact the palette and idiosyncrasies of your own work.

To make the test page as useful as possible, it helps to incorporate the following elements:

- skin tones
- neutrals
- memory colors
- saturated colors with detail

FIGURE 3.15 *(top left)* Change in hue. The version of the image on the right shows a shift in the hue or color balance of the sky only to more magenta, resulting in a violet sky, which is not present in the original version on the left.
Credit: Photograph by the author

FIGURE 3.16 *(bottom left)* Kodak Color Evaluation Target, designed by Scott Gregory.
Credit: © Eastman Kodak Company

FIGURE 3.17 *(below)* Test page designed by the author with images by Tom Ashe, Barbara Broder, Jungmin Kim, Brittany Reyna, Christopher Sellas, and Adam Wolpinsky.

- highlight and shadow details
- color references (X-Rite ColorChecker)
- grayscale, grayscale steps, and spectrum gradations
- space for labels.

Let's look at three test-page examples and examine them for the elements they contain— and the ones they are missing—that could help make them more useful. Figure 3.16 shows the Kodak Color Evaluation Target, which was designed by Scott Gregory, a color scientist and engineer. Figure 3.17 is a test page I created with a

FIGURE 3.18 Test page designed and including photographs by Allen Furbeck, with added portrait by Tom Ashe.
Credit: Test page by Allen Furbeck (allenfurbeck.com) with portrait by the author

combination of my own images and images by photographers Barbara Broder, Jungmin Kim, Brittany Reyna, Christopher Sellas, and Adam Wolpinsky. Figure 3.18 is a target that was created by Allen Furbeck—a photographer, painter—which I slightly modified by adding a portrait.

All three examples have some very useful elements for evaluating color and tone quality.

Skin Tones

As mentioned before, we are naturally sensitive of how skin tones are rendered and reproduced, partly because they are relatively close to neutral, and partly because we look at each other more thoroughly than we do at inanimate objects. This is why you see at least one skin tone in most of the test pages. The use of a variety of skin tones in the Kodak target is especially helpful. One thing to watch for in skin tones is the transition from highlight to shadow. This is often an area that can produce defects such as posterization or oversaturation in the shadows.

Neutrals

Although there's no true black-and-white image in the Kodak Evaluation target, the image in the upper left focuses on subtle transitions in neutrals within a color image. The image in the upper left of the test page in Figure 3.17 is a black-and-white conversion from the image in the upper right. Allen Furbeck has included a black-and-white snow scene in his test page in Figure 3.18. As you might imagine, at least one black-and-white image in our test page should not have any toning, so it helps us to see neutral shifts as easily as possible. It is also useful if the image has a full range of tone, including highlights, mid-tones, and shadows. This can be useful for seeing color balance and cross curves and differences in color cast in the shadows, three-quarter tones, mid-tones, quartertones, and highlights.

Memory Colors

Since, as mentioned above, we are sensitive to inaccuracies or shifts in hue of memory colors (such as blue sky, green foliage, or product

colors), they are very useful to add to our test pages. The only memory colors in the Kodak target are the products in the image on the lower right. In my test page on Figure 3.17, there is the blue sky in the image on the upper right, the foliage in the lower left and the image of the red flower, the red of the tomatoes, and the yellow of the lemon. In Allen Furbeck's image in Figure 3.18, he has included blue sky, and both green and red-orange foliage.

Saturated Colors with Detail

We want to watch for the loss of detail in saturated colors, which may show up when we print our images. In the Kodak target, the towels in the lower-right image and the maroon portion of the necktie in the upper-left image are the most useful elements for watching what happens to details in saturated colors. In my test page, the saturated red flower by Barbara Broder serves this function.

Highlight and Shadow Details

With the compression of tones that occurs from scene to print in photography, the ability to maintain detail in the extremes is important. To monitor this, the Kodak target gives us the high-key pillow image in the upper right to monitor highlight detail and the dark grey mannequin form in the upper-left image (as well as the models' dresses in the portrait) to monitor shadow detail. My test target in Figure 3.17 uses the rock-formation images on the upper right and left to monitor both highlight and shadow detail. In addition to images, Allen Furbeck has added two very useful targets for watching and measuring changes in highlight and shadow detail. Notice the dark area under the urban landscape in Figure 3.18. Here Allen has created a tool for watching shadow detail by fabricating squares on a pure black background. Each square is slightly lighter than the previous square by one unit of lightness from CIELAB, where 0 is black and 100 is white. He has also included a corresponding target to watch highlight detail, which is next to the grayscale and grayscale gradient. Here the background is white, with a code value of 255 in all three channels (red, green, and blue) and the patches get successively darker as the code values

go down from 254 (just under the maximum code value of 255). As you can see, I like his idea so much that I stole it and added the tools to my target as well.

Color References (X-Rite ColorChecker)

The colors for the X-Rite ColorChecker are very useful to have in your test page, since they are well known and representative of a wide variety of colors including: additive and subtractive primaries, skin tones, foliage colors, and neutrals. The actual target is one of the most photographed and filmed objects in the world and the patches are made from Munsell papers. I am a fan of including the ColorChecker in its well-known 6 x 4 patch formation, as I did in my test page in Figure 3.17. Although the colors from the X-Rite ColorChecker are not present in the Kodak target in Figure 3.16, that target does provide patches of primary colors—such as red, green, blue, cyan, magenta, and yellow—and reference colors from the images. Allen Furbeck has included all of the ColorChecker patches in his color swatches on the left side of Figure 3.18, in a formation that can be easily read by a spectrophotometer. These color-reference patches (as long as they are large enough) are especially useful for making measurements after the fact, with either densitometers or spectrophotometers, to evaluate color reproduction.

Creating Grayscale, Grayscale Steps, and Spectrum Gradations

The steps for creating these three tools in Adobe Photoshop are as follows:

1. Grayscale
 - Create a new layer on your test page document by clicking on the second button from the right at the bottom of the **Layers** palette, as shown in Figure 3.19.
 - Name the layer **Grayscale**.
 - Create a rectangular selection, about 1/2 inch high by 4 or 5 inches long.
 - Select the **Gradient Tool** from the toolbar, which shares a spot with the Paint Bucket tool, as shown in Figure 3.20.
 - Select the **Black, White** gradient, the **Liner** gradient, the **Normal Mode** and make sure **Dither** is NOT checked, as also shown in Figure 3.20.
 - Click and drag while holding the shift key, from the center of one end of the long dimension of the selection to the other.

2. Grayscale Steps
 - Duplicate the grayscale layer, by clicking on **Layer** on the menu bar and dragging down two spots to **Duplicate Layer.**
 - Name the layer **Grayscale Steps**.
 - Click on **Image** in the menu bar and drag down to **Adjustments** and then **Posterize**, as seen in Figure 3.21.
 - Select **10** as the number of **Levels** and press enter.

3. Spectrum Gradient
 - Create a new layer on your test page document by clicking on the second button from the right at the bottom of the **Layers** palette, as shown in Figure 3.19.
 - Name the layer **Spectrum Gradient**.
 - Create a rectangular selection, about 1/2 inch high by 4 or 5 inches long.
 - Select the **Gradient Tool** from the toolbar, which shares a spot with the Paint Bucket tool, as shown in Figure 3.22.
 - Select the **Spectrum** gradient, the **Liner** gradient, the **Normal Mode** and make sure **Dither** is NOT checked, as also shown in Figure 3.22.
 - Click and drag while holding the shift key, from the center of one end of the long dimension of the selection to the other.

FIGURE 3.19 Creating a new layer in Adobe Photoshop from the Layers palette.

FIGURE 3.21 Selecting Posterize in Image > Adjustments in Adobe Photoshop for creating grayscale steps.

FIGURE 3.20 Selections and options for creating a black-and-white grayscale gradient in Adobe Photoshop.

FIGURE 3.22 Selections and options for creating a spectrum gradient in Adobe Photoshop.

Grayscale, Grayscale Steps, and Spectrum Gradations

The incorporation of a grayscale gradation (as opposed to grayscale steps, which is useful for measurements) at the bottom of the Kodak target is an intriguing design element. The grayscale gradation in all three pages (like the neutral image) is very useful for watching for cross curves in both printing and monitor quality. Allen and my test pages also include a full-saturation spectrum gradation. The spectrum gradation, depending on the color space of the image, can show significant differences in the color gamut of devices, profile quality, and rendering intents with even more sensitivity than most images. The spectrum gradient shows what is happening at the extremes of the color gamut of your test page.

Space for Labels

In addition to the images and targets in our test pages, it is also useful to include a space for labels. This is useful for recording information such as: the color space of the image, the type of printer and paper used, and the driver and application settings.

Your Own Images

Make this test page as valuable to you as possible by including the type of photographs or images you are making that might not fit any of the categories mentioned above. As an example of this concept, Allen Furbeck has included a couple of his paintings, as you can see in the lower right-hand corner of Figure 3.18. This allows the target to help you see how the different parts of your digital workflow affect your images, with their specific idiosyncrasies.

Conclusion

Hopefully, this chapter will have you examining images more closely. You might start to detect problems you didn't notice in images before, such as posterization, a strong color balance, or too much saturation. This more critical eye will hopefully not ruin you for looking at magazines and photographic exhibitions. The real goal of developing a more critical eye is to help to find ways to improve your own images and prints.

EXPLORATIONS

There are two things that would be useful for you to do on your own at this point, based on what we've covered.

- *Make a print from a portrait.* Without looking ahead at how to print correctly, make your first print from a color portrait image or the test page you create. As we discussed, skin tones are especially useful for detecting issues relating to color balance, contrast, lightness, darkness, and especially saturation. Examine the print versus the display, and note the differences in all seven of the image quality aspects we discussed.
- *Make your own test page.* Using as many of the elements discussed in this chapter as possible, create a test page that helps you to see the quality and limits of your monitor and printer/paper combinations.

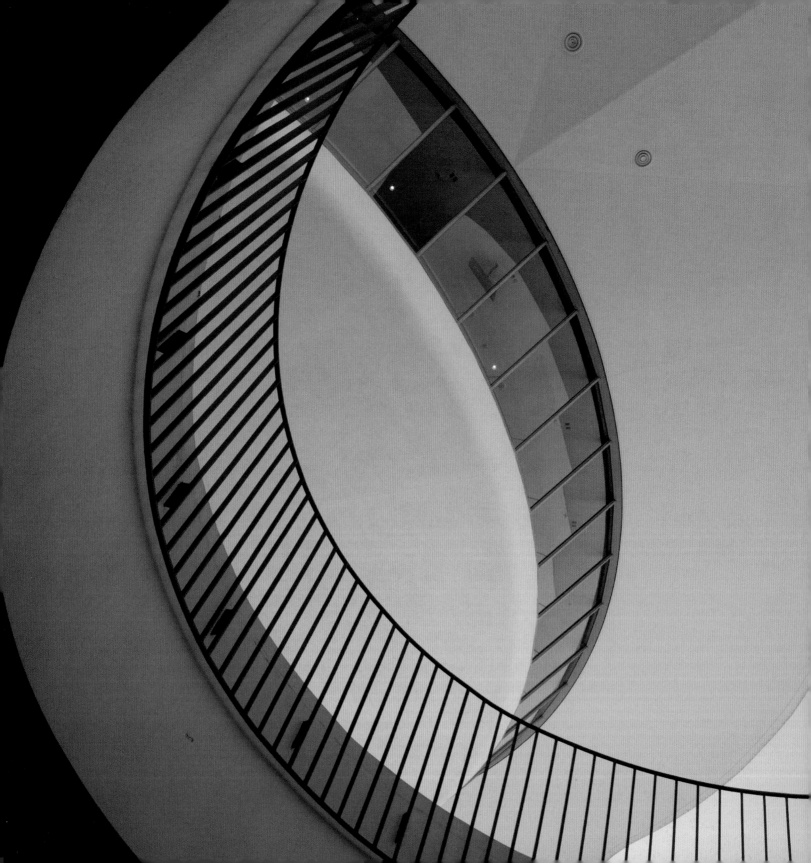

Four

DISPLAY ENVIRONMENTS, TECHNOLOGIES, CALIBRATION & PROFILING

In this chapter we are looking into the window of our digital world: our display. First we will introduce the visual phenomena called *simultaneous contrast* and use the lessons learned to help us set up an optimal environment for making color-critical decisions on our displays. Then we will review the different types of display technologies used with monitors and projectors. Finally we will cover the tools and techniques to use when calibrating and profiling our displays, so they can best match the type of output used in our applications.

Simultaneous Contrast

Are the purples on the right and left in Figure 4.2 the same or different? Upon quick inspection, it seems like the purple on the right is darker than the purple on the left. But as you can see in Figure 4.3, they are actually the same color on both sides. The fact that they appear

FIGURE 4.1 Los Angeles International Airport (LAX), 2011.
Credit: Photograph by the author

different is an example of the visual phenomenon known as *simultaneous contrast*.

Simultaneous contrast, originally identified in 1839 by chemist Michel Eugène Chevreul (who, incidentally, also discovered margarine), refers to the manner in which the colors of two different objects (when in proximity) affect each other.

We have discussed the ability to measure a color; but even if these two purples have the same CIE-LAB values, this does not completely determine the color perceived. There are many other variables at play. As the late Professor Richard Zakia has written, "Physical and psychophysical measurements made to specify color do not account for the effect that different backgrounds can have on the appearance of color."

FIGURE 4.2 Purple color from Sydney Opera House carpet in one of this book's cover images (top third from the left) on a graduated gray background.
Credit: Illustration by the author

FIGURE 4.3 Purple color from Sydney Opera House carpet in one of this book's cover images (top third from the left) on a uniform gray background. Credit: Illustration by the author

In Figure 4.2, it is the background that is actually changing, not the purple in the circles. Notice that the background is tonally gradated from darker on the left to lighter on the right. The darker background on the left makes the purple seem brighter, and the lighter background on the right makes the purple seem darker. In Figure 4.3 the gradation has been replaced by a solid gray.

As Figures 4.4, 4.5, and 4.6 show, this contrast effect can change the three attributes of color we discussed in the last chapter: hue, lightness, and saturation. In each of the three figures, the center color on the right and left is the same.

Figure 4.4 shows the effect of darker and lighter backgrounds. The lighter background makes the color appear darker, while the darker background makes the color appear lighter. Figure 4.5 shows the effect of the hue of the background. The warmer color background on the left makes the near-neutral color appear cooler (cyan-greenish), while the blue-green background makes the near-neutral color appear warmer (reddish). Finally, Figure 4.6 shows the effect of the saturation of the

background. The vivid orange background masks the somewhat orange color in the center by making it appear more neutral, while the neutral background makes the color very obvious.

The Work Environment

What does this discussion of simultaneous contrast mean to us on a practical level, as we try to optimize the environment in and around our computer display? Figures 4.5 and 4.6 show us that if we have strong colors on our computer interface or on the walls around our computer, this affects our perception of the colors we are viewing on the display. The effect can be to make us see colorcasts, lightness, or saturation that aren't there, or misread the aspects of the image that are. To optimize our environment for color correcting, we want to incorporate, if possible, a neutral surround for both the desktop and the walls. Also, to minimize the effect of darkening or lightening our

FIGURE 4.4 *(top left)* Same gray against black and white backgrounds.
FIGURE 4.5 *(middle left)* Same slightly warm gray against light red and cyan backgrounds.
FIGURE 4.6 *(left)* Same muted orange against saturated orange and gray backgrounds.

Credit: All three illustrations by the author

FIGURE 4.7 Eizo Display with hood.
Credit: Photograph, © Marko Kovacevic (markokovacevic.net)

(about what you might expect in a room lit well enough to allow you to read, but just barely).

Recommendations for a Color-Correction Environment

- Use indirect (e.g. reflected off the ceiling), subdued (under 64 lux, or preferably under 32 lux according to ISO standards) lighting, preferably at 5000 K.
- Block window light, since by its nature it is variable and inconsistent.
- Use a hood around your display to block surrounding direct light around the display—especially important if lighting cannot be controlled as recommended in the first two suggestions—as seen in Figure 4.7.
- Paint walls with spectrally neutral paint, such as GTI's Munsell Neutral Gray N7/N8 Paint.
- Change computer desktop and application backgrounds to a middle gray, while also removing clutter, and repetitive or distracting patterns.

Setting Desktop and Application Interfaces to Middle Gray

images, it would be better if the neutral color we used was not white or black, but instead a middle or slightly lighter gray.

We don't want the room where we are working on our images to be too brightly lit, if we can avoid it. To describe how brightly lit a room is, we use a unit called a *lux*, which is a unit of illumination equal to the number of lumens per square meter. Direct sunlight illuminates surfaces in the 25,000 to 125,000 lux range. Indirect light on a sunny day is about 10,000 to 25,000 lux. An overcast day might result in 1000 lux or less, down to as low as 100 lux if it is a very dark day. Offices are supposed to be lit at around 300 to 500 lux. Your home is probably less brightly lit, but is still brighter than 32 lux, the recommended condition for a color-correction environment

As we have discussed, the best way to ensure that we will be able to see subtle shifts in color, contrast, and brightness in our images, is set to as much of our computer interface to middle gray as possible. Let's look at how to do this in our operating system's desktop, Adobe Photoshop, and Adobe Photoshop Lightroom.

Let's start with the desktop. Although we will set up Photoshop and Lightroom to cover up your desktop, just in case you are using imaging applications that show the desktop, it is best to also set this to middle gray, by doing the following, in the Macintosh operating system:

1. Launch the **System Preferences** window.
2. Select the **Desktop & Screen Saver** button, as seen in Figure 4.8.
3. Once in this preference window (Figure 4.9), select **Solid Colors** on the left and then the first gray in the second row. This is **Solid Gray Medium**.

Next we will set up Adobe Photoshop to cover your desktop. In most Windows versions and in the Macintosh CS6 and CC versions, Photoshop automatically covers up your desktop. If your version does not do this automatically, click on **Window** from the menu bar and drag down to **Application Frame**, as shown in Figure 4.10.

FIGURE 4.8 System Preferences window in Apple Mac OSX with Desktop and Screen-Saver selected and circled.

FIGURE 4.9 Desktop and Screen Saver preferences in Apple Mac OSX with Solid Colors and Solid Medium Gray selected and circled.

FIGURE 4.10 Clicking on Window in the menu bar in Photoshop and dragging down to Application Frame to cover the entire computer desktop interface.

FIGURE 4.11 Dark default interface in Photoshop CC.
Credit: Photograph by the author

FIGURE 4.12 Lighter interface in Photoshop CC.
Credit: Photograph by the author

So, it's great that Photoshop is now covering the possible clutter and color on your desktop with its **Application Frame**, but, as you can see in Figure 4.11, there is a problem with the default interface in Photoshop CS6 and CC you might be able identify. It is TOO DARK. Remember, from our discussion of simultaneous contrast above, that a dark surround will make our images appear lighter and brighter. Why is that bad? One of our goals is to help make your display match your printed output, as closely as possible. The darker interface might be good, if you are only creating images for your website that has a similar interface, but since we are outputting our images to prints, which are often described as being too dark compared to the display, a lighter neutral interface will be better. To create the lighter interface shown in Figure 4.12, do the following:

1. Launch Photoshop's Interface Preferences window by clicking on **Photoshop** in the menu bar and dragging to **Preferences** and then **Interface**, as shown in Figure 4.13.
2. Once in this preference window, select the lightest **Appearance** on the right, as shown in Figure 4.14.

Luckily, at the moment there is nothing we need to do with Adobe Photoshop Lightroom. As you can see in Figure 4.15, the default settings already have the background set to medium gray.

So now we have made everything a nice medium gray. It really is the best thing for evaluating your images, but it does make me reflect on the fact that, sadly, this middle gray is the "joy" I'm bringing all over the world.

FIGURE 4.13 Clicking on Photoshop in the menu bar and dragging down to Preferences then Interface in Photoshop to launch the interface Preferences window.

FIGURE 4.14 Appearance Preferences window in Adobe Photoshop with the lightest Color Theme selected, which is the better choice for those of us working on print output.

FIGURE 4.15 Interface Preferences in Adobe Photoshop Lightroom with default Background settings circled.

Display Technologies

Before we begin our discussion about how to calibrate and profile our displays, we should first discuss display technologies, attributes, and limitations, so that you know what to look for when getting a color-critical display. The two major types of displays historically used in digital photography are *cathode ray tube displays (CRTs)* and *liquid-crystal displays (LCDs)*. Although the present and the future belong to LCDs, we will start this section with a brief look back at CRT displays. Then we will examine how LCDs work and the factors to be concerned about when purchasing an LCD display that will be best for making color-critical decisions.

Cathode Ray Tubes

Cathode ray tubes are the technology behind the monitors and television screens most of us knew growing up. They are easily identifiable by their larger footprint and chunky back. CRTs use scanning electron beams from an electron gun to stimulate different combinations of red, green, and blue phosphors on the inside face of the tube and produce a color image through additive color reproduction.

Benefits of Cathode Ray Tubes

- *Viewing Angles*—The range of angles from which you could view the screen without seeing a change in color and contrast.
- *Color Resolution*—The number of colors the display could produce.
- *Response Time*—How quickly the image faded after displayed, which was especially important for gaming and video.
- *Calibration*—True independent control of RGB signals, which allowed for better calibration.
- *Lower Luminance Range*—Helped the monitors match printed output more easily out of the box.

These benefits kept CRTs around for a while, especially for color-critical applications. They have, though, been supplanted by LCD displays, partially, because of their drawbacks.

Drawbacks to Cathode Ray Tubes

- *Size/Footprint*—CRTs had a large size and footprint (especially difficult in a small New York City apartment).
- *Power/Voltage*—CRTs required *additional power*.
- *Phosphor Decay*—CRTs got dimmer and dimmer over time, thus limiting their useful life.
- *Electronic Signal Drift*—This resulted in less stability over time and required more frequent calibration.

Because of additional economic and environmental reasons, along with the drawbacks mentioned above, and, of course, the benefits of LCDs, CRTs are no longer being manufactured.

Liquid Crystal Displays

So now, most of us, except for a few diehards, are using LCDs. But, how do they work? Unlike the phosphors in CRTs, LCDs do not emit light; they *transmit* light. The LCD display, as you might expect, is made of very thin layers. As Figure 4.16 shows, the image of the LCD starts from a (1) full-spectrum light source or backlight. The backlight goes through a (2) polarizing filter. The polarized light can then be modified (or twisted) by a (3) layer of liquid crystals depending on how much charge has been applied to them. This is all happening at a microscopic level and specific liquid crystals at each sub-pixel are adjusted. At whatever level the modified or unmodified light then goes to the corresponding (4) red, green, or blue sub-pixel filter at each pixel. The amount of modification changes the amount of red, green, and blue light at each pixel, and the color we see from each pixel. Then the light hits the other (5) polarizing filter, which is in opposition to the original polarizing filter. If the originally polarized light has not been modified by the liquid crystals, then, when it hits the next polarizing filter, the light will be completely blocked, and we will see black on the display. Note once again that we are using the *additive* mixing of red, green, and blue light to produce the image on our display. Below are the general benefits and drawbacks of LCDs.

FIGURE 4.16 Simplified parts of an LCD display: (1) backlight, (2) horizontal polarizing filter, (3) nematic liquid crystal layer, (4) red, green, blue filters, and (5) vertical polarizing filter.

Benefits of Liquid Crystal Displays

- *Size/Footprint*—Flat panels take up less space and can be used for laptops.
- *Power/Voltage*—LCDs require less power.
- *Little Color Fading*—LCD displays should last longer than CRT displays, except for the problem of "backlight bleed," where light (usually seen around corners of the screen) leaks out and turns black into gray or even a bluish/purple tint with TN-film (twisted nematic) based displays.
- *Electronic Signal Drift*—LCDs are more stable over time and require less frequent calibration and profiling to keep them consistent.

Drawbacks to Liquid Crystal Displays

- *Viewing Angle Limitations*—Depending on the technology of LCD, you will see changes in image color and contrast as you change your viewing angle, which makes it difficult for multiple users to look at the same display and see the same image—especially the TN-film (twisted nematic) based displays used in laptops.
- *Only Highest Quality at Native Resolution*—CRTs were able to look good at lower resolutions, as well as at their native resolutions.
- *Color Gamut and Color Resolution*—Except for high-end expensive displays (which can be even better than CRTs), the color gamut and resolution can be lower than that of CRTs.
- *Higher Luminance Range*—LCDs can produce a much brighter white luminance than CRTs, some as high as 400 candelas per square meter (cd/m^2) at their brightest setting. For some applications this would be a benefit, but since we are trying to match our displays to printed output, LCDs can be much more difficult to match than CRTs, if their luminance has not been reduced.
- *Screen Uniformity*—This is a problem with both CRTs and LCDs. Some monitors such as the NEC Multisync displays have circuitry to improve this, but even that doesn't necessarily solve the problem.

- *Blown-Out Pixels*—Each manufacturer has its own policy regarding how many blown-out pixels constitute a warranty-coverable problem. It can be very difficult to get an answer to this question and, depending on how particular you are about this, even a single pixel can be annoying.

Choosing a Display

When you purchase a color-critical LCD display, you should look at and compare the specifications, as you would with any other significant purchase. Important factors to consider will be LCD matrix type, the type of backlight, response time, resolution, gamut, vertical/horizontal viewing angle, uniformity, bit-depth of the internal processor, availability of a hood and integrated calibration and profiling software, and, of course, price.

Matrix Type

Some of the LCD matrix technologies you might run into during your comparison are TFT, IPS, and PLS. What do these "helpful" acronyms stand for? Most of the current LCDs use *thin film transistor (TFT)* active-matrix technologies, which allow for better contrast ratio, brightness, and sharpness. *In-plane switching (IPS)* panel technology was invented by Hitachi, is in NEC and HP DreamColor displays, and is meant to improve viewing angles and color reproduction. *Plane to Line Switching (PLS)* and *Super PLS* are display technologies developed by Samsung to also improve viewing angle and increase brightness.

Backlight

The two main types of backlights are fluorescent lamps and light-emitting diodes (LEDs). The backlight of the LCD is, typically, what would need to be replaced if the display started to flicker or become uneven. These displays/background types can be further broken down into four types:

- *CCFL*—Cold cathode fluorescent lamps have been the most common type of backlight for LCD displays for both desktop and laptops. Compared with White LED backlights, the CCFL backlights have a better fuller spectrum, which can make them more effective for color reproduction and gamut. On the negative side, the fluorescent lamps can become uneven or even fail altogether over time as they age.
- *Wide Gamut CCFL*—Wide gamut cold cathode fluorescent lamp displays use the same backlight as CCFL, but these displays have different red, green, and blue filters that they use to expand their gamut over traditional CCFL displays to cover all or most of AdobeRGB(1998). In some cases, to be able to build an accurate profile for these displays you will need a special colorimeter with specific filters to match the gamut of the display or a spectrophotometer/spectroradiometer, like the X-Rite i1 Pro or the i1 Pro 2.
- *White LED*—White LED backlights are becoming more popular, since they have the benefits that LEDs use more environmental materials and have better power efficiency than CCFL backlights. However, White LEDs—which are used in current Apple Cinema Displays, laptops, and iMacs—are made from a blue LED that has been coated with yellow phosphors. This means that White LEDs do not have as full a spectrum as CCFL and RGB LED backlights, which can lead to poorer color reproduction.
- *RGB LED*—RGB LED backlights use three different LEDs to produce white light. You guessed it: red, green, and blue! This allows for more control over setting the white point of the display and allows for very high color gamut. Currently, RGB LED backlights are found in a limited number of high-end NEC displays, Dell laptops, and the HP DreamColor display. Although some of these displays do project a long life, they potentially could have a problem with the different color parts of the LED changing or failing at different rates with age.

Response Time

Response time, the time for the display to transition from one color to another, will be especially important to you if you are using your display for video or gaming. LCD monitors have traditionally had slower response times than CRTs. The response time is reported as either the time (in milliseconds or ms) to transition from black to white and back to black or from gray to gray (which takes a shorter period of time than black-white-black). If you are strictly working with still images, this might not be as important a factor in making your decision.

Resolution

The native number of pixels wide by the number of pixels high gives you an idea of how much detail the display can produce. The higher the number of pixels in each direction, the more detail the display can show. The resolution for most displays of the same size, such as 27 inches, should be the same, but you should check. LCD displays look the sharpest when set to their native or highest resolution.

Gamut

As we discussed previously, the gamut—or range of colors an LCD monitor can display—is the result of many factors, including the RGB filters used, the matrix technology, and the backlight light source used. The gamut of displays is usually reported as a percentage of a standard RGB color space, such as sRGB, NTSC 1953, and AdobeRGB(1998). Remember that each of these color spaces has a different set of primaries and gamut associated with it, as seen in Figure 4.17. The smallest of the three gamuts is sRGB, and the larger spaces are NTSC 1953, AdobeRGB(1998). What if the Samsung S27A850D reports a gamut that is 100% of sRGB and the NEC MultiSync PA271W-BK reports a gamut that is 97.1% of AdobeRGB(1998)? Since Adobe RGB(1998) is the larger gamut, then in this case the NEC display has the larger gamut.

Horizontal/Vertical Viewing Angle

As we discussed earlier, one of the limitations of some LCD displays is that, depending on the angle you view them at, the color and contrast can shift. Most laptop displays are especially prone to this problem. High-end color-critical desktop displays typically report angle of view values of "H,V: 178°,178°." Since 180° would be perfect, 178° is very good.

Uniformity

Some higher-end displays will report information on uniformity in terms of Delta E. This is a measurement of color difference. The lower this value, the better—with 0 meaning that the display is perfectly uniform. Typically a display with a Delta E of less than or equal to 3 is acceptably uniform. Some monitors will allow for testing and tracking uniformity with colorimeters or spectrophotometers.

Bit-Depth of the Internal Processor

If the display can process the color values of the display with higher bit-depth lookup tables, this will allow for smoother gradation, less posterization, and more color resolution. You want a display with values higher than 8 bits per channel. Better displays have 12-, 14-, or even 16-bit processing per channel.

Hood and Integrated Calibration and Profiling Software

A hood and incorporated software can help to better color manage your display. As we discussed earlier, an incorporated hood, as seen in Figure 4.7, can be helpful in blocking out the impact of varying lights that might be falling on your display and in keeping your display more uniform. Also, some display companies, such as, Eizo, NEC, HP, and LaCie, have their own proprietary software you can use to calibrate and profile their displays. They use the same measurement (colorimeters and spectrophotometers) as the third-party software

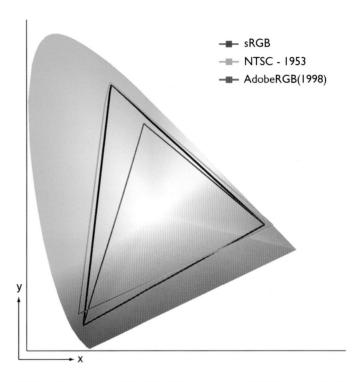

FIGURE 4.17 Gamuts of sRGB, NTSC-1958, and AdobeRGB(1998) in the CIE XY chromaticity diagram.
Credit: Illustration by the author

we will be discussing later this chapter, but by using the software that is more integrated with the display itself, the process can be more efficient and accurate.

Price

Not surprisingly color-critical displays are not cheap, but they have become more reasonable. The nominal range of prices for graphic-quality displays for photographers by Eizo, NEC, HP, and LaCie are from just under $1,000 to over $3,000. I know this is expensive, but your display is one of the most important parts of your photographic practice.

Note: The optics of the glossy LCD displays on Apple Cinema Displays, iMacs, and MacBooks make them difficult (or nearly impossible) to accurately profile. The best thing to do with glossy iMacs and MacBooks, and other laptops, is to connect them to one of the graphics-quality LCD displays.

Some of the newer LED-illuminated LCD displays don't work well with standard or older colorimeters, because of the difference in their gamut and RGB primaries. To help enable color management of these displays, some manufacturers (such as NEC) have commissioned the manufacturing of custom colorimeters with optimized filter sets for the RGB primaries on these displays. The other option is to use one of the two spectrophotometers (spectroradiometers) mentioned earlier, which should be able to adjust to these variations in display technology.

Why are we using a measurement device at all? It's possible to use a visual-based method instead of using a colorimeter or spectrophotometer. As the name implies, the visual-based tools (such as Adobe Gamma) give us the ability to make adjustments to gamma and white point, based on what we see on the display. But since there's so much variation in how each of us sees color, this is neither the most accurate nor repeatable option.

Calibration and Profiling of Displays

Colorimeters and Spectrophotometers

Now that you've bought your display and optimized your working environment, the first step in color-managing your system is to calibrate and profile the display. To do this, we are going to use a measurement device: either a colorimeter or a spectrophotometer (examples are seen in Figures 4.18 to 4.23). As a reminder, *colorimeters* use three to seven filters to measure tristimulus values according to a model of human vision. In this, they act something like our eyes. Examples of available colorimeters are the X-Rite i1 Display Pro, X-Rite DTP94, and Datacolor Spyder 4. The X-Rite i1Pro 2 and ColorMunki are *spectrophotometer*s, which act as *spectroradiometers* and measure the emittance of the display at many wavelengths throughout the visible spectrum (400–700 nanometers). Typically, this is done in increments of 10 nanometers, and results in approximately 30 different measurements for each emittance being measured. Colorimeters are less expensive than the spectrophotometers, but the two spectrophotometers mentioned can also be used for measuring reflected light (this is their principal function), and for building custom printer profiles. (More about custom printer profiles later in Chapters 8 and 9.)

Calibration of the display involves getting it to an optimal repeatable state. The three (possibly four) variables that need to be set are the luminance, contrast, white point, and gamma.

FIGURE 4.18 *(top left)* X-Rite i1 Display 2 colorimeter (discontinued).

FIGURE 4.19 *(top middle)* X-Rite i1 Display Pro colorimeter.

FIGURE 4.20 *(top right)* Datacolor Spyder 3 colorimeter (replaced by Spyder 4).

FIGURE 4.21 *(bottom left)* X-Rite i1 Pro spectrophotometer (discontinued).

FIGURE 4.22 *(bottom middle)* X-Rite ColorMunki spectrophotometer.

FIGURE 4.23 *(bottom right)* X-Rite i1 Pro 2 spectrophotometer.

Credit: All six photographs, © Marko Kovacevic (markokovacevic.net)

Luminance

As discussed before, the luminance or brightness of LCD displays can be too bright to match to a printed output. We therefore want to limit the white luminance of the display to approximately 80–120 cd/m² (candelas per meter squared, a measurement of emitted light), depending on the overall level of illumination in the room, as shown in Figures 4.24 and 4.25. Conversely, on CRTs our concern was typically the dark luminance and making sure the display was bright enough to maintain shadow detail. To optimize the white luminance, the calibration software first measures the current white luminance, then guides the user to adjust the manual hardware (or system brightness) until the desired white luminance is achieved.

Contrast

Some displays allow for an adjustment to the display's contrast. Certain calibration and profiling packages will help optimize (calibrate) this setting. Typically, this will involve adjusting the contrast up or down, while the software uses a colorimeter or spectrophotometer to measure the display. The software sends full white and slightly darker patches to the display. When only a slight difference is seen, the software "says" the contrast is at a good setting, which will maintain highlight detail. If the display doesn't have a contrast adjustment (such as with Apple displays), then skip this step.

White Point

The white point is a description of the color temperature of the monitor's white point. Typically the native white point (the color of the light emitted without any adjustment) for CRT displays is approximately 9300 K, which is much too blue. The native white point of LCDs can be somewhere between 6500 K and 7500 K. The white point should be set somewhere between 5000 K and 6500 K. 5000 K has typically been the white point for the graphic arts industry in the United States, where this has been a standard color temperature for controlled viewing stations. 6500 K has been the standard for video

FIGURE 4.24 Luminance Target and White Point Target selection in ColorEyes DisplayPro Software.

and web applications, and has become a somewhat standard white point, but as with many of the other choices in color management there are good arguments for both.

Since a setting of 5000 K can result in a white point that is too yellow, 5500 K is often used as a good intermediate white point, and was selected in Figures 4.24 and 4.25. (The choice will depend on the situation and artist involved.) To add more confusion to this decision in the case of laptops and projectors, it's best to select the "Native" white point, if this option is given. This will not force the display—which is already limited in bit depth—to adjust and possibly create "banding" or other artifacts.

Some displays allow for an adjustment to the display white point, by tweaking the individual red, green, and blue signals. Some calibration and profiling packages will help optimize (calibrate) the display's color-temperature setting. Typically, this will involve adjusting the red, green, and blue signals up or down, while the software uses a colorimeter or spectrophotometer to measure the white point of the display. The software guides the user until the desired white-point is achieved. If the display doesn't have a white point adjustment, such

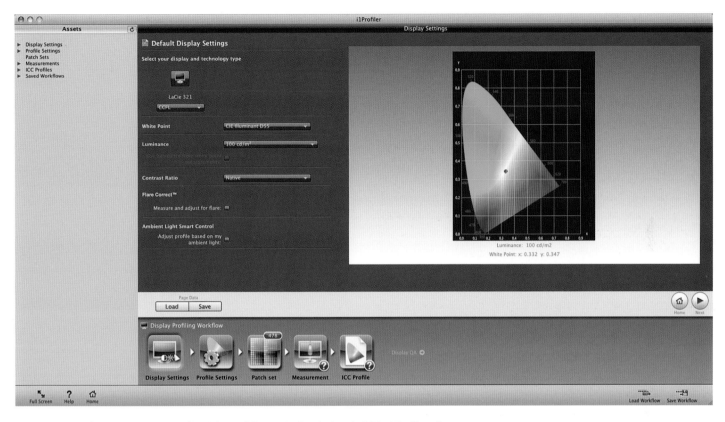

FIGURE 4.25 Display Type, Luminance, White Point, and Contrast Ratio selections in X-Rite i1Profiler software.

is the case with most LCD displays, then skip this step. Do not use video card adjustments to adjust white point, only use display hardware adjustments.

TRC or Gamma

TRC stands for *Tone Response Curve*, or *Tone Reproduction Curve*, and refers to the behavior of tonality between white and black for a device or color space. Some devices rapidly brighten from black to white, others do so more gradually, and there are other variations. It's simply a matter of how the device was designed to behave. A TRC describes that behavior.

The shape of the TRC can be defined several ways depending on the device. For displays, this is commonly done with a gamma function. A function is a mathematical expression involving one or more variables, and a *gamma function* refers to the exponent variable, "γ," which is the Greek character gamma. The value of the gamma variable determines the shape of a TRC defined by a gamma function. This is why we sometimes (incorrectly) refer to the "gamma" of the display. We really care about its TRC, which is often defined by a gamma function such as gamma 1.8 or gamma 2.2 (Figure 4.26)— but it could also be defined with a parametric function, or a sigmoidal function, or simply with points to define the curve (similar to Curves in Photoshop).

Because of the differences in the way devices display and capture tonal values (and the way in which we perceive them), it's often necessary to change the numerical values of the tones, redistributing them toward more or less contrast so that they look natural. This redistribution is called a *correction curve*, or *calibration curve*, and is most often applied in a lookup table (LUT) in the video card. Advanced displays have an internal LUT that contains this correction curve.

Once again, the choice is traditionally different for the applications involved. A TRC defined by gamma 1.8 has been used within the U.S. graphic arts industry, beginning with early Apple Macintosh displays, to help them better match the Apple LaserWriter printers, since ICC-based color management didn't exist at the time. A TRC defined by gamma 2.2 has traditionally been used in the video and web industries. As with white point, depending on the application, either TRC could be appropriate, but a display TRC defined by gamma 2.2 has become the most common and has been selected in i1Profiler in Figure 4.27. Starting with Mac OS X 10.6, Apple defaults to a display TRC defined by gamma 2.2, instead of gamma 1.8 as with

FIGURE 4.26 Gamma Target selection of L* in ColorEyes DisplayPro software.

previous versions of Mac OS. Integrated Color Corporation's ColorEyes Display Pro software has a proprietary option for setting the gamma to L* (as in lightness, the "L" in CIE-LAB), as seen in Figure 4.26, which adjusts the highlight, mid-tone, and shadow portions of the TRC independently.

FIGURE 4.27 Gamma of 2.2 and Matrix based profile selections in X-Rite i1Profiler software.

FIGURE 4.28 Number of patches for building the display profile selection in X-Rite i1Profiler software.

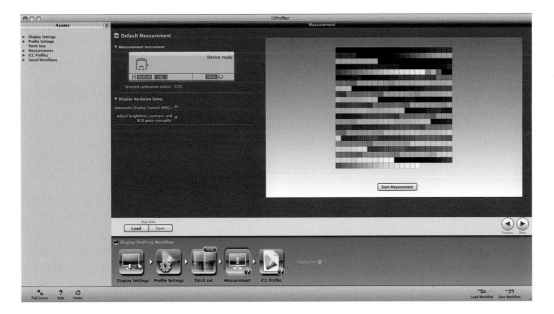

FIGURE 4.29 Measurement section in display profiling module of X-Rite i1Profiler software with manual adjustments selected for brightness, contrast, and RGB gains.

After the display is calibrated, the next step is to profile or characterize it. This can be as simple as the software sending a series of colors or RGB combinations to the display and reading them with the measurement device to see what color results on the display. This way, you can confirm the actual white point, black point, and TRC, and measure the RGB primaries. The software will then build a matrix-based profile, which is relatively small in file size, as seen in Figure 4.28. Some software packages, like i1Profiler will measure many more patches and build a look-up table (LUT) based display profile (as seen in Figure 4.28) similar to a printer profile. This would result in a larger file size, but can give slightly more accurate results.

Figure 4.29 shows the options in X-Rite's i1Profiler software to make the calibration adjustments (such as luminance) automatically, if the display is capable, or manually. Unless using the display's own software, I feel most comfortable selecting manual adjustments, as shown.

After measuring the patches, you must name and save the profile. Typically it is useful to name the profile with the display name, luminance, white point, and date the profile is created, as shown in Figure 4.30. You will also be asked where to save the profile: at the system level or the user level. It will usually be easier to keep track of profiles at the user level, but if there are many users, as there are in a computer lab, who use the computer and display, then the profile should be saved at the system level, if possible. Figure 4.30 also shows that, after the profile is saved, i1Profiler illustrates the results of the calibration in comparison to the targets we had set earlier.

Software Options

Displays can be calibrated and profiled using the software that comes with the spectrophotometer or colorimeter. Examples of these combinations are the i1Display2 with i1Match software, the i1Pro

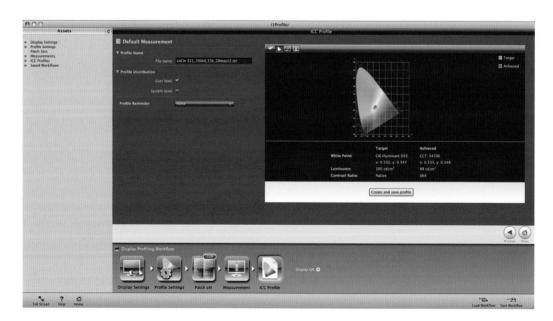

FIGURE 4.30 Naming the profile and evaluation of the results of display calibration and profiling in X-Rite i1Profiler software.

FIGURE 4.31 Measurement device selection in ColorEyes DisplayPro Software.

Digital Projector Technologies

Although they are used for presenting and displaying digital images, because of the image quality of most digital projectors and the variations in surrounding conditions and the surfaces where the image is projected, I would not recommend editing or color correcting images using digital projectors (also called video projectors). As you would expect, however, they can and should be used for presenting and displaying digital images. Especially in the wedding and portrait market, photographers use digital projectors to review proofs and give clients a feeling for how large prints will look on the wall. The quality varies among different projectors and projector technologies.

The main quality factors when looking at digital projectors are the native resolution (measured in pixels high by pixels wide), luminance (measured in lumens), and contrast ratio. Like other displays, digital projectors will look sharpest at their native resolution. The luminance of the display needs to be brighter as the image is enlarged, and in situations where there is increased ambient lighting. The *contrast ratio* is the brightness difference from the brightest white to the darkest black.

If there isn't enough contrast, the display can appear washed out. A good projector will give a contrast ratio of 1:2000 or higher. The three main technologies used in digital projectors are cathode ray tube (CRT), LCD light gates and Digital Light Processing (DLP).

- *Cathode Ray Tube Projectors*—Using three separate cathode ray tubes, CRT projectors are cost-effective for the size of the image produced and low in maintenance cost, because there is no expensive projector bulb. CRT projectors, however, have gone out of favor (as have CRT displays), partially because of their large footprint and cabinet size.
- *LCD Projectors*—In LCD projectors, red, green, and blue light are projected through LCD chips or light gates (which modulate each pixel, blocking or allowing light through), depending on the signals sent to them. This type of projector is the most common and affordable at the moment.

spectrophotometer or i1 Display Pro colorimeter with the i1Profiler software, or the Spyder3Pro colorimeter with the Spyder3Elite software. The measurement device can also be used with third-party software packages, such as Integrated Color Corporation's ColorEyes Display Pro software, as seen in Figure 4.31.

Some higher-end displays come with their own software, such as Eizo's Color Navigator and NEC's SpectraView II, which work with the same colorimeters and spectrophotometers mentioned earlier. The benefit is that the display is integrated with the software and makes the needed adjustments automatically.

The next issue is "How often should this be done?" The answer to this will depend on the stability of the monitor itself, and the application. Typically, once a week or month should be acceptable for LCD monitors, but once a day is not unusual for color-critical applications. LCD monitors stay consistent for a long period, but it's a good idea to recalibrate and profile before starting any new project.

- *DLP Projectors*—Digital Light Processing is a patented technology by Texas Instruments. There are two main versions of DLP: one-chip and three-chip. While the single-chip systems can produce a rainbow effect, they do offer some reduced artifacts, as well as tone and color quality benefits over LCD projectors. The three-chip DLP projectors are the market leader in digital movie projection.

Calibration and Profiling of Digital Projectors

If you've ever displayed your images with a digital projector from a laptop, you've probably said the words, "I know it looks terrible up on the screen, but you should see it on my laptop!" Often, this is the result of a dim or old projector, suboptimal settings in the hardware, or a lack of a useful display profile. One of the first things to do when working with a projector is to try to bring the settings back to factory default. Possibly the easiest thing to do is set the color settings to sRGB. As mentioned before, on the laptop display settings for the projector, the resolution should be set to the projector's native resolution. When setting up, some projectors can require testing to find the optimal frequency in Hertz (Hz). This should be the native frequency, but often it takes some adjustments to the frequency to get the projector to work with a specific laptop or computer.

The *X-Rite i1Pro and i1Pro2 spectrophotometers* and *i1 Display Pro colorimeter* (with i1Profiler software) and the *ColorMunki* and its software will calibrate and profile digital projectors. This can help to get much better color and tone quality from a projector. This is partially because the custom profile is taking into account the combination of the projector, the screen or surface projected onto, and the ambient condition—including the light level in the room.

When calibrating and profiling a digital projector, the spectrophotometer is stationed near the projector—if possible—and aimed at the

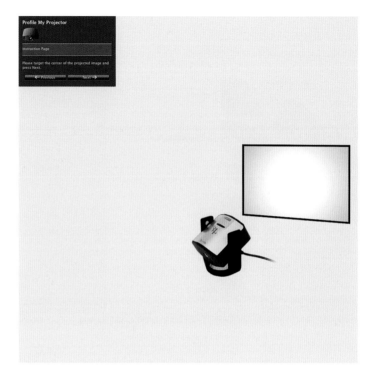

FIGURE 4.32 Projector profiling with i1 Display Pro Colorimeter and i1Profiler software.

screen, as shown in Figure 4.32. Before starting the calibration and profiling process, the laptop and the projector need to be taken out of "mirroring" mode. In most cases, but especially with dimmer projectors, it is best to use the native white point choice in the profiling

Tip: Most projectors by default target sRGB/Rec. 709 behavior, since that's the applicable standard. But projectors tend to get used by, well, everyone, and they will muck with the settings. Find the projector's on-screen menu, and search around for a reset option to reset the display to defaults, and then try to focus your adjustments by just setting white luminance (usually with the brightness setting).

software, since any adjustments to the white point will be at video-card level and can make the projector even dimmer. The software then helps you to aim the spectrophotometer at the center of the screen, and then it sends a series of colors to the projector. After the measurements are complete, the profile is built and saved.

Display and Projector Quality Verification

Once you have calibrated and profiled your display or projector, some software packages will allow you to verify the quality and even track that quality over time in a trend chart. i1Profiler will measure and track the quality of both displays and projectors. ColorEyes DisplayPro software will measure and track the quality of displays only. This is done by sending known colors, like the colors of the 24-patch Macbeth ColorChecker, to the display, measuring their accuracy, and calculating the *delta-E* (a measure of color difference), as in Figures 4.33 and 4.34. The bigger the difference in color, the higher the delta-E. Typically we can detect a delta-E of 3.0 or higher, so anything lower

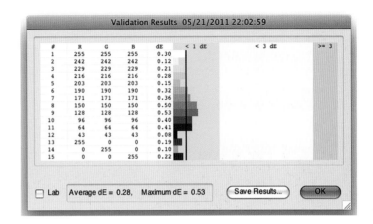

FIGURE 4.33 Validation Results in ColorEyes DisplayPro Software.

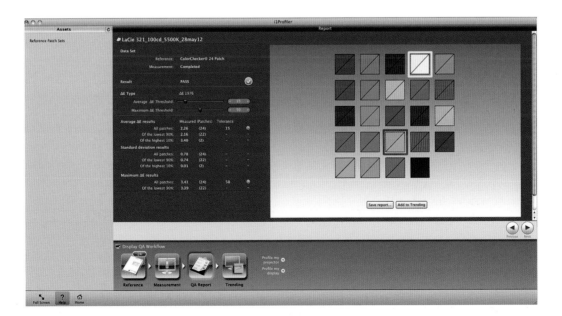

FIGURE 4.34 Display quality assurance in X-Rite i1Profiler software.

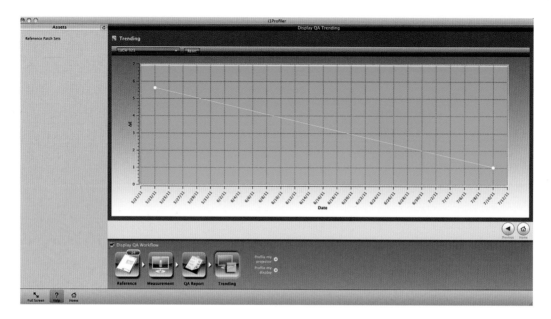

FIGURE 4.35 Display quality assurance trending in X-Rite i1Profiler software.

is acceptable. As a next step, you can record and track the display's performance over time, as shown in Figure 4.35. This can help us know if a display is not working well any longer, or if we need to recalibrate and profile.

Display and Projector Profiles at the System Level

Once the profile is saved, it becomes the default display profile at the system level, Mac OS X and ICM in Windows XP, Vista, 7, and 8. As mentioned before, ColorSync controls Apple Macintosh OS X system-level color management, and ICM controls Microsoft Windows color management. To see the active display profile on the system:

1. In Mac OS X, launch the **Display Preferences** from the **System Preferences** application. Select the **Color** tab. The display or projector profile you built should be the active profile, as shown in Figure 4.36. In this window, you can actively change the default display profile and see the effect of the change, which is not the case in any version of Windows.

2. In Windows, launch the **Control Panel**, click on Display Properties > Settings and highlight the monitor in question. Click the **Advanced** button and choose the **Color Management** button. The active profile for that display will be listed next to Default monitor profile. Two things to watch-out for with Windows:

 - Since Windows puts a lookup table from the display profile to the video card at startup, there can be a conflict if two applications are trying to load profiles to the video card. Deactivate or delete one in the startup menu or startup folder.

 - Because of the same video card issue, if you want both displays in a dual monitor configuration to be calibrated in Windows, you will need two separate video cards.

FIGURE 4.36 Current display color profile in Macintosh OS Display System Preferences.

EXPLORATIONS

Based on what we've covered in this chapter, there are two things that would be useful for you to do on your own:

- *Review your environment and display.* Examine your working environment. Could it be improved to minimize the influence of changing or non-optimal lighting? What about your display? Should you consider a change? Research options.
- *Calibrate, profile, and evaluate your display.* Of course, this assumes you already have a colorimeter or spectrophotometer and software. After you're done with this, evaluate your display and profile, with a hardware measurement, if this function is available in your software.

Regardless of the operating system, the default display profile is then used by ICC=compliant applications (such as Adobe Photoshop or Lightroom) to display colors accurately. You don't need to tell the application about the display profile; it will automatically find it. Remember: your monitor profile is not a working color space profile—we'll talk about those in Chapter 6.

Conclusion

Now that we've started to build your color-managed system, you have the tools to optimize your environment, find the ideal monitor, and calibrate and profile this display.

Resources

Simultaneous Contrast

Zakia, Richard, *Perception & Imaging*, Focal Press, Boston, 2002.

LCD Display Manufacturers

http://www.nec-lcd.com/
http://www.eizo.com/
http://www.lacie.com/
http://www.hp.com/sbso/busproducts_monitors.html

Display and Projector Calibration and Profiling Hardware and Software

http://spyder.datacolor.com/
http://www.xrite.com/
http://www.xritephoto.com/
http://www.integrated-color.com

INPUT PROFILING, SCANNERS & DIGITAL CAMERAS

Now that we have discussed color managing our monitors and projectors, next we will look at calibrating and profiling our input devices. Of course, the two main input devices of our imaging system are scanners and digital cameras. They are what we are using to digitize our images—turning them into 1s and 0s—so that we can work with them on the computer. What the input profile will do is tell us how our input device sees colors, so we can understand and interpret what the red, green, and blue values from our input devices mean. Why is this important? Because, helping applications like Photoshop or Lightroom understand the input device's RGB values will help us to reproduce the colors from these devices more accurately. In this chapter we will discuss the tools and methods used in characterizing scanners and digital cameras. We will also discuss when profiling our scanner and digital camera is most helpful, and when it isn't really necessary.

Scanner Profiling— Photographic Transparencies and Prints

The goal of profiling a scanner is to help match the colors of our originals, as closely as possible. The originals, we mean here, are our photographic color transparencies or prints, if we have any. (Many of you may have never shot film, so scanning prints and transparencies are not part of your life or workflow. Even if that is the case, please stick with this short section, since it will help in understanding digital camera profiles and using profiles in Photoshop.) Historically, photographic color transparencies, also known as slides or chromes, were exposed on reversal films like Fujichrome, Ektachrome or Kodachrome that went through the E-6 (in the case of Fujichrome and Ektachrome) or K-14 (Kodakrome) chemical processes to produce their positive, as opposed to negative, images. (As of this writing, Kodak has discontinued manu-

facturing their color reversal slide films, but, for now, they continue to produce the E-6 chemistry and Fuji continues to make both reversal films and E-6 chemistry.) Photographic reflection prints, on the other hand, are the prints made on an enlarger from color negatives onto light sensitive photographic paper, like Kodacolor, Fujicolor, Fuji Crystal Archive, or Kodak Endura papers, and put through the RA-4 chemical process.

So how do we do this? The basic steps are to: scan an IT8 reference target; bring the scanned target into some color management software, which will compare the known colors of the target, with the RGB values of the file; build and save the scanner profile; assign the scanner profile to images scanned in the same way in Photoshop; and, finally, enjoy how much more your images on your color-managed display look like the originals you put onto the scanner. Let's run through those steps in more detail.

IT8 Targets

1. Scan the IT8 Reference Target

Like we used a colorimeter or spectrophotometer for proofing or displays, when profiling a scanner we use a target. The standard scanner

To reiterate: the goal of profiling the scanner is to help match the colors of our original, as closely as possible; as good, or as bad, as the original; as well exposed, or as poorly exposed, as that original. The goal is NOT to make the colors look better than the original. It is to make them match, as closely as possible, the original transparency or print.

FIGURE 5.2 Reflective Photographic IT8 Target made by Eastman Kodak.

FIGURE 5.3 Two Kodak IT8 photographic E-6 transparency targets: 35mm on left and 4x5-inch on the right. Kodak IT8 targets are also called Q-60 targets.

reference targets on photographic print and transparency materials are called IT8 targets (Image Target Number 8). Figure 5.2 shows the Eastman Kodak's version for photographic papers, which is called a Q60-R2. (Q60 is Kodak's name for an IT8, and R2 stands for the second version of the reflective target.) The reflective photographic color paper IT8 target, like the one shown in Figure 5.2 is, typically, 5 x 7 inches in size. The two transparency film targets are, mainly, 35mm and 4 x 5 inches, as shown in Figure 5.3. These targets are made on Ektachrome, Fujichrome, and, in rare cases, Kodachrome reversal materials.

Scanner Settings

It's very important that the scan of the IT8 target should be made at the same settings as any original transparencies or prints. This is the reason for scanning the target at the beginning of each project. Specifically, the original and the target should be scanned to produce as "raw" an image as possible, with any automatic color adjustments turned off in the scanner settings. Figure 5.4 shows how to do this in Epson scanner software. If automatic color controls are not turned off, the target and the image will (most probably) be scanned at different color and tone settings. This will make the scan of the target useless for characterizing how the scanner sees color, since it is only characterizing the color and tone settings that were used to scan the target, not your transparency or print. The specific settings you use, and how you achieve the "rawest" scan, will depend on the scanner software. In Hasselblad/Imacon Flextight scanners, the best way to accomplish this is to manually reset the black points and white points of all three channels back to 0 and 255, respectively, as shown in Figure 5.5.

It's also important to scan at the highest bit-depth the scanner can produce (over 8-bit), so that future color corrections and edits to the file will not result in a loss of image quality. Such losses include posterization in gradations, which can be seen as breaks in the histogram.

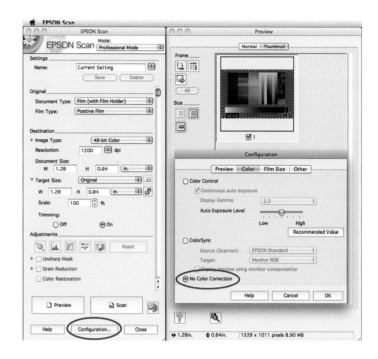

FIGURE 5.4 Turning off automatic color adjustments in Configuration section of Epson scanner software.

2. Bring the Scanned Target into a Color Management Software Package

Currently the main two software packages for input profile building are X-Rite i1Profiler and basICColor Input. Also, some scanning software packages, like Laser Soft Imaging's SilverFast, include their own IT8 targets and will allow you to calibrate and build scanner profiles, which can have excellent results. The other option is to use legacy and discontinued software packages, such as X-Rite's Eye-One Match, MonacoPROFILER, ProfileMaker PM5, or Pulse ColorElite.

IT8 Reference Files

As we said, the software is going to compare the known colors of the target with the RGB values of the scanned target file. How does the software know the actual colors of your IT8 target? Each IT8 target

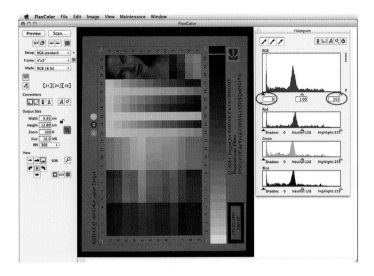

FIGURE 5.5 Resetting white and black points in Hasselblad/Imacon FlexColor scanner software.

has a corresponding reference or measurement file called a target description file (TDF), which contains averaged colorimetric values in CIE XYZ and CIE-LAB of all the patches on the target. For example, Figure 5.6 shows the inside of the reference file for a 24-patch X-Rite ColorChecker. The targets and measurements for the photographic IT8 targets have been made in small batches, corresponding to when the targets were made. The batch number is in the lower left-hand corner of the target. As you can see, the batch number in the lower left-hand corner of the IT8 target in Figure 5.2 is 2009:4. The reference file for this target is named "R2200904.Q60." The letters at the beginning of the file name refer to the type of target: R1 and R2 are 5 x 7-inch reflective R-A4 processed print; MONR is X-Rite Monaco Reflective print; E1 is 4 x 5-inch E-6 or Ektachrome transparency; E3 is 35mm E-6 or Ektachrome transparency; K3 is 35mm K-14 or Kodachrome transparency; MONT45, as you might guess, is X-Rite Monaco 4 x 5 E-6 transparency.

Once in the software, the process of building the profile is pretty straightforward: (a) tell the software what type of input profile you are building (reflective, transparency, or digital camera) and what type of

```
Date: 3/27/2000   Time: 19:04
LGOROWLENGTH 12
BEGIN_DATA_FORMAT
Sample_NXYZ_X   XYZ_Y   XYZ_Z   Lab_L   Lab_a   Lab_b
END_DATA_FORMAT
BEGIN_DATA
A1     38.81    15.21    16.41    38.81    15.21    16.41
A2     64.24    34.97    59.58    64.24    34.97    59.58
A3     28.98    21.02   -55.27    28.98    21.02   -55.27
A4     97.12    -0.09     2.38    97.12    -0.09     2.38
B1     62.46    16.87    18.52    62.46    16.87    18.52
B2     41.39     9.11    -43.8    41.39     9.11    -43.8
B3     55.64   -38.22    30.91    55.64   -38.22    30.91
B4     82.01    -0.42     0.72    82.01    -0.42     0.72
C1     49.58    -3.13   -22.35    49.58    -3.13   -22.35
C2     53.21    49.09    18.56    53.21    49.09    18.56
C3     43.53    58.97    30.55    43.53    58.97    30.55
C4     67.82     0.35     0.95    67.82     0.35     0.95
D1     44.28   -13.31    21.98    44.28   -13.31    21.98
D2     30.38    24.54   -22.75    30.38    24.54   -22.75
D3     84.5      3.79    80.87    84.5      3.79    80.87
D4     53.03    -0.54     0.39    53.03    -0.54     0.39
E1     56.62     9.52   -24.36    56.62     9.52   -24.36
E2     74.14   -23.72    57.56    74.14   -23.72    57.56
E3     52.5     51.79   -12.79    52.5     51.79   -12.79
E4     37.11    -0.55    -0.19    37.11    -0.55    -0.19
F1     70.59   -32.59     0.72    70.59   -32.59     0.72
F2     73.41    20.39    68.97    73.41    20.39    68.97
F3     50.38   -27.38   -29.61    50.38   -27.38   -29.61
F4     21.25     0.16     0.15    21.25     0.16     0.15
END_DATA
```

FIGURE 5.6 Contents of a target reference file for a 24-patch X-Rite ColorChecker.

target you are using, as in Figure 5.7; (b) open your scanned IT8 target file; (c) help the software to find the targets patches, if needed, by positioning on specific crop marks, as seen in Figures 5.7 and 5.8; (d) tell the software the reference file name that corresponds to your target, as in Figures 5.9 and 5.10; and finally, (e) build and save the profile.

3. Build and Save the Scanner Profile

When you build the profile, the color-management software compares the scanned RGB values and corresponding measured and averaged CIE-LAB values in the reference file of each of the patches on the target. From this comparison, the software builds a profile that characterizes or describes how the scanner sees color. The resulting profile, as we have discussed before, is made up of lookup tables that

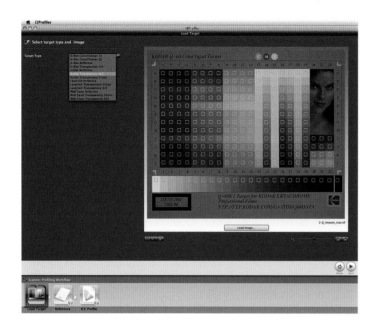

FIGURE 5.7 Selecting the Target Type for input profiling in X-Rite i1Profiler software and setting the crop mark positions to help it find the patches of the scanned photographic IT8 target.

FIGURE 5.9 Selecting the correct target reference measurement file for building an input (scanner) profile in X-Rite i1Profiler.

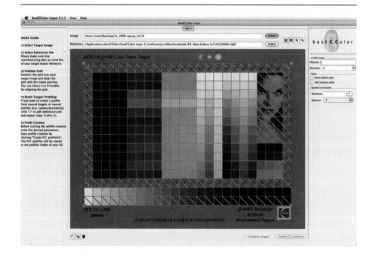

FIGURE 5.8 Setting up basICColor Input software to help it correctly find the patches of the scanned photographic IT8 target.

tell us when we have a certain combination of red, green, and blue values from this scanner, at the settings used when the IT8 target was scanned, and what that combination means in CIE-LAB. The scanner profile helps us to translate what the RGB numbers mean when we assign the profile in Photoshop. To be able to see the profile in Photoshop you will need to save the scanner profile in one of the proper folders, depending on your operating system. In Mac OS X this folder is **User/Library/ColorSync/Profiles**. In Windows this folder is **\Windows\system32\spool\drivers\color**.

4. Assign the Profile and 5. Enjoy

In the next chapter, we will talk about what is happening under the hood when a profile is assigned in Photoshop. Here we will just look at the results of using a scanner profile. Figures 5.11 and 5.12 are of the image of an IT8 target before and after assigning the scanner profile in Photoshop, while Figures 5.13 and 5.14 are of a portrait by

FIGURE 5.10 Selecting the correct target reference measurement file for building an input (scanner) profile in basICColor Input.

Jamey Lord, originally a 6 x 4.5 mm transparency, before and after assigning the same scanner profile. Of course, to make this work, both the target and the transparency were scanned at the same settings.

At this stage the resulting image does not look perfect (we will work on that when we discuss color correction), but it does look more like the original. And remember: that's the goal of profiling the scanner.

Better IT8 Reference Files and Targets for Better Profiles

The quality of the scanner profile you get is affected by the quality and accuracy of your reference file. On typical T8 targets, every individual target is not measured by a spectrophotometer. As we mentioned, in most cases, multiple representative targets of a batch are measured, and the data is averaged together to produce the reference file or TDF. The batch number for the target (which typically corresponds to the date the batch of targets was made) can be found in the lower left hand corner. The target in Figure 5.2 has a batch number of 2009:04. This means it is a target from the fourth batch made in 2009.

Although using a batch average reference file is not typically a problem, it's possible that an even better result can be obtained using a custom-measured IT8 target. One of the benefits of using the X-Rite EyeOne Match Scanner Profiling Module is that you're able to measure the supplied scanner target with the EyeOne spectrophotometer. By measuring the target just before it's scanned, you're also taking into account the age of the target, and any possible fading of photographic dyes in the print or transparency.

Some experts believe the quality of the characterization can be improved by using targets produced by the same manufacturer as the transparency film, or photographic paper being scanned. This could be true, in that different photographic media have more or less color saturation, while the gamut differences are usually slight.

There are times, however, when you definitely need a scanning target other than the three standard ones. One obvious example comes from the different dye-sets between Ektachrome and Kodachrome transparencies. An Ektachrome target should not be used to characterize a scanner for digitizing Kodachrome transparencies.

Another way to improve the quality of the scanner profile is to use a target developed and manufactured by color-management consultant Don Hutchison, called the HutchColor Precision Scanner Target. As seen in Figure 5.15, this target has more patches than the standard IT8 target. X-Rite ProfileMaker, EyeOne Match and Monaco PROFILER, along with basICColor input and PictoColor inCamera, all support the use of this target.

There are two other ways in which these targets can help create a better profile. First, they're made on specific types of photographic transparency films and papers (Kodak and Fuji), and second, each target is individually measured. Not surprisingly, these targets do cost more ($159–489, instead of $50–100 for IT8 targets).

FIGURE 5.11 Raw scan of Kodak 4x5-inch transparency IT8 target, before assigning scan profile in Adobe Photoshop.

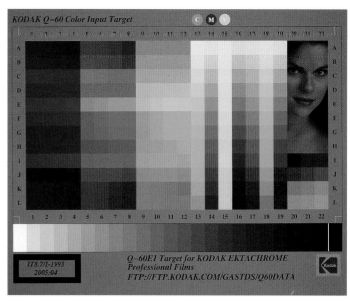

FIGURE 5.12 Scan of Kodak 4x5-inch transparency IT8 target, after assigning scan profile in Adobe Photoshop.

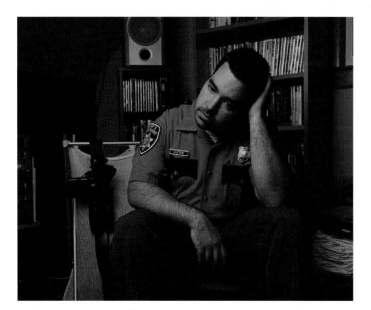

FIGURE 5.13 Raw scan of transparency by Jamey Lord before assigning scan profile in Adobe Photoshop.
Credit: Photograph, © Jamey Lord (jameylordphotography.com)

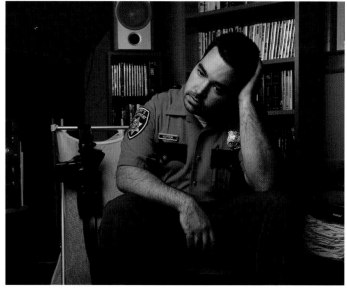

FIGURE 5.14 Scan of transparency by Jamey Lord after assigning scan profile in Adobe Photoshop.
Credit: Photograph, © Jamey Lord (jameylordphotography.com)

FIGURE 5.15 HutchColor HTC Precision Scanner Target.
Credit: Target, HutchColor, LLC

Another source for IT-8 targets is Wolf Faust of Frankfurt, Germany. He makes targets on many types of film bases and papers. His 4 x 5-inch transparency targets are measured individually, as opposed to batch measured, which, as mentioned, will result in more accuracy. His prices, as of this writing, range from $10 for reflective print targets to $75 for the individually measured targets (plus $10 for shipping). His targets are also supported in X-Rite i1Profiler, as you can see in Figure 5.7.

The two big things you want to remember about scanner profiling: (1) the calibration part of color managing the scanner is scanning the IT8 target and your images at the same settings, so, turn off or bypass any automatic color adjustments in the scanner software; and (2) the goal of profiling the scanner is to match the colors of the original print or transparency as closely as possible, irrespective of how the original looks—not to improve on the colors of the original.

Scanning Color Negatives

Scanner profiling, as we have discussed, is for color transparencies and reflection prints. What about color negatives? Many photographers use and have used color negative materials for their unparalleled exposure latitude. Do we build scanner profiles when scanning color negatives? The short answer is, "No." Unlike photographic transparencies and reflection prints, there is no target to use when scanning color negatives. Because of the variety of films, orange colored coupler masks (these are what create the orange color of color negatives), and

different possible exposures, color-managing these materials can be considerably more challenging.

Also, remember the goal of color managing a scanner: to match the colors of the original we are scanning as closely as possible. When you scan a negative, is the goal to match the original? Of course it's not. You don't want your image on the computer to look like the actual color negative. You could say your goal when scanning color negatives is to match the "good" print you would have made from the negative on the enlarger.

Since color negative films are designed to optimally work with photographic papers on an enlarger, not scanner, what should you do when scanning negatives? There are three things you should do: (1) scan at the highest bit-depth possible (48 bits or 16 bits per channel) to preserve smooth gradations through the destructive editing process; (2) set the white point and black point on the image without clipping or losing any part of the image; and (3) make sure you are editing on a color-managed display, since you don't have any other visual reference. (But, I didn't need to remind you of number 3. You are already doing it!)

Digital Camera Profiling

In this section we will look at how and when to build the other type of input profiles: digital camera profiles. The main goal of profiling a digital camera is to help us match the colors of the original scene more accurately. Just as we have discussed that scanner profiling is not necessary for all of us photographers who are scanning film and prints, digital camera profiling is not for all us who are shooting with digital cameras. That being said, we will cover the applications where these tools can be very useful. Finally, we will compare the two different types of digital camera profiles: ICC profiles and DNG Profiles.

Targets

How do you build an ICC profile for digital cameras? It's pretty straightforward. The first step is to add a target into the scene you are photographing. Could you use an IT8 target, like the ones mentioned for scanner profiling? No, for this purpose, you do not want to use an IT8 target, because an IT8 target is designed principally to characterize how a scanner sees the colors of photographic dyes. That's why the targets are made on photographic color materials. Our scenes, however, consist of a large variety of real world colors. The target we use for a digital camera profile should (as best as possible) reflect this variety of colors and colorants. Two such targets are made by X-Rite: the standard 24-patch ColorChecker (Figure 5.16) and the 140-patch Digital ColorChecker SG (Figure 5.17). As you can see, the Color-Checker SG has some potentially useful attributes over the classic ColorChecker, including: more colors, a darker black patch, and neutral white, 18% middle-gray, and black patches for watching exposure uniformity around the target. Both X-Rite targets are made from Munsell papers, whose reflective spectral power distributions are accurate, precisely known, and the same from one target to the next.

Because of this repeatability in the X-Rite targets, unlike with the IT8's, there are no batches and batch reference (measurement) files of X-Rite ColorCheckers. There are only standard reference values. However, as with the IT8, you could possibly improve the accuracy of the profile by taking measurements of your actual target with a spectrophotometer and building your own reference file. Also, to take it even a step further, if you have specific colors that you are always photographing, that are not represented on either of the ColorCheckers, then you could build a custom target and reference file. Happily for most of us, custom targets are not necessary.

Building the Digital Camera Profile

Once you have an image from your digital camera with the target placed in the scene, the image of the target is cropped and saved as a TIFF file (specifically for ICC digital camera profiles, not for DNG profiles, which we will discuss), and brought into the profile building software; which could be X-Rite i1Profiler, basICColor Input, PictoColor inCamera, or Integrated ColorEyes Camera. As with scanner profiling, after the software finds the patches of the target, it compares the RGB values from the image of the color patches with the known CIE-LAB colors of the patches from the reference file. From this comparison, the software is able to characterize how the camera sees

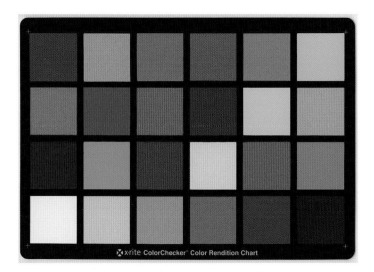

FIGURE 5.16 24-Patch X-Rite ColorChecker.
Credit: Target, X-Rite, Incorporated

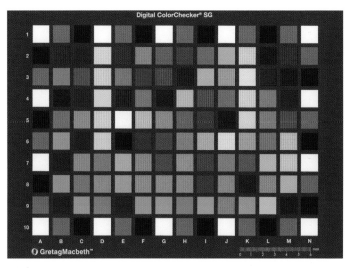

FIGURE 5.17 140-Patch X-Rite Digital ColorChecker SG.
Credit: Target, X-Rite, Incorporated

colors. This characterization is used to build the digital camera profile, which when assigned to other images photographed at the same time, and under the same situation in Photoshop, helps to match the colors of the original scene more closely, as shown in the product photographs in Figures 5.18 and 5.19. Notice the overall change in lightness and the shift in the hue of the Resolve bottle to a warmer, slightly more yellow red, which is more accurate than the original.

Applications for Profiling Digital Cameras

To limit the applications for digital camera ICC profiles even further, let's remember, as we mentioned before, the main goal of building ICC profiles for our digital camera is to help us match the colors of the original scene more accurately. Is this the goal of all photographs? Not really. Accuracy is not our greatest concern in portraiture or landscape photography. In both of those cases we want the

subject or scene to be rendered with the most "pleasing" colors, not necessarily the most accurate colors. Some of the photographic applications where it is very important for the colors to be rendered as accurately as possible, and for which it might be most useful for you to build digital camera ICC profiles, include: fine art reproduction, catalog photography, and product photography. Can you think of any others? While you're thinking, let's look at these three more closely.

This is a Very Specific Profile

It's important to note that when you profile a digital camera, you are not just profiling the camera, but also the lens, the ISO setting, neutral/white balance setting, and, most importantly, the light source you are using. If any of the variables change, you need to build a different input profile. Typically the digital camera profile will have the name of the camera and the light source. For this reason, building digital camera ICC profiles is, mainly, only practical for controlled lighting situations, such as in-studio.

FIGURE 5.18 Product and X-Rite ColorChecker Passport before assigning digital camera profile in Adobe Photoshop.
Credit: Photograph by the author

FIGURE 5.19 Product and X-Rite ColorChecker Passport after assigning digital camera profile in Adobe Photoshop.
Credit: Photograph by the author

- *Fine Art Reproduction*—If you are photographing or scanning or scanning a painting or other work of art, as shown in Figure 5.20, one important goal will be to faithfully render the colors of the original artwork as closely as possible. Figures 5.21 and 5.22 show an image of a painting by Allen Furbeck before and after assigning a digital camera ICC profile in Photoshop.
- *Catalog Photography*—In catalog photography it is very important to match the colors of the items being sold as closely as possible. For example, imagine you photograph a purple sweater and in the online or print catalog the sweater appears blue. What will happen? The customer who likes the blue she sees in the catalog could be disappointed or even angry because her expectations were not met.

- *Product Photography*—A major part of a company's brand goes into the color(s) of their products. Think Tiffany blue or Coca-Cola red. If these colors are not accurately rendered, at minimum you will have to deal with a concerned art director.

FIGURE 5.20 Two different fine art reproduction set-ups: (top) camera on tripod and X-Rite ColorCheckers for painting by Allen Furbeck with Marko Kovacevic measuring light uniformity and (bottom) using a staging table for the artwork with a camera stand and camera tethered to a computer, which is a much more efficient set-up, especially for a large volume of work. In both set-ups the polarized lighting is at a standard 45-degree angle.
Credit: Top photograph by the author and bottom photograph, © Katrin Eismann (katrineismann.com)

FIGURE 5.21 Digital capture of painting by Allen Furbeck before assigning scan profile in Adobe Photoshop.
Credit: Painting by Allen Furbeck (allenfurbeck.com)

FIGURE 5.22 Digital capture of painting by Allen Furbeck after assigning scan profile in Adobe Photoshop.
Credit: Painting by Allen Furbeck (allenfurbeck.com)

FIGURE 5.23 X-Rite ColorChecker Passport software for building custom DNG profiles for camera and light source combinations.

DNG Profiles

So far in this section we have been discussing ICC based digital camera profiles. These are not to be confused with DNG Profiles, which are also used for digital cameras. To finish this chapter, let's review three things about DNG profiles: what they do; how you can build and use custom DNG profiles with X-Rite ColorChecker Passport software; and why you would want use custom DNG profiles.

Adobe Photoshop Lightroom and Adobe Camera Raw offer the ability to select a profile for the camera in their Camera Calibration section. Changing this profile allows you to change the rendering or look of the image. As you might expect, selecting the Camera Portrait profile will result in skin tone that is less saturated than when you select the Camera Landscape profile, but if you are shooting land-scapes, typically, you want all your colors to be more saturated.

X-Rite ColorChecker Passport software allows you to build custom camera profiles that show up in this same section of Lightroom and Camera Raw. How do we do this?

In all three of these applications building a profile for the digital camera and the lighting situation could help.

Now that we've discussed the applications that could benefit most from digital camera ICC profiles, let's reiterate the photographic applications that *shouldn't* require this extra step. As mentioned, ICC profiling of a digital camera is not for situations where the light source is constantly changing, especially when shooting in natural light: as in landscape, nature, or exterior architectural photography. Digital camera profiling is also not meant for portraiture. The goal of portraiture is rarely to match the skin tone of the subject. Instead, the goal is typically to render the skin tone in a pleasing way. For these applica-tions, the use of a Raw workflow is preferable. Shoot in your camera's Raw format, images, and create your renderings and looks using Adobe Photoshop Lightroom or Adobe Camera Raw.

EXPLORATIONS

There are a couple things that would be useful for you to do on your own at this point, based on what we've covered.

- *Evaluate your photographic applications.* Could your work benefit from scanned images that better match the original prints or transparencies or digital captures that better match the colors of the original scene? If they could, test some targets and software.

- *Start photographing with a color checker.* You might not need custom DNG or ICC profiles right away, but by including shots of the color checker from the different scenes you are photographing, you will always have the option later.

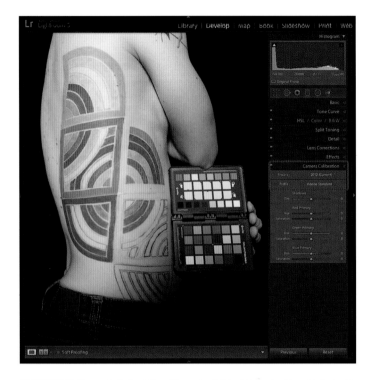

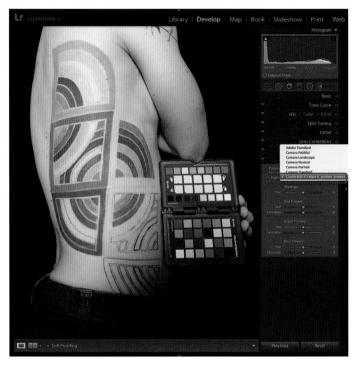

FIGURE 5.24 Figure study by Miho Aikawa (unfinished tattoo by Gene Coffey) with Adobe Standard profile applied Adobe Photoshop Lightroom.

Credit: Photograph, © Miho Aikawa (mihophoto.com)

FIGURE 5.25 Figure study by Miho Aikawa (unfinished tattoo by Gene Coffey) with custom DNG profile for her Canon 5D Mark II camera and strobe lights applied Adobe Photoshop Lightroom.

Credit: Photograph, © Miho Aikawa (mihophoto.com)

1. As with ICC camera profiling, take a raw capture of a classic 24-patch ColorChecker or this part of the X-Rite ColorChecker passport in your scene.
2. Take your other images in the scene with the color checker removed.
3. Convert the raw image that includes the color checker into a DNG (digital negative) file in Lightroom or Camera Raw.
4. Launch the free *ColorChecker Passport software*, shown in Figure 5.23.
5. Click and drag the DNG image file with the color checker into the window. The software should automatically find the patches.
6. Click on **Create Profile** button.

7. Include the light source in the name of the profile, which should automatically be the make and model of the camera from the camera's metadata.
8. Select the custom DNG profile in the Camera Calibration section of Lightroom or Camera Raw.

Figures 5.24 and 5.25 show the differences between the Adobe Standard profile on the left and the custom DNG profile on the right on Miho Aikawa's figure study. As you can see, the skin tone with the custom DNG profile is yellower and the blues and magentas are darker and more saturated.

Although the custom DNG profile might give slightly more accurate colors, including the jaundice skin tone, a really big reason to use custom DNG profiles is to help get more repeatability from camera to camera. If you are shooting an event with multiple cameras, even if they are the same make and model, the color can be subtly different. By building profiles for each camera and applying them in Lightroom and Camera Raw to their corresponding images, there will be more consistency in look and rendering across the cameras.

Conclusion

Once again color managing our devices, this time our scanners and digital cameras, can give us more accurate and consistent results. But as we mentioned many times throughout this chapter, scanner and digital camera profiling, while great, is not necessary for all photographic applications. Before spending the time and effort involved, we need to determine if our photography requires the additional accuracy and consistency we will get from our profiled scanners and cameras. Possibly the answer is "Yes, no, or sometimes." Thinking about this, and testing the results, while building *your workflow* will ensure that it is as efficient as possible, without any unnecessary extra steps.

Resources

Scanner and Digital Camera Calibration and Profiling Targets

http://www.kodak.com/
http://www.xrite.com/
http://www.basiccolor.de/
http://www.hutchcolor.com
http://www.datacolor.com/
http://www.silverfast.com/
http://www.targets.coloraid.de

Scanner and Digital Camera Calibration and Profiling Software

http://www.xrite.com/
http://www.basiccolor.de/
http://www.pictocolor.com/incamera
http://www.integrated-color.com/cecamera/

COLOR IN PHOTOSHOP & LIGHTROOM

Now that we have discussed how to create display and input profiles, it seems like a good time to review how color and color profiles are handled in the two software packages most commonly used by photographers: Adobe Photoshop and Adobe Photoshop Lightroom. In this chapter, we will first look into Photoshop's *Color Settings* window, explain the options, and give suggestions on the optimal settings to use depending on your applications. Next, we will cover the, all-important, difference between *Assigning a Profile* and *Converting to a Profile* in Photoshop, including when you should use one versus the other. You will get to see what to do with your input profiles from the last chapter. In the midst of these discussions we will introduce *working color spaces* and *rendering intents*. As a final step in Photoshop, we will review the importance of *embedding profiles* when we save our images. Then it's onto Lightroom. In the last part of the chapter, we will discuss: *RAW image files*; *RAW image processers*; how Lightroom handles and processes different types of files; how Lightroom displays color values; and how a color space is selected when exporting from or leaving Lightroom. Once we understand how color works in these two applications, we will be able to utilize and control it more fully to help us produce our images.

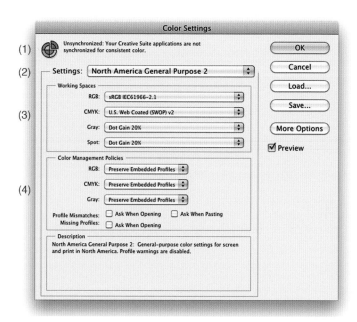

FIGURE 6.2 Default Color Settings in Adobe Photoshop – Few Options view.

Adobe Photoshop's Color Settings

The **Color Settings** in all the Adobe *Creative Suite* applications, including Photoshop, but not Lightroom, control how color is handled in opening, pasting, viewing, and saving files and images. To launch the Color Settings window in Figure 6.2, go to the Menu bar in Photoshop and select Edit > Color Settings. With your choice of color settings, you determine the default working color spaces, the way color management is handled, and the way color conversions and mode changes are completed.

Let's start from the top of the window.

1. First we are shown whether the color settings in Photoshop are synchronized with the other Adobe Creative Suite applications, like InDesign and Illustrator. In Chapter 18, we will talk about how and why to synchronize these applications.

2. Next is a pull-down menu, which gives you a series of standard groups of color settings. Figure 6.2 shows the default settings, which are called **North America General Purpose 2**. If we alter any of the individual settings, this designation will change to **Custom**. Figure 6.3 shows these default settings changed to **North America Prepress 2**, which can be better settings for us

FIGURE 6.1 Mermaid and the Sea Monster, 2011.
Credit: Photograph, © Julie Brown (juliebrownphotography.com)

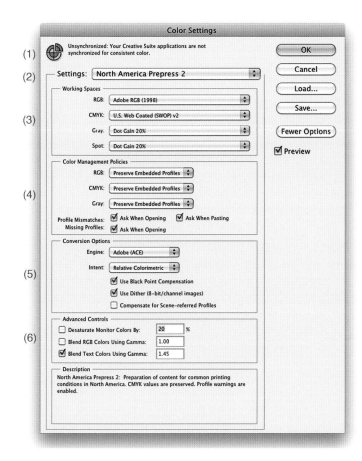

FIGURE 6.3 North America Prepress 2 Color Settings in Adobe Photoshop – More Options view.

since we are more concerned with printing. But the choices can vary, so we should discuss each of the next two sections of the **Color Settings** in greater detail: **Working Spaces** and **Color Management Policies**.

3. **Working Spaces**—In this window, you can select default working spaces for RGB, CMYK, and grayscale images, and spot colors. (Note that this is *not* necessarily the working space you will use when working with these files; only the default space that will be applied when creating a new document or opening a file that

has no color space specified.) In Chapter 17 we will talk about CMYK working spaces and dot gain; for this chapter we are most concerned with RGB **Working Spaces**.

RGB Working Color Spaces

We've seen that different devices can interpret RGB and CMYK color values differently; and so we need profiles to bring those interpretations into alignment with our expectations, in other words, to get a match. We've also seen that a number of color spaces (such as XYZ and LAB) are roughly equivalent to the range of colors we see in normal human vision. As we know, our ICC color-management system uses these two spaces as profile connection spaces (PCS), in order to describe the actual colors of our devices in an independent and standard way. There are also a number of RGB color spaces that are independent, but they differ in the amount of the gamut of human vision they include. These spaces are often called *RGB Working Spaces*. Working color spaces, like sRGB, AdobeRGB, ColorMatchRGB, and ProPhotoRGB, are standard, device independent, and neutral color spaces (and your images should be in one of these when editing in Photoshop).

Let's say that again! What all the RGB Working Spaces have in common is that they are *independent* and *neutral*. What do we mean by that? Working RGB color spaces are independent, in that they are not associated with any particular devices (such as monitors, scanners, digital cameras or printers). They are neutral, because when you have equal red, green and blue values in Photoshop's **Info** palette while sampling an area of an image in one of these spaces, the area being sampled is neutral, as in Figure 6.4, and has no colorcast. (This is

Note: You would not want to use a display profile as an RGB working color space. Monitor profiles, unlike the standard RGB Working Color Spaces, are not independent and neutral. Photoshop, and other color-managed applications, are already using your monitor profile to help display your colors as accurately and constantly as possible.

FIGURE 6.4 Info panel in Adobe Photoshop displaying RGB and Lab values for a marked neutral from an image in Adobe RGB (1998) working color space. Credit: Portion of photograph, © Christopher Sellas (chrissellas.com)

not necessarily the case if you are in a device space.) Images you are working on should be in one of these working color spaces, so that you can use the **Info** Panel to assist in color correction (discussed more in the next chapter), and so that when you share your images with others, their applications and systems will be more likely to correctly interpret the color from the image files.

The differences among these spaces are in the *gamma or tonal response curve (TRC)*, white point, and the gamut defined by their primaries, as shown in Figure 6.5. Figure 6.6 shows a gamut comparison of three working color spaces. The pink triangle shows the gamut of ColorMatchRGB, which is a smaller gamut space and is similar to sRGB (or Standard RGB; some people have said the "s" stands for more negative adjectives than "standard"). sRGB is the standard color space for the web, and the default space of many cameras and printers. Another thing to note about sRGB's tonal response curve, although it

RGB WORKING COLOR SPACES					
	sRGB	**ColorMatchRGB**	**AppleRGB**	**AdobeRGB(1998)**	**ProphotoRGB**
Gamma/TRC	~2.2	1.8	1.8	2.2	1.8
White Point	6500 K (D65)	5000 K (D50)	6500 K (D65)	6500 K (D65)	5000 K (D50)
Red Primary	x-0.640 y-0.330	x-0.630 y-0.340	x-0.625 y-0.340	x-0.640 y-0.330	x-0.7347 y-0.2653
Green Primary	x-0.300 y-0.600	x-0.295 y-0.605	x-0.280 y-0.595	x-0.210 y-0.710	x-0.1598 y-0.8404
Blue Primary	x-0.150 y-0.060	x-0.150 y0.075	x-0.155 y-0.070	x-0.150 y-0.060	x-0.0366 y-0.0001
Basis of Primaries	HDTV	P22 CRT Display Phosphors	Sony Trinitron	Custom	Custom

FIGURE 6.5 Chart comparing common working RGB color spaces for gamma, white point, and RGB xy primaries.

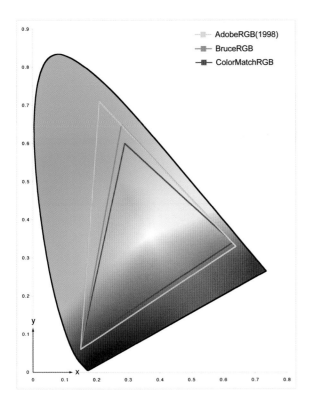

FIGURE 6.6 Gamut comparison of three working color spaces: ColorMatchRGB, BruceRGB, and AdobeRGB(1998).
Credit: Illustration by the author

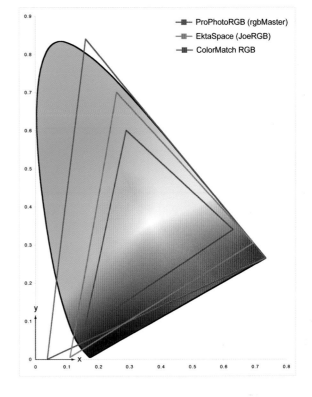

FIGURE 6.7 Gamut comparison of three working color spaces: sRGB, EktaspaceRGB, and AdobeRGB(1998).
Credit: Illustration by the author

nominally has a gamma of 2.2, in that it has an irregular shape, which has a lower gamma in the shadows and a slightly higher gamma in the highlights.

As you can see, the yellow triangle represents the gamut of AdobeRGB(1998), which is larger than that of sRGB or ColorMatch RGB. Why would you want to have your image in a color space that has more colors than most monitors can display? Think back to when we compared the gamut of a monitor, versus a print on coated paper, in Chapter 2. There were colors the printer and paper *could* reproduce that the monitor could *not*. To make sure we can maintain these colors

on output, AdobeRGB(1998) can be a useful working color space. And, as we discussed before, some higher-end monitors can now reproduce all (or almost all) of the gamut of AdobeRGB(1998).

Figure 6.7 shows even larger gamut working color spaces, like ProPhotoRGB, which have green and blue primaries that are outside the range of colors we can see. Kodak created ProPhotoRGB as the ultimate archiving space, so that you can maintain colors from your scene captured with a digital camera or from your saturated color transparencies that might be outside the gamut of most monitors, output, and color spaces like sRGB and AdobeRGB(1998).

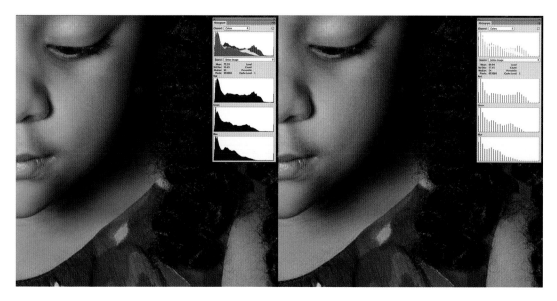

FIGURE 6.8 Image zoomed in to 300% in Photoshop showing without posterization on the left and with posterization on the right.
Credit: Photograph, © Brittany Reyna

If ProPhotoRGB is used as an editing space, files need to have always been kept and maintained at a higher bit-depth than 8-bit, like 16-bit, to avoid banding and posterization.

As we discussed in Chapter 3, posterization is the artifact you get when your image does not have enough tonal or color quality; and what should appear as smooth continuous gradations has defined breaks and flattening, as seen in Figure 6.8. Posterization is a factor for ProPhotoRGB, because it has larger steps between values, due to its large gamut. If you divide a one-foot ruler (small gamut) into 256 steps, each one would be smaller than the steps you would get dividing a yardstick (large gamut) this way, as seen in

Creating a Custom RGB Color Space

Did you know that Photoshop gives you the ability to create your own custom RGB color space? I'm not saying you should, because most probably you're going to be better off with one of the standard RGB working spaces, but you can. This ability in Photoshop is where color spaces like BruceRGB, JoeRGB, and TomRGB (no relation) have come from. How do you do it? With the **Color Space** window in the **More Options** mode, as in Figure 6.3, click on the **RGB** pull-down menu and drag to the top, where it says **Custom RGB . . .** The window in Figure 6.10 is launched. Here, as you can see, you would define the gamma, white point, and RGB primaries for a color space. Shown are the defined specifications of BruceRGB, which was created by the late Bruce Fraser to be an improvement over the gamut limitations of sRGB.

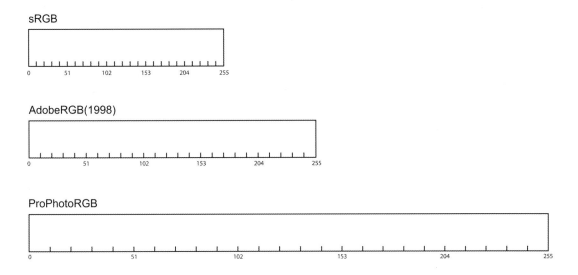

FIGURE 6.9 8-bit code values stretched over relative gamut sizes of sRGB, AdobeRGB(1998), and ProPhotoRGB, showing the need for images in very large gamut color spaces to have and maintain as large a bit depth as possible.
Credit: Illustration by the author

Figure 6.9. When the steps are larger, it's more likely that image adjustments will push tonal differences that appear continuous *farther* apart, so you can see the differences between adjacent values. When this happens, you get banding or posterization. As we said, to avoid this, if you are going to use very large gamut color spaces like ProPhotoRGB, your image should always have been in and maintained in a higher bit-depth than 8 bits per channel.

Your choice of RGB working space will change depending on the way you intend to use and present your photographic images. As mentioned, AdobeRGB(1998) is a good general choice for those of us who are working on maintaining the colors of our files for most print output. That being said, to make sure you are able to take advantage

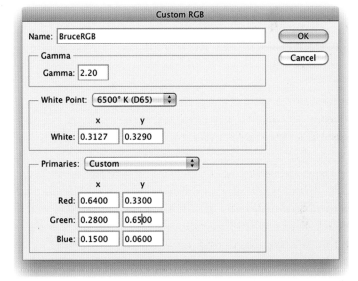

FIGURE 6.10 Custom RGB window in Photoshop used to define the gamma, white point, and RGB primaries for BruceRGB, which was created by Bruce Fraser.

of the full gamut of today's HDR (high dynamic range) and HiFi ink-sets, which use extra color inks, such as red, blue, green, and orange, you might consider a ProPhotoRGB as your working color space.

1. Color Management Policies—The choice of **North America Prepress 2** in the **Color Settings** window, Figure 6.3, results in the color management policies for Photoshop that turn on color management, preserve embedded profiles, and ask you what to do when profiles are not embedded (or don't match your defined working color spaces when opening or pasting images), which is helpful giving you control over how these files are color-managed.

The first choice of **Preserve Embedded Profiles** means that if your working RGB color space is AdobeRGB(1998), but you are opening an image that is in sRGB, Photoshop will keep the image in sRGB, instead of converting the image to AdobeRGB(1998). But wait, doesn't AdobeRGB(1998) have a larger gamut, closer to my printer? Yes, but, as we will discuss later this chapter, when you do a conversion, you are doing some mild damage to the file, but you are not gaining any additional gamut. So, it will most often be best to maintain the colors in the original space. One exception to this rule would be if your images were in a device space, not in a standard working RGB space, which will be better for editing.

Another exception to the **Color Settings** and policies in Figure 6.3 is that it is not always good to have Photoshop ask what to do when opening your images, if there is a missing or mismatched profile attached. If you are running automation, such as **Actions**, it is best to uncheck Ask When Opening. Since the reason for automation is to speed up repetitive tasks, stopping for the required dialog box could really slow things down for you.

2. Conversion Options—This section of the **Color Settings** window is only revealed when you select **More Options** in the **Color Settings** window. When you perform a conversion of your image, from RGB to CMYK, for example, using Photoshop's menu bar, shown in Figure 6.11, the settings used for this conversion will be what you have set in the **Color Settings** window, including the specific color space and the conversion options. We will cover **Rendering Intent**, **Black Point**

Compensation, and **Use Dither** later in this chapter, when we discuss Converting to Profiles. The only item you won't see in the **Convert to Profile** window is the **Compensate for Scene-referenced Profiles** check box. The choice is not important to those of us working with still images, but if you are working between Photoshop and Adobe After Effects on a video project it could be useful to have this box checked.

FIGURE 6.11 Image Mode changes from the menu bar in Photoshop, which are controlled by the Color Settings.

3. Advanced Controls—As with **Conversion Options**, this section of the **Color Settings** window is only revealed when you select **More Options** in the **Color Settings** window. The three controls here affect how Photoshop displays certain colors.

The **Desaturate Monitor Colors By** check box and percentage allows you to modify the colors of your display to help show color

differences in your image file that might be outside the gamut of your display. The problem with this desaturation is that it will make the in-gamut colors (which, most probably, make up the majority of colors in your images) less colorimetrically accurate.

Blend RGB Colors and Text Using Gamma check boxes and gamma choices control how RGB colors and text layers blend together. When the options are selected, RGB and text colors are blended in the color space corresponding to the specified gamma. As it says in Photoshop's description, "for RGB colors a gamma of 1.00 is considered 'colorimetrically correct' and should result in the fewest edge artifacts. When the option is deselected, RGB colors are blended directly in the document's color space."

One of the problems with all of these options is that when you select them, layered documents will look different when displayed in other applications than they do in Photoshop.

Showing the Document Profile

In order to see the ICC profile associated with a document in Photoshop, click on the right arrow on the lower left of the image window, then drag down to show, and select **Document Profile**, as shown in Figure 6.12.

FIGURE 6.12 Displaying the Document Profile, by clicking on the right arrow in the lower left hand corner of Photoshop.

Assign Profile or Convert to Profile

Now that we have touched on the underlying color settings in Photoshop, we now need to make sure we fully understand the difference between assigning a profile and converting to a profile, so we know when and how to use these important tools.

Assign Profile

We assign a profile in Photoshop, as in Figure 6.13, when either the image doesn't already have one, or when we think it has one that is interpreting the image color values incorrectly. The main goal of assigning an ICC profile to an image *is to tell Photoshop what the RGB values mean*, so the colors and tones in your image can be displayed accurately. When you assign a profile, you're not changing the RGB code values; you're changing how Photoshop *interprets* those values, and how the image will appear.

To help understand what's happening, we review what is going on inside the profile. As mentioned before, profiles consist of a series of matrixes or *look-up tables* (LUTs). In one look-up table, there's a column of different combinations of red, green, and blue values, and in the other column are the corresponding colors in Lab. This look-up table goes from **RGB > Lab**. This section of the profile is used when we assign a profile. The other look-up-table inside the profile goes in the opposite direction: from **Lab > RGB**. This section is used when we convert with a profile.

Let's look at an example: The image in Figure 6.14 was scanned on a flatbed scanner. A custom scanner profile was built. When the image was opened in Photoshop, there was no profile embedded with the image, as shown on the left. Since Photoshop was told not to color manage the image upon opening, the image was labeled with a document profile of "Untagged RGB." Photoshop doesn't know what these RGB values mean, so it displays the RGB values as if the image was in the default RGB color space selected in the **Color Settings**

FIGURE 6.13 Assign Profile window in Photoshop. Assigning a scanner profile.

window (in this case AdobeRGB(1998)). As a result, the image does not look like the original that was put on the scanner.

The lower right-hand portion of the image is labeled with its histogram. The RGB and Lab values from Photoshop's Info Panel for a middle-gray patch are on the left-hand side of the image.

To tell Photoshop what the RGB values mean, launch the Assign Profile window (Figure 6.13) by clicking on **Edit > Assign Profile** from the menu bar in Photoshop. As you select different profiles in this pull-down interface with the **Preview** checked, you'll notice that the

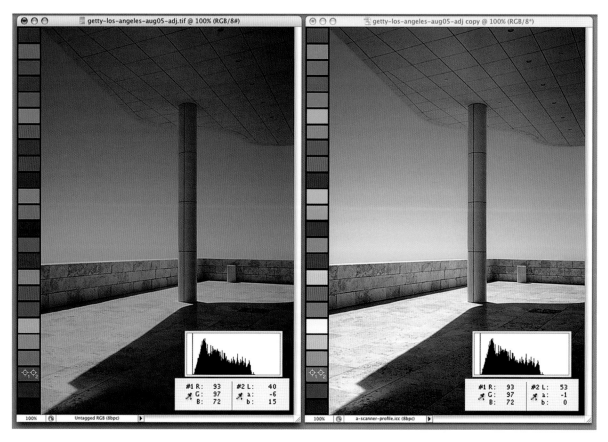

FIGURE 6.14 On the left: an untagged image from a scanner that has no profile associated with it. On the right: the same image after assigning the scanner profile. The original and resulting changes to the histogram, and RGB code values and underlying Lab values from an 18% middle gray patch are also shown.
Credit: Photograph by the author

image visibly changes with each profile selected. Each profile tells Photoshop that the RGB values in the image correspond to different tones and colors, or Lab values.

When we assign the profile that was built for the flatbed scanner (as we have done in Figure 6.14 on the right), we are correctly telling Photoshop what the RGB values from the scanner mean, so the colors on the monitor match the colors of the original print as closely as possible. Notice on this resulting image, the RGB values have not changed, and neither has the histogram. What *have* changed are the Lab values, and the appearance of the image.

As was said before, the goal of assigning a profile is to tell Photoshop what the RGB values mean, so that the colors and tones of an image can be displayed as accurately as possible.

Practical Reasons to Assign a Profile

- *Missing color space profiles from digital camera or other files.* If a digital camera does *not* embed a working color space to its JPEG files (or the file you are opening doesn't have an embedded a profile), but you know the images are processed to sRGB, AdobeRGB(1998), or WhateverRGB; simply *assign* the sRGB, AdobeRGB(1998), or WhateverRGB to get the color right.
- *Improved accuracy from input devices.* By assigning custom scanner profiles to their corresponding images, you get improved color matches to the original prints or transparencies. By assigning custom digital camera/light source profiles to their corresponding images, you can get colors that better match the colors of the original scene.

Note: If you have a profile from a lab, or a generic profile from a printer or paper manufacturer, you do NOT want to assign this profile to an image. In such a situation, you don't want to change the way the file looks; you just want it to look the same in another context (when printed). So, instead of assigning the profile to the image, you convert the image to the new profile, as we shall discuss.

Convert to Profile

When you perform a profile conversion, you go from one color space into another, without changing the look of the image. The goal is to change the RGB values, so that the colors that you perceive in the new space are the same as they were in the old space (or as close to the same as possible, given that the two spaces may have different gamuts and some of the colors from the first space may not be available in the second space).

To convert an image in Photoshop, launch the **Convert to Profile** window by clicking on **Edit > Convert to Profile** from the menu bar. In our continuing example, we are converting this image from our scanner space to sRGB, as shown in Figure 6.15.

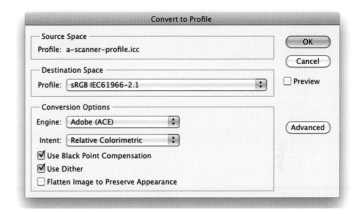

FIGURE 6.15 Convert to Profile window in Photoshop. Converting from scanner profile to sRGB.

As you can see, when we perform a conversion we have four options, beyond the destination space.

Color Engine or CMM

The color engine, or color management module (CMM), does the math "under the hood" when a conversion is performed. This selection does not have a big impact on the conversion, and Adobe (ACE) is a good general choice.

Rendering Intent

There are four rendering intent choices: Perceptual, Relative Colorimetric, Absolute Colorimetric, and Saturation. Your choice of rendering intent controls gamut compression, or how in-gamut colors that can be reproduced are handled during a conversion. Out-of-gamut colors (that cannot be reproduced) are always brought into the gamut of our destination space, but with photographic images we have two choices for handling the in-gamut colors. We can shift the in-gamut colors to maintain the overall relationship of colors, which is done when we select *Perceptual* rendering (Figure 6.16); or we can keep the in-gamut colors unchanged (or as close as possible), which is done when we select *Colorimetric* rendering (Figure 6.17).

There are two types of Colorimetric rendering: *Absolute* and *Relative*. The difference between the two is how they handle white

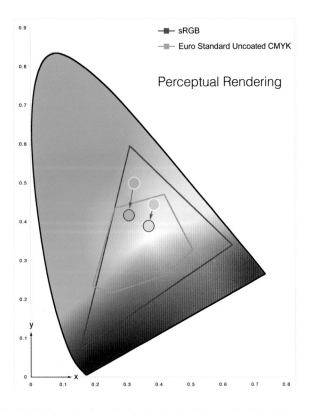

FIGURE 6.16 Conversion from sRGB to Euro Standard Uncoated CMYK with Perceptual rendering, where out-of-gamut colors come into gamut and in-gamut colors also shift, so the relationship of colors remains the same.
Credit: Illustration by the author

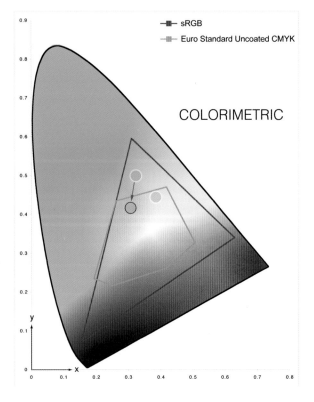

FIGURE 6.17 Conversion from sRGB to Euro Standard Uncoated CMYK with Colorimetric rendering, where out-of-gamut colors come into gamut and in-gamut colors stay the same, so they are as accurate as possible.
Credit: Illustration by the author

when doing a conversion. *Absolute Colorimetric* says, "White has color," and tries to match it from one color space to another. Absolute Colorimetric is used in some proofing applications, where matching the way a print will look exactly on the paper used for printing is very important. *Relative Colorimetric* says, "White is white," and always maps the brightest white from the source color space to the brightest white of the destination color space. Figure 6.18 illustrates this difference. Both images were made by converting from a printing press profile (US Web Uncoated CMYK) for an uncoated paper that has a dark slightly bluish white (L = 91, a = 0, b = -2). When we converted

using Relative Colorimetric, the resulting white around the color checker and light patches, as seen in the top of Figure 6.18, has been mapped to the brightest white in the destination space (L = 100, a = 0, b = 0). On the other hand, when we converted using Absolute Colorimetric, the resulting white around the color checker and light patches, as seen in the bottom of Figure 6.18, has been mapped to the actual white of the U.S. Web Uncoated paper (L = 91, a = 0, b = -2).

The fourth rendering intent is *Saturation* (Figure 6.19). If you choose Saturation rendering, out-of-gamut colors are brought to the

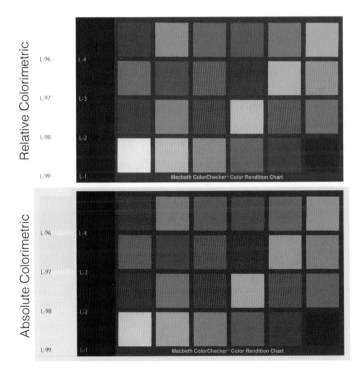

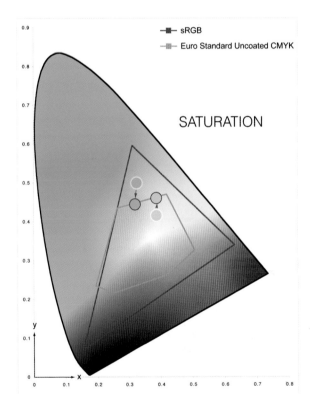

FIGURE 6.18 Comparison between Relative Colorimetric and Absolute Colorimetric renderings. Both are from a conversion from US Web Uncoated CMYK to sRGB. Notice the difference in white around the color checker and light patches.
Credit: Illustration by the author

FIGURE 6.19 Conversion from sRGB to Euro Standard Uncoated CMYK with Saturation rendering, where out-of-gamut colors come to the gamut boundary and in-gamut colors are also pushed to be more saturated, so they are vibrant and punchy as possible.
Credit: Illustration by the author

gamut border, and in-gamut colors are made more saturated. This is used to create more saturated, or "punchy" graphics, possibly for presentations where accuracy of colors are not important.

Once again, for us as photographers, the only two rendering intents we will typically be choosing between are Perceptual and Relative Colorimetric. Using the **Preview check box** in the **Convert to Profile** window, you can decide which intent you prefer for your image(s).

Black Point Compensation (BPC)

Use Black Point Compensation is checked to help you maintain shadow detail when using Relative Colorimetric rendering. If you check or do not check the BPC selection with Perceptual rendering there is no change, since Perceptual rendering will always map the darkest black of the source space to the darkest black of the destination space,

which is what Relative Colorimetric rendering will do when applying Black Point Compensation. As you can see in Figure 6.20, if you have not checked BPC with Relative Colorimetric rendering, your shadows can be blocked up. In Figure 6.19, you can see what happens when your source space has a light black (newsprint). If **Black Point Compensation** is not selected, as in this situation, the resulting image will be flatter than it would be if BPC had been checked.

Dither

Use Dither is checked to help maintain smoothness in gradations during the conversion of 8-bit images. Since converting to a profile, unlike assigning a profile, is destructive, the **Use Dither** function is meant to help us to avoid seeing posterization or banding in the results. This choice is not selectable when converting 16-bit images. The dither pattern that is generated in our 8-bit images as a result of this selection

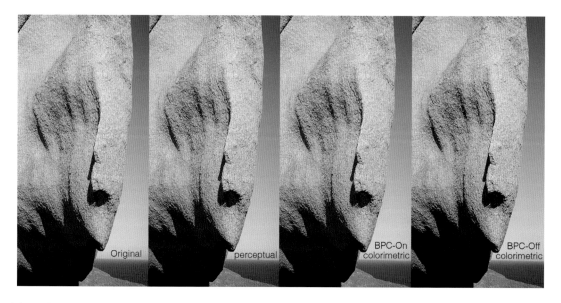

FIGURE 6.20 From left to right: an original image; the same image converted to a printing press profile using Perceptual rendering; the image converted using the same profile and Relative Colorimetric rendering with Black Point Compensation (BPC) checked, and the image converted using the profile and Relative Colorimetric rendering with BPC unchecked. Notice the lack of detail in the shadows of the final image on the right without BPC.
Credit: Photograph by the author

FIGURE 6.21 From left to right: an 8-Bit image that has been converted to a printer-paper profile with Use Dither checked and exaggerated dither patterns in the red, green, and blue channels of the converted image, respectively. Dither is added to help maintain the perception of smoothness in gradations when converting an image from one color space to another.

Credit: Illustration by the author with test page photographs by Jungmin Kim and Christopher Sellas

is pretty much imperceptible to the naked eye, since it consists of a slight change of one or two code values for random pixels in our image. In Figure 6.21, I've exaggerated the pixels that show a difference between a conversion with **Dither** checked and **Dither** not checked for each channel, red, green, and blue, so you can get an idea of what the dither pattern would look like, if you could see it.

Finally, Figure 6.22 shows the results of the conversion we performed with the settings in Figure 6.15. When our image was converted to sRGB color space, as seen on the right in Figure 6.22, the RGB values were adjusted so that the colors remained the same as when the image was in the scanner space. Notice that both the RGB values *and* the histogram have changed, but the underlying Lab values and the appearance of the image have remained the same.

Practical Reasons to Convert to a Profile

- *Putting images into working color spaces.* Before working on images in Photoshop, it's better to have them in standard, independent, neutral color spaces, like sRGB, ColorMatchRGB, or Adobe(RGB). One reason is so that the Info Panel's RGB values will have more meaning. When the red, green, and blue values are equal in one of these spaces, the color is a *true neutral*. If you're in a device space (such as scanner or monitor space), this is most likely not the case, and values can't be used.

- *Preparing images for printing by a lab, service bureau or printer.* You can convert using your lab's printer and paper profile before sending images. But remember, it's important to tell them *not* to make any adjustments or conversions to these images, once you've converted them. We will be covering this more in depth in Chapter 16.

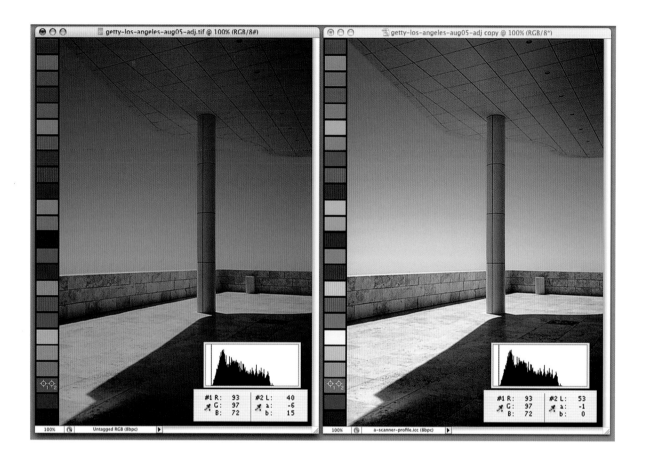

FIGURE 6.22 On the left: an image that has had a scanner profile assigned to it. On the right: the same image after converting from the scanner space to sRGB. The original and resulting changes to the histogram, and RGB code values and underlying Lab values from an 18% middle gray patch are also shown.
Credit: Photograph by the author

- *Preparing images for the web and tablets.* If you're saving files for the web and tablets, it's best to convert the images to sRGB, which is currently the standard color space for this industry. Make sure to embed the profile when saving the image. We will be covering saving images for the web and tablets more in depth in Chapter 20.

Another place Photoshop performs conversions is in the **Print** window. When you select **Let Photoshop Determine Colors** option under **Color Management** and select the printer paper profile, the conversion to the printer and paper color space will happen on the fly as you send the image to the printer. This will help you get the best match from your monitor to your printer and paper combination. We will discuss this more in Chapter 8.

Understanding the difference between assigning a profile and converting to a profile will help you in building the best settings and workflow for creating, correcting, and saving your images in Photoshop. So it would be valuable for you to go back and look again at what happens to the images and the RGB value in Figures 6.14 and 6.22, where we assigned a profile and converted to a profile respectively. When we assigned the scanner profile in Figure 6.14 the RGB numbers didn't change, but the image and the underlying Lab values did. This is because, when we **Assign a Profile**, we are telling Photoshop what the RGB numbers in the file mean, so it can display the color accurately. When we converted to the profile in Figure 6.22, the RGB number did change, but the image and the underlying Lab values didn't. This is because, when we convert from one color space to another, we are adjusting the RGB numbers, so we can get the match (as closely as possible).

An Analogy

To hammer home the difference between assign and convert, let's finish up by using an analogy. Let's see, sex and religion aren't quite workable, so let's go with MONEY. If we start out with ten pieces of paper money, they will have very different values depending on the denomination or currency, as seen in Figure 6.23. Ten U.S. dollar bills would have a very different value than ten Chinese yuan notes, just as when we assign a profile the RGB numbers don't change but the colors look different. Next let's convert our ten U.S. dollar bills to Chinese yuan notes. As you can see in Figure 6.24, ten U.S. dollars would give us about 63.7 yuan—at today's rate. The numbers are different, ten and 64, but the value is the same, just as when we convert an image the RGB numbers change but the colors remain the same.

I hope this makes the difference clearer and I also hope all future conversions work out in your favor.

Embedding Profiles

Now that you've converted your image into a working color space, it is important that the profile stays with your image. If the profile does not stay with your image, the next time you, or someone else (like a client), opens the image, Photoshop, or any application being used, won't know how to interpret the RGB numbers of the file and how do display them correctly. Luckily most image file formats allow us to embed an ICC Profile into the header tags of the image. This does make your file size slightly larger, but it is worth it in most cases. You choose to embed (or not embed) the profile in Photoshop when you are saving your image, as shown in Figure 6.25.

Note: When Photoshop opens an image without a profile and designates it as **Untagged**, it will display the colors as if the file is in the RGB **Working Space** you chose in **Color Settings**.

Color in Adobe Photoshop Lightroom

Lightroom handles editing and color management of files differently than Photoshop. This is mainly because Lightroom is, first and foremost, a Raw processor. It has other important functions, such as image asset management and the production of web galleries, but its primary purpose is working with Raw digital camera files. In reviewing how color is processed in Lightroom, we will review the Raw digital camera file format, color processing in different parts of Lightroom, how Raw image files (and other files) are edited in Lightroom, and, finally, the benefits of editing Raw digital camera files.

FIGURE 6.23 An analogy. Determining the currency and denomination of the ten pieces of paper money tell us the underlying values, which are different for dollars and yuan. This is like assigning a profile, where the numbers stays the same, but the underlying value the numbers represent changes.
Credit: Illustration by the author

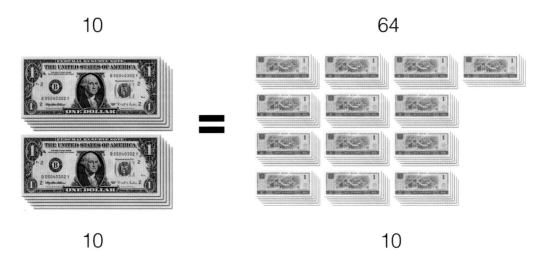

FIGURE 6.24 An analogy. Converting ten US dollars to Chinese Yuan, where the number changes, but the underlying value is the same is like converting to a profile, where the numbers change, but the underlying value the numbers represent remains the same.
Credit: Illustration by the author

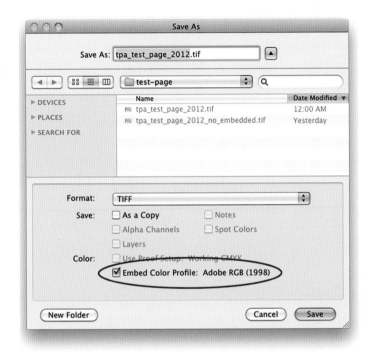

FIGURE 6.25 Save As window in Photoshop with Embed Color Profile option circled. Embedding a profile with your images insures that when they are opened later, Photoshop and other applications will know how to interpret the RGB numbers and display the colors correctly.

FIGURE 6.26 Bayer mosaic pattern found on some digital camera sensors.

Credit: Illustration by the author

Raw File Format

The Raw file from a digital camera contains a single digital value for each pixel in the file, corresponding to each photo-site on the camera's sensor and the, typically, red, green, or blue filter that was over that photo-site. The pattern of red, green, and blue filters over the photo-sites of the sensor is called the mosaic pattern. One specific mosaic pattern you might have heard of is the Bayer pattern, which is shown in Figure 6.26. Notice that in the Bayer pattern there are twice as many green pixels as red and blue. In the Raw digital camera file, the image has not yet been interpolated or processed to have three values

(red, green, *and* blue) for each pixel. The image has not yet been "de-mosaiced." Also, since the Raw digital camera file hasn't been processed, it is still at the bit-depth produced from the camera's analog-to-digital converter, typically 10, 12, 14, or 16 bits per channel.

Color Processing in Lightroom

There are several different imaging pipelines in Lightroom, and each has different color-management handling. For all non-Raw image files (in formats like JPEG, PSD, or TIFF), the embedded profile is used, but if there is no embedded profile, Lightroom assumes the image is

in sRGB. If the image is Raw or DNG (Raw), the base sequence of image processing is: **Raw/DNG(Raw) file > (1) de-mosaic > (2) conversion from Camera Calibration to linear ProPhotoRGB > (3) Develop Module adjustments > (4) tone mapping > next_colorspace_here.**

1. Since the Raw digital camera file has not been de-mosaiced, and is still (approximately) linear-encoded, it isn't viewable due to differences between capture and display dynamic range. The first step in making the image viewable is to interpolate or de-mosaic the file, so there are red, green, and blue values for each pixel.
2. The linear RGB data has a color space defined by the setting in **Camera Calibration** as well as the **White Balance** and **Tint** settings, and it is converted to linear ProPhotoRGB. Linear ProPhotoRGB has a gamma of 1.0, while standard ProPhotoRGB has a gamma of 1.8. This is the point of the processing where the effect of the DNG profile we discussed in the last chapter would have its impact.
3. Develop Module adjustments are applied at this point.
4. The image data is tone mapped, so it can be displayed on our restricted dynamic range displays.

From here, how color is processed in Lightroom depends on context or module involved:

1. **Library module**—Rendered previews are converted to either Adobe RGB (1998) or ProPhotoRGB, depending on the **Lightroom > Catalog Settings > File Handling > Preview Quality** setting. If set to either **Low** or **Medium**, the color space is Adobe RGB(1998). If set to **High**, the color space is ProPhotoRGB. (Embedded previews in Raw files are generated by the camera itself, and are assumed by Lightroom to be sRGB. So if you don't use rendered previews, they are sRGB.)
2. **Develop module**—Image data is converted to the current monitor RGB profile to display the image in the develop module.

3. **External Editing of images**—Image data is converted to the profile set in **Lightroom > Preferences > External Editing > Color Space** pull-down menu shown in Figure 6.27.

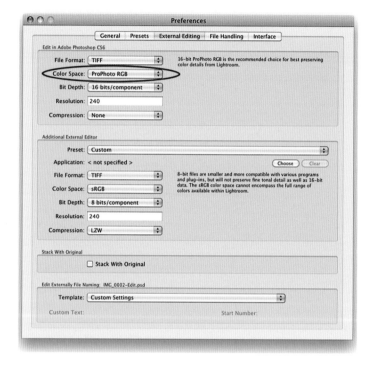

FIGURE 6.27 External Editing section of Preferences window in Lightroom with ProPhoto RGB selected as the color space.

4. **Exporting images**—From the **Library Module**, clicking **Export** uses the profile set in **File Settings > Color Space** pull-down menu, as seen in Figure 6.28.
5. **Printing images**—Draft Mode Printing uses the image preview profile (sRGB if an embedded preview, Adobe RGB (1998) or ProPhotoRGB) as the source profile, and passes this onto the OS for ColorSync (Apple) or ICM/WCS (Windows) color-management handling at the OS and print driver level. If **Draft Mode Printing** is unchecked, the image is converted to the profile you select in the Print Job > Profile pull-down menu.

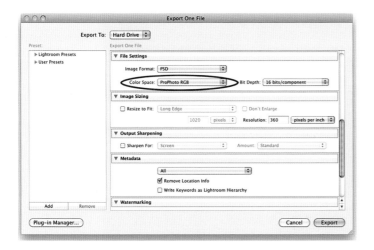

FIGURE 6.28 Export window in Lightroom with ProPhoto RGB selected as the color space.

6. **Histogram, curves, numbers in Develop Module**—For the histogram, curve adjustments and RGB numbers shown, the image data is converted to a color space defined as ProPhotoRGB primaries, and the sRGB tone response curve (TRC). As mentioned before, the TRC of sRGB is close to, but, as mentioned before, not exactly the same as a gamma of 2.2. This is done because, if the RGB data were used with a linear TRC, the histograms, curves, and numbers would provide a distorted amount of information and control over highlights compared to the rest of the image tonal range.

As you can see in Figure 6.29, when Lightroom's develop module is in its standard mode, the RGB values shown for selected pixels from the image (under the histogram) are displayed as a percentage of calculated RGB numbers (ProPhoto primaries and sRGB TRC). Adobe decided not to show standard 0–255 8-bit code values, since they would not correspond to any values you would see in applications like Photoshop. In Lightroom 4, things changed: Adobe added a Soft Proof mode, as shown in Figure 6.30. Soft Proof mode lightens the neutral background and allows you to select any ICC profile for the Develop

module to simulate. This allows you to select standard working color space, like AdobeRGB(1998), and the RGB values are displayed as standard 0–255 8-bit code values.

Image Editing in Lightroom

Since none of the data in a Raw digital camera file can be altered, the only way we can change the file is by the addition of extra information (called XMP data), either as an accompanying sidecar file, or by placing data into the beginning (the header) of the file itself. All the pixel data stays untouched. The same is true if you import a file as a TIFF or a JPEG to Lightroom. While they are in Lightroom, only instructions for further changes are added; none of the actual pixels are altered.

Benefits of Editing the Raw Image in Lightroom

- *Less Damage from Edits*—This compilation of all the changes into one set of instructions (that are applied only on export) is one of *Lightroom's* greatest strengths. First, because all of the pixel values are changed at one time; image artifacts don't accumulate sequentially, and the file will, therefore, have less overall damage. (This is true of TIFFs and JPEGs as well as of Raw files processed from Lightroom.)
- *Virtual Copies*—*Lightroom* also allows us to make virtual copies of files, by attaching different sets of XMP data to one basic file.
- *Improved Tonal Processing*—By making adjustments while the file is still in a linear state, we gain certain advantages in tonal output that aren't possible when making adjustments to non-linear image data, as we do in Photoshop.

FIGURE 6.29 The Develop module in Lightroom in standard mode showing a histogram and RGB values in percentages of internal color space using ProPhotoRGB primaries and the sRGB tone response curve. RGB values are for the clouds in the top of the image.
Credit: Photograph by the author

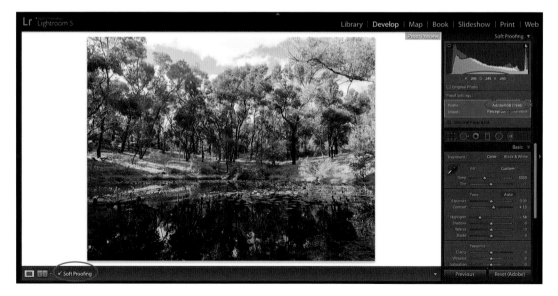

FIGURE 6.30 The Develop module in Lightroom in Soft Proof mode showing a histogram and actual RGB code as if the image was in AdobeRGB(1998). RGB values are for the clouds in the top of the image.
Credit: Photograph by the author

Conclusion

In this chapter we have discussed many things we will be coming back to in the future: Adobe Create Suite Color Settings, working color spaces, assigning profiles, converting to profiles, and rendering intents. Whether you are working in Photoshop, Lightroom, or both, hopefully this chapter has allowed you to feel more comfortable with how they are handling color, so you can use them more confidently and effectively. This will be important as we start to color correct our images in the next chapter.

EXPLORATIONS

To reinforce what you've learned about Photoshop and Lightroom, it's time to spend some time in both.

- *Compare the differences between assigning profiles and converting to profiles in Photoshop with some of your images.* Start from a copy of the test page you built earlier. Assign different profiles. Convert to different working color space profiles; use different rendering intents; turn on and off **Black Point Compensation** and **Use Dither**. Use the **Info Panel** to watch what is happening with the RGB values as you make these changes. See the next chapter for more information on how to use the Info Panel.
- *Save different versions of your test page, embed the profile in some, not in others.* Name the files so you actually know what color space the image files are in and if the profile is embedded or not. Then take these files and import them into Lightroom. Here you will see how Lightroom is interpreting the files that don't have embedded profiles. Remember: Lightroom assumes the image is in sRGB if there is no embedded profile.

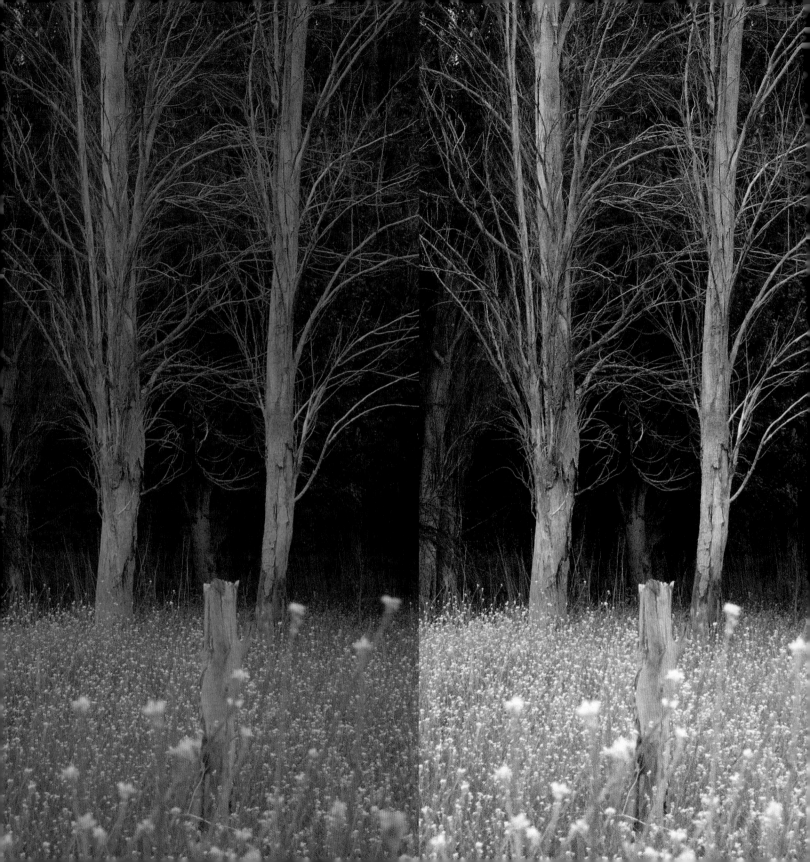

BASIC COLOR CORRECTION & IMAGE RENDERING

Now that we have looked at how to calibrate and profile our displays and how color works in Adobe Photoshop and Lightroom, we are at a good point to discuss some basic strategies and techniques in color correcting our images. In this chapter we will discuss color correction philosophies. (Are you surprised that there are color correction philosophies?) Specifically, we will look at the ideas of trusting what you see on your display versus using the RGB (or CMYK) numbers. Then we will go into Photoshop and Lightroom and review their basic color-correction tools. Finally, we will end the chapter with a discussion of *rendering* our images with specific looks and styles.

Historically, the graphic arts scanner operator is the highly trained and skilled professional technician and craftsperson whose job is to digitize and translate our photographic transparencies, negatives, or prints for reproduction, typically, on a printing press. The advent of desktop scanners and digital imaging technology in the 1990s greatly reduced the ranks of this profession, and, at the same time, put much of their color management and color correction responsibility on us as photographers.

application; profile our monitor, so Photoshop, Lightroom, and other applications can correctly use this characterization from the operating system level of our computer to translate and display colors accurately.

Color Correction Philosophies

As an oversimplification, let's say there are really two main philosophies of color correction. One says you should trust what you see on your display. The other says you should never trust what you see and that you can only trust the RGB or CMYK numbers that make up your image. Let's take each one individually and then find a compromise.

Trust What You See

As photographers, we are generally visual people, so color correcting based on what we actually see on our display seems very intuitive and reasonable. We see a colorcast or lack of contrast in the image on the display and then we make adjustments until the colorcast is removed and contrast is corrected. As we have discussed in Chapter 4, this should be a good strategy, as long as we have taken some important steps: set up a good working environment that includes subdued, indirect, and consistent lighting, neutral walls, and a hood around our graphics quality display; use a middle gray background for our desktop and imaging applications; calibrate our display to a reasonable luminance (80–120 cd/m^2) and an appropriate white point for our

Only Trust the Numbers

The other school of thought says that we should never trust what we see on the display, we should only trust the RGB code values or CMYK percentages that make up our image files and correct based on this, more objective, information. By this method, there are target values for white, black, neutrals, and skin tones within an image, so overall adjustments are made to bring the values of the image to the specific aims. The color-correct-by-the-numbers philosophy is mainly from experts with a background as commercial printing or graphic arts *scanner operators*. Their arguments on the limitations of visual color correcting should be familiar to you: our visual system and color judgment are too variable and subjective, and our displays are not of high enough gamut and quality to accurately show how the image will look on the printed page. As an extreme act of their belief in this philosophy, when color monitors were introduced, some scanner operators turned off the color of the display (rendering the images to black and white). This way, they would not be distracted or confused by what colors they were seeing on the "inaccurate" monitors.

FIGURE 7.1 Uncorrected (left) and corrected (right) versions of the same landscape image shot in Mendoza, Argentina.
Credit: Photograph by the author

The Best of Both

As you might guess, the philosophy I'm going to recommend is somewhere between the two extremes. *We will trust what we see on our displays, within limits, and use the numbers to examine our images and verify what we are seeing.* However, the trust in our displays will be able to go up as we do the things we mentioned earlier: setting up as good a viewing environment as possible; using a graphics quality display; and calibrating and profiling our display, we have to remember our visual limitations and the limits of our displays. In the next sections of the chapter we will look at using the numbers in Photoshop and Lightroom to color correct our images.

Color Correction in Adobe Photoshop

Our review of basic color correction in Photoshop will consist of: setting up the Info and Histogram Panels; setting the white and black points of our images using a **Levels** adjustment layer; correcting colorcasts and improving contrast with **Curves**; and making local adjustments using **Layer Masks**.

The Info and Histogram Panels

We use the **Info** and **Histogram Panels** in Photoshop to help us to better understand our images and the adjustments we are making to them. These are the "numbers" we should be watching.

To launch the Info Panel, click on **Window > Info** from the menu bar, as seen in Figure 7.2, or press the **F8** key. The **Info Panel** can show two different values for any pixel or average of a range of pixels.

FIGURE 7.2 Launching the Info panel from Photoshop's menu bar.

FIGURE 7.3 The Info panel from Photoshop on top. Bottom Info panel showing Panel Options selection when clicking on right-hand horizontal lines pull down menu.

The **Info Panel** in Figure 7.3 is in the default color space condition with RGB on the left and CMYK on the right. You can change the color space in two ways: click on the down arrow next to the horizontal lines and drag down to **Panel Options**, as seen at the bottom of Figure 7.3 and in Figure 7.4, or click on down arrow next to the eyedropper, as seen in Figure 7.5. As you can see the choices are **Grayscale** (percentage), **RGB Color** (code values), **Web Color** (indexed values), **HSB Color** (hue angle, saturation percentage, and brightness percentage), **CMYK Color** (percentages), and **Lab Color** (Lightness, a = red-green value, and b = yellow-blue value). In this case we are going to select **Lab**, but if you were color correcting to CMYK numbers, you would keep CMYK colors displayed.

As discussed in the last chapter, to use the Info Panel to its full potential, we need our images to be in an RGB working color space, like sRGB, AdobeRGB(1998) or ProPhoto(RGB). Using these independent and neutral color spaces will insure that when we see equal red, green, and blue values in the Info Panel, we are looking at a true neutral. When we are in a device space, like a monitor, camera, or printer, then equal red, green, and blue does not necessarily mean what we are sampling is a neutral.

Next, select the **Eyedropper Tool** or the **Color Sampler Tool** from the toolbar, as shown in Figure 7.6. They both take up the same position on the toolbar. Notice the options you have for **Sample Size** at the top of Figure 7.6: **Point Sample, 3 by 3 Average, 5 by 5 Average,** etc. You want to select at least **5 by 5 Average**, which will display the average of 25 pixels around and including the pixel your cursor is over. The reason not to use **Point Sample**, which gives you the value of one individual pixel, is because it is possible that because of noise in the image, you could inadvertently select pixels that do not represent the other pixels around them, which could lead you to make incorrect adjustments to your image depending on the pixel your cursor is over.

FIGURE 7.4 The Info Panel Options window in Photoshop.

FIGURE 7.5 Selecting Lab Color to display in Info panel from Photoshop by clicking on the down arrow next to the eyedropper.

FIGURE 7.6 Eyedropper Tool in Photoshop tool bar on the right with Sample Size options at the top.

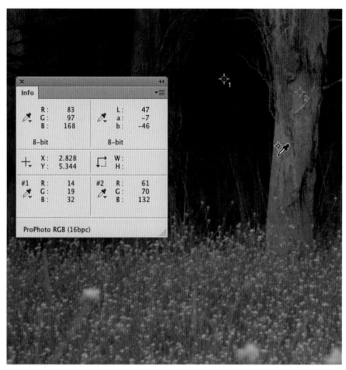

FIGURE 7.7 Image and Info panel with two anchored Color Sample Points. Top RGB and Lab values are for the values at the cursor/Color Sampler Tool icon.
Credit: Photograph by the author

As we said, the **Info Panel** is always showing you the color values for the pixel(s) the cursor is hovering over. Because of this, it is difficult to watch what is happening in one part of your image consistently. Luckily, Photoshop allows you to watch the color values in four separate anchored spots on your image. You do this by placing *Color Sampler Points*. These points are placed in two possible ways: if you are using the Eyedropper Tool, hold the **Shift** key down and click on the pixel(s) you want to display the color values; or if you are using the **Color Sampler Tool**, simply click on the pixel(s). The method for moving or removing the **Color Sampler Points** also depends on the tool you are using: if you are using the **Eyedropper Tool**, hold the **Option** key down and click on the sample point and move it to a new point or off the image to delete it; or if you are using the **Color Sampler Tool,** simply

click on the sample point to move it and hold the **Option** key to delete it. In Figure 7.7, you can see the result of placing two **Color Sampler Points**. The measurements for these two points show up at the bottom of the Info Panel. The values at the top are for the average of the 25 pixels at the **Color Sampler Tool**.

Notice that both the values from the shadow and the tree are confirming the blue cast we can see. For example, the RGB values in Sampler Point #2 on the tree are R-61, G-70, B-132. If the tree were supposed to be close to neutral, then the three values would be closer together, but the red value is slightly lower than green (which means a slight cyan color from neutral) and the blue value is, simultaneously, higher than green (which means there is also a very strong blue cast).

FIGURE 7.8 Changing Channel to Colors in Histogram panel from the full image in Figure 7.10.jpg with Uncached Refresh button circled.

FIGURE 7.9 Changing to All Channels View in Histogram panel from the image in Figure 7.10.jpg by clicking on the panel pull down menu in the upper right hand corner.

The **Histogram Panel**, like all histograms, is a graphical representation of the color and tonal information in your image. The horizontal part, or x-axis, of the histogram is made up of the possible code values, from 0 to 255. The vertical part, or y-axis, shows the number of pixels in the image that have this value. To launch the **Histogram Panel**, click on **Window > Histogram** from the menu bar.

You can change the basic histogram to show the three histograms together that make it up from the three channels (red, green, and blue) in their individual color by clicking on the **Channel** pull-down menu and selecting **Colors**, as shown in Figure 7.8, resulting in the **Histogram Panel** in Figure 7.9. Notice the histogram now consists of distinctive red, green, and blue parts, which makes sense, but what about the cyan, magenta, yellow, and gray? Why are they there? You see cyan where blue and green values only overlap; magenta where red and blue values overlap; yellow where red and green overlap; and gray where red, green, and blue values overlap. You can further change the **Histogram Panel** to show

the RGB histograms individually by clicking on the pull-down menu in the upper right and selecting **All Channels View**, as shown in Figure 7.9, resulting in the **Histogram Panel** in Figure 7.11.

Let's compare the image in Figure 7.10 to its histogram(s) in Figure 7.11. The values of the histogram, as with the tones of an image, can be divided into three parts: shadows, mid-tones, and highlights. This histogram shows an image that has very few tones in the lighter mid-tones and highlights on the right side of the histogram, so it is somewhat dark. Also when we look at the individual histograms

Cached Data Warning

When you get a small triangle with an exclamation point in the upper right-hand corner of the **Histogram Panel**, this means the histogram is not based on the full information in file, it is based only on the limited representative information stored in cache memory. You can refresh the histogram by doing any of the following: double-click anywhere in the histogram; click on the **Cached Data Warning** icon; click on the **Uncached Refresh** button, circled in Figure 7.8, or choose **Uncached Refresh** from the Histogram Panel menu, as seen in Figure 7.9.

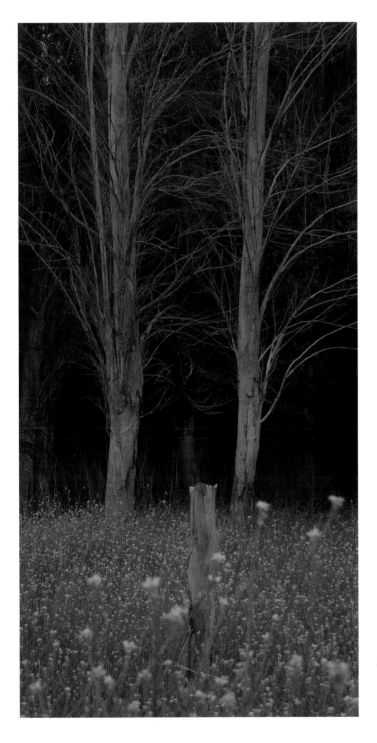

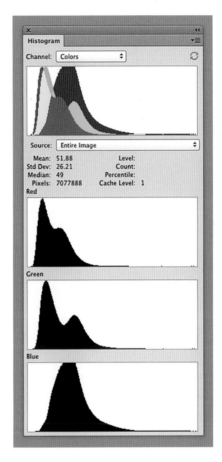

FIGURE 7.11 All Channels View in Histogram panel from the image in Figure 7.10.jpg.

we can see that the blue histogram goes the farthest to the right, which means there is more blue in the image overall. This confirms what we see in the image and what we found when we examined the code values in the **Info Panel**. Now we will correct the image using **Levels** and **Curves Adjustment Layers**.

FIGURE 7.10 *(left)* Uncorrected landscape image, shot in Mendoza Argentina.
Credit: Photograph by the author

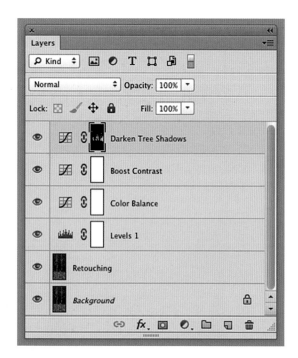

Adjustment Layers

As a review of Photoshop basics, for all of the color correction we do in Photoshop we should be using **Adjustment Layers** (and not making adjustments to the original image directly, using the early Photoshop image adjustments) where possible. The use of **Adjustment Layers** and **Layer Masks**, shown in Figure 7.12, allows us to refine and adjust our image with great control and flexibility, without damaging the file.

FIGURE 7.12 *left)* Adjustment Layers palette in Photoshop for image in Figure 7.15.

FIGURE 7.13 *(below)* Red, Green, and Blue Levels Properties panel in Photoshop with adjustments for image in Figure 7.15.

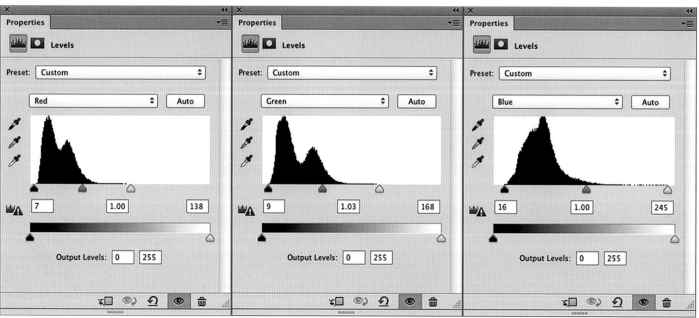

Setting White and Black Points Using a Levels Adjustment Layer

The first big step in color correcting our images is to define their white and black points, the goal of which is to reduce or remove any unwanted colorcast and improve lightness and contrast while not losing or clipping any details in the highlights or shadows. For RGB images we make these changes to each of the three channels individually as shown in Figure 7.13. We move the black point slider over until we hit the darkest shadow in each channel, then we move the white point slider over until we hit the brightest highlight in each channel.

We don't want to move too far into the image, because this could lead to clipping or lots of detail. To help you make sure you are not clipping, you hold down the **Option (Alt)** key when clicking and moving the shadow (black) or highlight (white) point. Photoshop will then only show the parts of the image that are being mapped to highest or lowest pixel values, as seen in Figure 7.14, which shows what happens when you move the red highlight over to the left this far with this image. The flowers in the shot would have lost some detail, if the settings were kept here, so we positioned the red highlight point further to the right as shown in Figure 7.13. The only parts of an image you might find clipping to be acceptable are in specular highlights, where you are seeing a light source directly or in a reflection.

Let's look at the effect of the RGB Levels adjustments made in Figure 7.13. The resulting image is in Figure 7.15, along with the **Histogram** and **Info Panels** in Figure 7.16. (Remember the original image is in Figure 7.10.) The **Info Panel** now shows two values, for example "R: 64/112". The first number (64) is the value before the adjustment, and the second (112) is the value after the adjustment has been made. The new black and white point made from this adjustment have made the image much less blue by increasing the red and green values; this has also made the image lighter and given it more contrast. The Info Panel values in Figure 7.16 also show that the color of the bark in tree Sample #2 is still slightly bluish even after the Levels adjustment, since the blue value is still higher than the red and green values (R-105, G-100, B-129). Although the bark is not necessarily perfectly neutral, it is still too blue.

FIGURE 7.14 Holding the Option (Alt) Key while clicking on the highlight slider (circled) in the Red Levels in Photoshop changes the view, so that values that are adjusted to 255 Red are displayed as red and everything else is displayed as black. Positioning this slider further to the right will help avoid clipping or loss of details. Credit: Photograph by the author

Correcting Color Casts and Improving Contrast with Curves

The next step in color correcting our images is to further adjust the overall color balance using a **Curves Adjustment Layer**, which is a flexible tool that allows us to make color balance and contrast adjustments to specific parts of our image. We are able to add points to the curve and define the Input and desired Output for each of these points on the curve. When we open the **Curves Adjustment Layer**, we start out with a slope of 1.0. At a slope of 1.0, if an Input is 120,

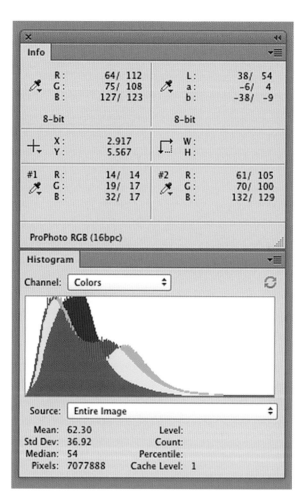

FIGURE 7.16 Info and Histogram panels in Photoshop reflecting the Levels adjustments for image in Figure 7.15.

FIGURE 7.15 *(left)* Image in Figure 7.10 with the Levels adjustments from Figure 7.13, which reduced the blue cast and increased lightness and contrast.

Credit: Photograph by the author

then the corresponding output will be 120, and, therefore, there would be no change to the image. There are four **Curves**, just as there were four **Levels** histograms: RGB, red only, green only, and blue only. If we want to lighten, darken, or change contrast to the overall image, we can use the RGB combined curve. If we want to make the image more red or cyan, we use the red curve. If we want to make the image more green or magenta, we use the green curve. And if we want to make the image more blue or yellow, we use the blue curve.

In the case of the image in Figure 7.15, after adjusting the white and black point, we still need to reduce the overall amount of blue in the image. To do this, we select the blue curve and add a point onto the curve by clicking on it. The point can be anywhere in the middle of the curve. As you can see in Figure 7.17, to remove blue we pull down on the blue curve, until we see the desired change in the image and the values in the Info Panel. This reduces the amount of blue and increases its complement, yellow, in the image.

Once the point on the curve is active, we are able to define specific values in the image, by entering them into the **Input** and **Output** fields. This can be an effective method to use when you have specific values you are trying to achieve. The first step is to type into the Input field the "before" value in the Info Panel you are watching. In Figure 7.17, the starting or "before" blue value in Sampler #2 value is 129, which was entered into the Input field. To bring down the blue, 114 was entered into the **Output** field. One trick you can use to fine-tune a value in the **Input** or **Output** fields for a specific point is to click on either field and press the up or down arrows on your keyboard to move the code value up or down by one unit. In addition to decreasing the blue curve, as you can see in the **Info Panel** Sampler #2 values in Figure 7.17, the green curve was increased subtly, bringing the green code value from 100 to 105. In balancing out the changes in other parts of the image this seems like a good balance. The result can be seen in Figure 7.18.

A **Curves Adjustment Layer** is also a great tool for you to manipulate contrast in your image. To do this we start by adding two points to your curve: one in the highlights and one in the shadows. To increase contrast, as seen in Figure 7.19 and resulting in the image in Figure 7.20, you would: move the highlight point up, which will make the light parts of the image lighter; move the shadow point down, which will make the dark parts of the image darker; or both. This is called an *S-Curve* because of the subtle s-shape of the resulting curve. The **Curves** adjustment in Figure 7.19 is mainly an increase in the light areas, while holding the dark areas. To reduce contrast you would do the opposite: move the highlight point down, which will make the light parts of the image darker; move the shadow point down, which will make the dark parts of the image lighter; or both. Notice that the increase in contrast has given the resulting image in Figure 2.20 more depth and made the lighter trees and yellow flowers stand out more.

Contrast and Saturation

When we increased contrast using the **Curves Adjustment Layer**, resulting in the image in Figure 7.20, we also increased saturation in the green and yellow of the foliage at the bottom. This is confirmed in the Info Panel in Figure 7.21, where we can see in the Lab values from the foliage that the Lightness (L) has increased as expected, but "a" and "b" have also increased in absolute terms. This absolute increase to the "a" and "b" values (more positive or more negative) means there has been an increase in saturation. This increase in saturation might be desirable or undesirable depending on the type of image. In a landscape, like we are using here, it is, possibly, more acceptable, but in a portrait a more saturated skin tone might be something we want to avoid. To make the contrast adjustment curve only affect contrast or tonal information and not saturation, we need to change the **Blend Mode** for the **Curves Adjustment Layer** from **Normal** to **Luminosity**, as seen in Figure 7.22. The result is seen in Figure 7.23 in both the image and the **Info Panel**. In **Luminance** blend mode, the Lightness increases, but the saturation does not increase; it basically stays the same or slightly decreases.

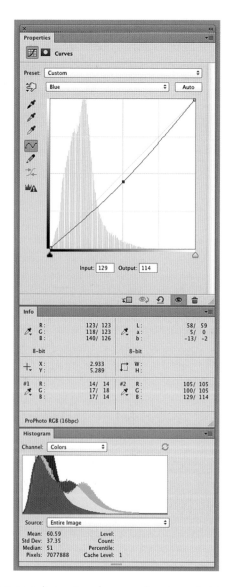

FIGURE 7.17 Curves adjustments, and corresponding changes to Info and Histogram panels in Photoshop resulting in image in Figure 7.18.

FIGURE 7.18 *(right)* Image in Figure 7.15 with the Curves adjustments from Figure 7.17, which further reduced the blue cast.

Credit: Photograph by the author

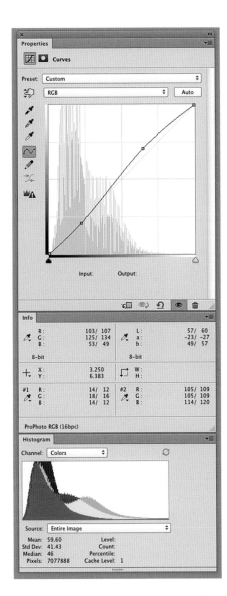

FIGURE 7.19 Curves adjustments to S-curve to increase mid-tone contrast, and corresponding changes to Info and Histogram panels in Photoshop resulting in image in Figure 7.20.

FIGURE 7.20 *(right)* Image in Figure 7.18 with the Curves adjustments from Figure 7.19, which increased the contrast.
Credit: Photograph by the author

FIGURE 7.21
Portion of image in Figure 7.20 with the Curves adjustment from Figure 7.19 with Normal Blend Mode. The corresponding Info panel shows ProPhoto RGB and circled Lab values for green in the foliage, which confirm the resulting increase in saturation.
Credit: Photograph by the author

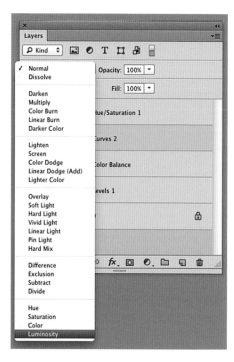

FIGURE 7.22
Changing the Blend Mode from Normal to Luminosity for the Curves Layer in Figure 7.19 in Photoshop Layers palette, which results in the image and Info panel values in Figure 7.23.

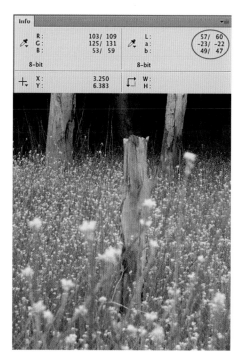

FIGURE 7.23
Portion of image in Figure 7.20 with the Curves adjustment from Figure 7.19 with Luminosity Blend Mode. The corresponding Info panel shows ProPhoto RGB and circled Lab values for green in the foliage, which confirm the resulting subtle decrease in saturation.
Credit: Photograph by the author

Making Local Adjustments Using Layer Masks

At this point the **Levels** and **Curves** adjustments we have discussed and made in the example have been *global adjustments*, which means we have made the changes to the entire image at the same time. Local adjustments, on the other hand, are changes or edits we make to select parts of our image. We use *Layer Masks* in Photoshop to make these local adjustments. In the traditional darkroom, localized changes consisted of *burning-in* some areas of the print to make them darker, or *dodging* other areas of the print to make them lighter. While we still make these adjustments digitally, **Layer Masks** allow us to make them with more precision and repeatability.

When examining a mask using the **Info Panel**, it can be useful for you to change the display to present grayscale values, as shown in Figure 7.24.

Masks by their nature block some areas of an image from being affected by a change, while allowing the changes to completely or

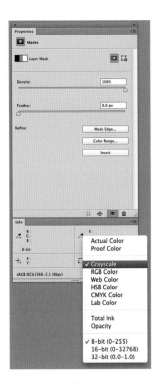

FIGURE 7.24 Changing the Info panel in Photoshop to display Grayscale values, which will be useful in examining Layer Masks.

FIGURE 7.25 Two views of a Photoshop Layer Mask: black-and-white and ruby red, with three amounts of masking and the corresponding Info panel displays.

partially affect other parts of the image. Figure 7.25 illustrates the different attributes of a mask and the two ways masks can be viewed. The top of Figure 7.25 shows the mask consisting of black, white, and gray areas, which is the way Photoshop displays masks alone, without an image. The bottom shows the view of the same mask in different shades of red. This default red color is used in Photoshop when it shows the **Layer Mask** and the image simultaneously. Why red? The ruby red color used mimics the red masks from graphic arts printing. Traditionally the red masks were used because the photographic materials in the process were not sensitive to the red part of the spectrum and, therefore, they saw red as black or no light. To summarize the mask in Figure 7.25: (1) where the mask is black

with K = 100 percent, or most red in the view with images, it is blocking the full effects of that layer; (2) where the mask is gray with K = 50%, or less red in the view with images, it is blocking and letting through half the effect of that layer; and finally (3) where the mask is white or clear with K = 0%, or no red in the view with images, it is letting through the full effect of that layer.

In our basic example, let's say the next step we wanted to make was to darken the shadows behind the trees only and not to impact the tree trunks or the green and yellow foliage in the front. This can be done with a Color Range Mask, shown in Figure 7.26, and would give the image some additional contrast and depth. To do this you would first create a **Curves Adjustment Layer** pulling down the RGB

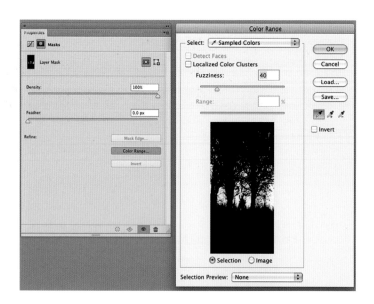

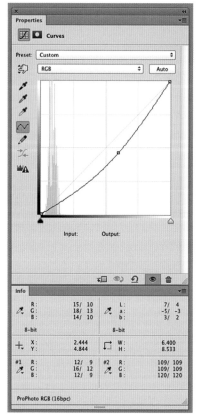

combined curve, as seen in the top of Figure 7.27. At first, this darkening is happening everywhere in our image, so our next step is to create the desired mask. Once you select the **Adjustment Layer Mask**, one method for doing this is to paint black with a soft brush into the areas of the image you want to mask (tree trunks and foliage) or inverting the mask to black (**Command-i**) and painting white into the areas you want to darken. As a faster method for doing this, you could select a **Color Range** from the **Layer Mask Properties Palette**, as seen in Figure 7.26. Once in the **Color Range** window, holding the **Shift** key and clicking on different areas of your image, you can expand the parts of your image what will be unmasked, and, therefore, show the impact of the adjustment (darkening in our case).

The **Info Panel** in Figure 7.27 and the image in Figure 7.28 show the effects of the darkening **Curve Adjustment Layer** and the resulting **Color Range** mask in Figure 7.26. The mask is only permitting the darkening in the shadows behind the trees, as we desired. This is confirmed by the color samples in the **Info Panel**. As you can see, Sample #1 from the shadows is going down from R-12, G-16, B-12 to R-9, G-12, B-9, while Sample #2 from the tree has remained the same, since it is masked out.

FIGURE 7.26 *(top far left)* Layer Mask Properties palette and Color Range window in Photoshop.
Credit: Photograph by the author

FIGURE 7.27 *(bottom far left)* Curves adjustments pulling down the RGB combined curve and corresponding change to Info panel in Photoshop, which along with the Layer Mask in Figure 7.26 resulting in darkening of the shadows in the image in Figure 7.28.

FIGURE 7.28 *(left)* Image in Figure 7.20 with additional Curves adjustments from Figure 7.27 through the Layer Mask from Figure 7.26, which darkened the shadows behind the trees.
Credit: Photograph by the author

Color Correction in Adobe Photoshop Lightroom's Develop Module

As mentioned in the last chapter, Lightroom's real strengths lie in its ability to allow you to organize and process large numbers of images quickly and efficiently for different types of output. The **Develop Module** in Lightroom (and the Adobe Camera Raw application, which are very similar), in particular, give you very powerful tools for effective global color corrections of a large volume of images. Although you can do some selective tonal and color adjustments in Lightroom using the **Graduated Filter** and the **Adjustment Brush**, these tools are not as controllable and flexible as Photoshop's Adjustment Layers. In this section we will look at the basic global color correction tools from the top down in Lightroom's **Develop Module: White Balance**, **Basic Tone** and **Presence**, **Tone Curve**, and **Hue, Saturation, and Luminance** (HSL).

White Balance

The first adjustment we encounter in Lightroom and Adobe Camera Raw is **White Balance** (WB). Raw digital camera files will typically come in with a **White Balance** defined by the camera. You might have your camera set to a standard **WB** setting like tungsten, daylight, overcast, flash, or fluorescent; set to a defined white point color temperature like 5400 Kelvin (K); or set to a custom white point measured under a specific light source. If the light source you photograph under and the defined white point in the camera do not match up, you will get a colorcast. Neutrals will not be neutral. In the case of the Raw image we are now very familiar with in Figure 7.29, the color temperature of the white balance has been defined as 2850 K by the camera. This is much too low, considering the shot was made under daylight. This is why the image appears very blue.

To remove a cast, you want to try match up the **White Balance** settings of **Temp** (color temperature) and **Tint** in Lightroom with the actual light source(s) used to make the photograph. The **Temp** range

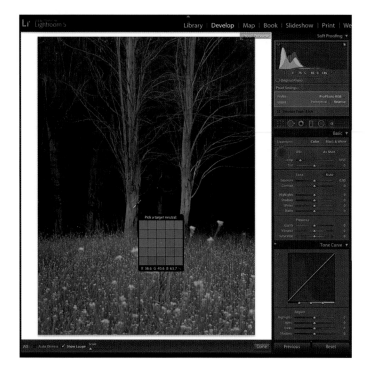

FIGURE 7.29 Raw uncorrected image with White Balance Selector tool in Lightroom before clicking on neutral tree bark, resulting in Figure 7-30.
Credit: Photograph by the author

FIGURE 7.30 White balanced image from Figure 7-29 showing the changes to its interpreted ProPhotoRGB numbers and Temp (color temperature).
Credit: Photograph by the author

for Raw images in Lightroom is from 2000 to 50,000 K (and from −100 to +100 for non-Raw images), along a blue-yellow axis. The **Tint** range for Raw images in Lightroom is from −150 to +150 (and from −100 to +100 for non-Raw images), along a green-magenta axis. You will typically use **Tint** adjustments when the light source used is fluorescent, which can have pronounced spikes of energy in the green part of the spectrum.

You can either manually use the sliders for Temp and Tint or you can use the White Balance Selector tool by clicking on the eye dropper or pressing **W** on your keyboard. You then move the **White Balance Selector** and click on a point in your image you wish to be neutral, as seen in Figure 7.29. This results in Lightroom finding the

combination of Temp and Tint that will force the code values or percentages at the point selected to be equal, thus neutral, as seen in Figure 7.30.

Basic Tone and Presence

The next set of adjustments we encounter in Lightroom and Adobe Camera Raw is **Tone** and **Presence**. Below are summaries of each of the **Tone** and **Presence** sliders in the 2012 Process Version. Note that there is a correlation between the tone adjustments and different parts of the histogram: shadows, three-quartertones, midtones, quartertones, and highlights. If you place your cursor over the

histogram, either the **Exposure**, **Highlights**, **Shadows**, **Blacks**, and **Whites** sliders will be illuminated.

The **Exposure** slider sets the overall image brightness and illuminates the mid-tones section of the histogram. Adjust the slider until the image has the desired brightness. Exposure values are in increments equivalent to full f-stops on a lens. An adjustment of +1.00 is similar to increasing the exposure by one stop, by aperture or shutter speed. Similarly, an adjustment of −1.00 is similar to reducing the overall exposure by one stop. The **Exposure** range for Raw images is from −5 to +5 stops (and from −4 to +4 stops for non-Raw images).

The **Contrast** slider increases or decreases image contrast, mainly affecting mid-tones. When you increase contrast, the middle-to-dark image areas become darker, and the middle-to-light image areas become lighter. The **Contrast** adjustment range for Raw and non-Raw images in Lightroom is from −100 to +100.

The **Highlights** slider adjusts lighter areas of your images and illuminates the quartertones section of the histogram. Drag the slider to the left to darken highlights and recover blown-out highlight details. Drag the slider to the right to brighten highlights, while minimizing clipping. The **Highlights** adjustment range for Raw and non-Raw images is from −100 to +100.

The **Shadows** slider adjusts dark areas of your images and illuminates the three-quartertones section of the histogram. Drag the slider to the left to darken shadows while minimizing clipping. Drag the slider to the right to brighten shadows and recover shadow details. The **Shadows** adjustment range for Raw and non-Raw images is from −100 to +100.

The **Whites** slider adjusts clipping in the light areas (highlights) of your images and illuminates the extreme highlights section of the histogram. Drag the slider to the left to reduce clipping in highlights. Drag the slider to the right to increase highlight clipping. Highlight clipping is not minimized with the **Whites** slider, as it is with the Highlights slider. You may want increased clipping in the specular highlights, such as reflections of light sources on metallic surfaces. The Whites adjustment range for Raw and non-Raw images is from −100 to +100.

The **Blacks** slider adjusts clipping in the dark areas (shadows) of your image and illuminates the extreme shadows section of the histogram. Drag the slider to the left to increase black clipping (map more of the shadows in your image to pure black). Shadow clipping is not minimized with the **Blacks** slider, as it is with the **Shadow** slider. Drag the slider to the right to reduce shadow clipping. The **Blacks** adjustment range for Raw and non-Raw images is from −100 to +100.

The **Clarity** slider can change depth in your images by increasing or decreasing local contrast. When using **Clarity**, it is best to zoom in to 100% to see its effect on your images as clearly as possible. Drag the slider to the right to increase local contrast and enhance texture and perceived sharpness. Drag the slider to the left to decrease edge contrast and get a softening or haziness at edges. The **Clarity** adjustment range for Raw and non-Raw images is from −100 to +100.

The **Vibrance** slider adjusts the overall saturation of your images so that clipping is minimized as colors approach full saturation. Also, **Vibrance** does not change the saturation of less saturated and warm colors as much as it does more saturated colors and cool colors, like blues and cyans; because of this **Vibrance** helps prevent skin tones from becoming oversaturated. Drag the slider to the right to increase saturation, while also darkening blues and cyans, like blue skies. Drag the slider to the left to decrease saturation, but not to fully desaturated or monochrome, even at −100.

The **Saturation** slider adjusts the saturation of all the colors in your image equally from −100 (monochrome) to +100 (double the saturation), including skin tones.

Tone Curve

Like the **Curves** in Photoshop, the **Tone Curve** in Lightroom can be used to increase or decrease contrast. However, the **Tone Curve** adjustment in Lightroom is different than **Curves** in Photoshop in two ways: there is only one curve instead of three or four, as in Photoshop, so there are no color balance adjustments with **Tone Curve** in Lightroom; and the movements of the curve are limited to four sections: the highlights, light areas, dark areas, and shadows, so you can't break

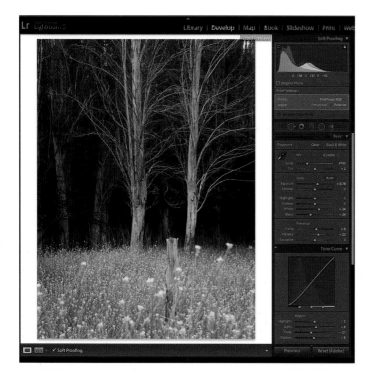

FIGURE 7.31 Image from Figure 7.30 further corrected with the shown Basic Tone, Presence, and Tone Curve adjustments in Lightroom's Develop module, showing the changes to its interpreted ProPhoto RGB numbers of a green patch to the left of the tree stump in the front center of the image.
Credit: Photograph by the author

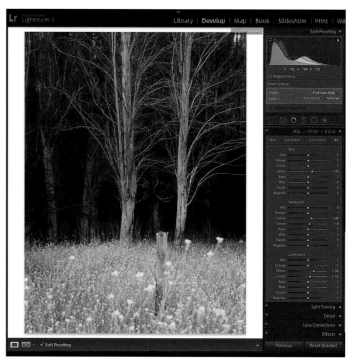

FIGURE 7.32 Image from Figure 7.31 further corrected with the shown Hue Saturation Luminance (HSL) adjustments in Lightroom's Develop module, showing the changes to its interpreted ProPhoto RGB numbers of a green patch to the left of the tree stump in the front center of the image.
Credit: Photograph by the author

your image with **Tone Curve** adjustments in Lightroom, like you can with **Curves** in Photoshop. A useful aspect of the **Tone Curve** tool is the ability to make **Targeted Adjustments** to parts of your image. You do this by selecting the **Targeted Adjustment** tool and placing it any area of your image. The **Tone Curve** tool determines which one of the sections of the tone curve the cursor is over and when you click up or down on the keyboard arrows that part of the tone curve gets lighter or darker, respectively.

Figure 7.31 shows the changes made to the **Basic** sliders and **Tone Curve**, along with the corresponding changes to the image. The

RGB values shown are for a green area to the left to the tree stump in the front center of the image.

Hue, Saturation, and Luminance (HSL)

As seen in Figure 7.32, Lightroom allows you to change the three attributes of individual colors we discussed in Chapter 2. For example: with **Hue** you could make reds more orange or magenta; with **Saturation** you could make the same reds more or less vibrant; and with **Luminance** you could make them lighter or darker. As with **Tone Curve**

Before and After View

One of the powerful things we can do in Lightroom's **Develop** module is to compare different versions of our image side by side, as seen in Figure 7.33. As you can see, when doing this we can also see before and after RGB values for different points on our image.

tool, you have the ability to make **Targeted Adjustments** to select colors in your image. You do this by selecting the **Targeted Adjustment** tool and placing it any colors of your image. The HSL tool determines which one of the eight colors the cursor is over and when you click up or down on the keyboard arrows the attribute of that color to be adjusted accordingly.

In Figure 7.32, the hue of greens in the foliage has been adjusted to be less yellow and more cyan. The saturation of yellows and greens has been increased and both have been made lighter. As before, the RGB values shown are for a green area to the left to the tree stump in the front center of the image.

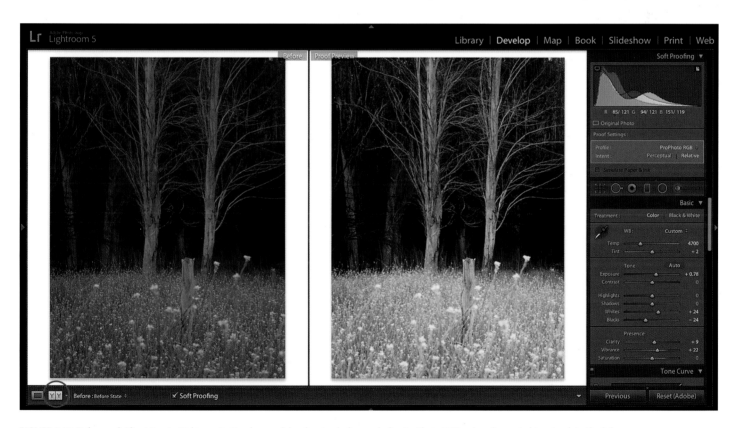

FIGURE 7.33 Before and After View in Lightroom's Develop module, showing before and after ProPhoto RGB values for neutral tree trunk to the left.
Credit: Photograph by the author

Rendering Our Images

Our photographs have always been a translation or interpretation of the colors and tones of the world around us. Before digital photography the way colors and tones were interpreted or rendered was mostly predetermined and limited by the manufacturers of the photographic film and paper. We as photographers and cinematographers would pick the film and paper for the signature looks they would produce: Fuji Velvia's saturated greens for landscapes, Technicolor's strikingly unreal palette, Kodak Portra NC's subtle contrast and neutral skin tones, and Kodachrome's vibrant reds and warm cast. With digital the power is with us to determine how we want colors and tones rendered in our images. Although I spent much of this chapter discussing how to get perfect neutrals in our image, you might prefer warmer or cooler neutrals. You might desire more or less saturation or contrast than the colors of the scene. Neutrality and accuracy are important at times. But your creative vision and unique way of seeing and interpreting the world is equally, if not more, important.

Conclusion

In this chapter we have looked at color correcting our images in Adobe Photoshop and Lightroom. These are not the only applications we might be using. You might be making adjustments with PhaseOne's CaptureOne or Nik Software's Snapseed or Viveza. Regardless of the software you are using, the important things to remember are to: calibrate and profile your graphics quality display so that you can make adjustments based on what you see, as well as possible; use the info panel, histogram, or display of numbers from the software to reinforce and confirm what you are seeing; and enjoy taking the responsibility to render your images with a look that reinforces your vision.

EXPLORATIONS

To reinforce what you've learned about Photoshop and Lightroom, it's time to spend even more time in both.

- *Color correct one image in both Photoshop and Lightroom.* Using the steps we discussed, color correct one image in both pieces of software and attempt to get them to match. This will force you to look at the numbers in both applications.
- *Attempt to duplicate the photographic renderings and looks you see in movies and magazines.* First you need to start looking at how different photographers and cinematographers are interpreting the colors and tones of the world in terms of brightness, contrast, saturation, and colorcasts and rendering. Once you have analyzed the look, try to duplicate it yourself on some of your images.

Resources

We have only scratched the surface on the color-correcting capabilities in Photoshop and Lightroom. If you are interested in more information, please see the following:

Adobe Photoshop Help
> http://helpx.adobe.com/photoshop.html

Adobe Lightroom Help
> http://helpx.adobe.com/lightroom.html

Video Tutorials by Chris Orwig at lynda.com
> http://www.lynda.com/Chris-Orwig/43-1.html

Eismann, Katrin, & Duggan, Seán, *The Creative Digital Darkroom*. O'Reilly Media, Inc, Sebastopol, CA, 2008. ISBN: 0–596–10047–7.

Evening, Martin, *Adobe Photoshop CC for Photographers*. Focal Press, Boston, 2013. ISBN: 978–0–415–71175–3.

Evening, Martin, *The Adobe Photoshop Lightroom 5 Book: The Complete Guide for Photographers*. Adobe Press, Berkeley, CA, 2013. ISBN: 978–0321934406.

Margulis, Dan, *Professional Photoshop: The Classic Guide to Color Correction*. Wiley Publishing, Inc., New York, NY, 2002. ISBN: 0–764–53695–8.

Padova, Ted, & Mason, Don, *Color Correction For Digital Photographers Only*. Wiley Publishing, Inc., New York, NY, 2006. ISBN: 0–471–77986–5.

Schewe, Jeff, & Fraser, Bruce, *Real World Camera Raw with Adobe Photoshop CS5*. Peachpit Press, Berkeley, CA, 2010. ISBN: 0–321–71309–5.

Walker, Michael, & Barstow, Neil, *The Complete Guide to Digital Color Correction*. Lark Books, Inc., New York, NY, 2006. ISBN: 1–579–90822–5.

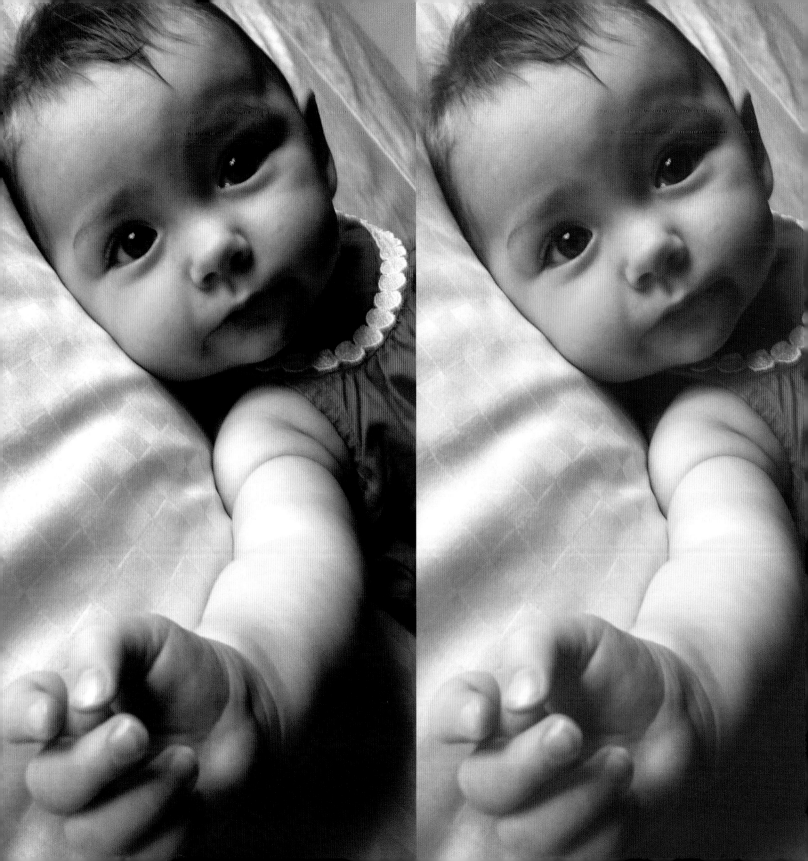

Eight

OUTPUT PROFILING & SOFT PROOFING

So far we have reviewed display profiles, scanner profiles, digital camera profiles, and working color space profiles. In this chapter we will finally get to *output* or *printer profiles*. If we want our images to match on our displays and prints, as closely as possible, it is imperative that we understand what output profiles are, how they are created, and how to properly use them. We will start by reviewing the process of building custom inkjet printer profiles. Next we will examine the difference between *custom* and *generic printer/paper profiles*. Finally we will discuss how to use output profiles in Photoshop and Lightroom, including effectively using these profiles to create a simulation of the print on our display, called a *soft proof*.

Building Custom Inkjet Printer/Paper Profiles

The three main stages in building a custom printer/paper profile are to optimize the printer and printer driver (and save the printer driver settings), print a set of color patches using these settings, and then measure those color patches with a spectrophotometer and save the profile.

Optimize the Printer and Printer Driver

As we discussed before, the two stages we use in color managing any device are (first) calibration and (second) characterization or profiling. Remember that calibration means setting up your device in an optimal condition first. The calibration of a printer consists of first optimizing the printer using the printer utility, and then optimizing the settings of the printer driver and saving the settings. Below, we will set up the Epson 3880 print driver for Moab Entrada Rag Natural 190 paper.

FIGURE 8.1 iPhone image of Iseult on the left and the image soft proofed in Photoshop using a profile for the Epson 3880 and Moab Entrada Rag Natural 190 paper using Perceptual rendering and Simulate Paper Color settings on the right.
Credit: Photograph by the author

Optimizing the Printer

First we will make sure your printer is working properly before we start to profile it, with the following three or four steps:

1. *Launch the printer utility* from the applications folder or the Printer/Fax System Preferences window. This will bring up the main window of the printer utility, shown in Figure 8.2.

FIGURE 8.2 EPSON Printer Utility main window.

2. *Verify ink levels.* Once in the printer utility, use the **Status Monitor** to check ink levels, as shown in Figure 8.3. Make sure that the ink levels are at least high enough to print your output profile-building target (one to three pages). This also shows the remaining capacity of the maintenance tank, which is used to absorb the excess ink when cleaning the printer nozzles.
3. *Run a print head nozzle check on plain office paper.* If print head nozzles are not clean, the result is *banding* (lines in the direction of the print head movement) on prints, which we will

FIGURE 8.3 EPSON Printer Utility Status Monitor section that shows ink levels and remaining capacity of the maintenance tank before it needs to be replaced.

Output Profile or Printer Profile or Printer/Media Profile?

What is the difference among all these terms? First *output profiles* are the overall class of ICC profiles we are using for producing tangible forms of our images, as things we can touch, like the print. As with all ICC profiles, output profiles describe the limitations (gamuts) of the equipment and media combinations we are using. The output forms could be an inkjet print off your Epson printer on luster paper; a photographic transparency from an LED film recorder; a postcard from an HP Indigo short-run printing press; or a glossy fashion magazine off a Heidelberg web offset printing press. (We cover all these different types of output more closely in Section 2 of the book.) A *printer profile* is an output profile where the equipment used, as the name implies, is a printer, like the Canon PIXMA Pro 1 or Epson 3880 inkjet printers. But, as just mentioned, we have to remember that a printer or output profile is NEVER just describing the color capabilities and the limits of the printer. The profile is describing these characteristics for the printer in combination with the media or paper you are printing onto. It's always about the printer and media combination, not just the printer. Why am I saying "media" instead of "paper"? Because there are other things we can be printing onto, besides paper, like plastic, cardboard, canvas, metal, or fabric. For these reasons it might be more accurate for us to describe these output profiles as *printer/media profiles* or *printer/paper profiles*.

discuss more in Chapter 13. If an entire head is clogged, this results in discoloration of the print. Such as, if the cyan nozzles are entirely clogged, the resulting prints would be red in appearance, because of the lack of cyan ink. If the nozzle check results in a print like Figure 8.4 with missing lines in some of the ink colors, run the head cleaning function, as seen in Figure 8.5. Repeat these two steps until the test page shows all the lines. It can be faster (and use less ink) to run the manual, not automatic, nozzle check.

FIGURE 8.4 Nozzle Check test page on plain paper for the Epson 1280 that shows clogged cyan, magenta, yellow, and light cyan nozzles, which require Head Cleaning. Credit. Photograph by the author

FIGURE 8.5 EPSON Printer Utility Head Cleaning window during the head cleaning process.

Optimizing the Printer Driver

The printer driver is the software on your computer that controls your printer that is supplied by your printer manufacturer. Our next step in calibrating or setting up your printer in its best condition is to make sure the settings for the printer driver are correct for the paper or media you are printing onto, using the following nine steps:

Head Alignment

If High Speed mode is going to be used, which will allow the printer to print in both directions, run a head alignment, which makes it so High Speed mode should only be used on the Epson Professional x800, x880, and x900 series printers. While nozzle checks can be done on plain office paper, head alignments should be done using glossy photo paper, even if the printer is using matte black ink.

1. *Launch the print driver* from the printer profiling software or any other software. Once there, select the printer you are profiling, as seen in Figure 8.6.
2. *Click on the driver pull-down menu,* which reveals the sections of the driver, as seen in Figure 8.7. The three sections we will need to check and set to optimize the printer driver are **Color Matching**, **Printer Settings**, and **Advanced Media Control**.
3. *Select printer color controls in the Color Matching Window.* If these choices are not grayed-out, which they should be if the application you are printing from is managing color to the driver, you want to choose the printer color controls over the operating system level color controls, as seeing in Figure 8.8. If the operating system level controls are selected, this will cause a poor-quality printer/paper profile to be built.
4. *Move to the Printer Settings section of the driver.* In this section you will check and set the **Media Type**, **Color Mode**, **16-Bit Printing** and **Output Resolution**, as shown in Figure 8.9.
5. *Select media type.* The **Media Type** controls the amount of ink the printer will put down on the page, as well as the size of the gap between the bed of the printer and the print head nozzles, which is adjusted according to the thickness of the paper. (Every paper type will require a different amount of ink to get optimal results.) You don't want too much ink, as this could result in ink pooling or possibly the bleed-through of the image to the other side of the page. Too little ink will result in not getting the full range of colors (gamut) possible.

How do we choose the correct media type? Notice the choices Epson gives us for the Epson 3880 in Figure 8.10. (Not surprisingly, the choices are all Epson papers.) Some other paper manufacturers will tell you on their box or data sheet which of these choices is optimal for their media on this printer. For example in Figure 8.11 Moab gives the optimal media type to use for its Entrada Rag Natural 190 on the Epson 3880 on their website in the section for downloading their generic printer profiles. Ilford gives the media type in a code as

FIGURE 8.6 Epson 3880 printer driver, as launched from X-Rite i1 Profiler.

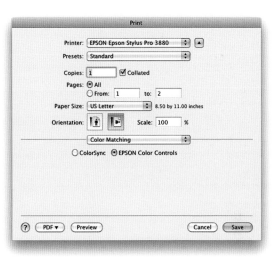

FIGURE 8.8 Color Matching section of the Epson 3880 printer driver with printer color controls selected instead of the operating system color controls. Often these choices are grayed-out, but they are important to check.

FIGURE 8.7 Sections of the Epson 3880 printer driver as revealed from the center pull down menu with the three sections to check and set when optimizing the driver circled.

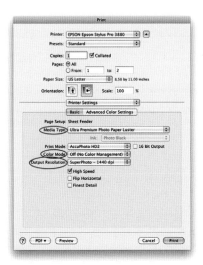

FIGURE 8.9 Printer Settings section of the Epson 3880 printer driver with the three settings to adjust when optimizing the driver circled.

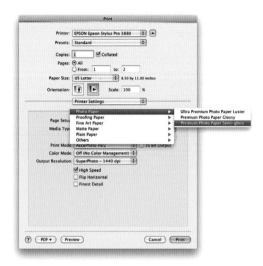

FIGURE 8.10 Printer Settings section of the Epson 3880 printer driver with the media type choices for Photo Paper shown and a selection of Premium Photo Paper Semi-gloss for use with ILFORD Galerie Prestige Gold Fibre Silk.

🗋 MOAB Entrada Bright Epson 3880.icc (1.5M)
 Media Type: Watercolor Paper Radiant White

🗋 MOAB Entrada Natural Epson 3880.icc (1.5M)
 Media Type: Ultra Premium Presentation Matte

🗋 MOAB Kayenta Matte Epson 3880.icc (1.5M)
 Media Type: Ultrasmooth Fine Art

🗋 MOAB Kokopelli Photo Satin Epson 3880 UPPPL.icc (1.5M)
 Media Type: Premium Luster

🗋 MOAB Lasal Exhibition Luster Epson 3880 EPL.icc (1.5M)
 Media Type: Premium Luster

🗋 MOAB Lasal Gloss Epson 3880.icc (1.5M)
 Media Type: Premium Gloss

🗋 MOAB Lasal Luster Epson 3880.icc (1.5M)
 Media Type: Premium Luster

🗋 MOAB Lasal Matte Epson 3880.icc (1.5M)
 Media Type: Ultrasmooth Fine Art

FIGURE 8.11 Section of Legion's Moab website showing Moab paper profiles and the corresponding media type for use on the Epson 3880.

part of their generic printer profile name. For example, the file name for ILFORD Galerie Prestige Gold Fibre Silk on the Epson 3880 is "n_GPGFS13_EPSpro3880_PSPPn.icc." The profile comes with a PDF to help decode the name. Figure 8.12 shows part of the sections on paper name and media type from the Ilford PDF. This shows that the optimal media type to use for this printer and paper combination is Premium Photo Paper Semi-Gloss, as was selected back in Figure 8.10. If no suggestion is given, you can choose the paper type that is closest to the one you are using.

6. *Turn off color management and deselect 16-bit printing.* In the **Color Mode** setting you should select **Off (No Color Management)**, as opposed any of the Epson **Color Controls** turned on, as shown in Figure 8.13. This removes any color processing the print driver is currently using, and allows you to get the raw color from the printer, which will give an increased gamut for profiling. Although you may wish to select 16-bit printing in the print driver when you are printing a 16-bit image that has smooth

1. Media Codes – Note: not all products are available in all formats

Desktop and Rolls: GALERIE PRESTIGE

GPGFS13 = ILFORD Galerie Prestige Gold Fibre Silk
GPSGP11 = ILFORD Galerie Prestige Smooth Gloss Paper
GPSPP11 = ILFORD Galerie Prestige Smooth Pearl Paper
GPSGP12 = ILFORD Galerie Prestige Smooth Gloss Paper
GPSPP12 = ILFORD Galerie Prestige Smooth Pearl Paper

3. Printer Driver Media Type - Epson®:

Choose the correct media type in the printer driver
PP: Plain Paper
PGP: Photo Glossy Paper
PGPP: Premium Glossy Photo Paper
PGPP250: Premium Glossy Photo Paper (250)
PLPP: Premium Lustre Photo Paper
PSPP: Premium Semigloss Photo Paper
PSPP170: Premium Semigloss Photo Paper (170)
PSPP250: Premium Semigloss Photo Paper (250)
PQGF: Photo Quality Gloss Film
PQIJP: Photo Quality Ink Jet Paper
SMP: Singleweight Matte Paper

FIGURE 8.12 Sections of the PDF document that comes with Ilford printer/paper profiles, which is needed to decode the profile filename that includes the optimal media type to select for ILFORD Galerie Prestige Gold Fibre Silk on the Epson 3880: Premium Photo Paper Semi-gloss.

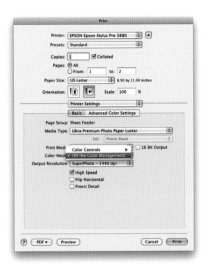

FIGURE 8.13 Printer Settings section of the Epson 3880 printer driver with the choice of Color Mode set to Off (No Color Management) instead of using Epson's Color Controls to get more gamut from the printer when profiling.

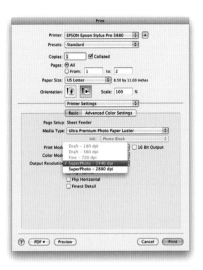

FIGURE 8.14 Printer Settings section of the Epson 3880 printer driver with the choices of Printer Resolution.

gradations, it is not necessary to have it selected when profiling the printer paper combination.

7. *Select the printer Output Resolution.* Print quality refers to the resolution of the printer in *Dots Per Inch (DPI)*, not to be confused with image resolution, which is described as pixels per inch (PPI). A higher print quality/resolution results in smaller dots of ink, an increase in the amount of ink used, and an increase in the amount of time it will take to print the image, but also the possibility of more print detail (depending on the image). Because of the increase in time and ink usage, you never want to use a higher **Output Resolution** than you need. Print size could be a determining factor. Would you require a higher printer resolution for a 4 x 6" print or 11 x 14" print? It might surprise you to know, the answer is the 4 x 6" print. This is because the viewing distance for the 4 x 6" print is much closer than it would be for the larger print. (Most of the time 1440 DPI is a very high resolution, and it is rare that you will see a difference using 2880 DPI.)

8. *Make a change in ink lay-down, platen gap, or paper thickness, if necessary.* With some printers, turning off the color management will result in a printer-profiling target with more ink than is optimal. In this case, the ink lay-down or color density should be reduced. Move down to the **Advanced Media Control** section of the driver. Click and drag the **Color Density** slider to the left to bring down the ink density. You can also adjust the **Paper Thickness** setting in this section, as shown in Figure 8.15. If you are profiling a paper that shows head strikes after it is printed, increasing the thickness value and widening the platen gap may help. In Chapter 13 we discuss how to determine the correct paper thickness and other settings in the **Advanced Media Control** section of the driver.

9. *Save the print driver settings.* Since part of what we are profiling are the settings in the printer driver, we need to get back to this "calibrated" state when we print the printer-profiling patches, and when we print our images using the resulting profile. Click on the **Presets** pull-down menu, drag down, and

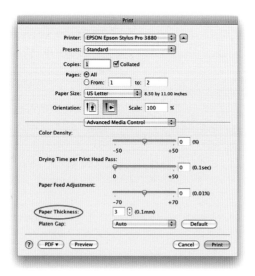

FIGURE 8.15 Advanced Media Control section of the Epson 3880 printer driver, which could require changes to Ink Density or Paper Thickness, depending on the media.

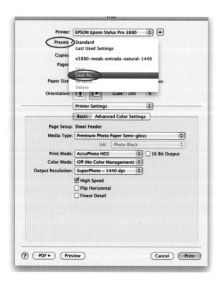

FIGURE 8.16 Saving the settings chosen as a Preset in the Epson 3880 printer driver will help you quickly return to these optimal settings when using printer/paper profiles.

select **Save As**, as shown in Figure 8.16. As shown in Figure 8.17, name the preset and include the name of the printer, the paper, and the output resolution. You can use the same name here that you will use for your profile, or, if you may be using this preset with more than one profile, you can select a name for the preset that can later be used as part of the profile name. (Doing this can make it much easier to remember which printer settings go with which profiles.) Finally, close the print driver.

Print the Output-Profiling Patches

The next step is to print a series of color patches. These patches contain known RGB values and need to be printed on the printer/paper combination we want to characterize with the same driver settings that were saved in Step I. Although the following will focus on X-Rite i1 Profiler software, other printer profiling software packages will give different options when creating and printing the output-profiling patches. I'll attempt to describe the most universal steps and concerns.

1. *Launch the printer-profiling software.* Some software packages like X-Rite i1 Profiler are comprehensive, in that they are used to calibrate and profile monitors, projectors, as well as printer/paper/ink combinations. Click on the **Printer Profiling** option, shown in Figure 8.18.
2. *Select the printer or type of printer.* Depending on the type of software, printer, and driver you are using, this choice could be

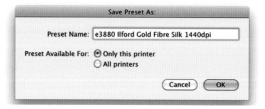

FIGURE 8.17 Naming a Preset in the Epson 3880 printer driver and including the printer, media, and output resolution.

FIGURE 8.18 Main window in X-Rite i1 Profiler software with Printer Profiling button circled.

RGB, CMYK, Hexachrome, five color, six color, etc. Here the choice is either RGB or CMYK. If you're profiling true RGB printers such as the Kodak Dye Sub printer, Fuji Pictography, Océ Lightjet or Durst Lambda, the choice is easy: RGB. If you're profiling an inkjet printer, the choice could be a little more confusing. An inkjet printer typically uses CMYK inks, so it's reasonable to think we should print CMYK patches, but this is seldom the case. If you're using an Epson, HP, Canon, or other inkjet printer with the standard driver that ships with the printer, you have to remember that the driver is expecting to be sent RGB data. This is because most of these printers are aimed at photographers who are printing from digital camera, which are in RGB, typically sRGB. To give the most reasonable results for the most users, it's best for the printer to expect RGB data. For the Epson 3880 in our example, RGB will automatically be understood, when we select the printer, as you can see in Figure 8.19. If, on the other hand, you are using a third party RIP (which will be discussed in Chapter 11) to control the printer, instead of the manufacturer's driver, with these same inkjet printers, you could be building an RGB or CMYK profile. As we will discuss, which type of profile will depend on the specific RIP used.

3. *Select a number of patches for printing.* In most cases, the more patches in the printer profiling test chart, the more we learn about the printer and paper combination, and therefore the better the quality of the profile. (Of course, one side effect of this is that you'll have to use more paper and ink to profile the printer.) In Basic mode *X-Rite i1 Profiler* gives three options for the test chart size: small, medium and large, as shown in Figure 8.20. The small test chart has 400 color patches; the medium chart has 800 patches; and the large chart has 1600 patches. In the Advanced mode *i1 Profiler* can produce a chart or charts with up to 6000 patches. The beginning of Chapter 9 has a comparison of different ICC printer profiling applications, including the number of patches in the test charts.

At this point, you have two options, as you can see in Figure 8.20:

Option 1: Print Target from the color management (CM) software

Option 2: Print Target from Adobe Color Printer Utility

More is Not Always Better

A smaller number of patches should be used when profiling uncoated papers that produce a small color gamut. Using too large a number of patches with these papers and their small gamut will over-sample colors that are too close to each other, which could result in errors and a "noisy" profile. It's best to use a smaller sample size in this case.

FIGURE 8.19 Initial Printer Profiling window in X-Rite i1 Profiler software, where the Epson 3880 has been selected as the printer to profile.

FIGURE 8.20 Initial Printer Profiling window in X-Rite i1 Profiler software, selecting the test chart size. The Basic mode medium sized chart uses 800 patches.

We will follow both of these alternative paths.

Option 1: Printing the Target from the Color Management Software

4a. ***Click on Print*** . . . This selection allows the user to print the target right from the profile building software, which is the simplest and most trouble free option. Once this choice is selected, the print driver is launched.

5a. ***Reset printer-driver settings and print the target.*** Click on the **Preset pull-down menu**, and drag down to the optimized settings for your printer/paper combination, which were saved in Stage I. Double-check to verify that these settings are still the same. Sometimes, the drivers can be somewhat unstable and will reset themselves, which can be very frustrating. When printing

FIGURE 8.21 Select the saved settings for the printer and paper type you are profiling in the Presets pull down menu in the printer driver. Then double-check that all the settings are right, since the driver doesn't always work perfectly. Specifically, make sure the Color Matching section is set with printer color controls instead of the operating system color controls. This is most important with X-Rite ColorMunki software.

patches from some color management software packages, especially X-Rite ColorMunki, it is also necessary to verify that the **Color Matching** setting is set to **EPSON Color Controls,** as seen in Figure 8.21. When you're certain that all the settings are all the same and the **Color Matching** is set correctly, click Print.

Option 2: Printing the Target from Adobe Color Printer Utility

4b. ***Click on Save Target.*** This selection allows the user to save the target as a TIFF, PDF, or EPS file, which can be useful if you need to profile a printer or output device that isn't hooked up to your computer with your color management application.

5b. ***Download and install the Adobe Color Printer Utility.*** Since our goal is to not change the RGB of the printer profiling test chart patches as they go to the printer driver, we need an application that will not muck with the values and not allow the operating system to muck with the values. Adobe Photoshop used to do this. Before version CS5, Photoshop had a **No Color Management** handling option, but since CS5 it does not. To make up for this, Adobe introduced the Adobe Color Printer Utility specifically to help us to print profiling patches without any changes. The utility can be downloaded using the following link:

> http://helpx.adobe.com/photoshop/kb/no-color-management-option-missing.html

6b. ***Open saved target TIFF file after launching Adobe Color Printer Utility.*** Once the target page is open, click on File > Page Setup from the menu bar. Select landscape or portrait mode depending on the target orientation, while keeping the scale at 100%, as seen in Figure 8.23. Click on OK.

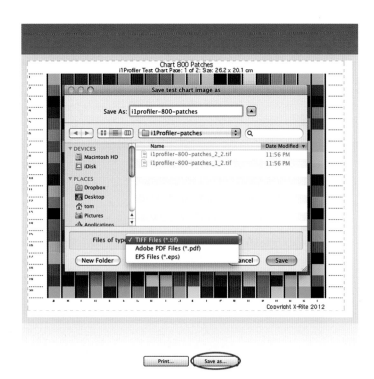

FIGURE 8.22 Save test chart image as . . . window from Initial Printer Profiling window in X-Rite i1 Profiler software. Saving the two-page 800 patch test chart as TIFF files.

FIGURE 8.23 Page Setup in the Adobe Color Printer Utility.

7b. ***Re-check the printer-driver settings and print the target.*** Click on the **Preset** pull-down menu and drag down to the optimized settings for your printer/paper combination, which were saved in Stage I. As when printing the patches directly from the printer profiling application, double-check to verify that these settings are still the same, as you can see in Figure 8.24. When you're sure that the settings are all the same, click print.

Leave the Scale Alone

It is very important not to change the scale of the printer profiling chart or select Scale to Fit Media. Often, if the target size and patch sizes change, the spectrophotometer won't be able to read the target.

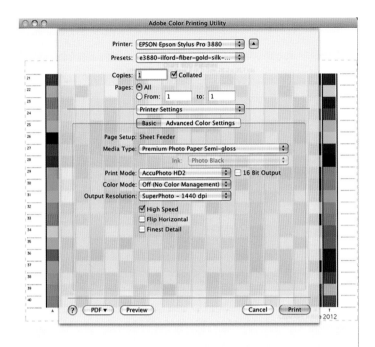

FIGURE 8.24

Epson 3880 printer driver in the Adobe Color Printer Utility with saved Preset Settings in Printer Settings section verified.

Measure the Output-Profiling Patches

Wait

Before the target is measured, as in Figure 8.25, the first thing to do is wait. We need to wait for the targets to dry. Even if they are dry to the touch, as inkjet prints dry down, their colors are changing. The amount of time we wait depends on the type of ink used. For dye-based ink prints, a drying time of 12 to 24 hours is needed. For pigment-based ink, a drying time of 1 to 12 hours should be enough.

Once the target is dry, it can be measured. To build an accurate printer/paper profile or characterization, the profiling software, like X-Rite i1 Profiler, needs to measure the colors that result when we print the various RGB values in the patches on this combination of printer, ink, paper, and driver settings.

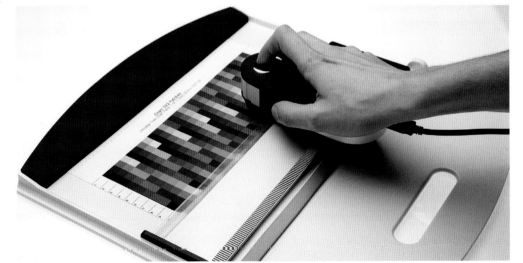

FIGURE 8.25

(right) Fadi Asmar measuring printer profiling patches with i1 Pro 2 spectrophotometer into the i1 Profiler software by scanning one row of patches at a time.

Credit: Photograph, © Marko Kovacevic (markokovacevic.net)

1. *Calibrate the spectrophotometer.* To make sure the spectrophotometer (or other measuring device) is measuring accurately, the profiling software will have you calibrate the device first, as seen in Figure 8.26. In the case of the X-Rite i1Pro, the spectrophotometer is placed on a special white calibration tile that comes with it. The i1 Pro calibration tile shares the same serial number as the spectrophotometer itself. If you send the spectrophotometer in for repair or recertification, the calibration tile goes with it.

2. *Measure the patches with the calibrated spectrophotometer.* If there is a problem when measuring the patches, as seen in Figure 8.27, re-measure the patches or row of patches. Once the Basic mode measurements are complete, the i1 Profiler software shows the geometry of the measurement device and the **Measurement Conditions** used, as seen in Figure 8.28. The **Measurement Conditions** are M0, M1, and M2. The **Measurement Condition** will depend on whether the presence of fluorescence or optical brighteners is detected in the paper and/or ink. When paper, inks, or any objects are fluorescing, we mean that they are converting light from the ultraviolet part of the spectrum, which we can't see, into the visible spectrum. This makes papers whiter and colors almost unnaturally saturated and glowing. The fluorescing can cause problems in measurements and quality of the profile. If there is no fluorescence in the paper or ink there should be no difference in measurements under the three different conditions. We will discuss the **Measurement Condition** differences and how they can affect the quality of the printer profile with more detail in Chapter 10.

3. *Select a viewing light source for the printer/paper profile.* X-Rite's i1 Profiler and other printer profiling software allow you to select a viewing light source to base the profile. We know that all objects, including prints, will appear different under different light sources. The ability to select the viewing light

FIGURE 8.26 The Measurement window in X-Rite i1 Profiler's Basic Printer Profiling module. Calibrating the i1 Pro spectrophotometer using its corresponding white calibration tile.

FIGURE 8.27 The Measurement window in X-Rite i1 Profiler's Basic Printer Profiling module, showing a problem when measuring the patches using the i1 Pro spectrophotometer. When the top-half of the displayed patch or patches do not match the bottom-half in hue, then those patches or rows should be re-measured.

FIGURE 8.28 The Measurement window in X-Rite i1 Profiler's Basic Printer Profiling module. Once the measurements are complete the software shows the measurement geometry and conditions that it automatically uses.

FIGURE 8.29 The Lighting window in X-Rite i1 Profiler's Basic Printer Profiling module, showing the standard CIE Illuminant viewing conditions that could be selected to customize your printer/paper profile, if you know the light source.

source for the printer/paper profile lets you customize your profiles for different print viewing conditions, if you know them. You can select from standard CIE Illuminant viewing conditions, as shown in Figure 8.29, or you can measure the conditions with a spectrophotometer, which will be shown in Chapter 10. The default setting is for D50 or daylight 5000 K.

4. *Save the profile.* In Mac OS X, save the printer paper profile in the user's profiles folder under **User > Library > ColorSync > Profiles**, which we will discuss more later this chapter. When naming the profile, include the name of the printer, the paper, ink (if non-standard), and resolution, as shown in Figure 8.30.

When you click on **Save** or build in the output profiling software, it compares the RGB values of all the patches with the actual resulting colors that were printed and measured. From this understanding or characterization of the printer and paper combination it builds the profile. Once the custom printer/paper profile is built, X-Rite i1 Profiler shows you the gamut of the printer/paper combination, as you can see in Figure 8.31. The printer/paper profile will now be used to *convert* and adjust the colors of our image, so we get as close a match as possible to our display when printing.

FIGURE 8.30 The ICC Profile window in X-Rite i1 Profiler's Basic Printer Profiling module. Selecting the name for the output profile, which should include the printer, paper, and resolution used. It can also be helpful to include an acronym of the media type used in the printer driver.

FIGURE 8.31 The ICC Profile window in X-Rite i1 Profiler's Basic Printer Profiling module. After the profile has saved, the gamut of the printer/paper combination is displayed in a 3D rotatable rendering.

When to Build a New Custom Inkjet Printer/Paper Profile

As we said, printer/paper profiles describe the characteristics for the printer, the paper, the ink in the printer, and settings used in the driver, as well. When any of these factors change, you should build a new profile. Also you should rebuild profiles as your printer ages, since the old one may no longer be as accurate. These and other reasons for a new printer profile include:

- Changing media type or manufacturer.
- Choosing a different printer resolution.
- Switching to a different black ink on the same paper, such as from Photo Black to Matte Black on a presentation matte paper
- Replacing Ink with a bulk inking system.
- Updating or changing printer driver.
- Aging of the printer (about every 6–10 months depending on the amount of use).
- (It is typically not necessary to re-profile the printer/paper combination when you are replacing an empty ink cartridge.)

Generic versus Custom Profiles

The profiles supplied by printer and paper manufacturers are called *generic printer paper/profiles* because they were not built for your individual printer and the conditions in which you are printing. On the other hand, the custom profiles we just discussed describe the color capabilities of our individual printer and paper combinations, along with the specific computer operating system, version of the printer driver, the age of the printer, the current level of head usage; and local conditions, such as temperature, humidity, and altitude.

That being said, some generic profiles produce excellent results. Some are built with high-end software packages, which might use a high number of color patches, or even average the measurement data from multiple sets of profiling patches from a population of printers. When using a new paper, it is always worth testing the available generic profile(s).

To get the most from these generic profiles, it's important to read the documentation included. The documentation will tell you how to install and use the profile, specifically the settings to use in the application you are printing from and in the printer driver. These should

Photo Black (PK) versus Matte Black (MK) Ink

Many printers allow for printing with either of two different types of black ink: Photo Black or Matte Black. Photo Black ink can be used to print on any type of paper, but it is optimized for photographic inkjet papers, such as luster or glossy. When using the Photo Black ink on matte or fine art papers, the resulting D-Max or darkest black is not very dense. The Matte Black ink is more viscous and stays on the surface of the paper, giving a darker denser black on matte and fine art papers. Matte Black ink should not be used with the photographic inkjet papers, since they will sit noticeably on the surface.

Generic Printer Profiles versus Generic RGB Profile

Generic printer/paper profiles should not be confused with the *Generic RGB Profile*. Generic RGB, like sRGB or AdobeRGB(1998), is a working color space. It has nothing to do with output or printer and paper combinations. Therefore, the Generic RGB Profile SHOULD NOT be used as a printer profile!

Print Driver / Media Settings:

5) Media: Ultra Premium Photo Paper Luster

6) Quality: 4 (1440 dpi)

7) Mode: Colormanagement Off

FIGURE 8.32 Detail from instructions that come with the generic profile for Hahnemühle's Photo Rag Baryta for use with the Epson 3880, which tell you what media type, resolution, and color management setting to use in the printer driver in conjunction with the generic printer/paper profile.

be the same settings that were used when the profiles were built, just like we want to use when we print with our custom printer/paper profiles.

Sometimes it takes some digging to find the settings. As an example, if you were using Hahnemühle's Photo Rag Baryta on your Epson 3880, you would go to Hahnemühle's website to download the profile for this combination. The settings you should use can be found in the instructions PDF that is downloaded with the profile, as you can see in Figure 8.33. All these settings should be put into the printer driver and saved for future printing (including the media type), which as we can see should be set to Ultra Premium Photo Paper Luster. Also remember: all of this information the paper manufacturer gives us is also helpful in optimizing the setting for the driver when building our own custom profiles.

Installing ICC Profiles for Use in Adobe Applications

So, now we have either created a custom printer/paper profile or downloaded a generic printer/paper profile. Our next step is to install these ICC profiles so they can be used in Adobe Photoshop and Lightroom. If they're not installed correctly, the profiles won't be

Epson Stylus Pro 3880

A General Guide for Printing on Hahnemühle FineArt Papers

Glossy FineArt	Tinte	Media Type	Quality
Baryta FB	PK	Ultra Premium Photo Paper Luster	2880 dpi
FineArt Baryta	PK	Ultra Premium Photo Paper Luster	1440 dpi
FineArt Pearl	PK	Ultra Premium Photo Paper Luster	2880 dpi
Photo Rag Baryta	PK	Ultra Premium Photo Paper Luster	2880 dpi
Photo Rag Pearl	PK	Ultra Premium Photo Paper Luster	2880 dpi
Photo Rag Satin	MK	Velvet Fine Art Paper	1440 dpi
Matte FineArt - Smooth			
Bamboo	MK	Velvet Fine Art Paper	1440 dpi
Natural Art Duo	MK	Velvet Fine Art Paper	1440 dpi
Photo Rag	MK	Velvet Fine Art Paper	1440 dpi
Photo Rag Bright White	MK	Velvet Fine Art Paper	1440 dpi
Photo Rag Ultra Smooth	MK	Velvet Fine Art Paper	1440 dpi

FIGURE 8.33 Detail from instructions that come with the generic profiles for Hahnemühle FineArt Papers for use with the Epson 3880, which tells you what black ink, media type, and resolution to use in the printer and printer driver with the corresponding papers.

It can be useful to install an alias to the **Profiles** folder on the sidebar of your **Finder** window, as shown in Figure 8.34, so you can install these profiles more easily.

Note: With Mac OS 10.7 and 10.8, the Library folder is hidden. To make the **Library** folder visible, hold down the **Option** key and click on **Go** in the **Finder** window.

selectable in these applications. Where to install the profiles depends on your computer's operating system. In Apple Mac OS X, profiles need to be placed in either the user's or the hard drive's *Profiles folder* (Figure 8.34).

Macintosh HD > Library > ColorSync > Profiles
or **User > Library > ColorSync > Profiles**

If there are multiple users who will be using the profile on the same computer, it is better to put the profile in the hard drive's **Profiles** folder. If, on the other hand, only one user will use the profiles, it's better to put them in the user folder.

In Windows Vista and 7, you can simply right-click on the profile and select **Install Profile**. For Windows XP, you need to manually put the profile into the following folder: **C:\Windows\system32\spool\drivers\color**.

FIGURE 8.34 User level Profiles folder in Apple OSX, where printer/paper profiles need to be installed so they can show up and be used in Adobe Photoshop and Lightroom.

Possible Reason for Missing Profile in Adobe Applications

After installation, if the profile cannot be found in the places where an application lists profiles, try closing and reopening the application. If the profile still can't be found, check the name, but not the file name. The name of the profile that is shown in Adobe applications is not the file name on the outside of the profile. Adobe applications show the internal profile tag called the *ASCII Name*. In Mac OS X, you can view this internal name by opening the profile in the **ColorSync Utility** (Figure 8.35). The **ColorSync Utility** allows you to edit this internal file name.

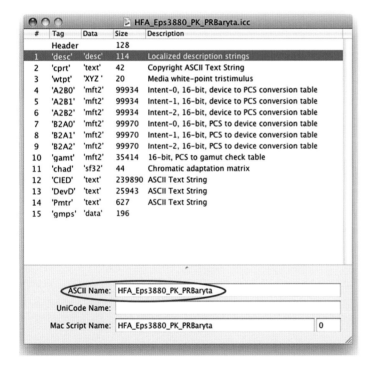

FIGURE 8.35 Generic profile for the Epson 3880 with Hahnemühle's Photo Rag Baryta opened in Apple's ColorSync Utility, revealing the internal name (or 'Localized description strings') of the profile, which is displayed in Adobe applications. This internal name can be edited in the ColorSync Utility.

Using Printer/Paper Profiles in Adobe Photoshop

There are four things we can do with our printer/paper profiles in Photoshop: print using the these profiles, soft proof our images, investigate out of gamut colors, and convert our images with them.

Print with Photoshop Print Settings Window

The most common use for a printer/paper profile is, of course, making a print. As we discussed, to get the desired monitor to print match, you need to convert your image to the printer/paper profile before you send the image data to the print driver, but Photoshop allows us to keep the image in the working color space until the last minute and perform this conversion on the fly, as the image is sent to the print driver. This is done from the Photoshop **Print Settings** window (Figure 8.36), which is launched by clicking **File > Print** from the menu bar.

Printing out of Photoshop involves a number of windows (three, if you count the Proof Set-up window, which we'll talk about in the section on soft proofing). This is because we're using two pieces of software: Photoshop and the printer driver. Both have to be given instructions as to how to handle the file.

The steps to take when printing an image from the Photoshop **Print Settings** window and using a profile are: (1) Select and Verify

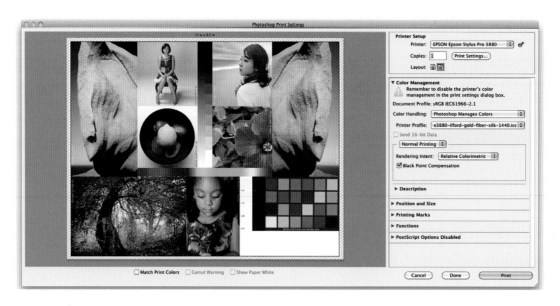

FIGURE 8.36 Printing the test page from Chapter 3 in the Photoshop Print Settings window.
Credit: Test page designed by the author with photographs by Tom Ashe, Barbara Broder, Jungmin Kim, Brittany Reyna, Christopher Sellas, and Adam Wolpinsky

the Printer and Driver Settings; (2) Set the Color Management Settings and Printer/Paper Profile; (3) Position or Scale the Image on the Page; (4) and Click on Print. Steps (2), (3), and (4) are all done in Photoshop's **Print Settings** window.

1. *Select and Verify the Printer Setup and Driver Settings.* Click on the Print Settings in the upper right Printer Setup section of the Photoshop **Print Settings** window (which is, definitely, a confusing redundancy) to launch the printer driver window, shown in Figure 8.37. Here you will select the printer, preset settings for the paper, and the paper size. Click on the **Preset** pull-down menu and drag down to the optimized settings for your printer-paper combination, which were saved when you printed the color patches during printer profile building. This is very important! These driver settings are the calibrated state we profiled. If we're not consistent and don't get back to these settings, we won't get accurate results. As mentioned before, it is important for you to double-check and verify these settings are still

the same, especially the **Media Type**; **Color Mode** set to **Off (No Color Management)**; and the **Output Resolution**. When you're sure that the settings are all the same, click **Save**.

2. *Set the Color Management Settings and Printer/Paper Profile.* On the right-hand side of the Photoshop **Print Settings** window, shown in Figure 8.36, make sure you're showing the **Color Management** section. From there, verify that the **Document Profile** shown is the same as your image's color space. If they are not the same, Photoshop might make a false assumption about the colors in your image and give you an inaccurate print.

Next, under **Color Handling**, select **Photoshop Manages Colors**, as shown in Figure 8.38. This makes it possible for you to select the printer/paper ICC profile, along with the desired rendering intent, and to turn on **Black Point Compensation**. (These settings tell Photoshop to convert your image from the **Document Profile** to the printer/paper profile before sending it to the printer.)

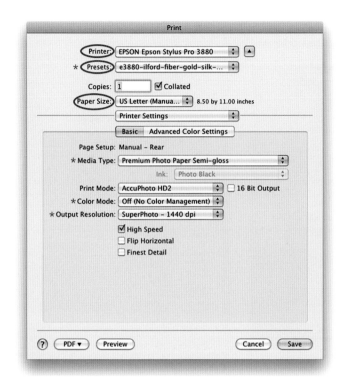

FIGURE 8.37 Printer driver settings for the Epson 3880 when launched from the Photoshop Print Settings window. Make sure the Printer, Preset, and Paper Size are set correctly for the printer and paper combination you are using and that the Media Type, Color Mode, and Output Resolution are the same as when the output profiling patches where printed. This CONSISTENCY is VERY IMPORTANT to get accuracy when using the printer/paper profile!

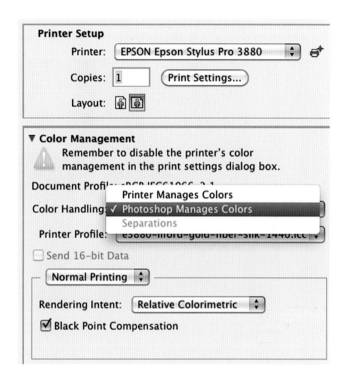

FIGURE 8.38 Color Handling options in the Color Management section of the Photoshop Print Settings window. Since we turn off color management in the printer driver, we select "Photoshop Manages Colors", which allows us to select our printer/paper profile.

When converting to a printer/paper profile, the selection of rendering intent (typically either **Perceptual** or **Relative Colorimetric**) is especially important, and can result in significant differences in image quality. Some profile building software packages produce better results in one rendering intent or the other. (See Chapter 6 for the differences among the rendering intents.) Also, remember that if you're using **Relative Colorimetric** as your rendering intent, you should select the **Use Black Point Compensation** checkbox checked so that you maintain shadow detail. (You shouldn't need to do this if you're using a **Perceptual** as a rendering intent. Perceptual rendering should include a BPC adjustment.

Since Photoshop CS3, the preview image in the Photoshop Print window has been color-managed. With CS4, it was improved further to allow gamut warnings and to show the paper white. To see how the image should look when printed using the printer and paper used in the **Printer Profile**, click on the **Match Print Colors** checkbox, as seen

FIGURE 8.39 Printing the test page from Chapter 3 in the Photoshop Print Settings window with 'Match Print Colors' check box selected and showing a change in scale and addition of corner crop marks compared with Figure 8.36.
Credit: Test page designed by the author with photographs by Tom Ashe, Barbara Broder, Jungmin Kim, Brittany Reyna, Christopher Sellas, and Adam Wolpinsky

in Figure 8.39. We will discuss all of this further in the Soft Proof and Gamut Warning sections.

3. *Position and Scale the Image on the Page.* Now that Photoshop correctly knows the page size and the margin limits of the printer, we can place the image in different positions on the page, or scale it to fill the printable area. Although it is better to size or scale your image using the Image Size tool, the scale functionality in the Photoshop

Print Settings window can be useful to fine-tune the image for the margins of the printer and paper size. The diagonal lines at the edge of the image you can see in Figure 8.39 indicate the area of the print that is outside the margins. To move the image on the page manually, the Scale to Fit box cannot be checked.

4. *Click on* **Print button**. This starts the processing of the image, including the conversion from the image's color space to the

printer/paper color space, and then the processing of the image through the settings in the printer driver. If you have the settings between Photoshop and your printer driver set correctly, you should get a reasonable match between the image as seen in Photoshop and the resulting print. One thing you could have done to make the match even closer is to soft proof the image to simulate your printer and paper combination, which we will discuss now.

Soft Proof the Image

We want the step of converting the image to the printer/paper profile to be the last thing we do before sending the file to the printer. One benefit of converting to the printer/paper profile when editing would be that any gamut limitations of the printer and paper combination (or difference in the rendering intent) will be visibly shown on the display. This is useful to see before you print the image, and allows for some fine-tune editing before you send the image to the printer. But we just said, "Don't do the conversion, if we are still editing our image!" We want to stay in the working color space, right? Guess what? There is a way to do both: soft proofing.

Soft proofing is simply defined as creating a simulation on your display or monitor of how the image will look on print. The simulation on a display is called a "soft" proof, as opposed to a "hard" proof. A hard proof is a print. Sometimes, a hard proof is printed in one medium (such as inkjet), which is meant to simulate how the print would look in another medium, like an offset printing press. Sometimes, it may be printed in the final medium itself to give us a (hopefully) definitive example of what the final print will look like.

To create a soft proof in Photoshop, launch the **Customize Proof Condition** window by clicking on **View > Proof Setup > Custom** from the menu bar. Then select the printer/paper profile from the Device to Simulate pull-down menu (bottom parts of Figures 8.41 to 8.45).

Figure 8.40 shows an original portion of the test image in sRGB. Figure 8.41 simulates what would happen if you sent these sRGB values to the printer without converting to the printer/paper profile, by clicking on the **Preserve RGB Numbers** checkbox, as shown. With CMYK images and CMYK profiles the display says **Preserve CMYK Numbers**

instead. Notice how different this proof is from the original. It is desaturated, especially in the skin tones, higher in contrast, and darker in the shadows and saturated colors, like green. This is what the final print would look like if we selected sRGB as the Printer Profile in the Photoshop **Print Settings** window. Obviously, this is not something we would want to do, if our goal is to match the original. Typically, you do not use **Preserve RGB Numbers** for soft proofing, since we are going to perform a conversion when printing. We will discuss the use of **Preserve RGB Numbers** for proofing when we send images to a service bureau in Chapter 16.

More commonly, we will leave **Preserve RGB Numbers** unchecked and see the more subtle difference, as you see in Figures 8.42 and 8.43, compared with the original in Figure 8.40. You should be able to see changes in the more saturated sections, especially in the flower and the gradient that runs across the bottom of the image. Photoshop is trying to simulate how the image will look when printed on this printer and paper with different rendering intents: relative colorimetric in Figure 8.42 and perceptual in Figure 8.43. Soft proofing is a great way to choose what rendering intent we like better for printing specific images, without using any paper. Notice the difference in detail in the flower. Does this make sense considering the difference of what happens when we convert with these two different rendering intents? (See Chapter 6.)

When we click on **OK**, the simulation is active in Photoshop. You can see it's active because the information at the top of the document window changes to let you know what device you're simulating. But what hasn't changed is the color space of the document. Just as we wanted, our image looks more like the final print, but is still in the working color space for editing!

Of course, the accuracy of this simulation depends on a few factors, including the quality of the printer/paper profile and the quality of the monitor profile. Photoshop is using this to help create the simulation and, most especially, the viewing conditions around your image, both on other parts of your display and in the room in which you are doing the proofing.

The other options in the **Customize Proof Condition** are *Simulate Paper Color* and *Simulate Black Ink*. The **Simulate Paper Color** option changes the brightest possible white and the darkest black of your

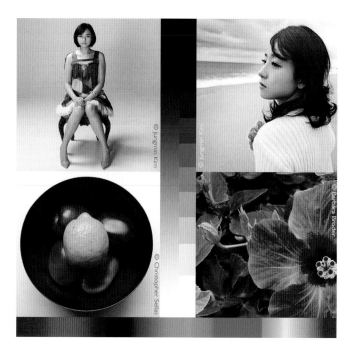

<div align="center">ORIGINAL</div>

FIGURE 8.40 Portion of original test page in sRGB.

FIGURE 8.41 Portion of original test page in sRGB soft proofed using Customize Proof Condition in Adobe Photoshop with the settings shown at the bottom, specifically Preserve RGB Numbers selected. This is simulating how the print would look on this printer and paper and settings if the sRGB values were sent without converting to the profile.

Credit *(both figures)*: Portion of test page with photographs by Barbara Broder, Jungmin Kim and Christopher Sellas

FIGURE 8.42 Portion of original test page in sRGB soft proofed using Customize Proof Condition in Adobe Photoshop with the settings shown at the bottom. This version is simulating how the print would look on this printer and paper, if converted using Relative Colorimetric rendering intent.

FIGURE 8.43 Portion of original test page in sRGB soft proofed using Customize Proof Condition in Adobe Photoshop with the settings shown at the bottom. This version is simulating how the print would look on this printer and paper, if converted using Perceptual rendering intent.

Credit *(both figures)*: Portion of test page with photographs by Barbara Broder, Jungmin Kim and Christopher Sellas

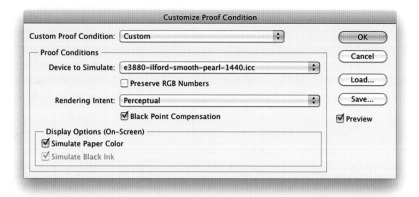

FIGURE 8.44 Portion of original test page in sRGB soft proofed using Customize Proof Condition in Adobe Photoshop with the settings shown at the bottom, including the paper white. This version is simulating how the print would look on this printer and paper, if converted using Perceptual rendering intent. Notice the images have less contrast and white is darker and slightly cooler than the original.
Credit: Portion of test page with photographs by Barbara Broder, Jungmin Kim and Christopher Sellas

FIGURE 8.45 *(facing page)* Portion of original test page in sRGB on the left and with Gamut Warning turned on in Photoshop on the right. Gamut Warning turns any colors out of gamut for the printer and paper profile selected in the Customize Proof Condition window. In this case it is based on the gamut of Epson 3880 with Moab Entrada Rag Natural (190) paper.
Credit: Portion of test page with photographs by Barbara Broder, Jungmin Kim and Christopher Sellas

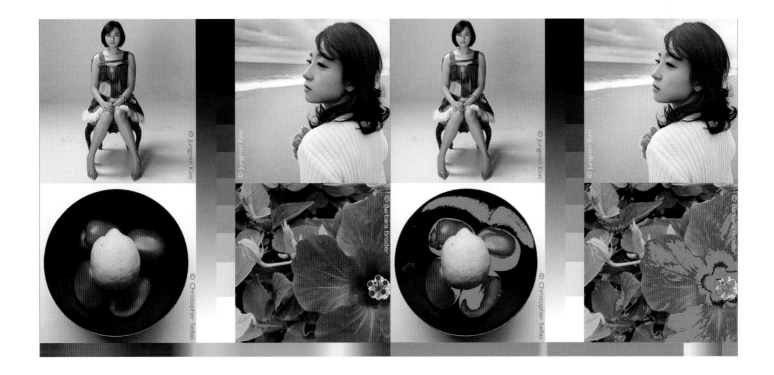

image, from the brightest white and darkest black of your display, to the brightest white and darkest black of the printer and paper combination, as described in the printer/paper profile. This type of soft proof is shown in Figure 8.44. Clicking on **Simulate Paper Color** is a way to help make the simulation even more accurate, but sadly is not as accurate or practical as you would hope. If there are other white points on your display (in menus, panels, palettes, thumbnails, etc.), the simulation doesn't work. The paper white typically seems too dark. To make the simulation work, you must eliminate any white point on the display around your image. One way to do this in Photoshop is to hit the **F** key twice. This leaves you with just your image, which is fine viewing the image, but not very practical for editing. Note: The paper color simulation doesn't work with all printer profiles.

The *Simulate Black Ink* option, instead, only changes the darkest black of your image, from the darkest black of your display to the darkest black of the printer and paper combination as described in the printer/paper profile. It shows some of the change in dynamic range, without changing the white point.

Gamut Warning

Colors that can't be printed or produced on a printer/paper combination are described as out of gamut. In Photoshop, to show any colors in your images that are out of gamut, simply click on **View > Gamut Warning** from the menu bar. This will display any colors in your image that are out of gamut for the printer and paper combination as middle gray, if you haven't changed the gamut color preference. The right image in Figure 8.45 shows the result of the gamut warning on the colors of the image. Note: the gamut warning is referring to whichever printer paper combination has been selected in the **Customize Proof Condition** window. In this case it is based on the gamut of Epson 3880 with Moab Entrada Rag Natural (190) paper. You might notice

that Photoshop's gamut warning can be somewhat conservative compared with other gamut viewers like ColorThink or Monaco Gamut-Works. The reason for this is that Photoshop is looking mainly at color gamut, not dynamic range from highlight and shadows like the two gamut viewers.

The main reason for using either soft proofing or the gamut warning is to help set your expectations (or the expectations of your client) to what colors are possible on the printer and paper combination, and what colors you might have problems in reproducing. This is especially important if you're trying to print your client's product colors.

Convert to Profile

As we've discussed, when you convert to a profile (such as a printer paper profile), the values are adjusted or changed to produce the closest match possible from one color space to another. Figure 8.46 shows Photoshop's conversion window.

Before we do this, we should ask ourselves a question. When should we convert the image to the printer paper profile? Although the

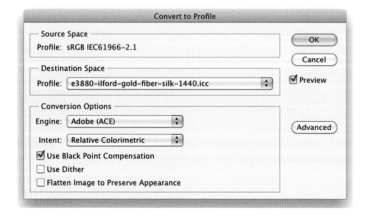

FIGURE 8.46 Convert to Profile window in Photoshop showing a conversion from sRGB to a printer/paper profile for Epson 3880 with Ilford Gold Fiber Silk paper. You would not do this type of conversion before printing from Photoshop. You would possibly do this before sending an image to a service bureau.

conversion to the printer paper profile needs to happen, it should be one of the last steps you take before sending the image to the printer. You should not convert to the printer paper profile if you're still editing and making color corrections to an image. Why? Because, if you are editing an image, it's best to keep it in an *independent neutral working* color space, like AdobeRGB(1998) or ProPhotoRGB, so that when you use the Info Panel, the values will have more meaning. Remember that it's typically only when you're in a working color space that equal red, green, and blue code values will mean you are sampling a perfect neutral. After you convert your image into the printer/paper color space, a neutral will, most probably, NOT be represented by equal red, green, and blue values; thus making editing more difficult. Also, since printer gamut is usually missing at least some parts of working gamut, you'll most likely be significantly reducing the colors in your image. If you print this image on some future printer with a larger gamut, you'll have to return to the original image and do all your editing over, or settle for the gamut of the earlier printer.

If you are printing from Photoshop, it will ALWAYS be best to convert the file from the Photoshop Print Settings window as you are sending the data to the printer driver, NOT from the Convert to Profile window. In Chapter 16 we will discuss when you would convert to output profiles, before sending files to a service bureau.

Using Printer/Paper Profiles in Adobe Photoshop Lightroom

As with many things Adobe has tried to do with Lightroom compared with Photoshop, options for using printer/paper profiles are more limited to make the software easier to use. That's not to say the **Print** module in Lightroom isn't powerful, because it is. It has amazing functionality for producing contact prints and print packages. It also allows for output sharpening, which we'll discuss in Chapter 17. Of the four things we discussed that Photoshop allows us to do with printer/paper profiles, Lightroom allows us to do three of them with limited functionality: **Convert**, **Print**, and **Soft Proof**. Currently, Lightroom does not have gamut warning capabilities.

FIGURE 8.47 Export Module in Adobe Lightroom, showing the ability to export to printer/paper output profiles.

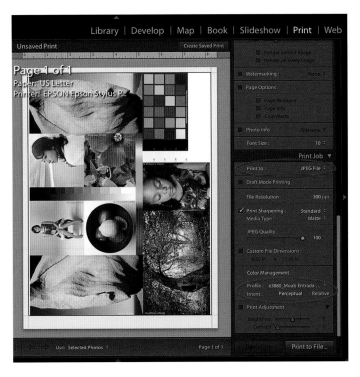

FIGURE 8.48 Print Module in Adobe Lightroom, showing the ability to Save to JPEG file while converting to a printer/paper output profile.
Credit: Test page designed by the author with photographs by by Tom Ashe, Barbara Broder, Jungmin Kim, Brittany Reyna, Christopher Sellas, and Adam Wolpinsky

Convert to Profile

In Lightroom, there's no direct way to convert to or assign any profile, but there are two places in Lightroom where you can indirectly convert to a profile: (1) **Export** and (2) **Print to JPEG**.

1. *Export.* From the Library module's **Export** window (a portion of which is shown in Figure 8.47), you can select the destination color space, which can be a printer/paper profile. But notice what's missing that you have in Photoshop. You have no option to select a color engine, rendering intent, black point compensation, or use dither. To give a cleaner interface, Adobe is deciding these things for us. Depending on the application and the profile, not having control (especially over rendering intent) can be a serious limitation. So, what rendering intent is Lightroom using during an export? Perceptual. If you were going to choose one rendering intent, then this is a good one. Typically,

exporting to an output profile will mainly be useful for preparing images for some service bureaus, which we will discuss in Chapter 16.

2. *Print to JPEG File.* In the Print Job panel of the Print module (Figure 8.48), you're given the option to send the output to a compressed JPEG file instead of a printer. You might use this option for proofing, or for preparing files to be printed on another computer that doesn't have Lightroom installed. In the lower right, or the **Print Job** panel, you can see the **Color Management** area. Here, we can select the **Profile** to convert to, when printing to the JPEG file and the rendering intent to use. The choices of rendering intent are limited to two: **Perceptual** and **Relative** (meaning Relative Colorimetric).

FIGURE 8.49 Print Module in Adobe Lightroom, showing the ability to print images, converting to a printer/paper output profile on the fly to the printer driver. Click on the circled Print Settings button, to launch the printer driver and select the optimal settings for the printer/paper combination.

Credit: Test page designed by the author with photographs by Tom Ashe, Barbara Broder, Jungmin Kim, Brittany Reyna, Christopher Sellas, and Adam Wolpinsky

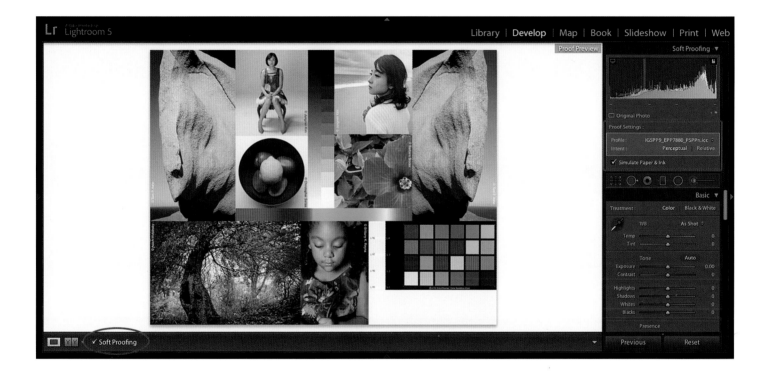

FIGURE 8.50 Develop Module in Adobe Lightroom, showing the ability to soft proof images with printer/paper output profile for different rendering intents and paper and ink color and density.

Credit: Test page designed by the author with photographs by Tom Ashe, Barbara Broder, Jungmin Kim, Brittany Reyna, Christopher Sellas, and Adam Wolpinsky

Print

The **Print Module** (Figure 8.49) also allows us to convert to printer/paper profiles on the fly, as we send the data to the printer. As mentioned before, here in the Print module Lightroom gives us the option of two different rendering intents, **Perceptual** and **Relative** (Colorimetric). Notice what we're told with the arrow to the right of **Color Management** in the **Print Job** panel turned down. "When selecting a custom profile, remember to turn off printer color management in the Print [driver] dialog before printing. Black Point Compensation will be used for the print."

Soft Proof

As we discussed in Chapter 6, Lightroom, since version 4, has the capability to soft proof images in the **Develop Module**, as shown in Figure 8.50, but not in the **Print Module**. As in the **Print Module**, Lightroom only gives us the option of two different rendering intents for Soft Proofing: **Perceptual** and **Relative** (Colorimetric). As you can see in Figure 8.50, **Soft Proof** in Lightroom does allow you to simulate the paper and ink color as well.

EXPLORATIONS

It's time to start making prints! You can build a custom profile for a printer and paper combination and then, using your test page, print the following versions and compare them to the image of the test page in Photoshop and Lightroom using soft proofing:

- Use a custom printer/paper output profile in the **Print Settings** or **Print Module**. Use the saved settings in the printer driver, as described above.
- Use a generic printer/paper profile for same printer and paper this time with recommended printer driver settings from the paper manufacturer. Compare this print with the one from custom profile.
- Instead of a printer/paper profile in the **Print Settings** or **Print Module**, select the working color space of your test page with the saved settings in the printer driver. This is a common mistake. See how the print looks and compare it to the soft proof with Preserve RGB Numbers checked.
- Once again use the **Custom** printer/paper output profile in the **Print Settings** or **Print Module** in Photoshop or Lightroom, but this time under **Color Mode** TURN ON the color controls in the printer driver, instead of setting it to **Off (No Color Management)**. This means color management will be happening in two places: the application and the printer driver, which is another common mistake. (**Note:** Some application and printer drivers no longer allow you to make this mistake, which is a good thing, even if you won't be able to make this print.)

Conclusion

In this very long chapter we have covered four things in detail about color managing printers: (1) How to optimize the printer and driver settings (calibration); (2) how to build a custom printer/paper output profile (characterization); (3) the difference between custom and generic printer paper profiles; and, finally (4) how to use printer/paper profiles in Adobe Photoshop and Lightroom. We are at an exciting point in this process. You now have everything you need to know to get a good match from display to print, about 85–90% of the way there. In the next chapter we will discuss how to optimize the output profiles to get even closer.

Resources

Printer Drivers

Canon Printer Drivers
 http://www.usa.canon.com/cusa/support

Epson Printer Drivers
 http://www.epson.com/cgi-bin/Store/support/SupportIndex.jsp

HP Printer Drivers
 http://www8.hp.com/us/en/support-drivers.html

Custom Printer Profiling Packages

basICColor print 3
 http://www.basiccolor.de/basiccolor-print-3-en/

Datacolor SpyderPRINT with Spectrocolorimeter
 http://spyder.datacolor.com/portfolio-view/spyderprint/

X-Rite Color Munki
 http://xritephoto.com/ph_product_overview.aspx?id=1115

X-Rite i1Profiler with i1Pro 2 Spectrophotometer (i1Photo Pro2)
 http://xritephoto.com/ph_product_overview.aspx?ID=1913

X-Rite 1Profiler Software—i1 Publish Version
 http://www.xrite.com/product_overview.aspx?ID=1470

Generic Printer Paper Profiles

Canson Infinity Digital Fine Art & Photo Media
 http://www.canson-infinity.com/en/icc_choice.asp

Crane Museo Digital Fine Art Media
 http://www.museofineart.com/index.php/icc-profiles/

Epson Photographic Inkjet Papers
 http://www.epson.com/cgi-bin/Store/jsp/Pro/ICCProfiles/proImaging
 ICCProfiles_StylusPro3880.do

Hahnemülhe Fine Art Inkjet Papers
 http://www.hahnemuehle.com/site/en/220/icc-profiles.html

Harman Photo Professional Inkjet Paper
 http://www.harman-inkjet.com/profiles/page.asp

Ilford Inkjet Photo Papers
 http://www.ilford.com/en/support/printer-profiles/

Inkpress Inkjet Paper
 http://www.inkpresspaper.com/papers_p1.asp

Innova Digital Art Media
 http://www.innovaart.com/en/icc-profiles.html

Moab by Legion Digital Inkjet Papers
 http://moabpaper.com/icc-profiles-downloads/

Oriental Photo USA Photographic Quality Inkjet Papers
 http://www.orientalphotousa.com/icc_profiles.htm

Pictorico (Mitsubishi) Inkjet Media
 http://diamond-jet.com/resources.aspx

OUTPUT PROFILE OPTIMIZATION & EDITING

OUTPUT PROFILING SOFTWARE COMPARISON

Software	Device(s) Supported	Number of Patches	Printer Configurations and Number of Inks	Features	Retail Price (USD)
1. basICColor Print 3	**Barbieri** – Spectro LFP, DTP 1150, Spectro 100xy, Spectro 50xy, **ColorPartner** – ColorScout A, ColorScout A+, ColorScout A+ (EyeOne), ColorScout A+ (SP6x), ColorScout S; **X-Rite** – i1 Pro, i1iO, Spectrolino SpectroScan, SpectroEye, DTP41, DTP20 (Pulse), SP6x, 520, 528, 530, 939, 962, 964	RGB: 364 or 1248 CMYK: 336 or 1485	RGB, CMYK, and Grayscale	Detects and automatically sets the optimum ink limit, gamut compression control, and correction for optical brighteners	$1,360.00 (Software Only)
2. Datacolor SpyderPRINT™	Datacolor Spectrocolorimeter	150, 225, or 729	RGB Only	Builds Black-and-White Profiles	$349.00 (Software and Hardware)
3. X-Rite ColorMunki Photo	ColorMunki Spectrophotometer	100 patches plus unlimited optimization with 50 additional patches at at time	RGB or CMYK	Also profiles displays and projectors	$499.00 (Software and Hardware)
4. X-Rite i1Photo Pro 2 (i1 Profiler Software)	i1 Pro 2 Spectrophotometer (plus i1Pro, i1iO, i1iSis and i1iSis XL spectrophotometers)	400–6000 patches	RGB Only	LUT Size, Bit Depth, Iterative Profile Optimization, Optical Brightener Compensation, and Quality Control	$1,549.00 (Software and i1 Pro 2)
5. X-Rite i1Profiler Publish	i1Pro, i1Pro 2, i1iO, i1iSis and i1iSis XL spectrophotometers	RGB & CMYK: 400–6000 patches 5 to 8-Color Inks: 800–6000 patches	RGB, CMYK, Hexachrome, 5–8 Ink configurations	Same as above plus Pre-Linearization, Ink Limits, and Black Generation	$1,099.00 (Software Only)

Now that we have reviewed the basics of building and using output ICC profiles, which should help to get us a good part of the way toward our goal of, as close as possible, a monitor to print match, the question has to be asked: *Can we do better?* In this chapter we will discuss how to build higher-quality output profiles and how to improve these profiles. We will start by comparing the different printer profiling packages and spectrophotometer options. Then we will cover the methods for optimizing output profiles. Finally, we will show the reasons and tools for editing output profiles.

Printer Profiling Packages

Getting better ICC profiles for our output devices starts with software and hardware used for building the profiles. Currently available software packages for building custom printer profiles vary in the measurement devices they support, the number of patches that can be used to characterize the printer/paper combinations, the printer configurations and number of inks that the profile can support, options available for building the printer profile, and price, as shown in the table in Figure 9.2.

Measurement Devices

Some of the software packages you could use support multiple measurement devices and others support only one. Both Datacolor SpyderPRINT™ and X-Rite ColorMunki come bundled with their measurement devices, a spectrocolorimeter and a spectrophotometer, respectively. What is a spectrocolorimeter? According to Datacolor, their device uses 18 LED light sources across the visible spectrum to illuminate the print when profiling, which gives more information than most colorimeters, but

FIGURE 9.1 Output-profiling patches from X-Rite i1Profiler (646-RGB patches on top and 646-CMYK patches on the bottom) for measurement with the X-Rite i1iO Automated Scan Table and the i1 Pro 2 spectrophotometer.

FIGURE 9.2 Table comparing output profiling software packages.

FIGURE 9.3 X-Rite i1iO Automated Scan Table with an i1 Pro 2 spectrophotometer. Credit: X-Rite, Incorporated

less than a typical spectrophotometer. basICColor Print 3 and X-Rite i1Profiler both support multiple spectrophotometers.

The difference in price among the spectrophotometers is often for speed and the amount of *automation*. The most basic spectrophotometers would only measure one patch at a time. This becomes a real burden when you are measuring hundreds, let alone thousands, of patches. (Trust me, I've done this in the past!) The next level up, like the Datacolor Spectrocolorimeter, X-Rite ColorMunki, and the i1 Pro 2, will scan and measure one row of patches at a time by hand. This is good for hundreds of patches, but if you are measuring thousands or building many output profiles it could make sense for you to use a device with even more automation, like the X-Rite i1iO Automated Scan Table or the X-Rite iSis spectrophotometer. The X-Rite i1iO Automated Scan Table, as seen in Figure 9.3, takes an i1 Pro 2 spectrophotometer. You put the page of patches on the platform, tell it where three corner patches are on the target, and the device then measures all the patches on the page automatically. The X-Rite i1-iSis spectrophotometer, as seen in

FIGURE 9.4 X-Rite i1-iSis XL Spectrophotometer
Credit: Photograph, © Marko Kovacevic (markokovacevic.net)

Figure 9.4, allows you to simply feed the printer profiling target into the front and it feeds in and measures all the patches. Although very fast, because of its feed mechanism the iSis is limited to media that is 0.08mm to 0.45mm thick.

Number of Patches

Typically the more patches we use in profiling an output device the better. The additional patches allow us more information in characterizing the printer and paper combination and result in a more accurate profile. The one exception, discussed in the previous chapter, is when we are profiling output onto uncoated (small gamut) media, like newsprint. This is because the extra measurements in the small range can lead to more measurements of noise in the process than actual differences in the colorcharacteristics. Should you always use the maximum number of patches when profiling for output on coated media? Not always. As we can see in Advanced Mode X-Rite i1Profiler allows you to use up to 6000 patches. For building an RGB output profile for an inkjet printer using the standard driver, you could use about 2000 patches. Typically the increases in quality won't be as large from 2000 to 6000 patches. If you are building a true CMYK or 5- to 8-color ink profile, then these additional patches might be more necessary.

Printer Configurations and Number of Inks Supported

Some software and software configurations are only meant for building RGB profiles, which is fine for building a profile for an inkjet printer using the standard driver. Other software packages will allow you to also build CMYK profiles for color laser printers, proofing devices, or

Spectrophotometers with and without UV Cutoff Filters

When profiling papers that contain optical brighteners, it can be better to use a spectrophotometer that filters out the ultraviolet (UV) part of the spectrum. Both the X-Rite i1 Pro and the ColorMunki spectrophotometers come in versions with and without UV cutoff filters. However, if you're using either of these devices exclusively with their corresponding i1Profiler or ColorMunki Photo or Design software, respectively, you don't need the device with the UV cutoff filter, since the software detects and corrects for the UV brighteners in these papers. On the other hand, if you use these devices with other software packages, such as RIPs, then you'd want the version of the spectrophotometer with the UV cutoff filter. The exception to this are the X-Rite i1 iSis and the i1 Pro 2 spectrophotometers, which allow for measuring both with UV and without UV light, which we will discuss later in this chapter when we look at Optical Brighter Compensation techniques for improving printer profiles.

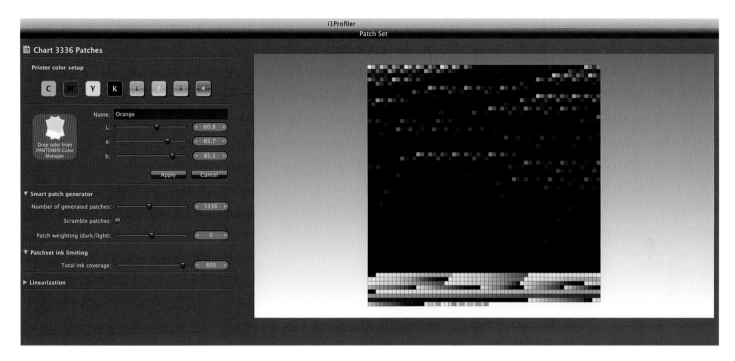

FIGURE 9.5 Building a CMYK + 4 Ink output profile in X-Rite i1Profiler.

printing presses. Very high-end output profiling software packages, like X-Rite i1Profiler Publish, allow you to build profiles for CMYK plus up to four additional inks, as seen in Figure 9.5. This configuration is not meant for profiling an inkjet printer that has more than four inks when you are using the standard driver. As we have said before, you would build an RGB profile when using the standard driver, since the standard printer drivers are expecting RGB data coming into them.

Output Profile Optimization Features

Beyond using more patches when we are profiling a printer paper combination, we can divide the output profile optimization features into two categories: CMYK specific and overall features. The CMYK specific features will be covered in Chapter 17. The overall optimization

features affect all the different types of output profiles and include: Customized Lighting Condition, Profile Settings, Iterative Profile Optimization, and Optical Brightener Compensation.

Customized Lighting Condition

As we discussed in the last chapter, X-Rite i1Profiler allows us to optimize the profile for the specific light source the print will be viewed under. basICColor Print 3, also, allows us to select from a series of standard illumination light sources to use to customize the profile, as seen in Figure 9.6. X-Rite i1Profiler, additionally, allows us to optimize the profile from a measured light source, as shown in Figures 9.7 and 9.8. This should allow the profile to be even more customized to the exact viewing condition. Since we know that lighting has a lot to do with the colors we perceive, it makes sense for us to base the profile on the actual viewing condition, instead of the standard

FIGURE 9.6 Choices of Illumination in basICColor Print 3. D50 or 5000K is the default viewing illumination for output ICC profiles, if it is not changed.

FIGURE 9.7 Building a printer/paper profile based on a measurement of 4100K Solux lighting in X-Rite i1Profiler.

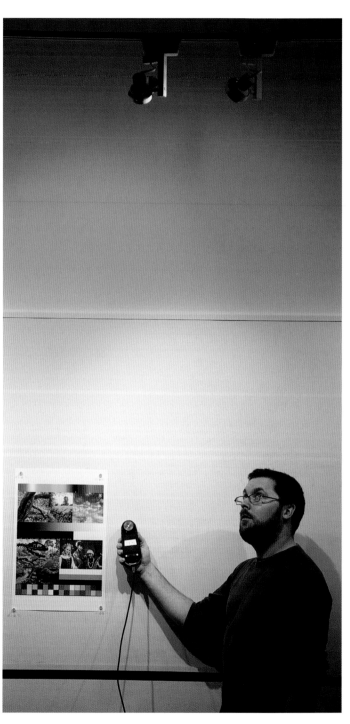

Create profile

Measurement file(s):	RGB.CIE
Profile name:	RGB.icc
Preset:	▲ custom settings

Special Parameters

Gamut Mapping – perceptual Rendering Intent

● Standard compression with chroma: 0%

○ Reference profile: ...

Quantifier

perceptual colorimetric 0

○ Relative compression with chroma: 0%

○ Black compensation with chroma: 0%

FIGURE 9.9 Perceptual Gamut Mapping options in basICColor Print 3.

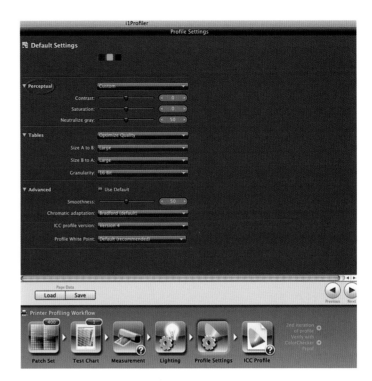

FIGURE 9.10 Profile Settings in Advanced Mode of X-Rite i1Profiler for building output profiles.

5000 K or D50. Of course, this only works perfectly if we know the print viewing condition and there is only *one*, which is not usually the case.

Profile Settings

basICColor Print 3 and X-Rite i1Profiler (in its Advanced Mode) allow us to some of their settings for building output profiles. As Figures 9.9 and 9.10 show us, both allow us to adjust the look and gamut

mapping for **Perceptual Rendering**. As we have discussed, when we use **Perceptual Rendering** to a profile during a conversion, out-of-gamut colors come into gamut (because they have to) and in-gamut colors are also shifted, so the overall relationship of colors remains the same (see Chapter 6). The amount we change the in-gamut colors in **Perceptual Rendering** is not an exact science; there is some art to it. Both applications give you the ability to adjust saturation and contrast for the **Perceptual Rendering**. X-Rite i1Profiler also allows you to adjust the way neutrals are dealt with in **Perceptual Rendering**: a

FIGURE 9.8 *(left)* Measuring of 4100K Solux lighting in X-Rite i1 Pro 2 spectro-photometer into i1Profiler software.
Credit: Photograph, © Marko Kovacevic (markokovacevic.net)

higher-value maps neutrals to be more in line with the color of the media or paper and lower-values map neutrals to be more purely neutral regardless of the color of the media.

X-Rite i1Profiler also allows us to change the quality of the profile by making the profile Look-Up Tables (LUTs) larger and the bit depth higher. In the **Advanced** settings i1Profiler lets us change the importance of smoothness in building the profile; the method to use when calculating chromatic adaptation from a light source other than D50; whether the profile should be an ICC Version 2 or Version 4; and the white point of the profile. Typically the default settings for all of these will be best. In the next chapter we will discuss one of the reasons to use Version 2 output profiles.

Iterative Profile Optimization

Both X-Rite ColorMunki and i1Profiler allow you to improve an output profile you have already built by generating and measuring an additional set of patches. ColorMunki derives the additional 50 patches from an image, as seen in Figures 9.11 and 9.12. You then print and measure these patches to get the improved profile. The iterative part means you can keep doing the steps over and over again to improve the output profile. Select the updated profiles, additional images for ColorMunki to use, then print and measure more patches. The images should be representative of the colors and tones you use in your images to help the improvements be as valuable as possible to your work and its specific pallet and subject matter.

FIGURE 9.11 Optimizing an existing printer/paper profile in X-Rite ColorMunki software using the colors from the selected product image.

FIGURE 9.12 The 50 optimization color patches generated by X-Rite ColorMunki from the product image in Figure 9.11 to improve the printer/paper profile.

FIGURE 9.13 Generating 30 patches from an image that includes three images as part of the Printer Profile Optimization Workflow in X-Rite i1Profiler.
Credit: Right two images by Mariana Becker

FIGURE 9.14 Generating 3339 patches from the Smart Patch Generator (at the top), the Pantone Coated Solid Colors Swatch Book (at the bottom), and an image (circled in the center) as part of the Printer Profile Optimization Workflow in X-Rite i1Profiler.

Like ColorMunki, X-Rite i1Profiler also lets you use up to 30 patches generated from a selected image to improve the profile, as shown in Figures 9.13 and 9.14. In addition to this, i1 Profile also has some other ways to generate many more patches for improving your output profiles. The first is the Smart Patch Generator, which examines your printer/paper profile and generates up to 6000 patches based on any areas of the gamut that seem to be less represented. The second method is using spot color measurements or Pantone(r) swatch book colors. If you are working with a client product or artwork, you could take spot measurements of them with the i1Pro or i1Pro 2 spectrophotometers and add them so that they are part of the calculations when improving the profile and hopefully make their rendering even more accurate. In addition to these measured or specified colors, i1Profiler will generate either four, 16, or 24 patches of surrounding colors close to the original spot colors. All of this can end up producing thousands of patches to measure to optimize the profile. If you are doing this a lot, you will definitely want a more automated spectrophotometer!

FIGURE 9.15 Fadi Asmar comparing X-Rite Optical Brightener Compensation (OBC) Standards with the OBC Test Chart printed from i1Profiler and viewed under the expected print viewing conditions, as part of the OBC workflow for improving output profiles for media that contains optical brighteners.
Credit: Photograph by Marko Kovacevic

FIGURE 9.16 OBC window in X-Rite i1Profiler with entered rows for each column where there was a match to the corresponding X-Rite OBC standard, as part of OBC workflow for improving output profiles for media that contains optical brighteners.

Optical Brightener Compensation

As mentioned before, optical brighteners are chemicals added to some papers to make them appear brighter and less yellow. They do this through a fluorescing mechanism, in which they absorb the light source energy in the (invisible) ultraviolet (UV) portion of the spectrum and reflect the energy back in the visible, mostly blue, part of the spectrum. However, optical brighteners can cause us some problems when we are trying to build accurate printer/media profiles for the papers that include them. One of the issues is that each paper with optical brighteners can have different amounts of optical brighteners additives with slightly different properties. Also, each light source we might be using to view our prints with can have different amount of UV energy, which will affect the final colors we see. To deal with this, X-Rite has done two things: made i1iSis and i1Pro 2 spectrophotometers with measurement conditions to help in dealing with optical brighteners and added **Optical Brightener Compensation** (OBC) tools to i1Profiler.

There are *three ISO types of measurement* in i1Profiler: **M0**—no filter with UV included and a light source similar to Type A (tungsten); **M1**—no filter with UV included and a light source similar to D50 (5000K viewing booth); and **M2** —UV cut with UV excluded and a light source similar to Type A (tungsten). You can use the i1iSis and the i1Pro 2 with two different modes to make these different types of measurements: Single Scan and Dual Scan. In **Single Scan** mode the i1iSis makes M2 measurements, while the i1Pro 2 makes M0 measurements. In **Dual Scan** mode the i1iSis makes M0, M2, and OBC measurements, while the i1Pro 2 uses both of its light sources and makes M0, M1, M2, and OBC measurements.

When you are building an output profile using the Optical Brightener Compensation workflow in X-Rite i1Profiler with either the i1iSis or i1Pro 2, the measurements are made in Dual Scan mode. After the profiling patches are measured, the next step is to print the OBC Test Chart on the same printer and paper combination you are profiling. The OBC Test Chart has four columns of neutral patches: the first column consists of light gray N-8 (8 corresponds to 80% reflectance) patches; the second column consists of slightly darker gray N-6.5 patches; the third column consists of middle gray N-5

FIGURE 9.17 Brightener Correction slider in basICColor Print 3.

patches; and the fourth column consists of dark gray N-3.5 patches. Each row of the columns goes from a warmer cast at the top to cooler cast toward the bottom, and neutral somewhere in the middle.

The goal of the **Optical Brightener Compensation** tools and workflow is to take into account the combination of the ink, paper, and the light source the print will be viewed under to get a more accurate profile. To do this, you take the OBC Test Chart under the light source the print will be viewed under. Once there, compare the four X-Rite OBC matte or glossy (depending on your media) Gray Standard viewers with the corresponding columns on the printed OBC Test Chart, as seen in Figure 9.15. For each column find the row that best matches the standard and enter the value into i1Profiler, as you can see in Figure 9.16.

basICColor Print 3, also, allows us to perform some level of optical brightener compensation, as seen in Figure 9.17. However, it is not clear how this level would be determined without trial and error.

Output Profile Editing

When the subject of output profile editing comes up for the first time in a color management class, there is typically resistance. The feeling is, "If we are doing everything right in building monitor and printer/paper profiles with our objective measurement devices and software, there should never be a need to edit output profiles." Justifiably, the feeling is that the only editing should be to individual images, not profiles. We will start by talking about the factors that can make profile editing necessary and situations where profile editing is and is not appropriate. Next we will discuss how different parts of the output profile are edited depending on the situation. Finally, we will review different types of profile editing tools.

To Edit or Not to Edit?

There are many assumptions and factors involved in monitor to print matching with our imaging systems. Monitor profiles are built with assumptions about the color temperature and intensity of the viewing conditions surrounding them (5000 K at 60 lux according to ISO standards) and output profiles are built with assumptions regarding the color temperature and intensity of the viewing conditions we use to look at prints (5000 K at 2000 lux). We have also discussed, since the first chapter, that we all see color somewhat differently from one another. On top of this, subjective decisions are made by profile building software and color engineers to determine how color and color relationships should be reproduced by the different rendering intents of output profiles. The inaccuracy of some of the assumptions (working and viewing under slightly different viewing conditions), as well as the variations in some of these and other subjective variables (choices made by software engineers), can cause us to feel like our color managed system is not as good as it could be. As far as monitor to print match goes, we might feel like we are 95% of the way there. The ability to edit our output profiles is meant to give us users some control and help us with the final 5% on this journey. *Considering all of this, you should only edit profiles under the following limited circumstances:*

- *To make SUBTLE adjustments to all of your print output and/or soft proofs.* Editing the profile is about getting that last 5% that will make the profile as good as possible. Editing your profile is not about making big adjustments, which correct for a poorly built profile or incorrect application, driver, or RIP settings. If you are making aggressive adjustments when you edit a profile, there is most likely a problem with your profile building process or workflow. Troubleshoot these possible problems before editing a profile, which we will discuss in the next chapter. How do you know if the adjustment you want to make is *subtle*? The truth is, it's hard to say.

- *If you are making the same adjustments to every print.* After you have been using a printer and paper profile for some time on many images, if you find you are consistently making the same subtle adjustments to get to the final print, such as making all prints slightly lighter, then editing the profile might be the right option.

Output Profile Editing Options

The first thing to remember when editing an output profile is that, depending on the problem or goal, we are going to be given choices to edit different parts of the profile. As a point of review, your ICC profiles are made up of two look-up tables that go in different directions for each rendering intent: (1) *the inverse or output table*, which goes from the profile connection space (XYZ or Lab) to the device color space (typically RGB or CMYK) and (2) *the forward or input table*, which goes from the device color space to the profile connection space. Since there are three rendering intents—perceptual, colorimetric, and saturation—this makes for a total of six different tables in each ICC profile, as shown in Figure 9.18. The inverse tables are marked with a tag of B2A and the forward tables are marked with a tag of A2B, denoting the direction of the table. The number after this table portion of the tag is a 0, 1, or 2, denoting the rendering intent: perceptual is "0"; colorimetric is "1"; and saturation is "2." So, if we are editing the B2A1 table, this is the inverse table for the perceptual rendering intent.

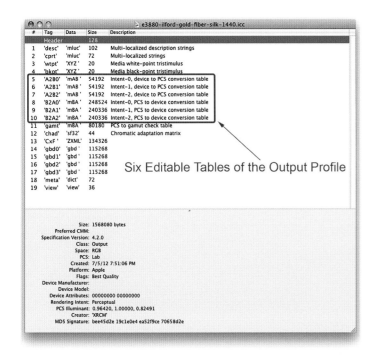

FIGURE 9.18 An output ICC profile opened in ColorSync Utility showing the six editable tables.

Most profile edit software packages allow us to edit either the inverse or the forward table. In addition to this, X-Rite's ProfileEditor 5, which is the only remaining module of ProfileMaker 5 still for sale, also lets us edit both tables at the same time, which is not typically useful, as we will discuss. In X-Rite ProfileEditor 5 you make the decision of what profile table direction to edit, as well as, which rendering intents (**Perceptual, Relative Colorimetric, Absolute Colorimetric,** or **Saturation**) to edit, in two places: (1) when you are selecting the workflow at the beginning, as seen in Figure 9.19; and (2) when saving the edited profile, as seen in Figures 9.20, 9.21, and 9.22. So, when would you edit the inverse table and would you edit the forward table? And should you ever save edits to both at the same time? Let's look at the differences and what happens with each type of editing.

Inverse Table Editing (B2A)

Inverse table or B2A table is the most common profile editing choice. This is where you are editing the output portion of the profile going from the profile connection space (Lab) to the output space (RGB in this case). *This is the portion of the profile you edit if you are happy with the match between your soft proofed image and the output, but you want both to be changed slightly in the same direction.* For example, if you edit this portion of the profile by adding more cyan to the mid-tones (same as reducing red), both the soft proof and the print will show this increase in cyan in the mid-tones.

Forward Table Editing (A2B)

Forward Table Editing or A2B is the next most common table editing option. In this profile editing option you are editing the input portion of the profile going from the output space (RGB in this case) to the profile connection space (Lab). *This is the portion of the profile you edit if you are happy with your print output, but not with the soft proof image.* For example, if you edit this portion of the profile by adding more cyan to the mid-tones (same as reducing red), the soft proof will show this increase in cyan in the mid-tones, but the print output will remain the same.

Forward and Inverse Table Editing

Hold onto your hats for this one. Combined A2B and B2A table editing option is a little confusing. In this profile editing option, you're editing both the input and output portions of the profile at the same time. *This is the editing option you would use if you saw a disagreement between the soft proof and printed output. This is not a common option to take.* Typically when this disagreement happens, the printer has drifted, so you should just build a new output profile, not edit the profile. If you use this editing option, it would work like this: let's say your prints are coming out too cyan compared to the soft proof that is slightly red. You edit the preview image in the profile editor and reduce the amount of cyan. By applying this edit to both tables, you will end up reducing the cyan on the print and not showing the effect in the soft proof, which will, theoretically, bring better agreement between the print and the soft proof. Good luck. This type of profile editing is not for the faint of heart.

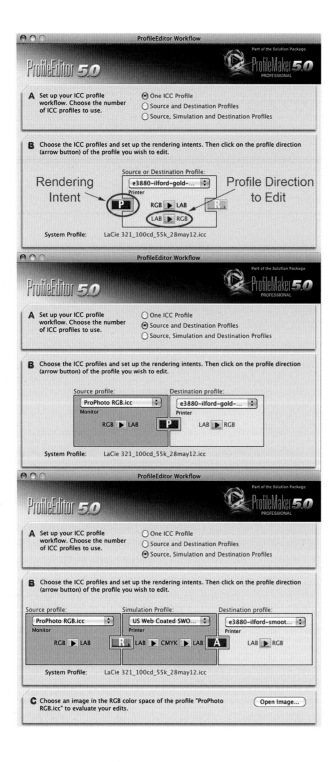

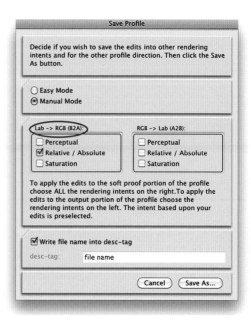

FIGURE 9.20 Selecting the Inverse Table (B2A) that goes from Lab to RGB, when saving the edited profile in X-Rite ProfileEditer 5. This is the most common type of profile editing and results in the same adjustments to both the printed output and the soft proof for the selected rendering intent.

Output Profile-Editing Tools

Once you select which portion of the output profile should be edited, the profiling software will provide you with a test image or let you select your own test image to use when editing. In some software packages the next step is to select the rendering intent to edit. *Remember: you can only edit one rendering intent at a time, but as you have seen X-Rite ProfileEditor allows you to apply the edits to all the rendering intents when saving the edited profile.*

FIGURE 9.19 (*left*) Selecting from the three workflows, four rendering intents, and two profile table directions at the beginning of the profile editing process in X-Rite ProfileEditer 5.

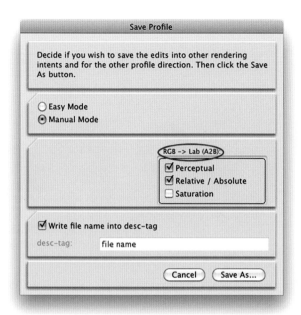

FIGURE 9.21 Selecting Forward Table (A2B) editing that goes from RGB to Lab, when saving the edited profile in X-Rite ProfileEditer 5. This results in a change to the soft proofed image for the selected rendering intents, but not to the printed image.

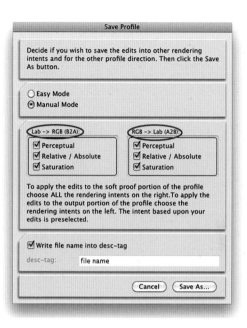

FIGURE 9.22 Selecting both the Inverse Table (B2A) that goes from Lab to RGB, and the Forward Table (A2B) that goes from RGB to Lab, when saving the edited profile in X-Rite ProfileEditer 5. This results in opposite adjustments to the printed output and the soft proof for the selected rendering intent. This method is very confusing and not typically used.

There are three levels of editing tools that the different profile editing software packages offer: **Overall Edits**, **Selective Color Edits**, and **Fine-Tune Neutral Edits**.

- *Overall Edits*—Every profile editing software package has tools to adjust brightness, contrast, color balance, and saturation. X-Rite ProfileEditor uses two different Curves tools (Gradations and Gray Balance) to adjust lightness, contrast, and color balance, as seen in Figures 9.23 and 9.24. It also has **Global Correction** sliders to control lightness, contrast, and saturation, which you can see in Figure 9.26. Notice the changes in the right and bottom portions of the test pages, as well as the adjusted RGB numbers in the **Values** palette. Can you see the changes?

- *Selective Color Edits*—Only a few profile editing software packages have tools to selectively edit the rendering of certain colors and color ranges. X-Rite ProfileEditor can change the rendering of selected color ranges. The selected color and adjusted ranges in Lightness, Chroma, and Hue made to reds in Figure 9.26 would result in a slight drop in lightness, a change in hue toward blue, and a slight increase in chroma or saturation in the reds on prints or soft proof images made with this profile, as you can see in Barbara Boroder's flower image in the test page.

- *Fine Tune Edits*—Even fewer profile editing software packages have tools to adjust the media white and black points in the editing process. X-Rite ProfileEditor is able to adjust the media or Profile White Point, which is used with the Absolute Colori-

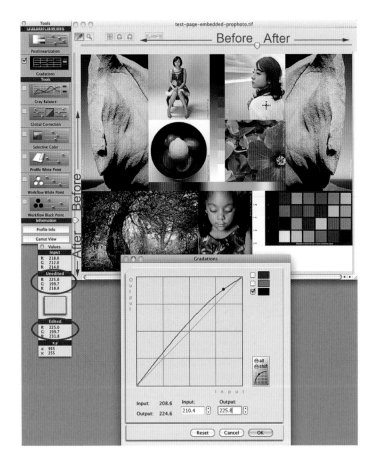

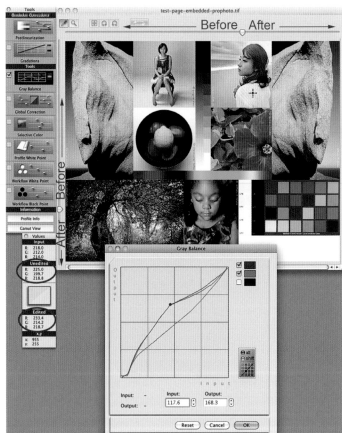

FIGURE 9.23 Gradations adjustment in X-Rite ProfileEditer. Raising the blue curve in the highlights and mid-tones will result in a bluer print and/or soft proof, as shown in the Values Pallet and the after portion of the preview test image.

Credit: Test page with photographs by the author, Barbara Broder, Jungmin Kim, Brittany Reyna, Christopher Sellas, and Adam Wolpinsky

FIGURE 9.24 Gray Balance adjustment in X-Rite ProfileEditer. Raising the red and green curves in the mid-tones will result in a yellower print and/or soft proof, as shown in the Values Pallet and the after portion of the preview test image.

Credit: Test page with photographs by the author, Barbara Broder, Jungmin Kim, Brittany Reyna, Christopher Sellas, and Adam Wolpinsky

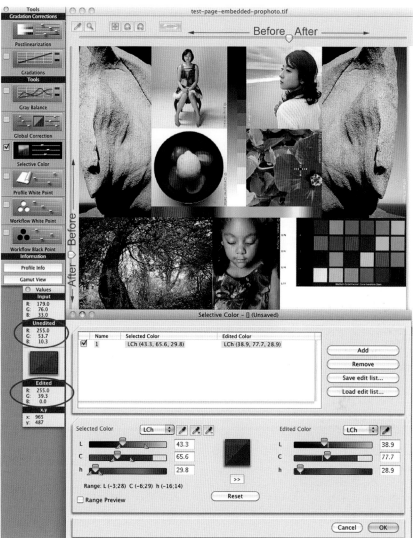

FIGURE 9.25 *(above)* Global Correction adjustments in X-Rite ProfileEditer. Increasing the Lightness and Contrast, while decreasing the Saturation, will result in lighter, more contrasty and less saturated prints and/or soft proof images, as shown in the Values Pallet and the after portion of the preview test image.

Credit: Test page with photographs by the author, Barbara Broder, Jungmin Kim, Brittany Reyna, Christopher Sellas, and Adam Wolpinsky

FIGURE 9.26 *(right)* Selective Color adjustments in X-Rite ProfileEditer. The edits to this range of reds will result in darker, more saturated, and bluer reds in prints and/or soft proof images, as shown in the Values Pallet and the after portion of the preview test image, specifically Barbara Broder's flower image.

Credit: Test page with photographs by the author, Barbara Broder, Jungmin Kim, Brittany Reyna, Christopher Sellas, and Adam Wolpinsky

FIGURE 9.27 Profile White Point tool in X-Rite ProfileEditer to make the brightest white of the print lighter, less saturated, and warmer. This edit is only for the Absolute Colorimetric rendering.

FIGURE 9.28 Workflow White Point tool in X-Rite ProfileEditer. This tool allows the user to select an input to output workflow (series of ICC profiles) and modify the final for white in the output.

metric rendering in proofing, as shown in Figure 9.27. ProfileEditor also gives the ability to adjust the rendered RGB numbers (or CMYK numbers for CMYK profiles) for both white and black with its **Workflow White Point** and **Workflow Black Point** tools, as seen in Figures 9.28 and 9.29. This can be especially useful with CMYK profiles to eliminate unwanted extra density in the highlights.

Profile Editors or Software Containing Profile Editors

Although we focused on X-Rite ProfileEditor in our review of profile editing, there are other software packages that can also be used for editing output ICC profiles, but the sad fact is that many are old or have been discontinued. X-Rite's i1Profiler does not have a profile editor. Here is a partial list of profile editors:

- *Datacolor SpyderPRINT(tm)* (contains the basic editor from SpyderPROOF)
- *Kodak Custom Color Tools* (profile editing using Photoshop; last updated in 2005)

FIGURE 9.29 Workflow Black Point tool in X-Rite ProfileEditer. This tool allows the user to select an input to output workflow (series of ICC profiles) and modify the final value for black in the output.

- *Fujifilm ColourKit Profile Editor* (discontinued)
- *X-Rite i1Match* (for use with the i1Pro spectrophotometer; last updated in 2009)
- *X-Rite MonacoProfiler* (discontinued; last updated in 2009)
- *X-Rite ProfileMaker ProfileEditor* (last updated in 2009).

As you can see, profile editors have not been a priority for the software manufacturers. The use for the profile editor is not really for most photographers. It is really only for the high-end print and graphic arts professionals who want to be able to make fine-tune edits to their ICC workflow.

Conclusion

Hopefully this chapter has given you some ideas of the tools and procedures you can use to improve the quality of your output profiles, and therefore your final prints. The main thing to remember is that the first step is to build a good profile for the printer and paper combination, which will get you most of the way toward a reasonable monitor to print match. The use of a higher number of patches, print viewing condition measurements, iterative profile optimization, optical brightener compensation, profile editing, and other advanced techniques, will just fine-tune things to get them slightly better. But, as

EXPLORATIONS

The best way to reinforce what you've learned in this chapter is to use some of the profile optimization techniques we have discussed, if you have the tools. Build a different profile or profiles for each technique: (1) higher number of patches, (2) different profile building settings, (3) customized print viewing condition measurements, (4) iterative profile optimization, (5) optical brightener compensation, and (6) profile editing. Then test the profiles by printing your test page using each profile. Evaluate the results by comparing the test pages to each other and to the soft proofed version on your display. This will help you to determine the best way for you to build and optimize your printer/paper profiles. You will also figure out which techniques are worth the time and effort for your prints and applications.

you can see, it will take some work to get those final improvements. In the next chapter we will look at what to do when things aren't working: how to troubleshoot and solve some technical printing and color management problems.

Resources

More Information on ICC Profile Editors and Applications with Profile Editors

Datacolor SpyderPRINT™
 http://spyder.datacolor.com/portfolio-view/spyderprint/

Kodak Custom Color Tools
 http://tag.kpgraphics.com/color/colortools/

X-Rite i1Match
 http://www.xrite.com/product_overview.aspx?ID=758

X-Rite MonacoProfiler
 http://www.xrite.com/product_overview.aspx?ID=583

X-Rite ProfileMaker ProfileEditor
 http://www.xrite.com/product_overview.aspx?ID=1233

COLOR UTILITIES & TROUBLESHOOTING

Now that we've built, optimized, and, less likely, edited our output profiles, the next step is to verify that they, and the rest of our image processing, are working well. In this chapter we will start by reviewing tools and utilities that will help us to objectively evaluate our profiles and color in different parts of the workflow, especially the ones that let us examine and fix profile and image tags, take spot measurements, and view the gamuts of our devices. Sometimes these utilities will show us that there are deficiencies in our profiles. In the second half of this chapter we will discuss strategies to use when we are troubleshooting any of the many glitches we could be having in our quest for a monitor to print match and high quality print output.

Color Utilities

The first step in evaluating the accuracy and quality of our printer paper profile, as well as our display and the rest of our color-managed workflow, will most probably be to print our test page and compare the print to the display. That makes sense, especially if you view the print and display under their respective proper lighting conditions. That being said, there are, also, a handful of useful utilities that can help us manage, understand, and evaluate ICC profiles, along with applications to measure and compare spot colors and light sources, which you should know about. Let's go over the following utilities and applications and see how they can help us:

- *ColorSync Utility*
- *ColorSync Apple Scripts*
- *X-Rite ColorMunki ColorPicker*
- *X-Rite i1 Share*
- *X-Rite i1Profiler*
- *PANTONE Color Manager*
- *X-Rite ColorPort*
- *CHROMIX ColorThink Pro.*

ColorSync Utility

ColorSync and the ColorSync Utility are part of the Apple Macintosh operating system (OS X). As mentioned before, when an application like Photoshop performs a color conversion, it is relying on the operating system level color management (ColorSync on the Mac and ICM on Windows) to perform some parts of the process. Whenever a user double-clicks on an ICC profile on a Mac, the profile is opened in the ColorSync Utility, as we've already discussed. Remember in Chapter 6 we saw how to change the internal name (Localized Description String tag) of a profile that shows up in Adobe applications. If instead you launch the ColorSync Utility directly, you will see the interface in Figure 10.2, which includes five tools: **Profile First Aid, Profiles, Devices, Filters**, and **Calculator**. The tools in the ColorSync Utility can be useful in understanding our profiles and how color works with profiles.

The *Profile First Aid* tool in Figure 10.2 can be used to fix the tags in ICC profiles, if they are not visible in applications like Adobe Photoshop. Clicking on the **Verify button** tells **ColorSync** to review every ICC profile on the computer and reports if there are any "bad" profiles. You can then repair the tags in these profiles. To be on the safe side, backup all profiles before clicking on the Repair button.

The *Profile* tool in Figure 10.3 allows us to review all the profiles, which have been installed in different folders and drives on our computer. It also gives us a basic gamut viewer, which allows us to see the range of colors defined by different working color spaces and capable of being produced by different devices. The **Profile** tool allows you to view a three-dimensional gamut plot of different independent CIE color spaces, including Lab, Luv, and XYZ. After selecting the first profile, two profiles can be compared at the same time, by clicking on the inverted triangle in the upper left of the gamut plot, selecting **Hold for Comparison**, and selecting the second profile. Figure 10.3 shows a comparison between the gamut of sRGB and AdobeRGB(1998) in Lab.

FIGURE 10.1 What happened to the book's cover image? Find out at the end of the troubleshooting section of this chapter . . .
Credit: Photograph by the author

FIGURE 10.2 ColorSync Utility – Profile First Aid for detecting and repairing damaged ICC profiles.

FIGURE 10.3 *(top right)* ColorSync Utility – Profile tool, showing a gamut comparison between sRGB and AdobeRGB(1998), which is displayed as lighter and larger in volume, as you'd expect.

The **Devices** tool in Figure 10.4 shows users a list of the current input and output devices installed on the computer, along with the default and current profiles associated with each of the devices. For example, Figure 10.4 shows the **Factory Profile** and the **Current Profile** that was active on my LaCie 321 display.

The **Filters** window in Figure 10.5 manages and allows us to use Quartz system level image adjustments, which can be used in automated workflows in the print drivers and the **Preview** window, for example. Quartz is Apple's graphics system based on PDF. The top portion of Figure 10.5 shows the details of a default Quartz filter called **Blue Tone**. Figure 10.6 shows the result of applying this filter as an

FIGURE 10.4 ColorSync Utility – Devices tool, showing a default profile for the LaCie 321 display.

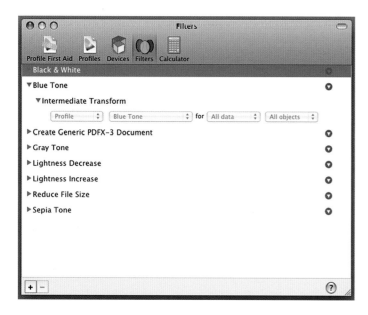

FIGURE 10.5 ColorSync Utility – Filters tool, showing the details of the Blue Tone Quartz filter, which was applied in Figure 10.6.

FIGURE 10.6 *(top right)* ColorSync Utility – Image Editor, showing the application of a Blue Tone Quartz filter, shown in Figure 10.5.
Credit: Test page designed by the author with photographs by Tom Ashe, Barbara Broder, Jungmin Kim, Brittany Reyna, Christopher Sellas, and Adam Wolpinsky

abstract profile in the ColorSync Utility after opening the image in by clicking on **File > Open**. Here you can also make some basic image adjustments, assign and convert profiles, and resize your images. Why would I use these tools if I have Photoshop? Although the image processing is fine, my guess is that you really wouldn't use these tools unless it was an emergency and you didn't have Photoshop on a computer where you were working.

Finally, the ColorSync Utility *Calculator* in Figure 10.7 allows users the ability to calculate resulting color values from conversions between different color spaces and profiles. In Figure 10.7, the resulting values for the yellow color in Lab were calculated for a conversion to AdobeRGB(1998). As you can see, RGB values are given from 0 to 1, with 0 being black and 1 being full red, green, or blue, instead of 8-bit code values from 0 to 255.

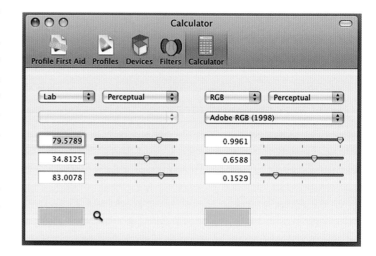

FIGURE 10.7 ColorSync Utility – Calculator, the conversion of CIE Lab values for a yellow color to AdobeRGB(1998).

What about Windows?

Although there is a modest equivalent to the ColorSync Utility for Windows XP, called the Microsoft Color Control Panel Applet, there isn't one for the Windows Vista or 7 operating systems. When working in these operating systems it would be especially useful to use CHROMIX ColorThink, since it will perform most of the functions and *many* more, which we will discuss later in this chapter. If you only need to change internal names of ICC profiles, you could use Andrew Shepherd's ICC Profile Toolkit, which can be downloaded at http://tlbtlb.com/links/.

ColorSync Apple Scripts

Apple provides us different tools and techniques for automating tasks and increasing workflow efficiency. This includes some standard scripts in the form of droplets. Droplets are small applications, which perform a given task when clicked on or when files are dragged onto them. The standard ColorSync droplet scripts are found in the **Hard Drive > Library > Scripts > ColorSync** folder. Figure 10.8 shows the scripts, which offer you the ability to remove a profile from or embed profiles into images, or rename the internal tags within profiles, among others. Figure 10.9 shows the result of taking a TIFF image and dropping it on the "Show profile info" droplet. Although this particular script is not as useful as in the past, since Adobe Bridge will show the embedded profile among other metadata and file information, using these scripts have potential to help you saving time and reducing repetitive operations.

FIGURE 10.8 ColorSync Scripts folder containing default Droplet Applications, which can be used for automatically embedding or removing profiles from images, without opening them in applications like Photoshop.

FIGURE 10.9 The result of using the 'Show profile info' ColorSync Droplet in the Scripts folder on an image. The same Droplet can be used with ICC profiles.

X-Rite ColorMunki ColorPicker

X-Rite has two different versions of ColorMunki: Design and Photo. They are very much the same, except for the white Design and black Photo spectrophotometers. ColorPicker is a stand-alone application that comes for free with the ColorMunki spectrophotometer and software combination. For designers and architects ColorPicker has some great abilities. It allows them (and us) to take spot measurements of objects and products. Or, like X-Rite i1Profiler, when optimizing a profile, ColorPicker is also able to pull colors from an image, as you can see in Figure 10.10. Then the software suggests contrasting,

harmonious or similar colors—specifically the closest Pantone colors to the measured colors, which are especially useful for graphic designers working in print. For us as photographers there are benefits as well. We can use spot measurements from the ColorMunki ColorPicker in evaluating the products or objects we are photographing, as well as the accuracy of cameras and print output, which we will continue to discuss when we cover X-Rite i1Profiler and CHROMIX ColorThink. To take a spot measurement you release the guide at the bottom of the ColorMunki and use it to position the ColorMunki to measure the object, like the product you are photographing, as you can see in Figure 10.11. Once you have the measurements of the objects or print

FIGURE 10.10 Selecting colors from an image in X-Rite Photo ColorPicker. The selected colors are shown in their original color in the upper left and in the lower right they are simulated (soft proofed) to look like they would appear output using the ICC profile selected in the lower left of the application.
Credit: Photograph at top by the author

FIGURE 10.11 Fadi Asmar taking spot measurements of products with an X-Rite ColorMunki spectrophotometer into Photo ColorPicker software.
Credit: Photograph, © Marko Kovacevic (markokovacevic.net)

FIGURE 10.12 Saving spot measurements of five products from X-Rite Photo ColorPicker software.

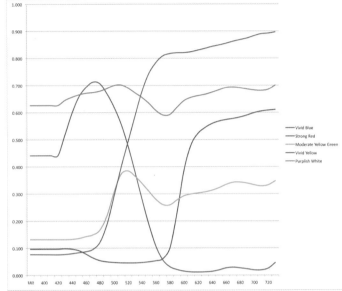

Name	L*	a*	b*	Name	380	390	400	410	420	430	440	450
Vivid Blue	52.7	-39.6	-53.3	Vivid Blue	0.441	0.441	0.441	0.442	0.442	0.519	0.599	0.658
Strong Red	46.4	57.1	21.8	Strong Red	0.097	0.097	0.097	0.097	0.097	0.098	0.096	0.091
Moderate Yellow	62.0	-11.4	26.3	Moderate Yellow	0.132	0.132	0.132	0.132	0.131	0.132	0.133	0.136
Vivid Yellow	86.3	4.5	79.5	Vivid Yellow	0.077	0.077	0.076	0.076	0.076	0.077	0.080	0.084
Purplish White	84.2	-0.6	-1.9	Purplish White	0.626	0.626	0.626	0.626	0.626	0.645	0.657	0.665

FIGURE 10.13 Spreadsheet and graph of spectral reflectance data of the spot measurements of five products from Figure 10.12 made in Microsoft Excel. The measurement data at the top only shows part of the spectral reflectance data. Not shown are the reflectance measurements from 460–730 nm.
Credit: Illustration by the author

output, you can save the measurements to a file, as in Figure 10.12. You can then take those measurements for evaluation and comparison in an application like Microsoft Excel, which is where I made the graph of the spectral reflectance measurements of five objects made with the ColorMunki and the ColorPicker software (Figure 10.13). It's good geeky fun!

X-Rite i1 Share

Eye-One Share is an older free X-Rite (GretagMacbeth) application that is used with the i1Pro (not the i1Pro 2) spectrophotometer to measure

and compare spot colors and light sources. The software has three sections: **Create**, **Evaluate**, and **Transform**.

- The **Create** section allows you to compare and utilize measured colors in producing color palates for creative designs, similar to parts of ColorMunki ColorPicker.
- The **Evaluate** section gives you the ability to measure and calculate the difference in color among different objects and light sources, as with the Accuracy module in Figure 14, which shows spot measurements of two different sections of a piece of fabric. The color difference or delta E (dE), in this case, is

FIGURE 10.14 Evaluate Accuracy section of X-Rite/GretagMacbeth's Eye-One Share, showing the difference between two spot measurements of orange objects made with the i1Pro spectrophotometer. The delta E of 4.7 is large enough to be noticeable.

FIGURE 10.15 Evaluate Accuracy section of X-Rite/GretagMacbeth's Eye-One Share, showing measurement of a photographic stobe/flash light source made with the i1Pro spectrophotometer. The color temperature recorded is 5815 Kelvin, which is noticeably higher and cooler than 5500K, standard color temperature for strobes.

measured to be 4.7. This is high. Typically we can see any dE higher than 3.

- The **Transform** section of Eye-One Share allows you to see what would happen to these measured colors, if they were transformed by profile conversions or by different light sources. Figure 10.16 shows how the orange color will be reproduced in the GRACol coated CMYK space and what combination of CMYK values would be used. Figure 10.17 shows how six different measured colors would look under four different light sources. We see more of a difference in colorants that are affected more by metameric failure, like the orange and yellow on the left.

The other useful part of the **Evaluate** section of Eye-One Share for us as photographers is the ability to evaluate light sources for intensity and color temperature. Especially unique is its ability to turn the i1Pro into a color temperature meter for flash or strobe light sources, as shown in Figure 10.15. The strobe in this case has a color temperature of 5815 K, which is slightly higher than 5500 K, the standard color temperature for photographic daylight light sources. Photographs under this light would result in slightly bluish images. You can use this part of the **Evaluate** tool to check your strobes for accuracy and consistency in color temperature and intensity.

FIGURE 10.16 Convert Spot function of Transform section of X-Rite (GretagMacbeth) Eye-One Share, showing the change in color of the measured orange object, if you converted the color to a chosen profile, GRACol coated CMYK in this case.

FIGURE 10.17 Lightbox function of Transform section of X-Rite (GretagMacbeth) Eye-One Share, showing the change in color of six measured objects would look under four different light conditions: two daylights (D50, D65), tungsten (A), and fluorescent (F2).

X-Rite i1Profiler

As we saw in Chapter 4, X-Rite i1Profiler contains tools to help us evaluate the quality of displays and projectors, and their corresponding calibrations and ICC profiles. As shown in Figure 10.18, i1Profiler also has tools to help us evaluate the quality and accuracy of our printer/paper combinations and their ICC profiles. The specific modules we will cover are: **ColorChecker Proof**, **Measure Chart**, and **Data Analysis**.

- The .**ColorChecker Proof** module shown in Figure 10.19 is the first method offered by i1Profiler to help us examine print quality. This is a very straightforward visual method of analysis. First, if you have i1Profiler, it should have come with a ColorChecker Proof target, which is basically a version of the X-Rite ColorChecker with holes in the center, as you can see in

Figure 10.20. After printing an image of the ColorChecker from the ColorChecker Proof module using your custom printer/paper profile on the same printer and paper, hold the ColorChecker Proof target over the printed ColorChecker, and evaluate the difference in color reproduction and neutrality. That's it! I said it was straightforward. In some ways, if you're already printing the ColorChecker as part of your test page, this is only slightly more valuable, since you get that direct comparison.

- The **Measure Chart** module allows you to define and measure a set of colors, or one or two spot colors for comparison and analysis. (This is our way to get spot measurements with the i1Pro 2 spectrophotometer.) For example, you have seen how to get a visual analysis of a printout of the ColorChecker with your printer/paper/profile combination, now let's look at how you can make a more objective comparison. First you start by defining a 4 x 6- (24-) patch chart to take the measurement

Older Software and Hardware and the Mac OS

As I mentioned above, Eye-One Share, while it is useful, is also OLD. This can be said of other color management and imaging software and hardware as well. The problem for older software on the Apple Macintosh Operating System is that since the release of OS 10.7 (Lion) legacy software built for the PowerPC platform no longer runs. The software must be either Universal or built for the Intel platform. You can check any applications or utilities to see if they are current, by clicking on it and going to **File > Get Info** from the menu Finder menu bar (or hit Command-I). Once in the Info window check the "Kind" field.

FIGURE 10.19 ColorChecker Proof module in X-Rite i1Profiler, which is used to visually evaluate the quality of printer against the colors of the X-Rite ColorChecker.

FIGURE 10.18 Home window of X-Rite i1Profiler software. The modules of i1Profiler's Advanced User Mode that evaluate display, projector, and output quality are circled.

FIGURE 10.20 Lavonne Hall evaluating a printout of the X-Rite ColorChecker from i1Profiler's ColorChecker Proof module with the ColorChecker Proof target.
Credit: Photograph by the author

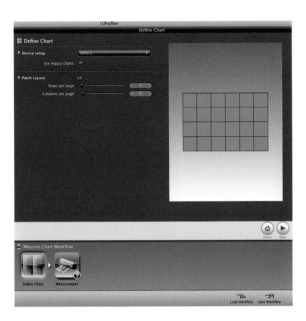

FIGURE 10.21 Defining 6x4 target in the Measure Chart module in X-Rite i1Profiler for measuring the colors of the X-Rite ColorChecker in test prints.

FIGURE 10.22 Fadi Asmar taking spot measurements of the printed colors of X-Rite ColorChecker with the i1Pro 2 spectrophotometer into the Measure Chart module in X-Rite i1Profiler.
Credit: Photograph, © Marko Kovacevic (markokovacevic.net)

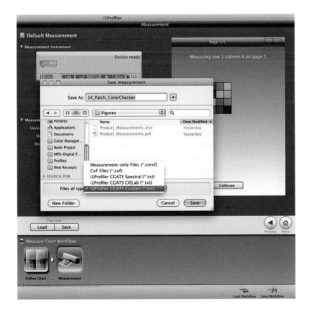

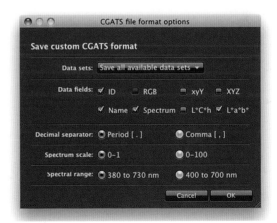

FIGURE 10.23 *(left)* Format options for saving measurement data in the Measure Chart module in X-Rite i1Profiler, which can include CIE-LAB or full spectral data.

FIGURE 10.24 *(above)* Evaluating a printout of the X-Rite ColorChecker from i1Profiler's ColorChecker Proof module with the ColorChecker Proof target.

values of the X-Rite ColorChecker, as shown in Figure 10.21. Then you measure the patches from an actual ColorChecker and, separately, our prints of the ColorChecker colors, as shown in Figure 10.22. The last step of measuring our charts is saving the data, as shown in Figures 10.23 and 10.24. Notice that when saving the measurements you have lots of options for the format and the spectral and colorimetric information you can include. One of the terms here you might not have seen before is *CGATS*. CGATS stands for Committee for Graphic Arts Technologies Standards, which is the standards organization that came up with how this type of measurement data should be organized, so it can be recognized by other applications.

- Now that we have measured the color patches we can use the **Data Analysis** module to compare the original X-Rite ColorChecker with how these colors have been reproduced. The **Data Analysis** module allows you to compare any two sets of data, including **Output Profiles**, as long as they have the same number of measurements and type spectral and colorimetric information. To do this you simply bring each set of measurements into the A and B portions of the **Data Analysis** module, which results in the **Comparison** window shown in Figure 10.25. This analysis shows a high average delta E or color difference and shows the colors with the largest difference. In looking at the data we can see the main problem with the reproduction on this printer and paper combination is that the results are darker than the original. We can confirm this by the numbers, since the value for L (Lightness) is low for almost all 24 colors.

PANTONE Color Manager

i1Profiler comes bundled with Pantone Color Manager, which has some of the functionality of ColorMunki's ColorPicker software. Specifically, PANTONE Color Manager contains virtual versions of the full library of existing Pantone Fan Decks of inks and colors on papers, as you can see in Figure 10.26. It also allows you to create a custom virtual fan deck based on the colors from an image, with the closest Pantone colors it can find, as you can see in Figure 10.27. PANTONE Color

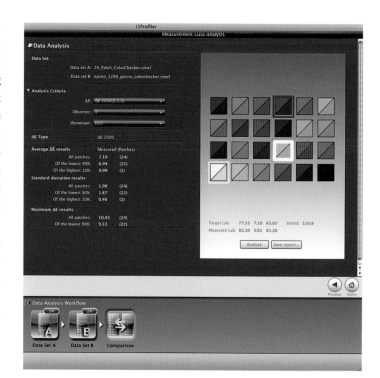

FIGURE 10.25 Calculating the difference between measurements of an original X-Rite ColorChecker and a reproduction of a ColorChecker within the Comparison window in Data Analysis module of i1Profiler.

Manager can then take any ICC profile and show how that Pantone color will be changed when it is reproduced on the selected profile's printer/paper combination. The software will also tell you if the Pantone colors are out of gamut for either the output or your display. Finally, the colors selected can then be exported for use in the Adobe Creative Cloud or other applications.

X-Rite ColorPort

As I mentioned earlier in this chapter, as measurement devices get older, it is possible that they will not be supported in newer software packages, which work on newer operating systems. Or, it's possible a

FIGURE 10.26 Selecting a virtual version from the choices of a standard Pantone Fan Deck from the menu bar in PANTONE Color Manager.

new measurement device will be released that isn't supported on older software. For both reasons, X-Rite created ColorPort, a standalone application that allows you to create, print, and measure output profiling patches (with the old or very new spectrophotometers), and save those measurements for profile building in other applications, like i1Profiler. But, that's not why I mention it in this chapter. The reasons I mention ColorPort are because you can, also, use (or the better word might be kludge) it to make spot measurements for analysis of objects and print quality, if you don't have ColorMunki or i1Profiler. To do this, you first create a custom Patch Set in the **Create Target** tab. The patch set could be made up of 24 patches, if you are measuring colors from X-Rite ColorCheckers, or fewer, as in the example in Figure 10.28. Once the patches are measured, you can then save the data using the options in Figure 10.29. The acronym in this window you might not have seen before is *XRGA*, which is a color measurement standard create by X-Rite for the graphic arts

industry, thus the initials. This standard is supposed to make measurements from different devices more comparable. You can then take the measurements into Microsoft Excel, i1Profiler, or CHROMIX ColorThink Pro for analysis.

CHROMIX ColorThink Pro

ColorThink, an application created by Steve Upton, does many things, but for this discussion it is, especially, a helpful profile, workflow, and measurement quality analysis tool. It has many similarities to the Apple ColorSync Utility, including that it allows you to examine and edit internal ICC profile tags and it has a gamut viewer, but ColorThink does a better job at all of these functions, in both Mac OS and Windows.

ColorThink lets you analyze the overall workflow of an image from start to finish and what happens to the color along the way using

FIGURE 10.27 Creating a custom Pantone Fan Deck based on a set of test page images in PANTONE Color Manager, which is showing the original Pantone color on the left and the color as it would look printed onto the printer and paper combination described in the output profile selected, Epson 3880 with Ilford Gold Fiber Silk paper in this case. The software also gives more information on how to reproduce each color online or on print when it is selected.
Credit: Test page on the right with photographs by the author, Barbara Broder, Jungmin Kim, Brittany Reyna, Christopher Sellas, and Adam Wolpinsky

its Color WorkSheet and 2D and 3D Graphers, as you can see in the example in Figures 10.30, 10.31, and 10.32. In the example the test page is starting in ProPhotoRGB and being converted for output on the Epson 3880 with Hahnemühle Photo Rag Baryta paper. The Color WorkSheet in Figure 10.30 shows three versions of the image from left to right: original, soft proofed through the profile and rendering intent, and a delta E version showing where there are more (red) or less (green) differences from the original. At the bottom are the measurements and calculations from selected parts of the image (show with crosshairs), including the ColorChecker. From this we can see the blue, green, and red selected from the spectrum gradient give most of the problem, which is not surprising. ColorThink's Grapher can then show us the gamuts of the Epson 3880 with the Hahnemühle PRB paper, a LaCie LCD display, and the selected colors from the test page in 2D (Figure 10.31) and 3D (Figure 10.32) with great flexibility in rendering the style. Notice that, although we can see in 2D that the blue from the spectrum gradient is out of gamut for both the printer/paper combination and the LCD display, it looks like green and

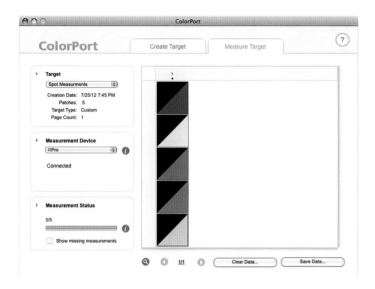

FIGURE 10.28 Using X-Rite ColorPort to make spot measurements using i1Pro. It can also be used for making measurements with many older X-Rite and Gretag Macbeth spectrophotometers including the Pulse (DTP 20) and the SpectroScan.

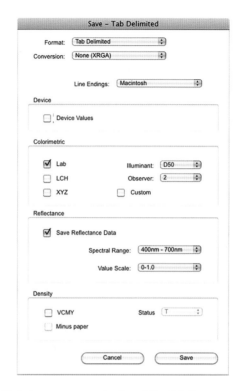

FIGURE 10.29 Saving measurement data from X-Rite ColorPort.

red are in gamut for the display. But when we explore the 3D viewer we can see that the red and green are both out of gamut for the display as well.

In addition to this, ColorThink let us examine measurement data, as we can in X-Rite i1Profiler, which you can see in Figures 10.33 and 10.34. On the left in the Color WorkSheet are the colors from the original X-Rite Color Checker. To the right of this are the colors from the ColorChecker as they were reproduced on a printer/ paper combination and measured with an i1Pro 2 spectrophotometer. As before, the delta-E view shows us where the differences are less or greater. This time we graphed the change in Lab values. Figure 10.34 shows the 2D version of this graph. Where the lines are longer, there is more of a difference in color (hue and chroma). We would need to be looking at the 3D view to see the changes in Lightness.

Besides being useful for analysis, using gamut viewers, like the one in ColorThink, are helpful in getting us to better understand the three-dimensional nature of color and the gamuts of different devices and processes. We will continue to use gamut viewers also as we start to troubleshoot problems with our workflow and profiles.

FIGURE 10.30 *(left)*
Color WorkSheet window in CHROMIX ColorThinkPro examining a workflow that takes the test page in Pro PhotoRGB to output on the Epson 3880 and Hahnemuhle Photo Rag Baryta paper. There are three versions of the image from left to right: original, soft proofed through the profile and rendering intent, and a delta E version showing where there are more (red) or less (green) differences from the original. At the bottom are the measurements and calculations from selected parts of the image (show with crosshairs), including the ColorChecker.
Credit: Test page designed by author with photographs by Tom Ashe, Barbara Broder, Jungmin Kim, Brittany Reyna, Christopher Sellas, and Adam Wolpinsky

FIGURE 10.31
(bottom left) Grapher window in CHROMIX ColorThinkPro showing a 2D view of the gamuts of a LaCie LCD display and output from Epson 3880 on Hahnemuhle Photo Rag Baryta paper, including the sampled colors from the image in Figure 10.30.

FIGURE 10.32
(bottom right) Grapher window in CHROMIX ColorThinkPro showing a 3D view of the gamuts of the same devices and colors as in the 2D view in Figure 10.31.

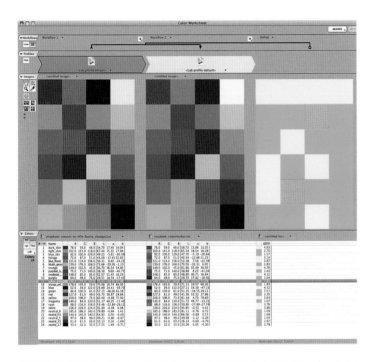

FIGURE 10.33 Color Worksheet window in CHROMIX ColorThinkPro showing a comparision of original X-Rite Color Checker on the left with the reproduced colors in the center. On the right we can see which colors are more (in green) and less (in yellow, orange, and red) accurate.

FIGURE 10.34 Grapher window in CHROMIX ColorThinkPro showing a 2D view of vectors illustrating the same shift from the orignial colors to the reproduced colors of the X-Rite ColorChecker as in the Color Worksheet in Figure 10.33.

Troubleshooting

Sometimes it feels like the more technology we have in our lives, the more problems that need to be solved. This can be painfully true. With the addition of more and more components to make our lives more convenient, the more complex the system of interconnected and interdependent components becomes. As you add different computers, operating systems, software applications, displays, printers, papers, ICC profiling software, measurement devices, drivers, and service providers to improve quality and efficiency, the possible sources of problems in producing your final output increase. Having a troubleshooting strategy to solve these problems can help. The steps of any troubleshooting strategy should include:

1. Identify the symptom.
2. Start with the basics.
3. Investigate.
4. Understand process and workflow components.

5. Isolate and test the components.
6. Duplicate the symptom(s).
7. Determine a solution.
8. Verify the solution.

After reviewing these steps, we will discuss some examples of symptoms encountered, troubleshooting techniques used, and the solutions found.

Identify the Symptom(s)

The first thing to do is identify the symptom being experienced. The degree of problems could include: complete system failure (the printer is not printing), a defective system (print is coming out with banding), or a non-optimized system (my prints are slightly dark). The first two levels are easy to identify and result in highly motivated troubleshooting. If the printer's not printing, or if it's producing banding, everything stops. The non-optimized system takes more observation, analysis, and experience to deal with. When a doctor is trying to diagnose a patient's illness, she uses measurements, like body temperature and blood pressure, to quantify the symptoms. Similarly, you can use color measurement tools we've discussed in this chapter: spot measurements with spectrophotometers and analysis with software packages, like i1Profiler, ColorMunki ColorPicker, and ColorThink, can help to confirm and quantify the problem or symptoms.

As an example, a few years ago I was testing the digital C-print output from different photography labs around the United States for an article I was writing. Of course, included on the test page I had the labs print were the colors from the X-Rite ColorChecker (see Chapter 3). I then made spot measurements of certain patches of the ColorChecker using a spectrophotometer. Figures 10.35 and 10.36 are plots and graphs made based on those measurements of X-Rite ColorChecker colors.

Figures 10.35 shows plots of the a* and b* (part of CIE-LAB) measurements of the same light gray patch. If a print was perfectly neutral, the light gray patch measurement would have been a*= 0 and b* = 0. The further from this point the less neutrality or more of a

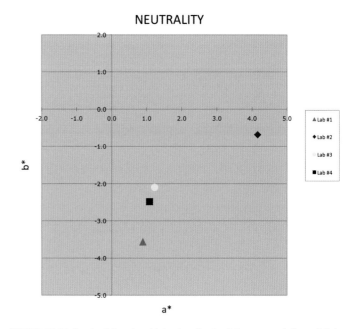

FIGURE 10.35 Graph of the a* and b* values for the light gray patch from digital c-prints from four different labs. Perfect neutral would have a result in values of a*= 0 and b*= 0. None of the prints are perfectly neutral. Graphing this allows us to understand the severity of the problem better.
Credit: Illustration by the author

cast the print has. Therefore the data and plot confirm a bluish cast in the print from Lab #1 (since a* = 1 and b* = –3.6) and a magenta/red cast on the print from Lab #2 (since a* = 4.2 and b* = –0.7).

Figure 10.36 shows plots and graphs of the a* and b* (of CIE-LAB) measurements of the (in clockwise order from the top in the graph) yellow, orange, red, magenta, blue, cyan, green, and yellow-green patches from the X-Rite ColorChecker. If a print reproduced the gamut, hues, and saturations of the ColorChecker perfectly, they would have lined up with the plots of the original X-Rite ColorChecker. All of the labs reproduced the colors with a smaller range of colors (gamut) than the original color checker colors in the file, especially Labs #1

PRINT GAMUT

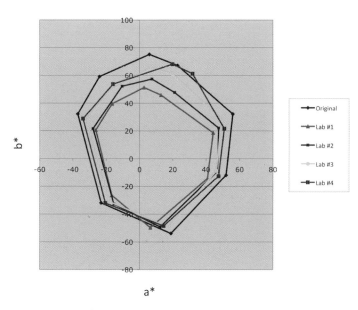

FIGURE 10.36 Graph of the a* and b* values for the blue, cyan, green, yellow-green, yellow, orange, red, and magenta patches of the X-Rite ColorChecker from digital c-prints from four different labs, which gives an idea of gamut for each print and how the colors are being reproduced. The graph shows that Lab #1 has an especially small gamut compared with the original and the prints from the other labs.
Credit: Illustration by the author

and #2. We can tell this, since their graph is the smallest. The print from Lab #4 has more saturation than the prints from Labs #1 or #2. The data also confirms a hue shift towards red for yellow and orange colors on the prints from Lab #4, since the measurements for both colors are far to the right (towards red) from the original yellow and orange on the color checker.

By taking measurements we have been able to identify problems for some of the labs, especially #1 and #2. Of course, one of the things we will want to further explore in identifying any symptom is whether it is a consistent or intermittent problem. Repeated measurements and observations will be needed to determine this.

Start with the Basics

Once the symptom(s) has been identified (the printer is not printing), the next step is to ask some basic questions about the possible sources of the problem. Is the printer plugged in? Is the printer turned on? Is the printer connected to the computer? It may seem obvious, but sometimes if we are anticipating more complicated solutions, we waste time by not verifying the most basic possible sources of the problem. Since much of troubleshooting is a trial-and-error method of narrowing down the list of possible sources of the problem, it makes sense to start with the basics.

Investigate

Research possible sources of the symptom and solutions to the problem using internet-based and other resources, including manufacturer support pages, PDF manuals, frequently asked questions (FAQs), and user forums. Using the community knowledge of the Web can help you to find a solution much more quickly. Sometimes to simply type the problem into a search engine such as Google can be the best way to find an answer. (That's why they call it a search engine.) It is surprising how often this will result in a quicker solution than wading through other sources.

Understand Process and Workflow Components

After we've looked at the basics and before we start narrowing down the list of possible causes of the symptom(s), we will need to first determine this list of possible causes. For us, building this list depends on understanding the component or variables within our process and workflow. By understanding the steps and factors involved in our workflow, we will be more capable of pinpointing where different problems could be introduced. If we're talking about printing problems, the list of factors could include, but are not limited to, the following:

I. Computer

II. Operating System

III. Application (Photoshop or Lightroom)

 A. Color Settings

 B. Print Color Settings

IV. Color Space Conversion

 A. Profiles

 1. Source

 2. Destination

 3. Version of ICC Profiles 2 or 4

 4. Display

 a. White Point of Display

 b. Luminance (cd/m2)

 c. Illuminance (lux) of Surround Light

 d. Color Temperature of Surround Light

 B. Rendering Intent

 C. Black Point Compensation

 D. System Level Color Management (ColorSync or ICM)

 E. CMM or Color Engine

V. Printer Driver or RIP

 A. Version

 B. Settings

 1. Ink Limiting or Media Type

 2. Linearization (for RIPs)

 3. Resolution (DPI)

 4. Printing Mode (Color, Black Only, Advanced Black, and White)

 5. Color Management On or Off

 6. Paper Thickness

 7. Platen Gap

VI. Printer

 A. Power

 B. Firmware

 C. Connection to Computer

 1. Cable

 2. Connection Sites

 E. Heads

 1. Alignment

 2. Age

 3. Nozzles (clogged or clean)

 G. Ink

 1. Manufacturer

 2. Technology

 3. Type of Black

 4. Levels (Are you out of ink?)

VII. Paper

 A. Manufacturer

 B. Surface

 C. Print Side (Front or Back)

 D. Thickness and Weight

 E. Curl

 F. UV Brighteners

VIII. Environment

 A. Temperature

 B. Humidity

 C. Pollutants

 D. Altitude/Air Pressure

 E. Lighting for Print Viewing

 1. Level of Illuminance (lux)

 2. Color Temperature

This isn't a short list of possible factors that could affect print quality or printer functionality, but as long as we keep things consistent as much as possible, we minimize the places where problems can be introduced and streamline the troubleshooting process.

Isolate and Test the Components

Once we know the factors to look at, we can start narrowing down the list of possible components or variables that are producing the symptom(s). By isolating components and then testing them on systems we know are working, we are able to quickly determine if the component is part of the problem. As an example, we are hitting **Print** from the print driver and nothing is happening on the printer. Earlier we made

sure the printer was plugged in, turned on, and connected by a USB cable. The three main components are the computer, the printer, and the USB cable. If we want to determine if the problem is originating from the cable, we could isolate the cable by either taking the cable and using it with a computer and printer we know are working, or replace it with a cable we know is working.

Duplicate the Symptom(s)

As part of isolating and testing components of the workflow in trying to determine the source of the problem, you need to be able to duplicate the symptom in a controlled situation. This can help narrow down the culprit component more quickly. In the example above, if we attach the USB cable to a computer and printer we know are working, and the same symptom (printer not responding) occurs, the evidence points more clearly to the USB cable as the source of the

problem. As another example, we printed a copy of our test page on an Epson 3880 with Moab Entrada Rag paper. The result was dark and desaturated. We have the custom ICC profile for the printer and paper. While troubleshooting the problem, we soft proofed the test page in Photoshop with the custom profile and clicked on the Preserve RGB Numbers (Figure 10.37), which resulted in the same symptoms or defects the print displayed (Figure 10.38). This duplication of the symptoms points to the possibility that the image was never converted to the printer paper profile. The ProPhotoRGB values were most probably sent directly to the printer.

Determine a Solution

Based on the evidence from isolating, testing, and narrowing down the components, find a likely solution to the problem. In the example about the printer not responding, the likely solution will be to replace

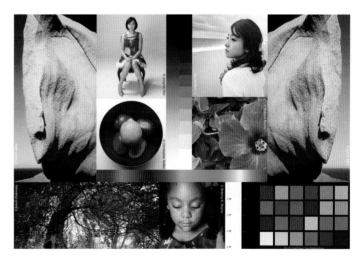

FIGURE 10.37 Customize Proof Conditions window in Adobe Photoshop with a custom output profile selected and the Preserve RGB Numbers box checked. This results in the image in Figure 10.38, which duplicates the problems seen in a print.

FIGURE 10.38 Image that resulted from the soft proof conditions in Figure 10.37, which duplicates the problems seen (dark tone and desaturation) in an earlier print. This duplication of the problem points to the fact that the image was not converted to the custom output profile.
Credit: Test page designed by author with photographs by Tom Ashe, Barbara Broder, Jungmin Kim, Brittany Reyna, Christopher Sellas, and Adam Wolpinsky

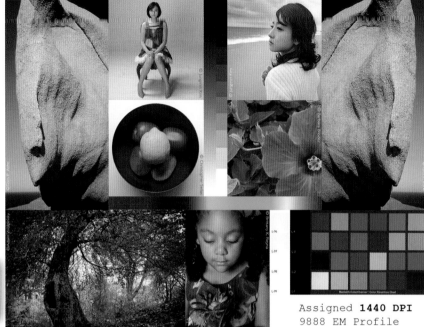

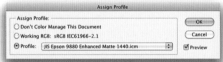

Assigned **1440 DPI**
9888 EM Profile

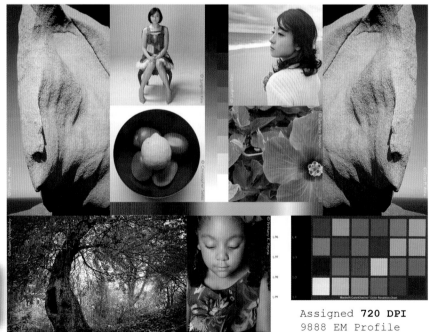

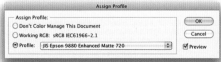

Assigned **720 DPI**
9888 EM Profile

the USB cable. In the second example, where it looks like the image was never converted to the printer paper profile, the solution would be for us to verify the print settings and make sure the custom profile has been selected.

Verify the Solution

Implement the solution and test to make sure that it has alleviated the original symptoms (now the printer is printing or the color and tone of the prints from the lab are closer to the original file). If the solution has not worked, go back to step two and continue to narrow down the components causing the problems.

Troubleshooting Examples

Now let's look at four more examples of printing problems, including the symptoms encountered, troubleshooting techniques used, and the solutions found.

Troubleshooting Example #1

Two ICC profiles were built for the same printer (Epson 9880) and the same paper (Epson Enhanced Matte) combination, but for two different printer resolutions (720 and 1440 DPI). The resulting prints from these two profiles were different. The 1440 print was accurate, but the print from the 720 DPI profile resulted in a print with a cyan cast. What was causing the difference? The possible cuprits, that could be causing the cyan cast, included: the profile, the printer, print and printer driver settings, normal printer variability. Since the testing of the second and third possibility would involve making one or many prints (and I'm cheap), the investigation started with the first

possibility: to see if there was a noticeable difference between the two profiles. Initial soft proofing comparison in Photoshop showed very little difference between the two profiles, and did not show the cyan cast from the 720 DPI print. But when we used the **Assign Profile** function (same as **Preserve RGB Numbers** in the soft proof window) to compare the two profiles, the resulting images (Figures 10.39 and 10.40), while not looking at all like either one of the resulting prints, *did show a difference*. The 720 DPI image showed a slight increase in red compared with the 1440 image. When converting the image using the 720 DPI profile, compensation was made for this expected red with additional cyan. Why was the profile expecting more red from the 720 DPI setting? Further investigation found slight banding in the printer profiling patches for the 720 DPI setting. There had been a clog in one or some of the light cyan or cyan print head nozzles. The solution was to print and measure a new set of patches at the 720 DPI settings. The main lesson in this troubleshooting example is to *accentuate the differences* when trying to compare two things that should be acting similarly, but aren't.

Troubleshooting Example #2

A print is made from a very saturated pink portrait results in posterization in the subject's nose, cheek, and lips. Other images made with the same profile look good and don't show any posterization. Soft proofing the original image (left in Figure 10.41) with the profile used duplicated the problem when selecting **Perceptual rendering** (center in Figure 10.41), which had been used when printing. Soft proofing also showed less posterization with a rendering intent of **Relative Colorimetric** (right in Figure 10.41). The obvious solution was to change the rendering intent when printing to **Relative Colorimetric**. Remember there can be image-specific reasons for changing the rendering intent,

FIGURE 10.39 *(top left)* Assigning a printer paper profile at 1440 DPI to the test page in Adobe Photoshop to accentuate the difference with printer paper profile at 720 DPI in Figure 10.40.
Credit: Test page designed by author with photographs by Tom Ashe, Barbara Broder, Jungmin Kim, Brittany Reyna, Christopher Sellas, and Adam Wolpinsky

FIGURE 10.40 *(left)* Assigning a printer paper profile at 720 DPI to the test page in Adobe Photoshop to accentuate the difference with printer paper profile at 1440 DPI in Figure 10.39, this difference helped explain that there was a cyan cast on the resulting print as a result of a problem in the building of this profile
Credit: Test page designed by author with photographs by Tom Ashe, Barbara Broder, Jungmin Kim, Brittany Reyna, Christopher Sellas, and Adam Wolpinsky

FIGURE 10.41 An original image on the left. Center version shows posterization in lips, nose, and cheek, when printed using Perceptual rendering. The problem was solved on the right by using Relative Colorimetric rendering.
Credit: Photograph, © Felix Kim

and *soft proofing* can be a great way for you to determine the optimal rendering intent for an image.

Troubleshooting Example #3

Prints made onto a certain paper are producing a strange lightening and posterization in the darkest grays and blacks. As with the other examples, one of our easiest options is to first look more closely at the profile we are using, which in this case was a generic profile from Hahnemühle. Standard soft proofing of the image in Photoshop showed a slight problem in the shadows, but not too much. The problem in the profile was further accentuated by selecting the **Relative Colori-metric** rendering intent and unchecking the **Black Point Compensation** check box (Figure 10.44). An original section of a test page is in Figure 10.42. In Figure 10.43 is the same section of the test page as it looked with soft proofing the image in Photoshop using the **Proof Setup** settings, and in Figure 10.44 with **Relative Colorimetric Rendering Intent** and the **Black Point Compensation** box unchecked. The

FIGURE 10.42 *(facing page, top left)* Portion of original test page for comparison with Figure 10.43, especially the shadow portion of the grayscale gradation.
Credit: Portion of test page and photographs by the author

FIGURE 10.43 *(facing page, top right)* Portion of original test page soft proofed in Adobe Photoshop using the settings and generic Hahnemühle profile in Figure 10.44, which accentuates a problem with posterization and hue shifts in the shadows.
Credit: Portion of test page and photographs by the author

FIGURE 10.44 *(facing page, bottom left)* Customize Proof Conditions window in Adobe Photoshop for a generic Hahnemühle profile for the Epson r1800 printer and William Turner paper with Relative Colorimetric rendering selected and Black Point Compensation unchecked to accentuate problems with this profile seen in Figure 10.43.

FIGURE 10.45 *(facing page, bottom right)* 2D Gamut of the generic Hahnemühle profile for the Epson r1800 printer and William Turner paper in the Grapher of CHROMIX ColorThink, which confirms the problems with this profile in the shadows with the irregular shape shown at an L* of 22.

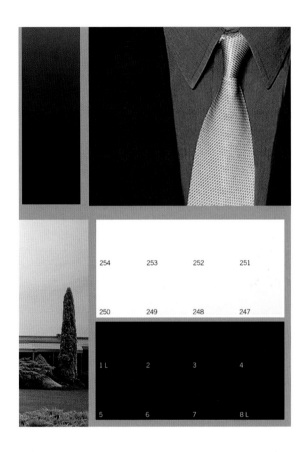

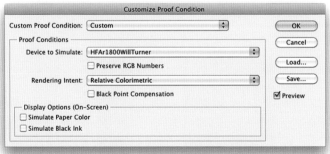

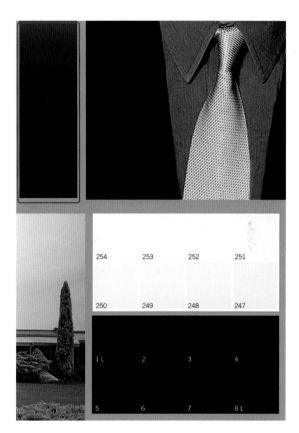

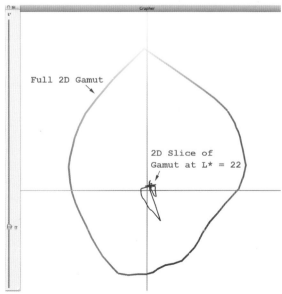

Read Patches

MonacoPROFILER

Import... Average... Export...

Reset...

exp	act	L	a	b
		29.95	40.07	23.59
		36.11	56.76	36.76
		39.77	57.51	40.96
		45.72	70.41	53.21
		20.88	-13.95	-7.37
		15.38	-1.19	-14.47
		27.38	-3.99	5.72
		20.84	6.49	-2.07
		35.08	9.34	21.75
		27.62	19.59	13.04
		28.11	31.11	14.64
		33.55	40.89	23.59
		36.82	43.90	29.84
		42.75	54.81	39.77
		47.33	59.20	47.34
		19.52	-20.17	-9.61

Column 1 Row A < Page 1 of 4 > Zoom In

☑ View Split Patches

accentuated soft proof version of the image in Figure 10.43 shows the severe posterization in the shadow portion of the grayscale gradient and a hue shift in the darkest black. Although it does not look like the print, this gives us strong evidence that there is a problem with this generic printer/paper profile. To further confirm this, the profile was examined in CHROMIX ColorThink. Looking at the shadow portion of the gamut (Figure 10.45) reveals a strange, unsmooth, gamut shape. The solution was to build a custom profile with the same printer and paper. Remember to look at all the parts of the profile, even if you're not using them, and to use gamut viewers to help reveal possible problems with a profile.

Troubleshooting Example #4

Finally, what happened to the cover image and the portion of the test page in Figure 10.46? Both were what was seen when the images where soft proofed in Photoshop with custom profile built with MonacoPROFILER (an older and since discontinued X-Rite profiling software) for the Epson 3800, with Exhibition Fiber paper. These really messed-up images have artifacts, posterization, and large hue and tone shifts. Thankfully no prints had been made. The profile was further examined in CHROMIX ColorThink, revealing the wildly warped gamut in Figure 10.47. So the profile has some serious problems, but why?

FIGURE 10.46 *(facing page top)* Portion of test page as soft proofed in Adobe Photoshop using a messed-up custom output profile for the Epson 3800 and Exhibition Fiber paper. Credit: Portion of test page designed by author with photographs by Tom Ashe, Barbara Broder, Jungmin Kim, and Christopher Sellas

FIGURE 10.47 *(facing page, bottom right)* 2D gamuts of the actual (in black) and the messed-up custom profile for the Epson 3800 printer with Exhibition Fiber paper in the Grapher of CHROMIX ColorThink, which confirms the problems with this profile seen in the soft proofs in Figures 10.1 and 10.46.

FIGURE 10.48 *(facing page, bottom left)* Patch measurement window in Monaco-Profiler Ouptut profiling module, which shows that the expected and measured patches did not match-up and resulted in the problems with this profile seen in the soft proofs in Figures 10.1 and 10.46 and the gamut in Figure 10.47.

What caused this? What lessons can be learned so it doesn't happen again? The patches were produced and measured in the X-Rite ColorPort software using the X-Rite Eye-One iSis XL spectrophotometer. Opening the measurement data in MonacoPROFILER revealed that there was a major disagreement between the expected measurements and the actual measurements (Figure 10.48). This mismatch caused very high delta-E calculations to be reported when the profile was rebuilt from these measurement data: Average delta E = 23, Average delta E_{94} = 15, and an Average delta E CMC = 10. Remember that anything over a delta E of 3.0 should be a point for concern in most cases. Why were the expected and measured values mismatched? It ends up that the target size used for printing the patches (A3) did not match up with the measured target size (Tabloid). The solution was to measure the patches again using the correct page size. The lessons learned are: *don't be complacent* and to *watch the details* as the measurements are being made and when profile-building statistics are being reported. Also, we confirmed once again that *soft proofing can save lots of time and media.*

Conclusion

After this long chapter, you should not be feeling like an expert in all the tools described, but hopefully you have a good idea of what they can do for you in evaluating the quality of your profiles, printers, papers, and workflow. Also, remember not to get too discouraged when going though the troubleshooting process. There is typically a solution to the problem. It may not always be the ideal answer. Sometimes our research and testing uncover the fact that something we want to do, like use a piece of hardware on a new operating system, will not work. It's easy to get frustrated at times, but in the end it is good to have any answer to a problem. The biggest benefit of troubleshooting these problems is that we continue to learn more and more about the components in our workflow.

EXPLORATIONS

Now it's time to use some of the tools and techniques described in this chapter: (1) take some spot measurements of different objects and types prints of your test page on different papers and through generic and custom profiles; (2) evaluate the data from these spot measurements in Excel, i1Profiler, or ColorThink as an objective analysis of neutrality and color reproduction in your output; (3) compare the gamuts of different profiles in the ColorSync Utility or ColorThink; (4) use soft proof to examine your output profiles thoroughly before printing, so you can catch any possible problems; and (5) use the troubleshooting steps listed above to help you in solving any of the inevitable problems you will encounter as you are making and evaluating your prints.

Resources

Automation and Utilities

Scott, Geoff, & Tranberry, Jeffrey *Power, Speed & Automation with Adobe Photoshop, Digital Imaging Masters Series*, Focal Press, London, 2012. ISBN-13: 978–0240–82083–5.

Color Utilities

Apple ColorSync Utility
http://support.apple.com/kb/PH3929

Chromix ColorThink Pro
http://www2.chromix.com/colorthink/

X-Rite ColorMunki ColorPicker
http://blog.xritephoto.com/?p=1990

X-Rite ColorPort 2.0
http://www.xrite.com/product_overview.aspx?ID=719

X-Rite Eye-One Share
http://www.xrite.com/product_overview.aspx?ID=765

Troubleshooting

Apple Computer and Operating System
http://www.apple.com/support/mac101/help/

Windows Help and Support
http://support.microsoft.com/

Adobe Support
http://helpx.adobe.com/support/

X-Rite Photo FAQ
http://www.xritephoto.com/ph_top_support.aspx?action=FAQs

Epson Troubleshooting & FAQs
http://www.epson.com/cgi-bin/Store/support/SupportIndex.jsp

FIGURE 11.1 Image by John Donich, technical editor for this book, is also a photographer and owner of Crossroads Editions, a digital printmaking studio that uses the Serendipity MegaRIP (crossroadseditions.com).

Credit: Photograph, © John M. Donich, The Norman School Teachers Lounge, Kansas City, MO, 2012 (johnmdonich.com)

Eleven

RASTER IMAGE PROCESSORS

The next tool we could possibly be using to color manage our printers and get better quality is a RIP (pronounced "rip," as in to tear something). In this chapter we will discuss what RIPs are, how they are different than drivers, the reasons we would use RIPs, and finally we will review some specific RIPs.

What is a RIP?

RIP is an acronym for "Raster Image Processor." A RIP transforms digital data from files of different formats (TIFF, JPEG, PostScript) and from different applications (Adobe Photoshop, QuarkXPress, MS Word) into commands for your printer to create the print. What does Raster mean? This is a good point to review some vocabulary.

On the most basic level, a printer driver is a RIP, since it processes the rasterized image (bitmap) and tells the printer how to print it. A separate third party, RIPs are most often more advanced than printer drivers that come for free with our printers.

For an inkjet printer, the RIP or driver commands tell the print heads where and when to put ink on the paper, as well as how much of each ink—cyan, magenta, yellow, black, light-cyan, light-magenta, and light-blacks (CMYKcmk)—to use, how large a halftone dot (resolution) should be, and what shape and pattern the halftone dots should have. For a photographic printer, such as the Durst Lambda or Océ Lightjet, the commands tell the light source (Laser, LED, or CRT) where to expose, with how much intensity, and for how long.

A RIP typically takes one of three forms: firmware and a processor on the printer, software on the user's computer, or software and a separate computer to run it. The last two are the types of RIP that users can buy to improve their output, but the improvements come at a cost, anywhere from fifty to thousands of dollars depending on the software, the size of the printer driven, and the complexity of the workflow. RIPs that are specifically designed for the graphic arts industry and meant to drive CtP (Computer-to-Plate) systems are the most expensive. For photographers, the cost of

Bitmap (Raster) and Vector Graphic Files

There are two basic graphic file formats: bitmap and vector. *Bitmap* formats, such as TIFF, are made up of pixels, and give one tonal value to each pixel for black-and-white images or multiple values for each pixel for color images, such as RGB or CMYK. The number of 1s and 0s used to describe each pixel is called the *bit-depth*. Every pixel or space on the file has specific tonal/color value(s). This ends up being an efficient form to use for images, but file sizes can get very large, depending on the resolution of the file. If the original image on the left of Figure 11.2 were to be described as a bitmap, it would be divided up into a certain number of pixels high by a certain number of pixels wide, and each pixel would have different combinations of red, green, and blue code values, which you can see on the right of Figure 11.2.

On the other hand, *vector* formats (such as fonts or logos made in Adobe Illustrator) are a description of shapes and elements on the page. To describe the image in Figure 11.2, a vector file format would say something like, "On an eight-and-a half by eleven-inch page there is a four-inch-square red box (with specific CMYK or RGB values) that starts at one half-inch down from the top, one half-inch from the left side, and a three-inch diameter blue circle starting at six inches down and four inches in." Vector files tend to be much smaller than raster image files, but images like photographs are typically too complex to make into vector files. Finally, let's clarify two related terms you might have heard before.

Rasterization is the process of converting an image from vector form to bitmap. Conversely, *vectorization* is the process of converting a file or image from bitmap to vector.

FIGURE 11.2 Original image with red square and blue circle on left with close-up of the vector version of file in the center, which shows no pixels, and a close-up of the rasterized bitmap version on the right, which shows its pixels.
Credit: Illustration by the author

a fully functional RIP to run a 24-inch-wide printer (like the Epson 7900) would be between $1000 and $1500.

How is a RIP Different from a Driver?

Like a RIP, a driver translates the image or file data into commands telling the printer where to put ink and how much ink to use. The driver generates and controls a halftone pattern that is used, like a RIP; however, a driver is a RIP with limited functionality and control over the printer. Typically, the functionality and control of the driver that comes with a printer is just enough to get reasonably good prints from sRGB images from basic applications. A RIP gives the user more

functionality and control over the printer, and can improve workflow productivity and print quality. That being said, some printer companies continue to make improvements and controls in their drivers, particularly for their high-end printers, which can make RIPs less important to some photographers than they were in the past.

The Main Benefits of and Reasons for Having a RIP

Processing More File Types and Formats

One of the main advantages of many RIPs over most drivers is that they allow the user to print directly and accurately from software, such

as QuarkXPress, Adobe InDesign, and Adobe Illustrator, which have vector file formats that can't be printed as accurately from standard drivers. RIPs will often have two versions, standard/raster and PostScript. The PostScript version will allow users to print to full PostScript specifications from these vector file formats and applications.

Print Quality and Accuracy

One of the main reasons for us to use RIPs is to get improved print quality over the standard driver. The improvement can be in accuracy or by giving a more pleasing rendering. Some RIPs improve print quality by supplying improved printer/paper profiles.

Improved Workflow and Automation

Many RIPs include workflow tools, such as hot folders. *Hot folders* are folders that can be placed on your computer or network. The RIP can then watch these folders. When a file is placed into the hot folder, the files are recognized by the RIP software, then processed and printed automatically without taking time to launch application software like Photoshop. This feature has the potential to process and print images much more quickly and efficiently, therefore increasing productivity.

Proofing, Verification, and Halftone Dot Simulation

Creating an accurate hard-copy proof (as opposed to a soft proof on the display), which simulates how images and pages will look on press, is very important in the graphic arts industry. Before spending tens of thousands or even hundreds of thousands of dollars to create the printing plates and set up the presses, a client first signs off on the color from a contract proof, which today is typically from an inkjet printer.

Some RIPs specialize in allowing users the ability to adjust the output of their inkjet printers to mimic or match printing presses, traditional proofing systems (like Imation MatchPrint, Kodak Approval, DuPont Cromalin), or standard press conditions (like FOGRA, GRACol, SWOP, which we will discuss in Chapter 17). These RIPs use profiles for both the inkjet printer and the printing press to match the color.

Higher-end RIPs also allow you to verify the quality of the inkjet proofing system. Some even let you measure some patches on the proof to confirm and label the output as a "Certified Proof" that meets desired specifications.

A couple of advanced proofing RIPs not only simulate the color from printing presses or proofing systems; they can also simulate the halftone dot that will be produced from the printing press on the inkjet proof. This feature has been difficult to achieve, but highly desired, since the advent of CtP (Computer-to-Plate) and direct-to-press (digital printing press) systems. When it works, it can give us the best idea of how images will look off the printing press, without making an expensive press run.

Package Printing and Optimizing Paper Usage

Some RIPs automatically process images into print packages of different sizes (two 5 x 7-inch prints with four 2 x 3-inch prints, for example). The combinations can be based on product numbers, or how different hot folders have been set up. Similarly, some RIPs will take the files in a hot folder and automatically calculate the optimal way to arrange the images so that the least amount of paper is wasted. The calculation is based on image size and borders requested.

Black-and-White Printing

Some RIPs aimed at photographers can process images through special profiles when printing to inkjet printers to produce improved black-and-white output. Typically, these profiles will allow the printing of all four colors in the shadows, to maintain a larger dynamic range, while reducing the amount of cyan, magenta, and especially yellow ink in the mid-tones and highlights to maintain neutrality.

Yellow ink is specifically reduced because it has been seen to be particularly responsible for the color balance shifts seen under different light sources with inkjet technologies such as Epson's UltraChrome Inks. The profiles used for this purpose are called "gray" profiles. They turn any image (including color images) into grayscale images.

Ink Limiting

As we've discussed before, in print drivers, the Media Type setting controls the amount of ink used to print an image with an inkjet printer. The choices of media type given in a driver are limited to, and optimized for, the specific papers sold by the printer manufacturer.

This choice is important for print quality, because too much ink can cause a loss of detail, bleed-through, or even a pooling of ink. Too little ink can lead to a smaller gamut than is possible on the printer and paper combination. Some RIPs produce better prints, because they give more flexibility by allowing users to fine-tune the total amount of ink and/or the amounts (percentages) of the individual inks. For example, the highest total ink percentage for a CMYK system is 400% (100% for each channel). This percentage could be brought down to 360% or 250%, depending on the media being used.

Calibration and Linearization

Calibrating a printer (or any device) is a process of putting it into an optimal condition that you can maintain over time. For a monitor, this could mean a certain brightness and contrast combination. One form of printer calibration, which RIPs often allow the user to perform, is linearization. *Linearization* is a form of calibration, in which the printer is brought into a linear stat. This means that the printer's output is brought into line (not to make a pun) with its input. In the case of inkjet output, when a file requests a 40% dot, a linearized printer will produce a 40% dot. A non-linearized printer, on the other hand, might produce a 50% or even a 60% dot (as can be seen in the charts in Figure 11.3).

Like profiling, the linearization process begins by printing a series of patches to the printer. The difference between linearization

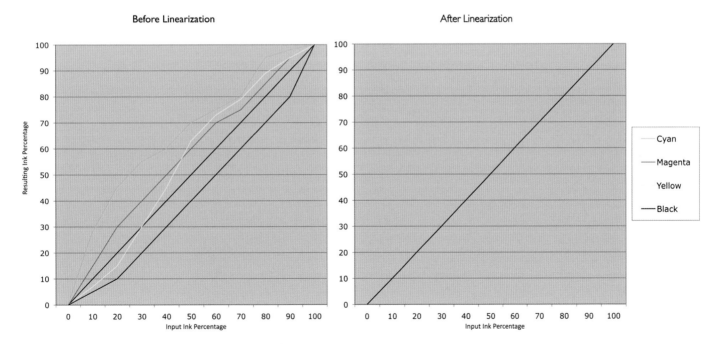

FIGURE 11.3 Chart showing a CMYK printer in an unlinearized state on the left and linearized on the right.
Credit: Illustration by the author

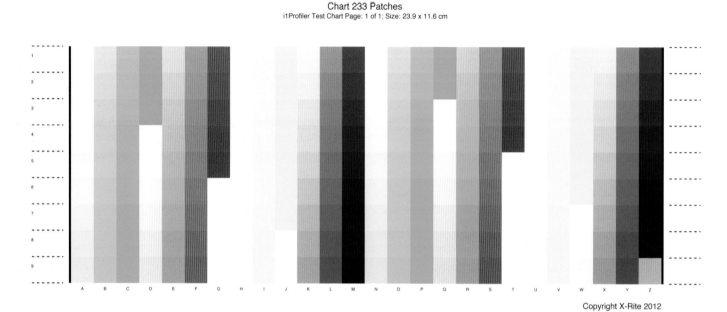

Chart 233 Patches
i1Profiler Test Chart Page: 1 of 1; Size: 23.9 x 11.6 cm

Copyright X-Rite 2012

FIGURE 11.4 Printer linearization target from i1Profiler for measurement with the i1Pro 2 spectrophotometer.

and profiling is that you only need to print around 20 to 160 patches (5 to 40 CMYK patches from 0% to 100%) in equal intervals. The example in Figure 11.4 shows an 80-patch, 20-step linearization chart produced in X-Rite ColorPort (a software program used to create and measure such charts), which would be measured with the X-Rite i1 spectrophotometer (or some other device).

The patches are measured and the data is brought into the RIP software, which makes the adjustments needed to keep the output in a calibrated linear state. Linearization is done before profiling a printer and then at regular intervals after profiling to prevent printer drift. This results in the user not having to update profiles as often, which can save time, effort, and hopefully money.

Bypassing Imaging Software/Printer Driver/Operating System Problems

Besides the workflow benefits of not needing to open an application like Photoshop to make a print, using a RIP allows you to avoid the many printing problems that have come up over the past few years between the software applications, printer drivers, and the operating systems. This is really one of the best reasons to have a RIP. It has saved me a few times.

Ways Color Management Hardware and Software Interact with RIPs

In examining any RIP (such as the ones in the chart in Figure 11.5) and their interactions with color management hardware and software, the following are the most important factors to consider.

Support for Measurement Devices

Does the RIP directly support the spectrophotometer, colorimeters, and densitometers needed to take measurements for linearization and other functions? If a spectrophotometer is not directly supported, it may still be possible to manually input values or import values from a program such as X-Rite ColorPort.

If you're purchasing a spectrophotometer (like the X-Rite i1 Pro) to work with RIP software for linearization or print verification, then you should get one that has an Ultraviolet (UV) cut-off filter. Although the X-Rite i1Profiler software's profile-building software packages can recognize and adjust for the UV brighteners in papers, most RIP software cannot, so the UV cutoff filter is needed in the spectrophotometer.

Support for Custom Profiles

Does the RIP support using custom ICC profiles? Some RIPs only let you use their profiles or settings. In such a case, any custom printer profiles you build, and use in conjunction with the RIP, would need to be applied in (or converted to) an application such as Adobe Photoshop, before any files go to the RIP.

Ability to Turn OFF ICC Profiles

If the RIP supports the use of custom ICC profiles, does it also give the user the ability to turn off ICC profiles when printing the profile-building patches?

Output Color Space(s) RGB/CMYK

What color space(s) does the RIP use for printing? As you know, the standard print drivers for inkjet printers are expecting RGB data coming in, even though they print in CMYK. Since most RIPs give the user more control than the driver, they'll typically print to inkjet printers in CMYK. If a RIP supports both RGB and CMYK, this means it supports both RGB and CMYK devices. Examples of RGB output devices are dye sublimation printers, photographic-like printers (Fuji Pictography), and true photographic printers (such as Fuji Frontier, Durst Lambda, Océ Lightjet).

Linearization Function

Is the RIP able to perform linearizations? If the RIP doesn't have a linearization function, then a high-end third party printer-profiling package like X-Rite i1Profiler could be used.

Ink Limiting Function

Does the RIP allow total ink limiting or individual ink limiting? If the RIP does not allow ink limiting and there's too much or too little ink when printing the profiling patches on an inkjet printer, you can't build a high-quality profile with most profiling software packages.

Comparison of RIPs

Figure 11.5 is a chart of RIPs used for photographic and graphic arts applications. We will take a closer look at the four RIPs highlighted in yellow: ColorBurst RIP X-Proof, ColorByte Software Imageprint, EFI ColorProof XF, and GMG FlexoProof. Other ones you might wish to look at are the Serendipity Software Blackmagic RIP and the Wasatch Computer Technology Soft RIP. Each RIP package has its own benefits and idiosyncrasies that can make it difficult to work with. Some are very powerful, but have counterintuitive interfaces. Others are limited in controls, but are straightforward in design.

RIPS - RASTER IMAGE PROCESSORS

Name of RIP	Company Country of Origin	Main Function / Market	Support Custom Profiles	Able to Turn OFF ICC Profiles	Output Color Space(s) RGB / CMYK	Linearization Function	Ink Limiting Function
Caldera Graphics VisualRIP+ http://www.caldera.com/	France	Signmaking, 64"+ and Grand Fomrat Printing	Yes	Yes	CMYK	Yes	Yes
CGS Publishing Technogies Oris Hybid Proofing Color Tuner / Web http://www.cgs.de	Germany	graphic arts, sign making, photography, fine arts, proofing, digital presses	Yes	Yes	CMYK	Yes	Yes
ColorBurst Systems RIP X-Proof http://www.colorburstrip.com	USA	Fine Art, Photography, Proofing, Prepress	Yes	Yes	CMYK	Yes	Yes
ColorBurst Overdrive http://www.colorburstrip.com	USA	Fine Art, Photography, Proofing, Prepress	Yes	Yes	RGB	No	No
ColorByte Software Imageprint http://www.colorbytesoftware.com	USA	Photography, Fine Arts, Proofing	Yes	Yes	RGB	No	No
ColorGATE Production Server, PhotoGATE http://www.colorgate.com	Germany	Graphics Arts, Proofs and new module for Photography , and Fine Arts	Yes	Yes	CMYK	Yes	Yes
EFI ColorProof XF, EFI Fiery, and EFI eXpress http://www.efi.com	USA / Belgium Germany	digital, commercial and hybrid printers, prepress providers, publishers, creative agencies and photographers	Yes	Yes	CMYK + RGB	Yes	Yes
ErgoSoft StudioPrint, TexPrint, PosterPrint http://www.ergosoftus.com	Switzerland	Fine Art, Digital Photography, Large Format Display Graphics, Dye Sublimation & Digital Textile printing	Yes	Yes	CMYK	Yes	Yes
Global Graphics Harlequin Plus Server RIP http://www.globalgraphics.com	USA	High End Graphic Arts	Yes	Yes	CMYK, N-Color, Gray	Yes	Yes
GMG Color Proof, Dot Proof, Proof Control http://www.gmgcolor.com	Germany	PrePress, Halftone Match Proofing, Media	Yes	Yes	CMYK	Yes	Yes
IPROOF Systems PowerRIP X http://www.iproofsystems.com	USA	PrePress, Design, Photography	Yes	Yes	CMYK	Not Really	No
Onyx Graphics PosterShop http://www.onyxgfx.com	USA	Prepress, Fine Art, Photography	Yes	Yes	CMYK	Yes	Yes
Onyx Graphics ProductionHouse http://www.onyxgfx.com	USA	Signmaking, Grand Fomrat Printing, Prepress, Fine Art, Photography	Yes	Yes	CMYK + RGB	Yes	Yes
Onyx Graphics RIP Center http://www.onyxgfx.com	USA	Prepress, Fine Art, Photography	Yes	Yes	CMYK	No	No
ProofMaster Plus and Certify http://www.proofmaster.net	Netherlands & Belgium	PrePress, Design, Photography	Yes	Yes	CMYK	Yes	Yes
QuadtoneRIP http://www.quadtonerip.com	USA	Photography, Black-and-White on Inkjet	Yes	Yes	RGB, Gray	No	No
Serendipity Software Blackmagic RIP (MegaRIP Lighter Version) http://www.serendipity-software.com.au	Australia	PrePress, Design, Photography	Yes	Yes	CMYK + RGB	Yes	Yes
Wasatch Computer Technology SoftRIP http://www.wasatchinc.com	USA	Wide-format digital `printing, screen separations, textile, photographic, giclee	Yes	Yes	CMYK + RGB	Yes	Yes

FIGURE 11.5 Comparison chart of RIP hardware/software packages.
Credit: Chart by the author

ColorBurst RIP X-Proof

ColorBurst X-Proof is a software-based CMYK RIP. There is no separate computer used when printing from ColorBurst X-Proof. You can either print from applications like Photoshop or InDesign, or you can print by simply dragging and dropping an image file onto the ColorBurst RIP Queue. ColorBurst will then print the file using the *Environment* settings selected for the printer/paper/resolution combination, as seen in Figure 11.6. The **Environment** in the ColorBurst X-Proof RIP is a combination of both calibration and profile. On the calibration side, the **Environment** keeps track of the optimal settings for the printer and paper, including: the ink limits and linearization. The **Environment** also automatically selects the corresponding ICC profile for the printer and paper that had been built with the calibrated setting (ink limits and linearization), as you can see in Figure 11.7.

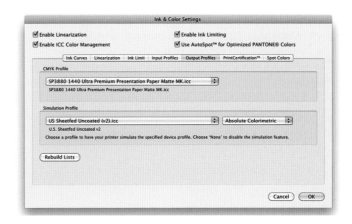

FIGURE 11.7 Ink & Color Settings window in ColorBurst X-Proof RIP, showing Ouput Profile section with CMYK profile for the printer/paper/resolution combination and printing press condition profile (SWOP Coated) for creating a hard proof simulation.

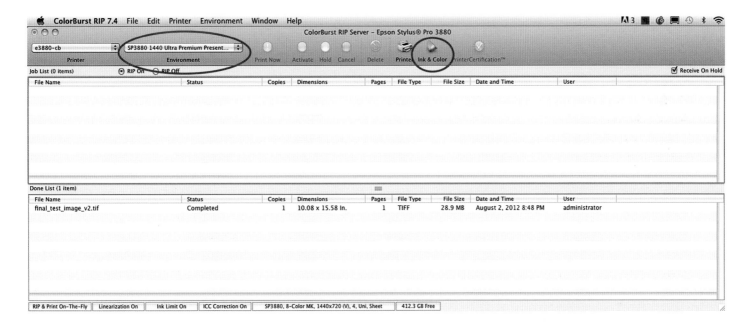

FIGURE 11.6 ColorBurst X-Proof RIP interface with selected Environment and Ink & Color button circled.

Paper Manufacturer Profiles and the RIP

You should not use generic profiles from the paper manufacturer profiles in the ColorBurst RIP (or any RIP for that matter)! This is because the paper manufacturer's generic profiles are based on printing from the printer manufacturer's driver (not the RIP). Also, remember we use RGB ICC profiles when printing with the printer driver, but we use CMYK ICC profiles when printing with the ColorBurst RIP. It is also worth noting that, for the same reason, you should not use the ColorBurst (or any other RIP's) profiles when printing to the printer driver. In general, both incorrect combinations will give you very inaccurate (and, in some cases, funky) results.

If there is no **Environment** found for your printer and paper combination, you need to download and install both the **Environment** and **ICC Profile** from ColorBurst's website, *not*, as mentioned above, from the paper manufacturer's website. If ColorBurst X-Proof doesn't have an Environment and ICC Profile you can build a custom environment and **ICC Profile** for your printer/paper combination.

You can find many of the benefits we discussed earlier this chapter in the ColorBurst X-Proof RIP: accurate printing from both vector and bitmap files; ink limiting and linearization capabilities, as discussed earlier; printing press proofing, as you can see in the lower part of Figure 11.7; an ability to optimize specific spot colors; and a print certification function. One limitation of the ColorBurst RIP is that you can only print to one printer with one environment at a time.

In the comparison of RIPs in Figure 11.5, ColorBurst has another RIP called ColorBurst Overdrive. This Overdrive RIP utilizes the standard printer driver for printing. This is why this version is described as an RGB RIP and it does not allow ink limiting or linearization.

ColorByte Software Imageprint RIP

ColorByte's ImagePrint RIP is a software-based RGB RIP. It is very much aimed at photographers. Like ColorBurst X-Proof, there is no separate computer used when printing from Image Print. And similarly, you can either print from applications like Photoshop or InDesign, or you can print by simply dragging and dropping an image file or open the image onto the ImagePrint window. ImagePrint will then print the file using the profile and corresponding settings to adjust the image before sending the file to the ImagePrint spooler utility, called Spoolface. If the desired profile is not on your computer, ImagePrint's Profile Valet will automatically download and install the profile.

As you can see in Figure 11.8, a unique aspect of ImagePrint is the variety of available ICC profiles. Besides the standard printer/paper/resolution facets, the profiles in ImagePrint can vary on the following factors: type of black ink configuration, including Photo Black, Matte Black and Phatte Black; whether it is a Color or Gray profile; the use of Dynamic Contrast Matching (DCM) technology; and print viewing light source. Let's look at these unique aspects of the ImagePrint ICC profiles.

Black Ink Configuration

Most inkjet printers have two types of black ink: **Photo** (PK) for glossy and luster type papers and **Matte** (MK) for fine art and matte papers. The **Matte Black** ink gives a darker black with more density on matte papers, but it does not look good on the glossy and luster paper, which we will discuss more in Chapter 13. In Epson printers, like the Epson 7800 and the 9880, only one type of black ink can be installed at a time. This can lead to an expensive loss of ink and time when switching between **Matte** and **Photo Black**. ImagePrint offers a **Phatte Black** option to allow you to have Matte and Photo Black inks installed at the same time on these printers. The way you do this is to install an adapted **Matte Black** cartridge from ImagePrint into the Light-Light Black position. Then you use the **Phatte Black** profiles, so the ImagePrint RIP knows about the change in configuration on the printer. Remember: once you set up the printer with using ImagePrint's **Phatte Black** method, you cannot use the standard printer driver.

FIGURE 11.8 ColorByte ImagePrint RIP with its print preview window and the Dashboard interface.
Credit: Test page designed by and photographs by Mariana Becker (marianabecker.com), Lauryn Gerstle (lauryngerstle.com), and Ksenia Tavrina (kseniatavrina.com)

Color or Gray Profiles

ImagePrint uses RGB color profiles when printing to CMYK printers, the same as we do when using the standard printer drivers. Gray ICC profiles convert any file that comes to it into black-and-white. ImagePrint's Gray profiles also make special adjustments to make better quality black-and-white prints from CMYK inkjet printers, which we will be discussing more in Chapter 17. This aspect of ImagePrint was especially important before Epson released the Advanced Black-and-White option in its printer driver. ImagePrint RIP also allows for easy toning of a black-and-white print.

Dynamic Contrast Matching (DCM)

ImagePrint's DCM technology is meant to adjust to the contrast of the print to the properties of the paper or media you are printing on to. For some profiles this technology is automatically incorporated. In the **Dashboard** in Figure 11.8 we had the option of selecting DCM, but didn't.

Print Viewing Light Source

As we saw when building profiles with X-Rite's i1 Profiler and other output profiling software, the ImagePrint RIP allows us to select profiles optimized for different light sources including daylight, fluorescent, and tungsten.

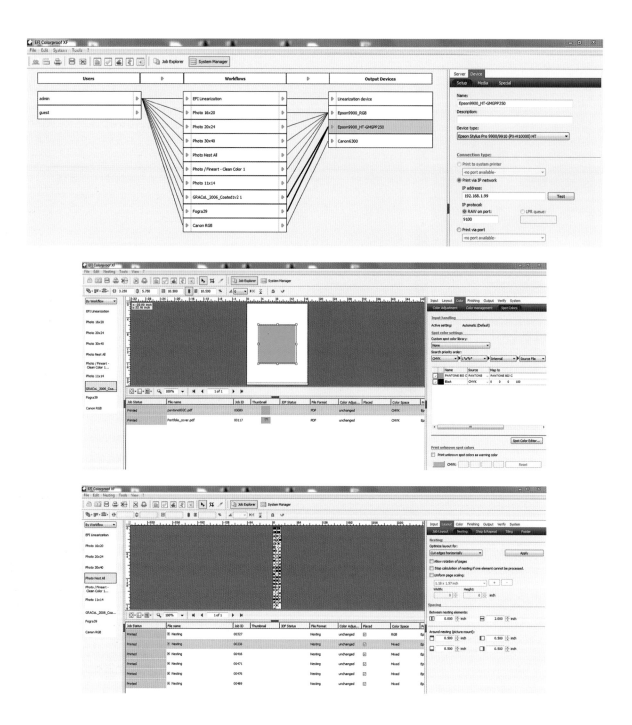

Although you can create hard-proof simulations with ColorByte ImagePrint RIP, this is not a RIP used for high-end graphic arts applications. Also, like both ColorBurst RIPs, you can only print to one printer at a time with ImagePrint. And, like ColorBurst Overdrive, since it is an RGB RIP, there is no ink limiting control or linearization.

EFI ColorProof XF

Electronics For Imaging's (EFI's) ColorProof XF is a hardware and software combination-based CMYK and RGB RIP. Unlike ColorBurst and ImagePrint, EFI ColorProof XF is able to print to multiple printers at the same time, as shown from its System Manager, shown in Figure 11.9. Also, since the RIP resides on a separate computer that controls the printers, you are able to use the RIP (and printers) from multiple computers.

EFI ColorProof XF is a good all-round RIP aimed at the graphic arts and prepress markets. The main function of importance for a RIP to the graphic arts industry is its ability to create accurate hard-copy proofs that simulate output from printing presses. Both EFI ColorProof XF and EFI Fiery XF RIPS come with many functions, including: **Spot Color**, **Layout/Nesting**, **Color Manager**, **Color Verifier**, and **Dot Creator/One-Bit Options**.

Spot Color

As you can see in Figure 11.10, the **Spot Color** option in EFI ColorProof XF allows you to select spot colors you or your client might be using for logos, products, or print jobs, so that they will be reproduced as accurately as possible in hard-copy proof.

Layout/Nesting

As discussed earlier, some RIPs offer the capability to take a large number of image files for printing on a large sheet or roll of paper and optimizing the position of all the images, so that you use as little paper as possible and make the layout optimal for trimming. Figure 11.11 shows the **Layout Nesting** window in EFI ColorProof XF.

Color Manager

As you can see in Figure 11.12, the optional EFI Color Manager software allows you to linearize a printer/paper combination, create and optimize output ICC profiles, and produce device link profiles, among other functions.

FIGURE 11.9 *(facing page, top)* System Manager window in EFI ColorProof XF RIP showing the custom workflows setup to the connected printers. EFI ColorProof XF allows you to print to multiple printers at the same time.
Credit: Screen shot supplied by Jodie Steen of 127 Productions (127productions.com)

FIGURE 11.10 *(facing page, middle)* Job Explorer window in EFI ColorProof XF RIP showing the optional capability to incorporate and handle spot ink colors. EFI ColorProof XF can then make the adjustments needed to accurately reproduce these colors on the hard-copy proof.
Credit: Screen shot supplied by Jodie Steen of 127 Productions (127productions.com)

FIGURE 11.11 *(facing page, bottom)* Job Explorer window in EFI ColorProof XF RIP showing the Layout Option capability to handle Nesting, which allows for more efficient use of paper when printing multiple images and graphic files.
Credit: Screen shot supplied by Jodie Steen of 127 Productions (127productions.com)

Device Link Profiles

Unlike most ICC profiles, device link profiles go directly from RGB to RGB or, more commonly, from CMYK to CMYK, without going through Lab. Because of this, they allow a conversion that preserves both color appearance and the black channel in CMYK files. Device link profiles are created by combining the input portion of the source CMYK profile, which goes from CMYK to Lab, with the output portion of the destination profile, which goes from Lab to CMYK. When used properly, device link profiles can help create better quality lines and text on press and in inkjet prints and hard-copy proofs.

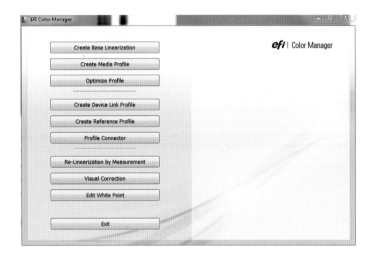

FIGURE 11.12 Main window of EFI Color Manager option that can come with EFI ColorProof XF RIP and EFI Fiery RIPs. As shown, EFI Color Manager allows you to linearize a printer/paper combination, create and optimize custom output profiles, and produce device link profiles, among other functions.
Credit: Screen shot supplied by Jodie Steen of 127 Productions (127productions.com)

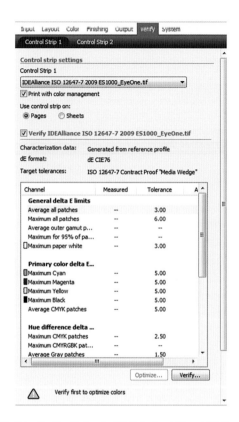

FIGURE 11.13 Color Verifier Option for EFI ColorProof XF and EFI Fiery RIPs, which allows you to measure color patches from your output, compare the measurements to known standards, and determine if the proofing process is accurate.
Credit: Screen shot supplied by Jodie Steen of 127 Productions (127productions.com)

Color Verifier

Like the color analysis tools discussed in Chapter 10, the **Color Verifier** option in EFI ColorProof XF, as shown in Figure 11.13, allows you to measure color patches from your output, compare the measurements to known standards, and determine if the proofing process is accurate and working well.

Dot Creator/One-Bit

This option in EFI ColorProof XF allows you to create a hard-copy proof that also simulates the halftone dot pattern that you will get from a printing press or process. As discussed earlier, when it works well, this functionality can create an inkjet proof that looks even more like the final printing press output.

GMG ColorProof, DotProof, and FlexoProof

GMG ColorProof, DotProof, and FlexoProof are high-end (meaning expensive) hardware and software combination-based CMYK RIPs. Like EFI ColorProof XF, the GMG RIPs are able to print to multiple printers at the same time, as shown from its Workflow window, as in Figure 11.14. Also, since the RIPs reside on a separate computer that controls the printers, you are able to use the RIPs (and printers) from multiple

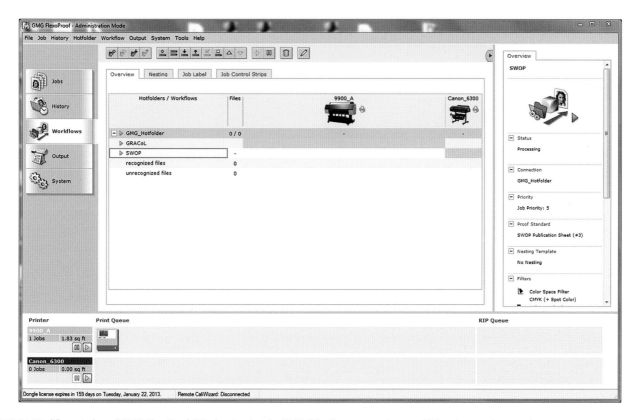

FIGURE 11.14 Workflow window of GMG FlexoProof RIP, showing that the GMG RIPs allow you to print to multiple printers at the same time.
Credit: Screen shot supplied by Jodie Steen of 127 Productions (127productions.com)

computers. GMG RIPs allow for a high level of automation in the workflow, not just by using hot folders, but by also watching for certain file names and types being created, so they can be pushed to the next stage in the process.

The GMG RIPs are best known for precision, accuracy, and workflow automation. ColorProof is aimed at commercial photographers and large-format printers. FlexoProof is aimed at the graphic arts and package printing industries, and, as before, very accurate hardcopy proofs that simulate output from printing presses is important, so the proofs can be considered certified according to standard graphic arts specifications.

In addition to a non-linearization calibration process that includes many more patches than a basic linearization, GMG ColorProof, DotProof, and FlexoProof RIPs come with different features for optimizing proof accuracy including: **Proprietary Profile Building Verification**, **Optimization**, **Quality Control and Profile Editing**, **Spot Color Optimization**, and **Halftone Dot Simulation**.

Proprietary Profile Building Verification, Optimization

While GMG's RIPs are ICC and use ICC profiles, they also build and use proprietary (meaning non-ICC) device link profiles that have the

FIGURE 11.15 Profile Editor in GMG FlexoProof, which verifies and improves print quality through cycles of test prints, measurements, and adjustments until the accuracy aims are met.
Credit: Screen shot supplied by Jodie Steen of 127 Productions (127productions.com)

FIGURE 11.16 Spot Color Option for GMG FlexoProof, which allows you to optimize the workflow for spot colors, like Pantone colors, separately from images and other parts of a page layout to give them more accuracy.
Credit: Screen shot supplied by Jodie Steen of 127 Productions (127productions.com)

.mx3 extension. After profiles are built, they are verified for accuracy by printing and measuring additional patches; then they are adjusted to get more accuracy. This process of verifying and adjusting continues until the profile produces the desired optimal result.

Quality Control and Profile Editing

After the optimized profiles have been brought into the workflow the proofing system can be continually monitored to determine if re-calibration or profile editing need to be performed. Figure 11.15, shows the **Profile Editor**, which will perform a verification and adjustment cycle until the measurement aims are met.

Spot Color Optimization

As you can see in Figure 11.16, like the **Spot Color** option in EFI ColorProof XF, GMG FlexoProof and the other two RIPs allow you to optimize the profiles for spot colors, like Pantone colors. The difference is that in the GMG RIPs the spot color reproduction goes through the same verification and adjustment cycle until the measurement aims are met and the spot reproduced accurately.

Halftone Dot Simulation

Like EFI ColorProof XF's Dot Creator/One-Bit options, GMG DotProof and FlexoProof (but not ColorProof) RIPs allow you to create hard-copy proofs that also simulates the halftone dot pattern that you will get from a printing press or process. GMG has a good reputation for having more success with implementing this technology.

Conclusion

In this chapter we have really looked at the benefits to owning and using RIPs over the standard printer manufacturer drivers. Putting it simply, RIPs should give you improved print quality, control, accuracy, and efficiency in printing. John Donich, the Technical Editor for this book, has mentioned another hidden benefit of using some of the more powerful RIPs. Since they give you much more control over your printer, they can teach you a lot about how your printer works—much more than using the driver can. The real question is: *Do I need a RIP?* Maybe you do, maybe you don't. It depends on what you are doing. The thing printer drivers have over the RIPs is they're *free*. So, like with other topics we have discussed, it really takes some investigation to see if the quality differences and the boost to your workflow and bottom line will be worth the investment.

EXPLORATIONS

Now that you've heard about these RIPs, it's time to try them! At least you should try the ones that are available to you and might be most useful to your workflow. Some of the RIP manufacturers have a trial usage period that allows you to test the software. If there is no trial version for testing, then you might need to borrow a software dongle from a company that sells the RIP locally. You might be saying to yourself: *What is a dongle?* Well, a *dongle* is a security key for the RIP and other expensive software packages. Most often it looks like a USB thumb drive that you plug into the computer running the RIP. This allows the RIP at run to full functionality. Without the dongle plugged in, many RIPs do not even launch. Basically, the dongle is what you are buying when you purchase an expensive piece of software like a RIP.

DIGITAL OUTPUT TECHNOLOGIES & PRINT LABELING

In this first chapter of the output section we will take an overall view of the different types of digital output you could be using. We will start by reviewing the important criteria that you can use for a comparison like this. Then we will evaluate the different types of digital media-based output: inkjet, photographic, dye-sublimation, electro-photographic, traditional printing presses, and hybrid. Finally we will take a look at how fine-art digital prints are labeled.

Criteria for Comparison

Let's review the different types of digital output and analyze them to determine the uses for which they're best suited. Before we can make these determinations, we should look at criteria for comparing various types of digital output. Some of the criteria we will use are:

- Longevity
- Variety of surfaces
- Halftone versus continuous tone
- Speed
- Size options
- Optimal volume
- Cost
- Dynamic range/gamut/aesthetics.

What other criteria would you add to this list?

Longevity

How long will the prints last? When comparing different types of digital output technologies for use as fine-art digital prints, it's important to consider how long the print will last without fading or physically changing. Chapter 21 expands upon the discussion of print longevity and the factors that affect a print's archival characteristics.

Variety of Surfaces

How flexible is the technology in allowing the user to print onto different types of media and surfaces? Some types of output are compatible with a very limited number of print surfaces, while others can print on virtually limitless substrates.

Halftone versus Continuous Tone

Some output types (like black-and-white darkroom silver halide or color photographic prints) are able, at their finest resolution, to produce a continuum of different densities, or brightness values. These types of output are described as being continuous tone. (Figure 12.2 shows a gradation of continuous values.)

As an example, the brightness of each picture element, or pixel, of an 8-bit display can have 256 different continuous values from the darkest to the lightest. The more able an output technology is at

FIGURE 12.2 Continuous tone gradation of black to white from top to bottom.
Credit: Illustration by the author

FIGURE 12.1 Portion of output from HP Indigo electrophotographic press, which shows the cyan, magenta, yellow, and black halftone dots that make the image.
Credit: Portion of original image by Daniel Bolliger (danielbolliger.com)

producing a continuous tone, the better its tonal quality will be. And, if you're trying to produce output with "photographic" quality, it is more easily done with continuous-tone output than with halftone output.

Other output types, like inkjet, electrophotography, or offset lithography, can't produce a continuous-tone density of ink or toner. With these output types, there is either ink or toner on the page at full strength, or there is no ink at all. There is no middle ground; the technology doesn't allow for density variations. Halftone dots (Figures 12.3 and 12.4) are utilized in order to simulate continuous tone with these types of technologies. As long as the halftone dots are small enough and have a high-enough frequency (dots per inch or DPI), our eye will combine the dots and the paper (or substrate) to perceive the intermediate tones.

The same visual effect occurs when viewing Pointillist paintings, like those of George Seurat. When you're very close to one of these paintings, you see a series of dots, but if you move far enough away, then you see the figures and shading. Figure 12.3 shows the same gradation as in the previous figure (Figure 12.2), this time reproduced in halftone form with black ink only. Figure 12.4 shows the same gradation reproduced in four colors: cyan, magenta, yellow, and black.

Of course, when we see the halftone pattern this close to our eyes, the illusion doesn't work.

The original halftone dot patterns were created from film screens that had very regular patterns. The size of the dot was changed by exposure. As Figure 12.1 at the beginning of the chapter and Figures 12.3 and 12.4 show, these traditional halftone patterns have fixed distances between the variably sized dots. This is called an AM (amplitude modulation) screening.

The other type of halftone screening is FM (frequency modulation). Starting in the late 1980s and early 1990s, computers were used to create the cyan, magenta, yellow, and black halftone film separations, which were used to make printing press plates, using the new random (or stochastic) halftone pattern that became available. The random stochastic halftone pattern is a frequency modulation process that allows the image to appear more like continuous tone.

Figure 12.5 shows the difference between AM and FM halftone screening and illustrates that the first-order stochastic halftone's randomness is a result of variable-dot spacing and that second-order stochastic halftone's randomness is a result of both dot spacing and dot size.

FIGURE 12.3 The same gradation as in Figure 12.2 as a black on white halftone. The illusion of continuous tone doesn't work in this illustration because the dots are too big.
Credit: Illustration by the author

FIGURE 12.4 The same gradation as in Figure 12.2 as cyan, magenta, yellow, and black halftones. The illusion of continuous tone doesn't work in this illustration also because the dots are still too big.
Credit: Illustration by the author

HALFTONE TYPES

AMPLITUDE MODULATION (AM) SCREENING FREQUENCY MODULATION (FM) SCREENING

FLAT TINT STANDARD HALFTONE FIRST ORDER STOCHASTIC SECOND ORDER STOCHASTIC

Fixed dot size
Fixed dot spacing

Variable dot size
Fixed dot spacing

Fixed dot size
Variable dot spacing

Variable dot size
Variable dot spacing

FIGURE 12.5 Illustration showing the difference between AM and FM screenings, tints, and conventional halftones, and finally the difference between first order and second order stochastic FM patterns.
Credit: Illustration by the author

Printer and printer-software manufacturers are constantly trying to improve halftone patterns and screening. Their goal is to make the dots less perceptible and to make their output appear more like continuous tone, and therefore more like a traditional photograph.

One example of a printer modification in inkjet printing is the use of light inks—such as light cyan, light magenta, and light blacks—to make the dots of ink less noticeable in the light areas (or highlights) of the print.

Speed

How quickly can prints be produced? Depending on the requirements of the printing or photographic project, the amount of time it takes to produce the print or prints can be pivotal. Speed could be measured from the time you click on the Print button in your software to the moment when the completed print comes out of the printer. On the other hand, if you're using a service provider for your printing, the "turn-around time" (the time it takes until you see a finished print) is likely to be considerably longer.

Size Options

How large a print can I make? On many printers, the width of the printer is the limiting factor. Typically, when you use a printer that allows for the use of roll media, larger (or at least longer) prints can be made.

Optimal Volume

Because of differences in speed and setup costs, some types of output will be more suited to making smaller numbers of copies and others will be suitable for high-volume printing.

Cost

How much does the print cost? This is a very important question. We need to look at the cost of the equipment, the media (ink, paper, chemicals, etc.), the time to produce the print, the labor costs, and other setup and maintenance costs. Some printers have very low equipment costs, but high media costs. Other output types have such high equipment and maintenance costs that—unless you're a service provider who specializes in printing—it isn't worth owning the equipment yourself. When you obtain prints from a service provider, you can simply consider the cost per print.

Dynamic Range/Gamut/Aesthetics

How does the print look? The various types of printing are associated with particular benefits and limitations regarding their physical appearance. Some types of output will only be able to produce a limited range of densities or colors, while others will be prone to specific artifacts.

Due to the factors mentioned above (and more), inkjet prints and digital-photographic prints are the two most common types of digital prints currently being produced by photographic artists today. Less commonly known printmaking techniques include: dye-sublimation or thermal dye transfer, Fuji Pictrography, electrostatic, traditional graphic arts printing, and hybrid printing.

Inkjet

Although we will cover some topics about inkjet printing more thoroughly in the next chapter, let's start by discussing it more generally for comparison with the other types of digital output. In inkjet printing, ink is sprayed onto paper, forming the image as a pattern of halftone dots. Most commonly fine-art inkjet prints are referred to as *Archival Pigment Prints*. Another name for a fine-art inkjet print, coined by Jack Duganne to imply uniqueness or quality printing, is *Giclée print*, which is a name based on the French word for "to spurt," or

"to spray." (Sadly, "Giclée print" might not be the best label to use in the French, or really any, art market, partially because *giclée* can also have a slang meaning in French that is sexual in nature.) Other terms that are used to label inkjet prints include the printer brand or product name, such as Iris prints, Epson prints, or UltraChrome (a type of Epson pigment-ink technology) prints. When describing a print, artists might also include the name of the type of paper they used. My recommendation, based on discussions with photographic and print curators and conservators, is to call inkjet prints *Pigment Inkjet Prints*, if pigment inks are used.

The two basic types of inks used in photographic applications are dye and pigment. Chemically, dyes are soluble compounds that dissolve, while pigments are larger insoluble organic particles that don't dissolve. Pigment-based inkjet prints are typically much more fade-resistant than dye-based prints, which is why pigment based inkjet prints will often be described as *archival pigment prints*. Dye-based

FIGURE 12.6 Epson 7900 Inkjet Printer at BFA Photography Department at School of Visual Arts in New York City.
Credit: Photograph by the author

prints, on the other hand, typically offer more color gamut than pigment-based prints because of their inherent transparency.

Epson's UltraChrome ink technology, used in printers like the Epson 7900, shown in Figure 12.6, is an attempt to get more color gamut out of pigment inks by coating the particles with gelatin, thus allowing light to go around them, which offers more transparency and color gamut than do traditional pigment-based inkjet inks. In the sign-printing industry, there are also UV-curable solvent-based inks, which are manufactured to be even more durable for outdoor-display purposes.

inkjet-printer technology has evolved since the early 1990s. The original fine-art inkjet prints were made on modified Iris proofing printers. On Iris printers, the paper is mounted to a drum, which spins during printing. The continuous inkjet system allows for high-quality printing, because it allows for printing of smaller drop-sizes and the ability to place multiple drops per location on the print.

Epson, Canon and HP inkjet printers use drop-on-demand inkjet systems. The Seiko Epson Corporation, of which Epson is obviously a part, also makes Seiko watches. Part of their watch technology includes piezoelectric crystals, which are used to control the size of the dots of ink that come out of the Epson drop-on-demand inkjet printers. Canon printers, on the other hand, use a thermal drop-on-demand system, which creates a bubble via heat—thus the name "Bubble-Jet"—to force ink onto the paper.

Let's look at inkjet printer technology with our eight criteria for comparison:

- *Longevity*—The longevity of inkjet prints can be anywhere from weeks to centuries, depending on the ink, paper, and the display or storage conditions.
- *Variety of Surfaces*—This is one of the most positive attributes of inkjet printers. They can print onto virtually any surface or substrate—and onto many different thicknesses of media, which allows for tremendous creative possibilities.
- *Halftone Versus Continuous Tone*—Most inkjet printers use some form of stochastic (FM) halftone screening.

- *Speed*—Per print, inkjet printing is slower than other types of output, although it keeps getting faster with almost every new generation of printer.
- *Size Options*—Size options can be a big benefit of inkjet printing, and as mentioned before, the width of the printer is the factor that limits print size. That being said, in the sign market, there are printers that are almost 200 inches wide, but for photography and fine-art printing, the typical maximum width used is around 60 inches.
- *Optimal Volume*—1 to 100 copies. Typically, because of the speed limitation of inkjet printers, you wouldn't want to use them to make more than 100 copies of an image.
- *Cost*—With inkjet printing, the general economic model has been that the printers are relatively inexpensive, but that the media (especially the inks) are very expensive. The spreadsheets in Figure 12.7 show a way to calculate the per-print cost for inkjet printers. The number of full-size 81/2 x 11-inch prints that can be produced without replacing all the ink cartridges is estimated. This number will depend on the specific images that are printed.

Notice that one way to combat the high cost of the ink is to buy a printer that uses larger ink cartridges. As the spreadsheet in Figure 12.7 shows, the cost of the ink (per print or per milliliter [ml]) is the highest for the 25.9 ml cartridges of the Epson r3000 and could be greatly mitigated by switching to the 80 ml or 220 ml cartridges of the Epson 3880 or 7880/9880, respectively.

To give us some perspective on the ink costs, let's translate them to units most of us in the United States are used to thinking about: dollars per gallon. As Figure 12.7 shows, the cost of ink in the Epson r3000 is $1.24 per milliliter, or $4,675.50 per gallon—while the cost of ink in the Epson 3880 is $0.75 per milliliter, or $2,836.69 per gallon. The cost of ink in the Epson 7880/9880 is $0.51 per milliliter, or $1,927.12 per gallon.

There's no getting around it: the ink is expensive! And these figures don't include prices for the ink used to maintain the

COST OF INK AND PAPER

	Price Per Cartridge and Price Per Milliliter of Ink USD	Full Set of Cartridges/ Box of Paper	Approximate 8.5 × 11" Prints Cartridge Set or Box	Ink/Paper Price Per Print USD	Price Per Gallon of Ink USD
25.9 ml UltraChrome Ink Cartridge for Epson Stylus Photo r3000 Printer 25 – 8.5 × 11-inch Prints	$ 31.99	$ 287.91	82	$ 3.51	
	$ 1.24				**$ 4,675.50**
Epson Exhibition Fiber Paper 25 – 8.5 × 11-inch Sheets		$ 59.00	25	$ 2.36	
Price Per Print				**$ 5.87**	
80 ml UltraChrome Ink Cartridge for Epson Stylus Photo 3880 Printer 25 – 8.5 × 11-inch Prints	$ 59.95	$ 539.55	255	$ 2.12	
	$ 0.75				**$ 2,836.69**
Epson Exhibition Fiber Paper 25 – 8.5 × 11-inch Sheets		$ 59.00	25	$ 2.36	
Price Per Print				**$ 4.48**	
220-ml UltraChrome Ink Cartridge for Epson Stylus Photo 7880 or 9880 Printers 25 – 8.5 × 11-inch Prints	$ 112.00	$ 1,008.00	700	$ 1.44	
	$ 0.51				**$ 1,927.12**
Epson Exhibition Fiber Paper 25 – 8.5 × 11-inch Sheets		$ 59.00	25	$ 2.36	
Price Per Print				**$ 3.80**	

FIGURE 12.7 Comparison of ink and per-print costs of various Epson inkjet printers.
Credit: Chart by the author

printer and clean the ink nozzles. The whole situation could lead you to consider using third-party inks in order to save money. The problem with this option, though, is that the ink's formulation and manufacturing process (including the milling of the pigment particles) is very difficult. The size of the pigment particles needed is directly related to the printer and printer head design. And when the pigment particle sizes are not correct or pigment quality is not consistent, then problems can arise—such as the clogging of print heads and variability from batch-to-batch of ink.

- *Dynamic Range/Gamut/Aesthetics*—Just as with longevity, the dynamic range and gamut of an inkjet print depend on the ink and paper combination.

Photographic

Photographic output is produced on light-sensitive materials that are exposed by a light source and processed in chemistry. There are three types of photographic materials (and corresponding processes) used in fine-art digital prints: chromogenic, silver dye bleach, and silver gelatin.

Chromogenic (C-Prints)

These materials are traditionally used to make prints from color negatives. The way the process works is that color couplers produce dyes (cyan, magenta, and/or yellow) that replace a developed silver image in the emulsion. The couplers reside in the emulsion along with the light-sensitive silver-halide crystals. They are colorless until activated during the color-development step in processing, as shown in Figure 12.8.

Most chromogenic photographic prints are on RC (resin-coated) papers; however, there are some translucent and transparent display materials on polyester supports, like Kodak Endura Transparency and Clear. The current process the materials go through after exposure is called RA-4. The most fade-resistant contemporary chromogenic papers

are Fuji Crystal Archive and Kodak Endura. Under certain display conditions, prints on these papers are projected to last from 30 to 60 years without fading.

Silver Dye Bleach or Dye Destruction

Much less common than C-prints, this type of material is commonly referred to by its manufacturer/product name, which is currently Ilfochrome (formerly Cibachrome). As opposed to the emulsions of chromogenic photographic materials, which start off with dye-couplers and silver halides, but no dyes, in dye-destruction materials, the actual cyan, magenta, and yellow (Azo) dyes are fully present in all the emulsion layers, along with the light-sensitive silver halides.

As shown in Figure 12.9, exposure and the initial developer produce a negative silver image, which is then bleached out along with the accompanying dyes, leaving dyes in the positive-image areas only. Although both negative and reversal materials of this kind are possible to create, only reversal Ilfochrome media (for making prints from transparencies) are available. Dye destruction/silver dye bleach prints are known for their high dynamic range, saturated colors, and fade resistance, especially when they are kept in dark storage.

Silver Gelatin or Black-and-White

In these materials, which we know as the classic black-and-white photographic materials of the 20th century, light-sensitive silver-halide crystals are suspended in a gelatin emulsion, which is coated on top of either an RC (resin-coated) paper or a fiber-based, baryta-core paper. Baryta is the name for several chemical compounds that contain barium. They are used to coat photo paper and provide a surface on which to put the light-sensitive layer.

The baryta layer lies between the light-sensitive and paper layers, hence the name *baryta-core*. A latent image is formed where the silver halides of the light-sensitive layer are exposed. In the black-and-white developer, the latent silver-halide image is amplified and transformed into silver metal. After the unexposed silver halides are removed by the photographic fixer or sodium thiosulfate, all that is left in the

CHROMOGENIC COLOR PRINT
EXPOSURE AND PROCESSING

CHROMOGENIC PHOTOGRAPHIC MATERIAL EMULSION STRUCTURE

Red Sensitive Layer

Green Sensitive Layer

Blue Sensitive Layer

LIGHT
FROM LASERS
RED GREEN BLUE

EXPOSED
CHROMOGENIC
COLOR PAPER

Exposure:

The green energy from the laser exposes the light sensitive silver halides in the green sensitive layer in the chromogenic color paper. Chromogenic photographic materials are negative working, which means that more exposure given with any red, green, or blue laser (or LEDs) will result in more density of each of the complimentary color dyes: cyan, magenata, and yelllow, respectively. Because of this, the image sent to the printer with these materials will be inverted first. Therefore, the green laser in the digital enlarger or mini-lab printer, as shown above, exposes the chromogenic paper for less time and/or intensity (lower exposure) when the green values in the RGB digital image file are higher. Conversely, when there are only higher blue and red values, but not green values, in the RGB image file, the green laser exposes for more time and/or intensity.

RA-4 PROCESS

(1)

Color Developer:
Exposed silver halides are transformed into silver metal. Simultaneously, in the layer where silver metal is produced, the color couplers release corresponding dye cloud: magenta dye in the green sensitive layer.

(2)

Bleach:
Dissolves silver metal.

(3)

Fixer:
Removes any unexposed silver halides in the emulsion layers, leaving only magenta dye. The more green exposure given by the laser (or LEDs), the more magenta dye that is produced in the chromogenic print.

KEY

Unexposed Silver Halides

Exposed Silver Halides
(Latent Image)

Developed Silver Metal

FIGURE 12.8 Exposure and Processing of Digital Chromogenic Photographic Materials.
Credit: Illustration by the author

SILVER DYE BLEACH COLOR PRINT
EXPOSURE AND PROCESSING

SILVER DYE BLEACH PHOTOGRAPHIC MATERIAL EMULSION STRUCTURE

Red Sensitive Layer
w/ Cyan Dye

Green Sensitive Layer
w/ Magenta Dye

Blue Sensitive Layer
w/ Yellow Dye

LIGHT
FROM LASERS

RED GREEN BLUE

EXPOSED
DYE DESTRUCTION
COLOR MATERIAL

Exposure:

As with chromogenic materials, the green energy from the laser exposes the light sensitive silver halides in the green sensitive layer in the dye destruction material. Dye destruction photographic materials start off with full strength cyan, magenta, and yellow dyes already incorporated into the paper. They are positive working, which means that more exposure given of any red, green, or blue laser (or LEDs) will result in less density of each of the complimentary color dyes: cyan, magenta, and yelllow, respectively. Therefore, the green laser in the digital enlarger or mini-lab printer, as shown above, exposes the silver dye bleach material for more time and/or intensity (higher exposure) when the green values in the RGB digital image file are higher. Conversely, when there are lower green values, in the RGB image file, the green laser exposes for less time and/or intensity.

ILFORD P3-X PROCESS

(1)

Developer:
Exposed silver halides are transformed into silver metal.

(2)

Bleach:
Dissolves silver metal and the corresponding dye in the same layer. This leaves the unexposed silver halides and their corresponding dyes.

(3)

Fixer:
Removes unexposed silver halides, leaving only cyan and yellow dyes, which combined appear as green on the silver dye bleach print.

KEY

Unexposed Silver Halides

Exposed Silver Halides
(Latent Image)

Developed Silver Metal

FIGURE 12.9 Exposure and Processing of Digital Silver Dye Bleach Photographic Materials.
Credit: Illustration by the author

emulsion are the very stable silver metal and the gelatin—thus the name, silver gelatin print. Fiber-based prints require more washing than RC prints, but the fiber prints have greater longevity.

Although these materials and processes are traditionally used in analog photography, digital photographic prints are output from a computer onto the same materials and processed as described above and shown in Figures 12.8 and 12.9. The digital images are exposed with one of three light sources: CRTs (cathode ray tubes), LEDs (light emitting diodes) or, more commonly, lasers, as with the Océ Lightjet or Durst Lambda printers.

Other names for these prints are: digital c-prints, LightJet Prints (the brand name of a laser enlarger originally produced by Cymbolic Sciences, then Océ and now discontinued) and Lambda Prints (the name-brand laser enlarger by Durst). In most cases, the chromogenic, dye-destruction or silver-halide materials are specially formulated and sensitized for exposure by these light sources.

Let's look at photographic digital output technology with our eight criteria for comparison:

- *Longevity*—The longevity of digital chromogenic, dye-destruction, or silver-halide prints is the same as it is for the traditional prints made with these technologies. This fact makes them very familiar to galleries, museums, and collectors and has helped them become more readily accepted than inkjet prints—even though the inkjet prints could offer even better longevity and light-fade characteristics. One benefit of photographic digital prints over inkjet prints is that the gelatin emulsion which protects the dye or silver image is very protective and forgiving. This trait allows these prints to resist scratches and handling marks better than untreated inkjet prints.
- *Variety of Surfaces*—Although there are some variations of surfaces (such as glossy, luster, metallic, and silk), photographic output doesn't offer the variety of choices that are possible with inkjet printing. With photographic output, we are strictly limited to the surfaces that Kodak, Fuji, Ilford, and Harman Technologies have chosen to coat with photographic emulsions.
- *Halftone Versus Continuous Tone*—A major benefit and identifying feature of digital photographic prints is that they offer truly continuous tone, as opposed to inkjet prints, which are halftones.
- *Speed*—Most photographic output devices will still produce a print faster than their inkjet counterparts, even though they need to process the material after exposure. Since most of us don't have direct access to these printers, we need to add in the time to have someone else—a service provider—make the print for us. For practical purposes, therefore, the speed of photographic digital output is typically medium to slow at best.
- *Size Options*—As with inkjet prints, size options can be a big benefit of photographic digital output. As mentioned before, the size limit is determined by the width of the printer. The largest photographic output available is 72-inch digital-chromogenic material, which is only made by Kodak for use on Océ's largest Lightjet laser enlarger.
- *Optimal Volume*—1 to 1000 copies. Although the speed is good, the limitation on higher volumes with photographic output will be the per-print cost.
- *Cost*—Unlike inkjet output, the equipment for photographic output is very expensive—anywhere from tens of thousands to hundreds of thousands of dollars. (This doesn't even include the expense of dealing with silver recovery and environment regulations due to chemical processing.) That being said, you can find a very large range of per-print prices for digital photographic prints from various service providers.
- *Dynamic Range/Gamut/Aesthetics*—The look and feel of digital chromogenic, dye-destruction, or silver halide prints is the same as that of traditional enlarger based photographic prints made with these technologies. Just as with longevity (fair or not), this makes photographic digital prints very familiar to galleries, museums, and collectors, which has also helped make these prints more easily accepted than inkjet prints.

Dye-Sublimation/Thermal Dye Transfer

This technology (Figure 12.10) produces a continuous-tone digital print that's created by heating a series of cyan, magenta, yellow, and possibly black dyes. The dyes are on a plastic donor ribbon (Figure 12.11) that transfers them to special receiving paper. *Sublimation* describes the change in physical state that the dyes go through. In sublimation, the dyes (which start off as solids) are heated until they become gases, at which point they hit the receiving paper and become solid again—all without ever becoming liquid!

Thermal dye transfer should not be confused with the traditional dye transfer color process, which is a painstaking multi-step photographic process that produces very stable, fade-resistant prints. The traditional dye transfer process was introduced by Eastman Kodak in the 1930s and was used by fine-art photographers who worked in color from the 1950s through the 1980s—including Elliot Porter, William Eggleston, Steven Shore, and Ernst Haas. In 1993, Eastman Kodak, the sole manufacturer of these products, discontinued the production of dye transfer materials.

Dye-sublimation technology is not typically used for fine-art applications, but let's look at it anyway, using our eight criteria for comparison:

FIGURE 12.10 Fujifilm ASK 2500 Dye-Sub Printer with a maximum print size of 6x9-inches.
Credit: Photograph by the author with help from Daniel M. Weiss (danielmweiss.com)

- *Longevity*—The longevity of these prints is not good. They are not very fade-resistant, and unless they include a final UV absorption coating, they will only last a few years without fading. A UV coating will help bring the longevity of dye-sublimation prints up to approximately 25 years. Also, these prints are very pressure-sensitive, which means that they lose density in areas where the dye is subject to concentrated or dispersed force. For example, I would not leave a paperweight on top of a dye-sublimation print over a long time, because the area where the weight was on the print would get lighter or disappear altogether.
- *Variety of Surfaces*—Typically, these types of prints are limited to one or two surfaces: glossy and, possibly, luster.
- *Halftone Versus Continuous Tone*—A major benefit and identifying feature of dye-sub prints is that they are truly continuous-tone. The density of the dye corresponds to the amount of heat the dye received.

FIGURE 12.11 Dye sublimation ribbon media with cyan, magenta, yellow, and ultraviolet absorbing layer for each print.
Credit: Photograph by the author with help from Daniel M. Weiss (danielmweiss.com)

- *Speed*—The big benefit of dye-sublimation and thermal dye transfer technology is the time it takes to create a print. This is why these printers are especially popular for event-photography applications, such as parties and Christmas photos of children with Santa. Under these situations, clients are willing to pay a premium to get the prints while the event is taking place.
- *Size Options*—Dye sub-prints are typically limited in size: they're 8½ x 11 inches at the largest, but are typically smaller.
- *Optimal Volume*—1 to 100 copies. Although the speed is good, printing higher volumes will be limited by the per-print cost.
- *Cost*—Both the equipment and the media costs are higher than inkjet costs. Also, there is a lot of waste involved with this process, since each ribbon can only be used once.
- *Dynamic Range/Gamut/Aesthetics*—Dye-sublimation prints have a look and feel that's very similar to traditional chromogenic prints. One of the reasons for this is that they are both continuous-tone prints.

Fuji Pictrography

Although the Fuji Pictrography printers are not as well supported and readily available as they were in the past, the media are still being sold and prints are still being made. During this process, a continuous-tone digital print is produced through a combination of two elements: (a) laser exposure to a donor layer and (b) thermal dye transfer to a special receiving paper. Distilled water is the only "wet" chemical used in the process. The prints are typically limited in size (11 x 17 inches or smaller). This technology falls somewhere between photographic output and thermal dye transfer prints. Like thermal dye transfer, this technology is also used for event applications.

FIGURE 12.12 HP Indigo 10000 Digital Press.
Credit: Photograph, © Hewlett Packard

Electrophotographic or Electrostatic

We know electrophotographic or electrostatic prints best as the Xerox prints, laser prints, and copier prints we've been making for years. In this half-tone process, toner/pigment particles are charged, transferred, and fused onto the paper's surface. Electrostatic prints are also called *print-on-demand* (PoD), *xerographic prints*, *laser prints*, and *color copier prints*.

This is the process used with short-run digital printing presses that are used for making postcards and books, by companies like Blurb and Lulu. The two major types of toner used by different electrophotographic printers (Figure 12.12) and presses are dry (powder) and liquid toners. Dry (powder) toner is used by Xerox and Kodak Nexpress machines, while liquid toner is used by the Canon and HP Indigo machines, which makes the liquid toner prints more similar to the output from traditional offset printing.

Let's look at electrophotographic output technology, using our eight criteria for comparison:

- *Longevity*—Because some toner particles (especially carbon black) are pigment based, their longevity can be quite good. Longevity is typically better for the dry toner than it is for the liquid toner. One bad side effect, depending on the resins used in this process, can be image transfer; the image on the paper sometimes transfers onto other surfaces with which it comes into contact.
- *Variety of Surfaces*—While it's possible to use some variety of papers and card stock on electrophotographic printers and presses, there are limits on the thickness of the substrates that can be used.
- *Halftone versus Continuous Tone*—Electrophotographic printers and presses use traditional (AM) and stochastic (FM) halftone patterns to produce intermediate tones and gradations. Figure 12.1 at the beginning of the chapter shows an example of the AM halftone pattern from the HP Indigo electrophotographic press.
- *Speed*—Individual prints can be made very quickly using the electrophotographic process. This process is very helpful in situations where variable data is used; that is, where information from databases (such as mailing lists) is combined with a

standard design to create custom mailing pieces (such as political or advertising mailers).

- *Size Options*—Typically, the size limitation of these printers is A3 or smaller; however, some of the digital printing presses are capable of making much larger impressions, similar to those output by offset printing presses, the large graphic arts commercial printing presses that produce magazines, newspapers, advertisements, and books.
- *Optimal Volume*—1 to 20,000 copies. These presses can be used for making even one copy of a book at a reasonable price.
- *Cost*—Some electrophotographic color printers are available for hundreds of dollars, but the larger printers and presses can range from tens of thousands to hundreds of thousands of dollars. The big benefit of using them (as compared to traditional graphic arts printing presses) is that with electrophotographic presses there are much lower set-up costs.
- *Dynamic Range/Gamut/Aesthetics*—Because the toner and resin sit on the surface of the paper in some electrophotographic prints and books, the look can be distinct and somewhat unappealing. The gamut and dynamic range are not especially large, but they are similar to that of traditional graphic arts offset printing presses, which we will discuss next.

FIGURE 12.13 Offset Lithographic Printing Press.
Credit: © Moreno Soppelsa/Shutter Stock

Traditional Graphic Arts Printing Press

Traditional commercial printing methods such as offset lithography, gravure, and flexography are optimal for printing a large number of copies. Each of these methods has benefits for use with different substrates, and for producing different levels of print quality. In all cases you are printing to a large printing press, like the Heidelberg press in Figure 12.13. Some presses are smaller and take cut sheets of paper, while others, which are larger and take large rolls of paper, are called web presses.

- *Longevity*—Just as with inkjet printing, the longevity of images from printing presses depends on the type of ink-and-paper combinations used, but the longevity on display would be much less than pigment inkjet prints.
- *Variety of Surfaces*—While a large variety of papers and card stocks are compatible with these presses, there are limits on the thickness of substrates that can be used.
- *Halftone versus Continuous Tone*—Traditional graphic-arts printing presses use (AM) and stochastic (FM) halftone patterns to produce intermediate tones and gradations.
- *Speed*—Although individual prints can be made very quickly from printing presses, it takes a long time to set them up.
- *Size Options*—Depending on the size of the printing press, the print size could be anything from A4 to up to three meters wide.
- *Optimal Volume*—Thousands to millions of copies.
- *Cost*—Printing presses can range in cost from tens of thousands to hundreds of thousands of dollars, so we wouldn't have one at home. Graphic arts printing presses take much more in materials and cost to set up than short-run digital (electrophotographic)

presses. For each color page printed, at least four (CMYK) metal plates must be made and installed onto the press. Since each printing plate needs to be hand-installed and removed, these presses are also more labor intensive. Due to the higher setup costs for printing presses, there is a minimum number of impressions needed to recoup the initial costs. If you were producing a limited-edition fine-art book and didn't reach that minimum number, you would need to charge a much higher price for each book.

- *Dynamic Range/Gamut/Aesthetics*—Just as with inkjet printing, the gamut and dynamic range of images produced on printing presses depends on the ink-and-paper combinations used. One way to increase dynamic range, gamut, or ink density would be to use more inks in making the prints. Black-and-white prints from a printing press using the addition of one or three inks more than black during printing are called *duotones* or *quadtones*, respectively. In color printing on a traditional printing press you can add one, two, or more inks, beyond cyan, magenta, and yellow, to get more color gamut. One example of this is Hexachome or Hi-Fi ink-sets, which include orange and green inks.

FIGURE 12.14 Australian painter and etcher Geoffrey Ricardo (left) looking over as Master Lithographer Peter Lancaster inks-up the cyan plate in making of the hybrid print Falling Palestine.
Credit: Photograph by the author

Hybrid

Hybrid prints are any prints that are made through a combination of digital and traditional printmaking processes. This combination could include digital and analog photographic techniques, like platinum printing or cyanotypes, and digital and fine-art printmaking techniques —such as lithography, etching, screen printing (aka serigraphy), and/or woodblock printing. About the only thing hybrid printing techniques have in common is that there is a computer used at some point in the process.

One simple example of a hybrid digital print process is a photographer shooting digitally, bringing the image onto a computer, then outputting the image to a 4 x 5 or 8 x 10 color negative using the LVT, and finally printing the color negative on an enlarger.

The more common hybrid process used by some artists who are making historical or alternative prints, like platinum, gum bichromate, or cyanotype prints, is to work on the image on the computer and use inkjet prints to produce the negatives for contact printing.

Another example of a hybrid printing process is seen in Figures 12.14 and Figures 12.15. Australian painter and etcher Geoffrey Ricardo scanned in some of his watercolor sketches. These etchings were then manipulated as layers in Adobe Photoshop. The files were output to four digital lithographic printing plates, which were brought to master lithographer Peter Lancaster.

Figure 12.14 shows Peter inking up the cyan plate, which was printed with a hand lithographic stone press into register with the magenta, yellow, and black plates to produce the print, "Falling Palestine," as seen in Figure 12.15. To print "in registration" means that, as each layer, cyan, magenta, yellow, and black, is printed separately and in succession, steps need to be taken to make sure

FIGURE 12.15 Hybrid print *Falling Palestine* by Australian painter and etcher Geoffrey Ricardo made in collaboration with master lithographer Peter Lancaster and others, including me. The print was made with a combination of digital printing press plates and traditional fine art lithographic inks and paper.
Credit: Image by the Geoffrey Ricardo

FIGURE 12.16 Detail showing magenta plate printing out of registration in hybrid print *Pyramid* by Tom P. Ashe made in collaboration with master lithographer Peter Lancaster and others.
Credit: Portion of original photograph by the author

the positioning of each plate and image is exactly one on top of the other. If they are not, the layers will be "out of registration," which can lower the print quality by making the images soft in appearance and difficult to view, as seen in Figure 12.16.

One of the major benefits of this specific process is that it uses traditional lithographic inks and papers, which are rated to last 500 years before fading.

Comparing the hybrid output in general to the other types of output is difficult, since these processes are somewhat unique and non-commercial. In the end, longevity, variety of sizes, cost, whether

the print is halftone or continuous tone, and the gamut will depend on the type of hybrid output you are using.

Labeling Prints

Now that we have looked at the different types of prints, let's take a short time to see how the two major types of fine digital prints are labeled when shown on exhibition: inkjet prints and photographic digital prints.

FIGURE 12.17 Print label for inkjet print by Carolyn Marks Blackwood as displayed at Association of International Photographic Art Dealers (AIPAD) show in New York City. Credit: Photograph by the author

FIGURE 12.18 Label for inkjet print by Elinor Carucci as displayed at Association of International Photographic Art Dealers (AIPAD) show in New York City. Credit: Photograph by the author

Inkjet Prints

Even with all the benefits of digital printing, it's often the case that photographic artists (or at least their galleries) do not want to mention part or all of the process that was used to produce the work. For example, a print by Carolyn Marks Blackwood has been labeled as an "archival digital print," as shown in Figure 12.17. Similarly, a print by Elinor Carucci has been labeled as an "archival pigment print," as shown in Figure 12.18. What process do "archival digital print" and "archival pigment print" describe? You guessed it: *inkjet*. Why not just call it inkjet? Partly because there is not yet an agreed-upon format or practice, but perhaps, more to the point, it's due to perception, prejudice, and marketing.

As mentioned before, the original digital inkjet prints (that were made from the Iris proofer and first Epson prints in the early 1990s) had longevity issues and fading problems, which we will discuss in Chapter 21. Because of these early problems, many dealers and collectors became averse to mentioning that prints were either digital or inkjet.

In addition, there has long been a preference for the unique object in the art world. This is one of the reasons that mechanical processes such as photographs and screenprints have taken longer to be accepted as fine-art objects. Some people feel that if the artist or gallery is too direct about saying that a photograph is an "inkjet print," it will take away the object's perceived uniqueness. They reason that if the viewer or collector has a similar type of printer at home, they won't think a photograph printed with the same technology could possibly be "fine art." Similarly, they might reason that by using the terms "digital" or "computer" when describing a print, it might lead to the perception that that the process was easy, or that the artist or

JOEL-PETER WITKIN
The History of Hats in Art, New York Times, 2006
20 x 16" Archival digital photographs in an ed. of 6
6 photographs in the portfolio
$ 15,000.00 for the set
$ 3000.00 ($ 3200.00 framed) each

Magritte, 2006 (Louis Vuitton wool garden hat)
Hopper, 2006 (Prada fur helmet)
Manet, 2006 (Alexander McQueen feather hat)
Rembrandt, 2006 (Balenciaga criss cross felt hat)
Matisse, 2006 (Dior glasses and head scarf)
Picasso, 2006 (Chanel bowler)

JULIE BLACKMON
Sick Boy, 2008
32 x 42" archival digital print
Ed. #1/10
$ 3800.00 / $ 4450.00 framed

FIGURE 12.19 Print label for inkjet prints by Joel-Peter Witkin as displayed at Association of International Photographic Art Dealers (AIPAD) show in New York City. Credit: Photograph by the author

FIGURE 12.20 Print label for inkjet print by Julie Blackmon as displayed at Association of International Photographic Art Dealers (AIPAD) show in New York City. Credit: Photograph by the author

photographer was less connected to (or more detached from) the artwork.

With these notions in mind, let's look back to Elinor Carucci's print label in Figure 12.18, "archival pigment print." While it doesn't lie, in fact this is the most common way I've seen inkjet prints labeled in the fine-art market, it does avoid mentioning that digital and inkjet are unique parts of the process and accentuates the positive attributes of this type of inkjet print over the dye-based inkjet prints of the past.

Ms. Blackwood and Ms. Carucci's prints and labels were one of many over the past few years that have been on display at the Association of International Photographic Arts Dealers (AIPAD) show in New York City. This show brings together a great variety of vintage and contemporary photography each spring. One of my favorite things is to see how the digital prints are labeled. Figures 12.19 through

12.32 show a number of other examples of the ways digital prints have been labeled at the AIPAD show and in the photographic art market in general.

Figures 12.19 and 12.20 show labels for photographs by Joel-Peter Witkin and Julie Blackmon, respectively. Like Elinor Carucci, both photographers avoided using the label "inkjet" for their prints; they focused instead on the "archival" nature of the inkjet process. Unlike Carucci, Witkin and Blackmon gave us a hint of their processes by telling us they are a "digital photograph" and a "digital print," respectively.

On her label (Figure 12.21), Cara Barer chose to take another route for describing her output. She used "Giclée Print," the name for fine-art inkjet prints coined by master printmaker Jack Duganne. As I mentioned earlier, I'm not a fan of this process description, since

FIGURE 12.21 Print label for inkjet print by Cara Barer as displayed at Association of International Photographic Art Dealers (AIPAD) show in New York City.
Credit: Photograph by the author

FIGURE 12.22 Print label for inkjet print by Dirk McDonnell as displayed at Association of International Photographic Art Dealers (AIPAD) show in New York City.
Credit: Photograph by the author

(1) it has a marketing pretension without substantive difference in meaning than the term "inkjet," and (2) to "spurt" or "spray" (*gicler*) is French slang for an output type that has nothing to do with photography.

Dirk McDonnell's work (Figure 12.22) is very interesting, over and above its misspelling. What process did he use? Mr. McDonnell's label mentions the paper, but nothing else. The print was not a blank piece of paper. The answer? Inkjet. Hahnemühle Photo Rag is a paper specifically coated to receive inkjet inks. It's a good idea to mention the specific paper in the documentation, since it can affect longevity (as we will discuss)—but on the label it should be enough to simply say, "inkjet or pigment ink on photo rag paper."

Chris Jordan and Anne Rowland's labels (Figures 12.23 and 12.24) specifically mention Epson's proprietary Ultrachrome ink technology. As already mentioned, this is a technology in which pigment is coated in gelatin to allow light to go around the particles, which helps both the gamut and the effect of reducing the metameric shift under different lighting conditions.

As with Dirk McDonnell's mention of the paper, Mr. Jordan and Ms. Rowland should contain the use of specific inkjet ink technology

to the print documentation, since the type of ink will affect print longevity, and they should not include it on the label. For the label, it should be enough to indicate that the work was printed as a "pigment inkjet print." Then again, if Epson is sponsoring them, then just like any sports figure they can wear logos with highly compensated pride.

On the second to last of our inkjet print labels (Figure 12.25), D. W. Mellor lets us know not only the name brand, but also the type of the inkjet printer used—plus the fact that it's a digital print. In addition to all of this we are also told that it is a "Fine" print. Once again, a print label should only contain objective process information, definitely not subjective judgments of quality.

The final label of "Epson Ultra Giclée" on Lui Xiaofang's print (Figure 12.26) combines so many things I would avoid in an inkjet print label it's amazing: name brand of printer, a subjective adjective of quality (in reality I think they might have meant Ultrachrome technology), and "Giclée." I can't tell you how excited I was when I was told about it.

So now that we've seen all these labels, what is the best way to label an inkjet print? In my opinion, as mentioned above, if they are pigment based, the prints should be labeled as *pigment inkjet*

FIGURE 12.23 Print label for inkjet print by Chris Jordan as displayed at Association of International Photographic Art Dealers (AIPAD) show in New York City.
Credit: Photograph by the author

FIGURE 12.24 Print label for inkjet print by Anne Rowland as displayed at Association of International Photographic Art Dealers (AIPAD) show in New York City.
Credit: Photograph by the author

FIGURE 12.25 Print label for inkjet print by D. W. Mellor as displayed at Association of International Photographic Art Dealers (AIPAD) show in New York City.
Credit: Photograph by the author

FIGURE 12.26 Print label for inkjet print by Lui Xiaofang as displayed at Association of International Photographic Art Dealers (AIPAD) show in New York City.
Credit: Photograph by the author

prints. This gives the possible collector enough information to know that the print should last over time without fading, but the label does not shy away from, or obfuscate, what the print is and how it was made.

Photographic Digital Prints

As is done in Figure 12.27 with Claudia Kunin's print, it is common to avoid mention of the fact that a computer was involved at all when it comes to labeling photographic prints, like digital chromogenic prints (digital C-prints). In some ways, I have no problem with this. When dealing with issues of longevity, it is typically enough to tell a collector or photo conservator about the way the print should be displayed and stored, as long as they know that the print is a chromogenic one. It's not completely necessary to know how the print has been exposed, i.e., whether it involved a traditional enlarger, lasers, or light emitting diodes (LEDs).

Similarly, the label for Masato Seto's digital C-print (Figure 12.28) only gives us generic information about the print material, with a slightly longer name: "Chromogenic Dye Coupler Print." My only issue with mentioning the dye couplers is that the couplers are colorless in print. What we see when we look at a chromogenic photographic print are the cyan, magenta, and yellow dyes—which were released in the color developer during the RA-4 process—not the couplers.

Vee Speers' print label from the same gallery (Figure 12.29) is not entirely appropriate, because her digital dye-destruction print describes the print as "Cibachrome." Once again, you should avoid describing prints by the name brand of the material, especially a name brand whose use was discontinued 15 to 20 years ago, which is when Cibachrome became Ilfochrome. This is a classic reason why it's better to restrict name brand and product information to the documentation and keep process names as generic as possible. As mentioned earlier, Ifochrome/Cibachrome prints should be described as dye-destruction or silver dye bleach prints.

The label for Mike & Doug Starn's digital C-print (Figure 12.30) includes the name of the device used to expose the light-sensitive chromogenic material, the Durst Lambda, which uses lasers to create exposures.

FIGURE 12.27 Label for photographic digital print by Claudia Kunin as displayed at Association of International Photographic Art Dealers (AIPAD) show in New York City. Credit: Photograph by the author

FIGURE 12.28 Label for photographic digital print by Masato Seto as displayed at Association of International Photographic Art Dealers (AIPAD) show in New York City. Credit: Photograph by the author

FIGURE 12.29 Label for photographic digital print by Vee Speers as displayed at Association of International Photographic Art Dealers (AIPAD) show in New York City. Credit: Photograph by the author

FIGURE 12.30 Label for photographic digital print by Mike + Doug Starn as displayed at Association of International Photographic Art Dealers (AIPAD) show in New York City. Credit: Photograph by the author

FIGURE 12.31 Label for photographic digital print by Andreas Gefeller as displayed at Association of International Photographic Art Dealers (AIPAD) show in New York City. Credit: Photograph by the author

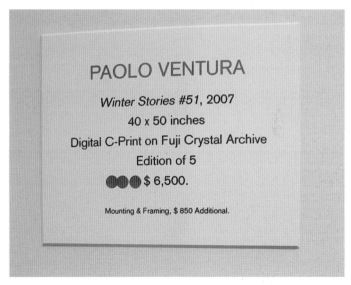

FIGURE 12.32 Label for photographic digital print by Paolo Ventura as displayed at Association of International Photographic Art Dealers (AIPAD) show in New York City. Credit: Photograph by the author

Finally, the labels for Andreas Gefeller and Paolo Ventura's digital C-prints (Figures 12.31 and 12.32) show the brand names of the chromogenic papers: Kodak Endura and Fuji Crystal Archive. As mentioned before, this information would typically be best left for the print documentation. Still, I can understand that promoting this information could be useful for sales if collectors generally know that both of these papers will have greater longevity than older types of chromogenic materials.

EXPLORATIONS

The main things for you to do now are to start looking closely at printed images in magazines and newspapers, and off your inkjet printer. Use a loop or magnifying glass to examine the halftone patterns. Are they AM or FM (stochastic)? At galleries and museums, inspect the prints, but not so closely that you get into trouble. Review the labels and see if you can identify the type of print.

Conclusion

All of the topics in this chapter have been about the various types of digital output—and about your options for labeling fine art digital prints. Hopefully, you are now more comfortable identifying the different types of digital prints and understanding the benefits and detriments of each. As you go to galleries and museums in the future, notice the types of prints and how other artists are labeling them. Enjoy!

Resources

Benson, Richard, *The Printed Picture*, Modern Museum of Art, New York, 2008. ISBN-13: 978–0870–70721–6.

Jürgens, Martin C., *The Digital Print: Identification and Preservation*, Getty Conservation Institute, Los Angeles, 2009. ISBN-13: 978–0892–36960–7.

Inkjet

Canon
> http://www.canon.com

Epson
> http://www.epson.com

HP Designjet Large Format Photo Printers
> http:// www.hp.com

Durst UV Curing Inkjet
> http://www.durstus.com/inkjet.php

Photographic Output

Océ (discontinued but still using Lightjet—currently display inkjet products)

Durst Lambda (discontinued)
> http://www.durstus.com/photo.php

FujiFilm Frontier Digital Minilabs
> http://www.fujifilm.com/

Noriitsu Digital Minilab and Large Format Printer
> http://www.noritsu.com

Polielettronica
> http://www.polielettronica.it/

ZBE Chromira LED Photographic Printers
> http://www.zbe.com/

Dye-Sublimation

KODAK PROFESSIONAL Thermal Printer Media
> http://www.kodak.com

DNP Event Retail and ID Printers
> http://www.dnpphoto.com

Electrophotographic

HP Indigo Digital Presses
> http:// www.hp.com

KODAK NEXPRESS Digital Color Presses
> http://graphics.kodak.com/

Xerox Digital Presses
> http://www.xerox.com/digital-printing/

Traditional Graphic Arts

Heidelberg
> http://www.heidelberg.com

INKJET
PRINTING

In the last chapter we discussed your different digital output options, including inkjet. Whether your final prints are called archival pigment prints, Iris prints, Epson Ultra Giclée prints, or pigment inkjet prints, as I'd recommend, inkjet is most probably the type of output most of you will be using, so in this chapter we will look more closely at inkjet prints. First we will look at the different types of inkjet printing and ink technologies. Then we will explore all the different types of media you might be printing onto using inkjet, since, as we mentioned before, one of the biggest benefits of using inkjet printers is the amazing variety of media on which you can print. We will then discuss the issues and procedures to use when printing onto thicker, ridged, and specialty media. Finally we will discuss how to choose the best media for your inkjet output depending on your project and your application.

Different Types of Inkjet Printers

As we have discussed in the last chapter, inkjet output is made from drops of ink forming our images as halftone dots. Typically these cyan, magenta, yellow, and black (CMYK) dots are in a frequency-modulated (FM) or random stochastic pattern. As you know, in addition to the random halftone dot pattern printed at a high DPI resolution, light cyan, magenta, and black inks might be used in the highlights (lighter areas of the image) to make some inkjet prints appear more continuous tone, as seen in Figure 13.1. There are three major types of inkjet printers used to make photographic inkjet prints: continuous, piezoelectric drop-on-demand, and thermal drop-on-demand.

Continuous Inkjet

Although not used as much as in the past for making fine-art and photographic digital prints, continuous inkjet printers have played an important role in fine-art digital printmaking.

In 1989, Graham Nash, the musician and photographer, was asked by a gallery in Japan to produce an exhibition of 20 x 24-inch black-and-white prints of his work. Because he did not want to spend the time in the darkroom, he looked for alternative methods for producing the prints. Of course, there weren't many at that time. Mac Holbert, his road manager and a technology enthusiast, introduced Nash to Steve Boulter, who worked for a company called Iris Graphics that produced a high-end, continuous inkjet-based output device, as shown in Figure 13.2. The main use of the Iris 3047 printer at the time was to produce digital proofs for the commercial printing industry. The proofs the Iris made were used as simulations of output from graphic arts printing presses, which allowed for evaluation and corrections before making the expensive print job. Nash, Holbert, and Boulter decided to attempt to use this specialized commercial device for printing Nash's exhibition. After lots of experimentation and adjustments, including making the Iris accept thicker fine-art papers, they were able to make the exhibition prints and had created a process for creating digital photographic prints. In 1991, Nash Editions was opened in Manhattan Beach, to help other artists and photographers produce digital prints. Soon other printmakers, like Jon Cone, Richard Adamson, and Jonathan Singer, were using the Iris 3047 to produce fine-art and photographic inkjet prints.

On the Iris 3047 continuous inkjet printer, the media is put onto a drum that rotates during printing. The print head with its cyan, magenta, yellow, and black nozzles then moves across the page sending droplets of ink to the surface of the media at a very fast rate. The number of droplets used to create the halftone dots control their size and density. Larger dots have more density than smaller dots, which are lighter. The fact that these halftone dots can vary slightly in density allows the prints to appear more like continuous tone than other types of inkjet.

For many reasons the Iris continuous inkjet printer is no longer being used as much for creating photographic prints. First, they have

FIGURE 13.1 Detail of cloud and sky in inkjet print from an Epson 3880 at 720 dots per inch (DPI) resolution showing its random FM stochastic halftone pattern and light magenta, cyan, and black inks, which help the final print appear more like continuous tone.
Credit: Portion of original photograph by the author

FIGURE 13.3 Epson 9880 Inkjet Printer, which uses Piezoelecronic Drop-on-Demand printing.
Credit: Photograph by the author

FIGURE 13.2 Iris Printer Proofer at Ribuoli Digital in New York City.
Credit: Photograph, © Andre Ribuoli (ribuolidigital.com)

been notoriously difficult and expensive to maintain; they also require an operator who is highly trained; as we will discuss in Chapter 21, the dye-based inks they use are not optimal for print longevity; and they have been largely supplanted by large format pigment-based drop-on-demand inkjet prints made by Canon, Epson, and Hewlett Packard. In fact, in 2005, Nash Editions original IRIS 3047 graphics printer was donated to the Smithsonian's National Museum of American History.

Piezoelectric Drop-on-Demand

Epson, which is part of the Seiko Group, utilizes piezoelectric technology, which is used in Seiko electronic watches. In this printing technology, as in the Epson 9880, shown in Figure 13.3, each nozzle of the print head has a piezoelectric element that changes shape depending on the amount of electrical charge sent to it. The first change in shape to the piezoelectric element pushes the ink from the nozzle and second change pulls back the ink and controls the size of the drop of ink released, as seen in Figure 13.4.

As mentioned before, to increase the speed of their printers Epson and other manufacturers have increased their print head size, so that more of the print area is printed with each pass of the print head.

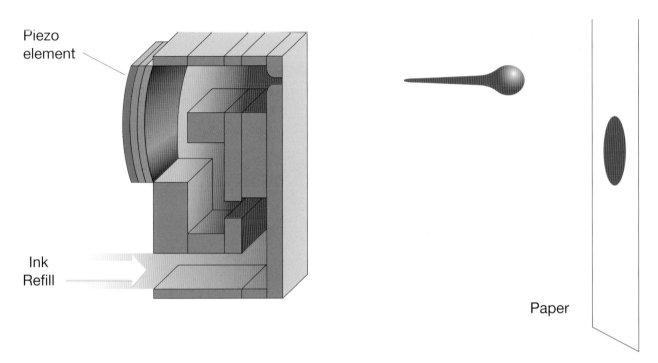

Piezo element

Ink Refill

Paper

FIGURE 13.4 Illustration of Piezoelecronic Drop-on-Demand printer nozzles forming and releasing a droplet of ink and dot on paper.
Credit: Illustration adapted from Jürgens 2009, Figure 4.19.

Thermal Drop-on-Demand

In the thermal drop-on-demand inkjet printers each nozzle of the print head has a heating element connected to it. To eject a droplet from each nozzle, a pulse of electricity is passed through the heating element causing a rapid vaporization of the ink in the nozzle chamber to form a bubble, which causes a large pressure increase, propelling a droplet of ink onto the paper. This is where Canon's trade name of Bubble Jet originated. Both Hewlett Packard and Canon inkjet printers, like the Canon PIXMA PRO-1 Photo Printer, shown in Figure 13.5, use the thermal drop-on-demand technology. Canon refers to their print head technology as FINE (Full-photolithography Inkjet Nozzle Engineering), which they say allows them to control the size of the droplets, and therefore resolution (DPI) with great precision.

FIGURE 13.5 Canon PIXMA PRO-1 Photo Printer, which uses Thermal Drop-on-Demand printing technology.
Credit: Photograph by the author

Ink Technologies

The type of ink used as a colorant in the continuous or drop-on-demand inkjet printers has a big impact on the aesthetic and archival properties of the final print, along with determining the types of surfaces and substrates that can be printed onto optimally. The main types of inks we will discuss are: aqueous dye, aqueous pigment, and solvent and UV-curable.

Aqueous Dye

The aqueous in aqueous dye and aqueous pigment refers to the fact that water is the main liquid vehicle for transporting the dyes and pigments to the printed page. With both types of aqueous inkjet inks, the water evaporates and leaves just the colorant.

The difference in particle size means that dye-based inks have some benefits over pigment-based inks. The main benefit is that the small particle size allows light to bend around the dye molecules, which results in a color transparency that gives prints made from dye-based inks a larger color gamut than prints made from pigment-based inks. The small particle size also allows dye-based inks to more easily permeate porous surfaces and substrates and not simply lie on the surface, as is common with pigment-based inks.

On the negative side, dye-based inks are more susceptible to moisture, impermanence, and fading. You do not want to get a dye-based inkjet print wet. The dyes will be more easily dissolved from prints and parts of the image could be removed. For this reason I make a habit of covering my mouth when examining digital prints, so any spray from my words do not inadvertently hit the print. As we will discuss more in Chapter 21, dye-based prints are also more susceptible to fading over time and when on display than pigment-based prints.

Dye-based inkjet systems can make more sense for applications where the print longevity is not as important. For example, if your printer is only being used to make hard-copy proofs, before a printing

What is the Difference between a Dye and Pigment?

The basic difference between a dye and a pigment is the size of the particle. A dye particle is very, very small. A dye is a molecule, which is the smallest set of atoms bonded together in a chemical compound. A pigment is a compound made of many molecules clumped together and can be made up of particles 1000 times larger than a dye molecule.

job goes to press. These proofs from dye-based inkjet may only need to be around for months or at the most a year without fading. They won't be saved after this.

Aqueous Pigment

For those of us making photographic or fine-art prints, we want our prints to last as long as possible, so we choose to use pigment-based inkjet printers and inks to give us better longevity and fade resistance.

Despite the loss of color gamut with pigment-based inkjet output, the increased longevity for us as photographers is worth it. That being said, the ink manufacturers do things to help increase the color gamut from pigment-based inkjet prints. The first thing they do is to mill the inkjet particles to be an order of magnitude smaller and a more uniform size (100 times larger, not 1000 times larger than the dye molecules). This increases the ability of light to bend around the particles, the color transparency and, therefore, the color gamut. They also mill the pigment particles so that the larger pigment particles will not clog print head nozzles. In the case of Epson UltraChrome ink technology, Epson, also, encapsulates or coats the milled pigment particles with a resin, which allows even more transparency and color gamut from the resulting prints.

The encapsulated resin coating on the pigment particles also helps somewhat to alleviate one of the other negative aspects of pigment-based inkjet prints: they are more susceptible to *bronzing* or *gloss differential*. Since the pigment particles are larger and they sit

FIGURE 13.6 Detail of post-printing pickoff of ink from the black areas of a pigment-based inkjet print fine-art paper by Simon Chantasirivisal.
Credit: Portion of print and photograph by Simon Chantasirivisal (simon-chantasirivisal.com)

on the surface of the print, more than dye-based inks, this results in us being able to see the inks on the surface of the print, especially when we view the print from the side and the print is on glossy or luster resin-coated photographic inkjet papers. This optical difference between where you have ink and do not have ink on the print can at times be distracting. In some inkjet systems, they add another ink Epson has called a gloss optimizer, which is coated in the areas that do not have ink, so the image and non-image areas look more similar.

The final side effect of pigment-based inkjet prints to watch out for is a lack of physical robustness. Since the pigment particles are larger and sit on the surface of the print instead of permeating the media, they can be more susceptible to physical damage or pick-off.

This is especially true of pigment-based inkjet prints on matte papers. As seen in Figure 13.6, the many white spots on the print are areas where the ink has come off the print due to abrasion. As we will discuss in Chapter 21, it will be important for you to remember to handle these pigment-based prints carefully and protect them from this type of physical damage, by framing them or spraying them with a lacquer.

Solvent and UV-Curable

Both of these non-aqueous inks, solvent and UV-curable, have a major benefit in that they can be used for printing directly onto a greater

variety of surfaces than the dye or pigment aqueous inks. Solvent and UV-curable inks are commonly used for outdoor signage and banners, as well as printing onto metal surfaces. The major downside to these types of inks is that they are not environmentally friendly or especially safe, since they typically contain toxic materials.

Solvent inks contain dyes in mainly solvents other than water, like ethanol, which will evaporate quickly and leave behind the colorant and a binder on the media. Solvent inks that use a combination of water and the non-water solvents are called *eco-solvent* inks. According to photograph conservator and author Martin Jürgens, the typical media used with solvent inks are "coated or uncoated paper, film, poly(vinyl chloride) banner, natural and synthetic textiles, and synthetic papers."[1]

UV-curable inks are printed onto the media almost entirely as pigment that is almost instantly covered and protected by a membrane whose formation is triggered by a brief exposure to ultraviolet (UV) energy. This allows the ink to stay on the surface, regardless to whether it has been treated to accept ink. UV-curable inks are used for printing directly onto many plastic and metal surfaces. For both commercial and fine-art purposes, you can print onto a variety of ridged materials using *flatbed* UV-curable printers. You do not want to use aqueous inkjet prints to print onto untreated outdoor display materials meant for UV-curable printing. If you do, the aqueous ink will not adhere, as you can see in Figure 13.7.

FIGURE 13.7 Detail of print made with aqueous pigment-based inks from an Epson 9880 printer onto an uncoated plastic meant for printing outdoor sign graphics with UV-curable ink printer showing the image not adhering to the substrate and smudging off.
Credit: Photograph by the author

Paper and Media Technologies

As we discussed in the last chapter, one of the best things about inkjet is the variety of surfaces we can print onto using this type of output compared with other types of output. The creative and aesthetic possibilities are amazing! But, as we can see from Figure 13.7, it is important for us to understand what types of media are compatible with, and optimal for, the type of inkjet printing and ink technology we are using. In this section we will look at issues and examples of inkjet printing onto uncoated papers, papers coated and treated for inkjet, resin coated papers, baryta papers, canvas, polyester and vinyl media, fabrics, and metal or ridged surfaces.

Uncoated Papers

Uncoated papers could mean anything from plain office paper, newsprint, handmade papers, or fine-art papers for etching or watercolor. What these papers have in common is that they have not been treated or coated for use with inkjet (or any other) inks. As we have discussed before, from an aesthetic and color reproduction standpoint, inkjet prints on uncoated media will have less dynamic range and color gamut (saturated colors). To review, by dynamic range we mean that the prints will not typically have as bright a white or as dark a black as they would on papers that have been coated for inkjet.

You can use dye-based or pigment-based inks with uncoated papers. The toughest part of printing onto these surfaces, as with other media, is finding the optimal ink limit or media type to select in the print driver. You want enough ink for as wide a dynamic range and gamut as possible, but not too much ink where the image bleeds through or can be seen on the other side of the page.

The reasons you might use these papers could vary from financial to aesthetic and artistic. Uncoated papers of all kinds will often be less expensive than papers that have been coated for use on inkjet printers. In Figure 13.8, the print made by Lindsey Elsaesser on handmade paper shows the expected limits in dynamic range and gamut for printing on uncoated paper, but this aesthetic does not hamper the image. In fact it enhances the more naturalistic aspect of the

FIGURE 13.8 Pigment inkjet print on uncoated handmade paper by Lindsey A. Elsaesser showing less dynamic range and gamut than a print on coated paper, but the print and paper combination does express the naturalistic feel of the image.
Credit: Print and image by Lindsey A. Elsaesser

subject and scene. Figure 13.9 shows Marla Silverstein's print on inexpensive newsprint paper. In this case, Marla has used the uncoated media as a statement about the preciousness of the "fine-art print" and to improve accessibility of her work to more viewers and collectors.

Coated Matte and Fine-Art Papers

Coated matte or fine-art papers have been treated so that ink will remain on the surface of the paper, unlike with uncoated papers, which absorb more of the ink. By allowing the ink to remain on the surface of the print, we get more ink density on the coated paper, which results in better dynamic range and gamut in the printed output, as seen in Figure 13.10.

Marla Silverstein RE: Nature

1/10

FIGURE 13.9 Pigment inkjet print on uncoated newsprint paper by Marla S. Silverstein showing less dynamic range and gamut than a print on coated paper, but the print and paper combination was used to express a more democratic and accessible version of a fine art image.
Credit: Print and image by Marla S. Silverstein

FIGURE 13.10 *(right)* Pigment inkjet print on coated Japanese Niyoda White paper by Olivia Stonner showing more dynamic range and gamut than a print on uncoated paper.
Credit: Print and image by Olivia Stonner (oliviastonner.com)

How do You Find the Coated Side of Matte or Fine-Art Papers?

Figure 13.11 shows what happens when you print on the wrong side of a coated inkjet paper: your print will have lower density, dynamic range, and gamut than expected. Sometimes it can be hard to tell which side is the coated side of the paper. There are two ways to determine which sided is coated and which side is uncoated: (a) compare the paper white and/or (b) do the lip or stick test: (a) on some coated matte papers, the easiest way to tell which side is coated is to examine both sides of the paper. The whiter/brighter side should be the coated side; (b) if it is too difficult to determine the brightness difference between the two sides, you can perform the lip or stick test. With the lip test you simply moisten your lower lip and place the paper to it. The side with the inkjet coating will stick; the uncoated side will not stick as much, if at all. If you don't want to put your mouth to the paper (and who can blame you for that), you can simply moisten the tips of your fingers. Once again, the side that sticks is the coated side.

FIGURE 13.11 Portion of pigment inkjet test print on the wrong side of a coated matte inkjet paper by Alexandre F. Nunes, showing the resulting lack of dynamic range than expected.
Credit: Print and image by Alexandre F. Nunes (zaxophoto.com)

Resin Coated Papers

Glossy and luster resin-coated or RC papers have been used in traditional photography for many decades. As the name suggests, these materials are made of paper that has been coated with polyethylene. These RC papers were originally used in photography, because they could be processed more efficiently, especially by machines, than traditional fiber/baryta-based photographic papers. The main efficiency is in washing. Resin coated papers do not absorb as much of the photo chemicals, so they don't require as much time to wash them out. The coating also allows the print to remain flatter, with less buckling or cockling than with the fiber/baryta-based photographic papers.

For inkjet printing, similar RC type papers have been created, so they would look like the photographic prints we are used to seeing. There are two main types of resin coated inkjet papers: *polymer* coated and *microporous*. Polymer coated or *swellable* RC papers, as seen in

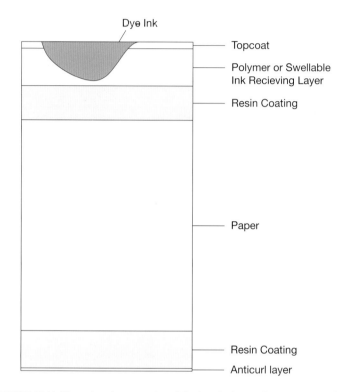

FIGURE 13.12 Illustration of cross section of dye-based ink on polymer resin coated (RC) inkjet paper, which is meant to be similar to photographic RC papers.
Credit: Illustration adapted from Jürgens 2009, Figure 4.25.

Figure 13.12, are for dye-based inkjet inks only. The tiny dye molecules in the dye-based ink permeate the polymer layer that swells from the water solvent that goes with the ink. The dye particles remain in the polymer layer, which returns to a smooth surface, after the print has dried.

Both dye-based and pigment-based aqueous inkjet inks can be used with microporous RC inkjet papers. As Martin Jürgens describes, microporous papers, as shown in Figure 13.13, have ink-receiving layers, which function "like inorganic sponges."[2] The water part of the dye-based or pigment-based aqueous ink is absorbed quickly into the microporous layer, leaving the ink near the surface and the print

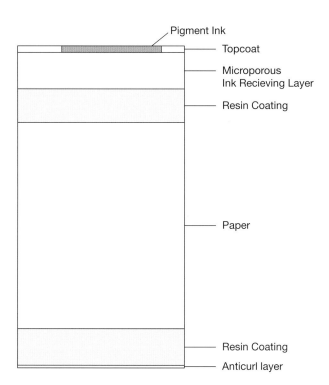

FIGURE 13.13 Illustration of cross section of pigment-based ink on microporous resin coated (RC) inkjet paper, which is meant to be similar to photographic RC papers. Credit: Illustration adapted from Jürgens 2009, Figure 4.31.

FIGURE 13.14 Detail of print where Epson UltraChrome pigment ink was incorrectly used to print onto HP polymer RC inkjet paper, which was meant for dye-based inkjet and resulted in the clumping of pigment particles on the surface of the print and gloss differential, especially in the darker areas.

feeling dry to the touch. Dye-based inks are somewhat absorbed into the microporous surface, but the large particles of pigment-based inks stay more on the surface.

It is important to make sure the inkjet paper you are using is meant for pigment-based ink. Figure 13.14 shows what happens if you print with pigment-based ink onto the polymer RC paper. The pigment particles remain on the surface, clump together, and cause a large amount of gloss differential.

Baryta Papers

More recently, inkjet manufacturers have been putting microporous ink receiving layers onto papers that are similar to traditional fiber-based silver-gelatin (black-and-white) photographic papers, as in Figure 13.5. The photographic silver gelatin fiber/baryta prints are historically more archival and considered higher quality than RC prints. Baryta refers to a coating of barium sulfate used to make these traditional photographic papers smoother and whiter. Some of the fiber/baryta papers have matte surfaces, which will look better when used with

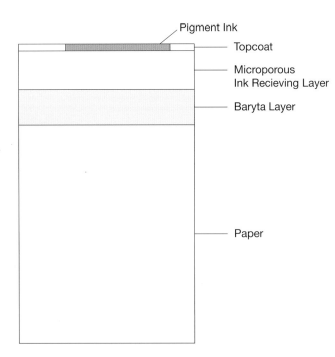

Pigment Ink

—— Topcoat

—— Microporous
Ink Recieving Layer

—— Baryta Layer

—— Paper

matte black ink, while others have a semi-gloss surface, which should be used with photo black ink. None of the fiber/baryta papers have a high gloss surface. Some examples are: Canson Infinity Baryta Photographique, Epson Exhibition Fiber, Hahnemühle Fine Art Baryta, Ilford Gold Fibre Silk, Innova FibaPrint Ultra-Smooth Glossy, and Moab Colorado Fiber Gloss.

Canvas Media

To produce inkjet output that references or looks more like paintings, you can output to canvas media, like Charles Putnins' images in Figure

FIGURE 13.15 Illustration of cross section of pigment-based ink on baryta fiber inkjet paper, which is similar to photographic fiber-based papers.
Credit: Illustration adapted from Jürgens 2009, Figure 4.31.

FIGURE 13.16 Charles Putnins with his landscape pigment inkjet prints on Epson canvas media before they have been stretched and attached to wooden frames.
Credit: Photograph by the author

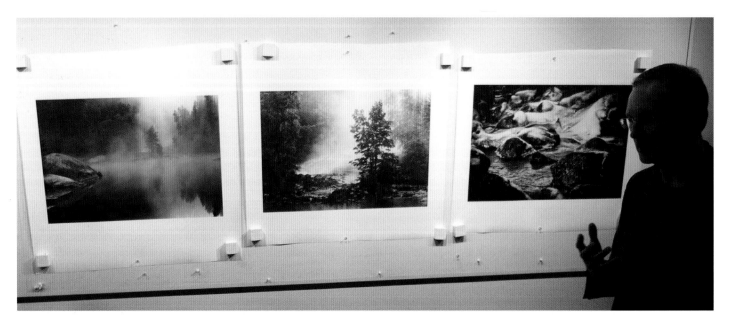

FIGURE 13.17 Pigment inkjet print on non-coated side of canvas media by Stephanie Sauer showing less dynamic range and gamut than would result on the coated side, but Stephanie felt this fit her work better.
Credit: Print and image by Stephanie Sauer

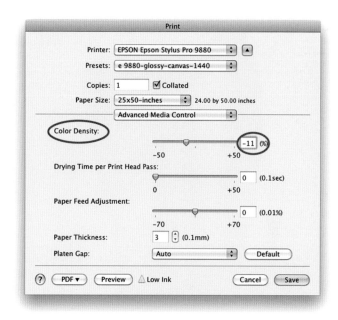

FIGURE 13.18 Advanced Media Settings in Epson 9880 printer driver when printing with Glossy Canvas media, showing the necessary reduction in color density.

13.16, which can then be pulled over traditional stretcher bars for display. Of course, it is also possible to print on the uncoated and untreated side of the canvas, as Stephanie Sauer did in her print in Figure 13.17. Besides original work, printing onto canvas is often done for fine-art reproduction. When printing onto canvas, it is important to refer to the media settings recommended by the canvas manufacturer. Figure 13.18 shows the **Advanced Media** settings Epson recommends when using its Glossy Canvas media in the Epson 9880. Notice that the **Color Density** has been brought down to −11%. Too high an ink laid down could lead to pooling of ink and a loss of detail. Pigment-based inkjet output onto canvas, because of the rough surface, can be especially delicate, so finishing the prints with a protective spray will be important, as we will discuss in Chapter 21.

Polyester and Vinyl Media

Prints on plastic media coated for inkjet can have very high-gloss dimensional stability, dynamic range, and gamut, like the print in Figure 13.19. These plastic media could be white polyester, clear polyester, polypropylene with adhesive, or Tyvek(r) banner materials. As we saw in Figure 13.7, it is important to make sure the material is compatible with the type of inkjet ink technology you are using. It should also be

noted that inkjet output onto clear media does not, typically, give as much density as photographic output onto clear film. Also, since many of the plastic media types we are discussing here are often used in the display and signage industry, for optimal outdoor stability and durability, solvent or UV-curable inks might be better than aqueous pigment inks.

Fabrics

Some fabrics are coated to be able to be compatible with direct aqueous dye and pigment-based inkjet printing. They range from cottons, to silks, polyesters, and satins. Some inkjet systems will require steaming and washing to make the image complete. There are also some systems that transfer the inkjet image to fabric by first printing onto a material that is then put in contact with the fabric and the image is transferred to the fabric by ironing. With these transfer

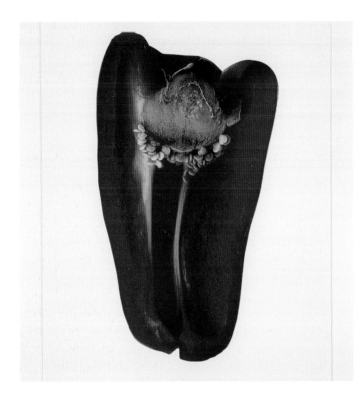

FIGURE 13.19 Pigment inkjet print on polyester based Mitsubishi Pictorico White Film media by Alan Woo showing high gloss, dynamic range, and gamut, which is appropriate for this very saturated somewhat commercial image.
Credit: Print and image by Alan Woo (alanwoo.com)

systems it is important to reverse the image by selecting a flip horizontal or mirror image option, so the image is right read on the final print.

Metal and Rigid Media

As with printing onto fabrics, it is possible to us the image transfer method on other ridged materials like wood, as Christopher Borrok did with his print in Figure 13.20. If you want to print directly onto thin pieces of metal, glass, or wood veneer, you would need to pre-coat the material with a spay like inkAID(tm). Hyun Suh Kim did this for the print she made of the image by Felis Nam Hoon Kim in Figure 13.21. There are also ridged materials like metal, which have been already coated for inkjet by companies like Booksmart Studio in Rochester, New York.

FIGURE 13.20 Transferred pigment inkjet image on a wooden plank by Christopher Borrok.
Credit: Print and image by Christopher Borrok (borrok.com)

FIGURE 13.21 Pigment inkjet print on coated brass plate by Hyun Suh Kim for an image by Felix Nam Hoon Kim shown at an angle so the image appears more fully. The metal plate needed to be coated first so that the aqueous pigment ink would adhere. The coating in this case was not very uniform.
Credit: Image by Felix Nam Hoon Kim (atelierbyfelix.com). Retouching and print by Hyun Suh Kim (hyunsuh.com).

Finding and Setting the Thickness of the Paper

The first step in setting the printer driver or printer correctly is finding the thickness of the paper. To do this you want to find the paper's specifications on the box or manufacturer's website. Figure 13.23 shows the specifications for two different papers: Hahnemühle Museum Etching paper on the left and Moab Entrada Rag Natural 300 on the right. As you can see in Figure 13.24, the Epson driver can set the **Paper Thickness** as a whole unit from 1 to 15. This number represents tenths of millimeters from 0.1 mm to 1.5 mm. Hahnemühle makes setting this easy for us, since it gives the thickness as "0.6 mm," which means we would set the **Paper Thickness** in the driver to **6**. The Moab Entrada is a little tougher, since it gives the caliper (another word for thickness) as "22.5mil." First, mils are thousandths of an inch, so 22.5 mils = 0.0225 inches. Our next step is to convert from mils into millimeters. I do this by typing the following into a Google search: "22.5 mils = ? mm." The result is 22.5 mils = 0.5715 millimeters. This rounds to 0.6 mm, so for the Moab paper we would also set the **Paper Thickness** in the driver to **6**, as shown in Figure 13.24.

Printing with Irregular, Thick, or Rigid Media

In Chapter 8 we briefly discussed some of the issues when printing on thicker media like fine-art papers, specifically setting the thickness of the media and the platen gap in the printer driver, so you do not get head strike from the print head hitting the edges of your paper as it is moving past the media while printing your output, as in Figure 13.22. Besides the head strike marks on the edges, not having the thickness set properly can also lead to abrasion lines from removed ink and knocking the print out of registration.

Like the **Paper Thickness** setting in **Advanced Media Control**, the **Platen Gap** controls the distance the print head is from your paper. When the **Platen Gap** is set to **Auto**, as in Figure 13.24, the media type selected in the **Printer** settings portion of the driver determines how the platen gap is set. According to the ImagePrint RIP blog, the correlation of platen gap setting to paper weight in grams per square meter (gsm) is: "Narrow = 150 gsm, Standard = 190 gsm, Wide = 260 gsm, Wider = 320 gsm and Widest = 500 gsm."[3] The only reason to manually set the platen gap is if you are getting head strike, which means you would make it larger; or image softness, which you would make smaller.

FIGURE 13.22 Pigment inkjet print on uncoated fine art paper that shows printer head strikes on the left- and right-hand sides of the print, which means the print head should have been raised slightly higher by changing the paper thickness setting in the printer driver.

Credit: Print and photograph by the author

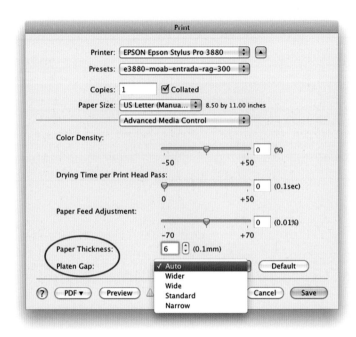

FIGURE 13.24 Setting the Thickness and Platen Gap in the Advanced Media Controls section of the Epson 3880 printer driver for Moab Entrada Rag Natural 300.

Technical Specifications

	Unit	Valuation	Test Norm / Notes
Test Conditions			23°C / 50% R.H.
Weight	gsm	350	EN ISO 536
Thickness	mm	0,60	EN 20534
Whiteness	%	87,0	ISO 11475, D65 2°
Media Colour		natural white	
Opacity	%	99,0	ISO 2471
pH-Value total		8,1	DIN 53124
Acid free		yes	
Calcium Carbonate buffered		yes	
Water Resistance		very high	
Drying Behaviour		instant	
Surface Finish		matt	
OBA Content		none	
Additional Comments			

All indicated data to be understood as typical average values.

Physical Specifications

Type of Material	100% Cotton
Basis Weight	300gsm
Caliper	22.5mil
Buffering	Calcium carbonate
Whiteness (RTM–0013)	84%
OBA Content	None
Acid Free	Yes
PH Value	8
Surface	Matte

FIGURE 13.23 Specifications for two different papers: Hahnemühle Museum Etching paper on the left and Moab Entrada Rag Natural 300 on the right, specifically highlighting the thickness of the two papers.

FIGURE 13.25 Sheet feeder on Epson 3880 printer, which can only be used for thinner and flexible media, like plain paper, some matte papers, RC glossy and luster papers. Credit: Photograph by the author

FIGURE 13.26 Manual rear feed mechanism on Epson 3880 printer, which is typically used for thicker, more ridged or delicate media, like fine art and fiber/baryta papers. Only one sheet can be fed at a time. Credit: Photograph by the author

FIGURE 13.27 Manual front feed mechanism on Epson 3880 printer, which is typically used for completely ridged media, like glass, metal, wood veneer or cardboard. Watch the thickness limitations. Only one sheet can be fed at a time using this method. Credit: Photograph by the author

Printing on thicker media often requires you to change how the material is being fed into the printer. Sheet feeders are typically limited to printing onto thinner and flexible media, like plain paper, some matte papers, RC glossy and luster papers, as shown in Figure 13.25. For printing on thicker fine-art and more delicate and ridged media like fiber/baryta papers, use a more direct route that doesn't bend the paper as much when the paper is being fed into the printer, as you can see on the Epson 3880 in Figure 13.26. Finally if you are printing onto metal, glass, plastic, or any other completely ridged material, you would need to use a feed mechanism with no bend in the media path at all, as with the front feed mechanism on the Epson 3880 in Figure 13.27. Both manual feed methods require feeding one sheet of media at a time when printing, which takes more operator intervention.

Choosing Media for Printing

So many options! How do you choose? Part of the ability to choose comes down to experience with printing on as much media as possible with your printer. The next part is to look at how the print will be used and displayed. Will the print be framed behind glass on a wall or pinned up and unprotected? If the print will be behind glass, possibly the surface does not matter as much as gamut and dynamic range. Will print be pages in a book? If the prints will be pages in a book, the thickness and fold-ability of the paper will be important. Will viewers be touching and handling the print? If your viewer is handling the prints, as in a book, the touch, feel, and weight will be more important. What aesthetic properties are most important? Shadow detail? Gamut? Smoothness? If you want as much shadow detail and gamut as possible, then you might want to be on the media that uses Photo Black ink, like luster, glossy, or fiber/baryta papers. If the smoothness of surface and a lack of reflections is most important, you should be looking at matte and fine art media.

Besides these practical and aesthetic reasons for a media choice, you should also consider conceptual artistic reasons for choosing a media. Ask yourself, what media or surface could I choose to print onto that would enhance and support the overall meaning of the work? There could be symbolic or personally meaningful reasons to choose a certain surface to print onto. Since inkjet technology allows for so many possibilities, be open to using something other than another sheet of luster RC paper.

Conclusion

Hopefully from this chapter you have gotten a more complete understanding in the different types of inkjet printers and ink. But the most important things you should be excited about are the possibilities of the different media you can print onto with inkjet. It's time to start experimenting!

EXPLORATIONS

As you can see there are so many options for what you can be printing onto with your inkjet printer depending on the piece you are creating. The only way for you to be sure which media is right, is to have experience with as many media types as possible. It's time to buy some sample packs of different papers, visit art stores and see what they have, and try printing your test page on the media you've found. For this testing, it should be fine to use the generic printer/paper profiles supplied by the paper manufacturers. Have fun!

Resources

Booksmart Studio, Rochester, NY
> http://www.booksmartstudio.com/

Darlow, Andrew, *301 Inkjet Tips and Techniques: An Essential Printing Resource for Photographers (Digital Process and Print)*, Course Technology PTR, Boston, 2007. ISBN-13: 978–1598–63204–0.

Epson Wide Format Users Group
> http://tech.groups.yahoo.com/group/EpsonWideFormat/

Johnson, Harald, *Mastering Digital Printing, Second Edition (Digital Process and Print)*, Course Technology PTR, Boston, 2004. ISBN-13: 978–1592–00431–7.

Notes

1. Jürgens, Martin C., *The Digital Print: Identification and Preservation*. Getty Conservation Institute, Los Angeles, 2009, pp. 99-100.

2. Jürgens, Martin C., p. 93.

3. ImagePrint Today (July 14, 2011), *The Platen Gap*. Retrieved from http://imageprinttoday.wordpress.com/2011/07/14/the-platen-gap/.

BLACK-AND-WHITE DIGITAL PRINTMAKING

Producing good quality black-and-white prints using standard inkjet technology is a big challenge—especially when those prints are compared against traditional silver gelatin prints. It doesn't help that most of us are very sensitive to shifts in neutrals; we're much more likely to see problems in neutrality that we'd overlook in color prints.

Problems of Printing Black-and-White Inkjet Prints

The problems that relate to black-and-white inkjet prints include: a lack of neutrality, cross curves, metameric failure, halftone dots, and dynamic range.

Lack of Neutrality

One of the most difficult things about using cyan, magenta, yellow, and black inks to produce black-and-white prints has typically been getting the prints to appear neutral. Even when we use the right application, driver settings, and custom profiles, we can still see colorcasts in black-and-white prints. This is because most drivers and ICC profiling packages are optimized for color output, not for black-and-white.

FIGURE 14.1 Black-and-white image from inkjet print series by Kevin Keith. Credit: Photograph, © Kevin Keith (kevinkeithphoto.com)

Cross Curves

At times, the colorcasts in black-and-white prints can appear different in the highlights, mid-tones, and shadows of an image. The term for this anomaly is a *cross curve* appearance. The term comes from a sensitometric defect in some color films and papers, where the delicate balance of cyan, magenta, and yellow dyes in these photographic materials can be thrown off if one emulsion layer has more or less contrast than the other two layers. For example, the top portion of Figure 14.2 shows a neutral gradient, while the bottom shows a magenta/green cross curve. The three-quartertone and shadows (dark areas) of the image are magenta, while the quartertone and highlights (light areas) have a green cast.

Metameric Failure

As mentioned in Chapters 1 and 10, some inkjet inks and inkjet technologies are more likely to show a shift in print color balance from one light source to another, which is much more noticeable with black-and-white prints. The original Epson pigment-based prints from the

FIGURE 14.2 Two gradients. Top portion shows a neutral gradient. Bottom gradient shows a magenta/green cross curve. Credit: Illustration by author

Epson Stylus 2000P were especially prone to this defect, with a change in viewing condition from daylight to tungsten. Although Epson's UltraChrome inks were developed to help alleviate the severity of this problem, they weren't able to completely eliminate it.

Halftone Dots

In black-and-white prints, we're used to seeing a subtle transition of tones that we expect with continuous-tone materials. As we've discussed before, inkjet printers use halftone dots, typically in a stochastic FM screening to simulate continuous shades of gray. These halftone dots are especially noticeable in the highlights of black-and-white-prints, especially if the halftone pattern includes cyan, magenta, or black dots. These noticeable halftone dots are described as "scum dots." To combat scum dots, printer manufacturers added light cyan, light magenta, light black, and light-light black inks. These inks are mainly used in the highlights and quartertones.

Dynamic Range

In the past, the question inkjet printer manufacturer representatives did not want to hear from traditional black-and-white photographers was, "What's the d-max?" In the past, the d-max, or maximum density of fiber-based silver-gelatin papers, was higher than the d-max possible on most inkjet printers and papers. This also meant that the dynamic range—the range of tones from paper white (d-min) to darkest black (d-max)—was greater in traditional silver gelatin prints than they were in inkjet prints.

Mainly, this was because the only way to get a neutral black-and-white print without cross curves using inkjet technology was to print with the black ink only. This necessity greatly limited the d-max and the dynamic range. I believe this situation has changed for two reasons: improvements in inkjet technology (which allows for use of all four inks), and the reduction of silver in current black-and-white silver-gelatin papers.

Black-and-White Digital Printing Methods

What can be done to improve the quality of digital black-and-white prints? There are general techniques that can be used when making either inkjet or digital C-prints, such as tinting and toning the image. There are also specific tools and materials that can be used when making inkjet or photographic digital output.

FIGURE 14.3 Neutral black-and-white image.
Credit: Photograph by the author

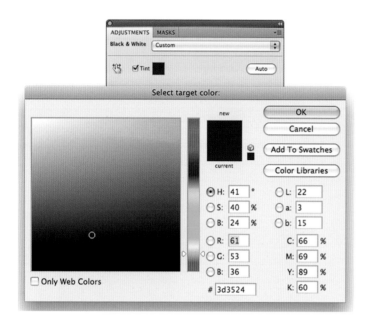

FIGURE 14.4 Selecting a target color for a Tint in Adobe Photoshop's black-and-white adjustment layer, which results in the image in Figure 14.5. Putting a tint on an image helps to mask any possible non-neutrality from the printing process.

FIGURE 14.5 Very warm toned black-and-white image resulting from the tint chosen from Photoshop's black-and-white adjustment layer shown in Figure 14.4. Credit: Photograph by the author

Image Tinting and Toning

The non-neutrality (color cast) and subtle cross curves from color (RGB or CMYK) printers can be masked or minimized by toning the image from a neutral appearance (Figure 14.3) to a slightly warm or cool appearance. This technique doesn't remove the colorcast; it just makes the cast or non-neutrality less noticeable, since the image is no longer completely neutral. There are many methods for accomplishing this in Photoshop. We will discuss three of them: tinting the image in the **Black-and-White** adjustment panel, toning the image with RGB curves, and converting the image into a duotone, tritone, or quadtone.

Tinting in the Black-and-White Adjustment Panel

Start with either a color or a black-and-white image in an RGB working color space, like AdobeRGB(1998). Add a **Black & White** adjustment layer. In the **Black & White** adjustment panel, check the **Tint** box. Then double-click on the color square to the right of where it says **Tint**. This will launch a version of the **Color Picker** window, where you will be able to select the target tint color, as in Figure 14.4. This will result in the toned image you see in Figure 14.5.

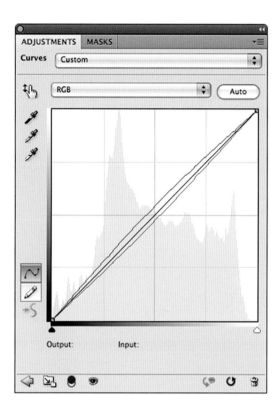

FIGURE 14.6 Adjusting the red curve in Adobe Photoshop's Curves adjustment layer, which results in the image in Figure 14.7. Putting a tint on an image helps to mask any possible non-neutrality from the printing process.

FIGURE 14.7 Cool toned black-and-white image resulting from Photoshop's Curves adjustment layer shown in Figure 14.6.
Credit: Photograph by the author

Toning the Image with RGB Curves

Start with a black-and-white image in an RGB working color space, like AdobeRGB(1998). Add a **Curves** adjustment layer. Slightly move the midpoint of the red, green, and blue curves to produce different toning effects, as in Figure 14.6. The cool-toned image in Figure 14.7 resulted from pulling up the blue curve and slightly pulling down the red curve.

Converting to Duotone, Tritone, or Quadtone

A common technique in the graphic-arts world for printing black-and-white images on a printing press is to use two or more inks instead of one (black) ink to print fine-art books. This technique helps to expand the tones and the dynamic range of the printed image, by giving the print more density from the additional inks. It's also common to use different color inks, not just another layer of the base black ink to add color tone.

To start, the image needs to be in 8-bit **Grayscale** mode, so that you can select the **Duotone** mode from the menu bar in Photoshop, as seen in Figure 14.8. Once in the **Duotone Options** window, you can select from a large variety of presets (Figure 14.9), which vary in inks and ink curves to produce different color, tone, and contrast effects.

The black curve was further pulled down from the preset curve, as seen in Figure 14.10. This resulted in the image seen in Figure 14.11. If you're printing to a printing press, then you would supply the duotone file to the printing company. If you're printing the image on inkjet yourself, then you would want to convert to your RGB working color space by changing the mode to RGB. The big limitation of this method is the need to convert the image to 8-bit. This should be done after most other tone adjustments have been done at a higher bit-depth.

Regardless of your tinting or toning method, you'll want to print using a good custom ICC profile for your printer and paper combination, along with the proper print driver settings for this combination. You're doing this to preserve the color you've just worked to introduce into the image.

FIGURE 14.8 Converting an image from Grayscale to Duotone from the menu bar in Adobe Photoshop.

Improving Black-and-White Inkjet Prints

Specific tools and materials for improving black-and-white inkjet prints include: RIPs with gray profiles, Epson's Advanced Black-and-White printing mode, and near-neutral and neutral ink-sets.

RIPs and Gray Profiles

As we discussed before, due to the separation and halftone methods used with some RIPs—as well as the control and consistency possible through linearization—the quality of black-and-white inkjet prints can be much better through some RIPs than they are through standard print drivers. For some older inkjet printers (like the Epson 2200), the *only* way to get a good quality black-and-white print was to use the ColorByte ImagePrint RIP, shown in Figure 14.12. This RIP uses

FIGURE 14.9 Selecting ink preset in Adobe Photoshop's Duotone Options window.

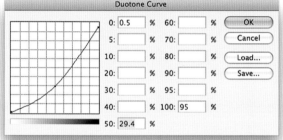

FIGURE 14.10 Adjusting the black ink curve in Adobe Photoshop's Duotone Options, which, along with the brown ink selected, results in the image in Figure 14.11. As with the other methods, putting a sepia look on an image helps to mask any possible non-neutrality from the printing process.

FIGURE 14.11 Sepia/brown-toned image resulting from Adobe Photoshop's Duotone Options in Figure 14.10.
Credit: Photograph by the author

special gray profiles, which convert any image to grayscale and adjust the printer settings to produce as neutral a print as possible. Like color profiles, ImagePrint's gray profiles are specific to the printer/paper combination. Also, the ImagePrint RIP allows you to tone your black-and-white prints using its **Narrow Gamut Tint Picker** (Figure 14.13), which can be used to build duotone, tritone, or quadtone (split-tone) images.

Another RIP that specializes in making black-and-white inkjet prints is the shareware QuadTone RIP. When installed, the QuadTone RIP works as a driver, as shown in Figures 14.14, 14.15, and 14.16.

Figure 14.14 shows the settings used when printing from Photoshop. A generic profile for QuadTone with matte or glossy paper is selected. In the driver/RIP you are able to select specific profiles for the printer and paper combination and the type of toning you want to use. Figure 14.15 shows the settings in the driver/RIP to use for a neutral print. Figure 14.16 shows the settings to use when creating a split-tone print using a combination of the Warm Curve and the Sepia Curve. Figure 14.17 shows the resulting prints through four different settings, including those used in Figures 14.15 and 14.16.

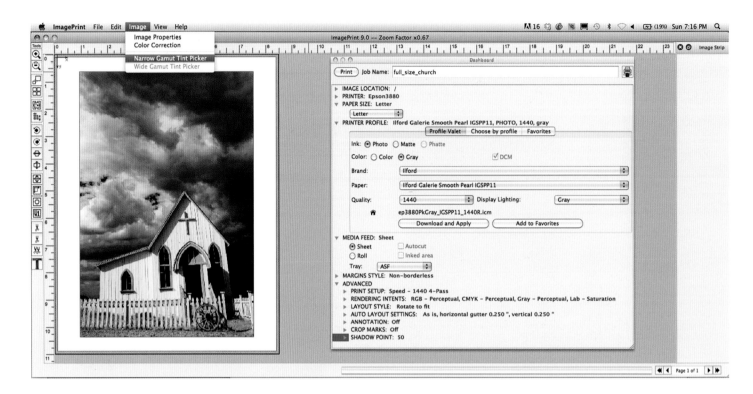

FIGURE 14.12 *(above)* ColorByte's ImagePrint RIP being used for making a black-and-white print using one of its Gray Profiles. Also shown is the selection of Narrow Gamut Tint Picker for toning mages.
Credit: Photograph by the author

FIGURE 14.13 *(right)* Narrow Gamut Tint Picker for toning prints in ColorByte's ImagePrint RIP. The Dynamic Contrast Matching (DCM) technology shown at the bottom allows you to boost the contrast in the toned print.

FIGURE 14.14 *(facing page, top)* Printing using the QuadTone RIP (driver) from Adobe Photoshop's Print Settings Window.
Credit: Photograph by the author

FIGURE 14.15 *(facing page, bottom left)* QuadToneRIP (driver) settings for creating a neutral print on the Epson 3880 for Ilford Smooth Pearl media.

FIGURE 14.16 *(facing page, bottom right)* QuadToneRIP (driver) settings for creating a split tone print with Warm and Sepia Curves on the Epson 3880 for Ilford Smooth Pearl media.

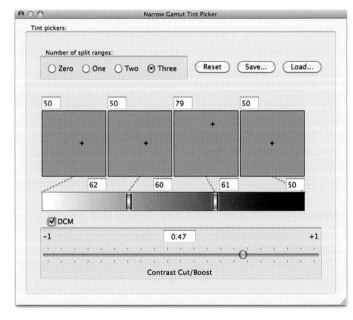

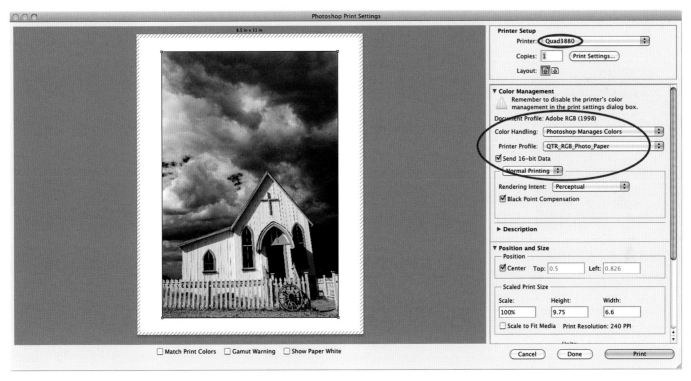

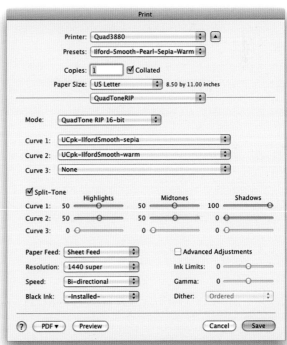

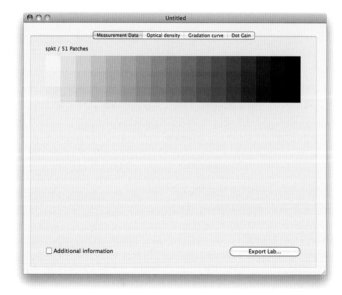

```
QTR-Create-ICC RGB version 2.7.2.0

File: /Users/tom/Desktop/qtr-3880-ilf-sm-pearl-out.txt
Step     Dens    Lab      A      B
0.00     0.074   93.61   -0.09  -4.87   -        b              al                        L    +
2.00     0.082   92.93   -0.16  -4.74   -        b              al                         L   +
4.00     0.096   91.79   -0.05  -4.57   -        b              al                          L  +
6.00     0.119   89.87    0.08  -4.20   -         b             a                          L  +
8.00     0.129   89.09   -0.04  -4.11   -         b             al                        L    +
10.00    0.143   87.92    0.11  -3.75   -          b            a                       L     +
12.00    0.164   86.31    0.25  -3.52   -         b             la                     L       +
14.00    0.174   85.49    0.17  -3.33   -          b            a                    L         +
16.00    0.191   84.22    0.21  -3.32   -          b            a                   L          +
18.00    0.210   82.73    0.36  -2.97   -           b           la                 L           +
20.00    0.227   81.45    0.25  -2.88   -           b           la                L            +
22.00    0.245   80.15    0.29  -2.75   -           b           la               L             +
24.00    0.265   78.65    0.39  -2.44   -            b          la              L              +
26.00    0.281   77.52    0.27  -2.32   -            b          la             L               +
28.00    0.294   76.56    0.33  -2.28   -            b          la            L                +
30.00    0.319   74.84    0.46  -1.94   -             b         la          L                  +
32.00    0.331   73.96    0.38  -2.05   -             b         la           L                 +
34.00    0.355   72.30    0.50  -2.04   -             b         la          L                  +
36.00    0.375   70.97    0.59  -1.60   -              b        l a       L                    +
38.00    0.398   69.46    0.52  -1.68   -              b        l a        L                   +
40.00    0.423   67.87    0.55  -1.63   -              b        l a      L                     +
42.00    0.447   66.32    0.73  -1.32   -               b       l a    L                       +
44.00    0.470   64.89    0.60  -1.38   -               b       l a     L                      +
46.00    0.496   63.28    0.65  -1.35   -                b      l a    L                       +
48.00    0.521   61.75    0.75  -0.91   -                b      l a  L                          +
50.00    0.546   60.30    0.61  -1.10   -                 b     l a  L                          +
52.00    0.570   58.92    0.67  -1.00   -                 b     l a L                           +
54.00    0.599   57.26    0.78  -0.58   -                  b    l aL                            +
56.00    0.631   55.46    0.64  -0.67   -                  b    l aL                            +
58.00    0.663   53.73    0.73  -0.53   -                   b   l a L                           +
60.00    0.691   52.25    0.81  -0.17   -                    blLa                               +
62.00    0.724   50.53    0.88  -0.33   -                    bL a                               +
64.00    0.767   48.39    0.93  -0.29   -                    bLl a                              +
66.00    0.793   47.10    1.12  -0.24   -                   Lbl  a                              +
68.00    0.827   45.48    1.22  -0.36   -                  lb l  a                              +
70.00    0.861   43.89    1.32  -0.40   -                 L b l    a                            +
72.00    0.903   42.00    1.35  -0.16   -                 l bl    a                             +
74.00    0.953   39.83    1.53  -0.07   -               L   bl    a                             +
76.00    1.004   37.66    1.57  -0.01   -              l    bl    a                             +
78.00    1.052   35.72    1.46   0.35   -            L      lb   a                              +
80.00    1.108   33.55    1.45   0.46   -            l      lb   a                              +
82.00    1.163   31.51    1.55   0.52   -          L        l b  a                              +
84.00    1.246   28.58    1.61   1.02   -         l         l b a                               +
86.00    1.313   26.35    1.38   0.78   -        L          l ba                                +
88.00    1.390   23.90    1.49   0.83   -       l           l ba                                +
90.00    1.511   20.37    1.41   1.12   -      l            l ba                                +
92.00    1.629   17.22    1.32   0.87   -     L             l ba                                +
94.00    1.761   14.03    1.28   0.72   -    L              l b a                               +
96.00    1.919   10.60    1.24   0.75   -   L               l ba                                +
98.00    2.096    7.24    1.10  -0.00   -  L                b  a                                +
100.00   2.196    5.75    0.45   0.31   -  l                lb                                  +

Created ICC file /Users/tom/Desktop/qtr-3880-ilf-sm-pearl-rgb.icc
```

The QuadTone RIP's other special capabilities are to allow you to linearize your prints for Lightness, confirm the linearity and neutrality of your system, and build ICC profiles for soft proofing in Photoshop and Lightroom. All three are done by printing a set of patches and measuring them with an X-Rite i1 Pro spectrophotometer and X-Rite's discontinued ProfileMaker software. Figure 14.18 shows the measurements in ProfileMaker, while Figure 14.19 shows how QuadTone formats and graphs the data. If the printer is perfectly linear, the line with Lightness Ls would be a perfectly straight diagonal. If the print were perfectly neutral, the a and b plots would be on the zero line all the way through the tone scale.

Epson's Advanced Black-and-White Printing Mode

Epson printers that use UltraChrome inks and include the light black and light light black inks (such as the 2400, 2880, x800 series, x880 series, x900 series, and x990 series) offer this Advanced print mode in their drivers (in addition to Color and Black Only). Like the gray profiles in the ImagePrint RIP, the Advanced Black-and-White print mode converts the image to black-and-white and produces improved black-and-white prints.

FIGURE 14.17 Resulting prints made with the QuadToneRIP (driver) from left to right: Neutral with settings in Figure 14.15, Warm, Split Tone with settings in Figure 14.16, and Cool, on the Epson 3880 for Ilford Smooth Pearl media.
Credit: Photograph by the author

FIGURE 14.18 After measuring QuadToneRIP patches in X-Rite ProfileMaker (discontinued) with an i1 Pro spectrophotometer. This data can be used to linearize the lightness of the output, confirm linearity and neutrality of the system, and build an ICC profile for soft proofing in Photoshop and Lightroom. Data is shown in Figure 14.19.

FIGURE 14.19 QuadToneRIP's reformatting of data from the Lab measurements in Figure 14.18.

Other Epson printers—(like the r1800 and the r1900) that don't use the light black inks and don't have the Advanced Black-and-White printing mode—are not recommended for printing good quality neutral black-and-white prints. Here are the steps to use when printing using the Advanced Black-and-White mode:

1. When printing with the Advanced Black-and-White mode, the image should be in the AdobeRGB(1998) color space, since this is what the driver is expecting. If the image is not in this space or you are printing from Lightroom, then select AdobeRGB(1998) as the printer profile space. If the image is already in AdobeRGB(1998), then select **Printer Manages Colors**, as seen in Figure 14.20.
2. Click **Print Settings . . .** in the Photoshop Print Settings window. The printer driver window will then launch. Click on the drop-down menu and choose **Color Matching**, as shown in Figure 14.21. Select **EPSON Color Controls**. This will allow you to use Epson's Advanced Black-and-White mode.
3. Click on the drop-down menu and choose **Printer Settings**, as shown in the center of Figure 14.20.
4. Select the correct media type for the paper you are using. Note: the Advanced Black-and-White mode is not available for every media type. You might need to try more than one media type.
5. Select the **Advanced Black-and-White** mode, as shown in Figure 14.20.
6. Go to the **Color Management** section of the driver, as seen in Figure 14.22. In this window, you will be able to fine-tune the image by adjusting the color tone away from neutral and make the overall print lighter or darker. Figure 14.23 shows the resulting prints through Advanced Black-and-White standard neutral settings and through the custom settings shown in Figure 14.22.

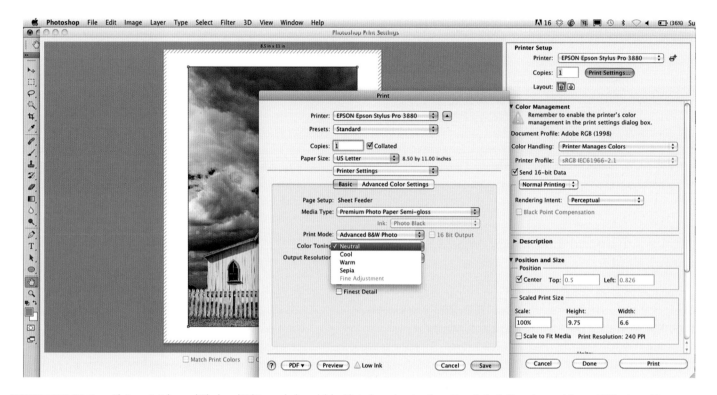

FIGURE 14.20 Printing with Epson's Advanced Black-and-White mode from Adobe Photoshop, showing the settings in both Photoshop and Epson 3880 printer driver.
Credit: Photograph by the author

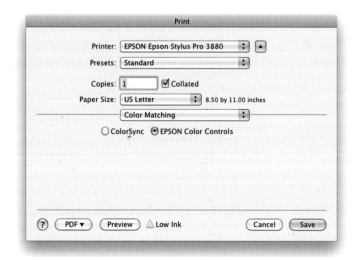

FIGURE 14.21 Setting the Color Matching to Epson Color Controls in the Epson 3880 printer driver, so the Advanced Black-and-White mode can be selected in the Printer Settings window, shown in Figure 14.20.

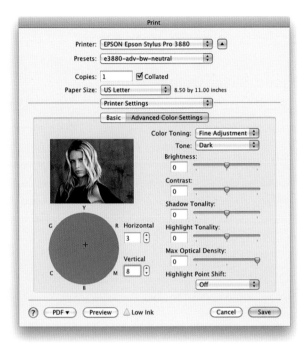

FIGURE 14.22
Advanced Color Settings window for the Advanced Black-and-White mode, showing the fine tune adjustments, such as toning, that can be made. Black-and-white portrait in this Epson window is by Greg Gorman.

FIGURE 14.23
Resulting prints made with the Epson's Advanced Black-and-White mode on the Epson 3880 on Ilford Smooth Pearl media. Print on left using the standard Neutral (Darker) setting. Print on the right using the fine tune settings in Figure 14.22, which slightly warms the print by changing the Horizontal and Vertical adjustments and makes is slightly lighter by selecting a Dark Tone, instead of Darker.
Credit: Photograph by the author

Near-Neutral and Neutral Ink-Sets

To help make better black-and-white inkjet prints, especially for neutrality, companies like MIS and Cone Editions produce third-party ink systems for inkjet printers.

Cone Editions manufactures the Piezography brand of mono-chromatic inks. All of these ink-sets require that you use special software RIPs with the printer, like the QuadTone RIP. The black-and-white prints with the Piezography inks can be of very high quality and excellent neutrality. But, as is the case with all third-party inks, head clogging can be an issue. The printer must be used on a regular basis to avoid clogged nozzles. It's also good to note that printer warranties are made null and void once any third-party inks are used. If you use them, the best thing to do is to dedicate an older printer to the use of these ink-sets.

Digital Photographic Black-and-White Prints

There are three options for making digital photographic black-and-white prints: digital C-prints, resin-coated (RC) silver gelatin, and fiber-based silver gelatin.

Digital C-prints

This is the easiest option to find, but, like inkjet, is the most likely option to result in poor neutrality or crossed curves. It's also the weakest option for print longevity. The benefit of the material being made of three-color (cyan, magenta, and yellow) dyes is that you can easily produce color-toned black-and-white prints.

Resin-Coated (RC) Silver Gelatin Prints

Prints on this material will be more neutral and have better longevity than digital c-prints (chromogenic prints), which are also on resin-coated RC papers, but they won't have as much longevity as fiber-based digital silver gelatin prints.

Fiber-Based Silver Gelatin Prints

Fiber-based silver gelatin prints have been the standard for archival fine art photography for over 90 years. Harman Technologies has developed a paper specifically sensitized for the lasers on the Durst Lambda laser enlargers. Only a few service providers around the world are currently offering digital prints on this material. Three that do so in the northeastern United States are Digital Silver Image in Belmont, MA (near Boston), Laumont Digital in New York City, and Modernage in New York City.

> When making digital silver gelatin prints, it is especially important to perform output sharpening on your images before they go to the lab. Better yet, run a sharpening test before you start making final prints, which we will discuss in the next chapter.

Conclusion

Although black-and-white prints can be challenging to make digitally, there are a good number of options for you to make great black-and-white prints. As we've discussed, the options include: toning your images and print using generic or (even better) custom printer/paper profiles; print with third-party RIP software packages like ImagePrint or the QuadTone RIP; print with the standard drive, but use the Advanced Black-and-White mode; or print to true silver gelatin papers.

EXPLORATIONS

It's time to make you own digital black-and-white prints! You should test as many of the methods we have discussed as possible using an image that has a good range of tones from shadows to highlights. Remember to compare and evaluate the prints for neutrality, smoothness of gradations, contrast, and dynamic range. With this experience you will be better able to determine the best method for you to get quality black-and-white prints in the future.

Resources

Black-and-White Inkjet Printing

ColorByte ImagePrint RIP
 http://www.colorbytesoftware.com/

Cone Editions Piezography System
 http://www.piezography.com/PiezoPress/

Gerry Eskin Article on Epson Advanced-Black-and-White
 http://gerryeskinstudio.com/ABW_sept08_paper/index.html

MIS Ultratone B&W Inks
 http://www.inksupply.com/bwpage.cfm

QuadTone RIP
 http://www.quadtonerip.com

Labs Providing Fiber-Based Silver Gelatin Output

Digital Silver Image—location: Belmont, MA (near Boston)
 http://www.digitalsilverimaging.com/

Duggal Visual Solutions—location: New York, NY
 http://duggal.com/

Harman Galerie FB Digital Paper (Ilford Photo)
 http://www.ilfordphoto.com/products

Laumont Photographics—location: New York, NY
 http://laumont.com/

Modernage—location: New York, NY
 http://www.modernage.com/

Fifteen

RESIZING & SHARPENING

Regardless of the type of output we are going to—display, inkjet print, digital C-print, or printing press—our last steps in preparing our files will include sizing the image and then sharpening for the specific type of output. This chapter will first discuss the different methods and algorithms used to resize our image in Photoshop and third-party image sizing software packages. Then we will review the importance, methods, and strategies for sharpening our images, as one of the last steps in preparing our files for printing.

Sizing Images for Output

Two other steps that should be completed toward the end of your workflow are sizing and sharpening your image for output. *Regardless of when they happen in your workflow, sizing and sharpening your images need to happen in this order.* You might be sizing your images larger for output on a wide format inkjet printer or smaller for use on your website. It doesn't matter which direction you are going; your goal is to use a sizing method that will make your resulting images look as sharp and smooth as possible without artifacts. In this section we will discuss the methods to use when resizing your images and important factors for you to consider.

Sizing Images in Adobe Photoshop

When you change the size of your images in Adobe Photoshop or in other applications, you are given many options for completing the task. At this point we will review the different choices we are given in the **Image Size** window in Photoshop, including: pixel dimensions, document dimensions, constrain proportions, and resample algorithm.

FIGURE 15.1 Surface of Sydney Opera House. Image sized in Photoshop with Bicubic Smoother algorithm and sharpened with Pixel Genius Output Sharpener 2. Credit: Photograph by the author

Pixel Dimensions

If you are asked to adjust your image to a specific number of pixels high or wide, you are able to enter the exact number of pixels desired. However, typically, this part of the **Image Size** window will simply show the resulting change in pixel dimensions and file size that result from a change in the document dimensions, as shown at the top of Figure 15.3.

Document Dimensions

More typically we will adjust our images to a specific size and/or resolution. The document size is pretty self-explanatory. The size can be defined in traditional lengths like inches or millimeters (mm) or a percentage. In Figures 15.7 and 15.9, we are reducing the size of the images to a specific size and resolution combination. In Figures 15.11 and 15.12, we are increasing print and image size, while reducing the resolution.

Constrain Proportions

To prevent your image from being distorted by stretching or compressing the height or width of the image more or less than the other, it is very important that the proportions are constrained when sizing your images. In Photoshop this is done simply by checking the **Constrain Proportions** check box in the **Image Size** window, as seen in Figures 15.3, 15.5, 15.7, 15.9, 15.11, and 15.12.

Effect of Changing Image Resolution on Output Width and Height with Constant File Size				
Resolution (PPI)	Width (inches)	Height (inches)	File Size (megabytes)	Pixels
72	41.67	41.67	25.7	3000 × 3000
180	16.67	16.67	25.7	3000 × 3000
240	12.50	12.50	25.7	3000 × 3000
300	10.00	10.00	25.7	3000 × 3000
360	8.33	8.33	25.7	3000 × 3000

FIGURE 15.2 Table showing the effects of changing image resolution on the image width and height, while keeping file size the same. Credit: Table by the author

What do We Mean by Resolution in Sizing the Image and How do We Choose the Correct Image Resolution?

The image resolution has to do with the density of pixels in our image and it is described either as pixels per inch (PPI) or pixels per centimeter. As we have discussed before, neither should be confused with the printer resolution, which is described in dots per inch (DPI). Even without resizing a file, we can have an effect on the image's height and width simply by changing the resolution, as you can see in Figure 15.2. When going to output, we are concerned with having a high enough resolution so that we do not notice the pixels. For output on most displays and monitors, like we use for our web galleries or emails, the resolution is 72 PPI. For printed output we need a higher resolution, typically somewhere from 180 to 360 PPI. 180 PPI should only be used for very large inkjet prints (more than 30 inches wide). Optimally, the resolution would be 240 or 360 PPI for output on Epson inkjet printers: 240 PPI on larger format prints (more than 13 inches wide) and 360 PPI could be used for smaller format prints (less than 13 inches wide). As we will discuss later, the reason for this difference in recommended resolution is because of the expected viewing distance from larger and smaller prints. In the end, the printer manufacturer, lab, or printing service provider should give you the optimal or required output resolution.

Resample Algorithm

When you decrease your image size (down-sampling) you are throwing away pixels, and when you increase your image size (up-sampling) you are adding pixels. To do this with an optimal amount of image quality in the final image (as sharp and smooth without artifacts as possible) Photoshop offers six different methods or algorithms to process the image, as shown in Figures 15.3 and 15.5—**Nearest Neighbor**, **Bilinear**, **Bicubic**, **Bicubic Smoother**, **Bicubic Sharper**, and **Bicubic Automatic** (which simply chooses between **Bicubic Sharper** and **Bicubic Smoother** algorithms). Your choice of resample algorithm will depend on the type of image you are sizing and the direction (larger or smaller) you are going.

Nearest Neighbor is the most basic resample algorithm. It simply looks at the pixels nearby and duplicates them when it increases the size. The problem with this algorithm for images, as seen in Figure 15.13, is that pixels quickly become visible, which means our images show aliasing (or stair-stepping) artifacts. When do we use this algorithm? Although not often, we use Nearest Neighbor when our image is made of only rectangles or squares and we want to maintain their hard edges as we increase the file size. One example of this is when sizing output-profiling patches. Figure 15.3 shows the selection of the **Nearest Neighbor** resample algorithm in Photoshop's **Image Size** window and Figure 15.4 shows the resulting image at 200%, which has hard edges. On the other hand, Figure 15.5 shows the selection of the **Bicubic Smoother** resample algorithm and Figure 15.6 shows its resulting image at 200%, which has soft edges that are undesirable in this application.

Bilinear is a sampling algorithm that makes an educated guess or interpolates the values for the new pixels in between the known pixels of the image when up-scaling. Bilinear interpolation results in less aliasing than you would get from **Nearest Neighbor**, but the results are not as sharp and smooth as with **Bicubic** interpolation.

Bicubic interpolation is a more complex algorithm than **Bilinear** interpolation, which results in improved image quality, as mentioned, and longer processing times. This difference in processing speed might have been an issue at one time, but the speed of modern computer processers now makes it a non-issue, so one of the **Bicubic** interpolation algorithms is almost always used. Also, Photoshop describes the standard **Bicubic** sampling as the choice to use for smoother gradations.

Bicubic Smoother is described as being the better sampling algorithm to use for enlargements, as you can see in Figure 15.9. This algorithm is meant to be better for making custom output sharpening

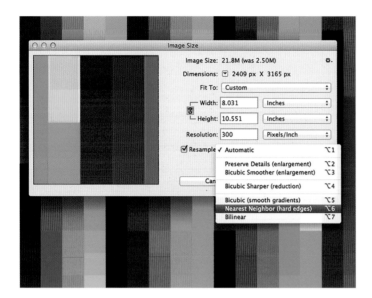

FIGURE 15.3 Image Size window in Adobe Photoshop showing the possible resample algorithm choices (Nearest Neighbor selected) for adjusting the size of profiling patches. Nearest Neighbor is the better choice for this application. Results shown in Figure 15.4.

FIGURE 15.4 Results of the Nearest Neighbor resizing in Adobe Photoshop shown in Figure 15.3. This algorithm results in the patches keeping their hard edges.

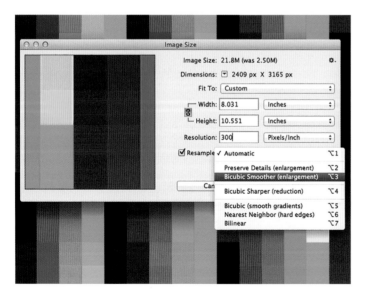

FIGURE 15.5 Image Size window in Adobe Photoshop showing the possible resample algorithm choices (Bicubic Smoother selected) for adjusting the size of profiling patches, which is not the best choice for this application. Results shown in Figure 15.6.

FIGURE 15.6 Results of the Bicubic Smoother resizing in Adobe Photoshop shown in Figure 15.5. This algorithm results in the patches losing their hard edges.

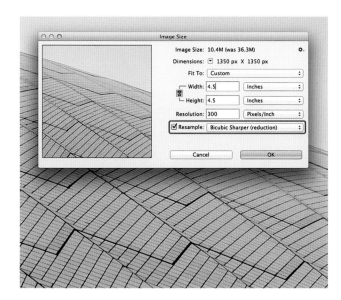

FIGURE 15.7 Image Size window in Adobe Photoshop showing the Bicubic Sharper sampling algorithm selected for reducing the size of an image. A portion of the resulting image is shown in Figure 15.18 at 200%.
Credit: Portion of photograph by the author

FIGURE 15.8 Portion of an image that results from the Bicubic Sharper resizing in Adobe Photoshop shown in Figure 15.17 at 200%. This algorithm compensates for the natural softening that comes from image down-sampling and results in a sharper image.
Credit: Portion of photograph by the author

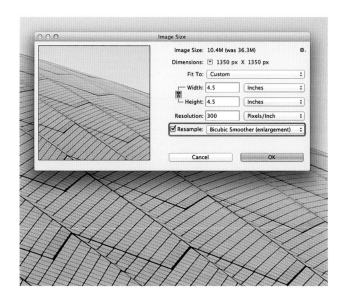

FIGURE 15.9 Image Size window in Adobe Photoshop showing the Bicubic Smoother sampling algorithm selected for reducing the size of an image. A portion of the resulting image is shown in Figure 15.18 at 200%.
Credit: Portion of photograph by the author

FIGURE 15.10 Portion of an image that results from the Bicubic Smoother resizing in Adobe Photoshop shown in Figure 15.19 at 200%. This algorithm exacerbates the natural softening that comes from image down-sampling.
Credit: Portion of photograph by the author

after resizing, with fewer artifacts. According to Adobe Engineer Chris Cox, in an Adobe Forum post, the amount of smoothing with **Bicubic Smoother** is less when the sizing is close to no change in size and more until a 400% increase in size.[1]

Bicubic Sharper, on the other hand, is described as being the better sampling algorithm to use for reductions or down-sampling, as you can see in Figure 15.7. This algorithm is meant to be better for helping with the softening that results from reductions in images size. In the same post mentioned above, Chris Cox also says the amount of sharpening with **Bicubic Sharper**'s sharpening is less close to 100% in size and more until a 25% decrease in size. Figure 15.7 shows the settings in Photoshop's **Image Size** window using **Bicubic Sharper** to down-sample an image, and Figure 15.8 shows a portion of the resulting image at 200%. For comparison, Figure 15.9 shows the settings in Photoshop's **Image Size** window using **Bicubic Smoother**

to down-sample an image, and Figure 15.10 shows a portion of the resulting image at 200%.

10% Iterative Method for Increasing Image Size

Figure 15.11 shows the standard method for enlarging images in Photoshop's **Image Size** window using the **Bicubic Smoother** sampling algorithm, via the **Bicubic Automatic** selection, to up-sample an image. Figure 15.14 shows a portion of the resulting image at 200%. As you'd expect, the resulting enlargement exhibits much less aliasing than the version to its left in Figure 15.13 that used the **Nearest Neighbor** sampling method. In addition, for many years a method

FIGURE 15.11 Image Size window in Adobe Photoshop showing the Bicubic Automatic (effectively Bicubic Smoother) sampling algorithm selected for enlarging the size of an image. A portion of the resulting image is shown in Figure 15.14 at 200%. Credit: Portion of photograph by the author

FIGURE 15.12 Image Size window in Adobe Photoshop showing the Bicubic sampling algorithm selected for increasing the size of an image by 10%. A portion of the resulting image is shown in Figure 15.16 at 200%. Credit: Portion of photograph by the author

FIGURE 15.13 Portion of an image that results from the Nearest Neighbor sampling algorithm used to enlarge the image in Adobe Photoshop shown at 200%. This algorithm shows much more of the aliasing and stair stepping that can result from image up-sampling.
Credit: Portion of photograph by the author

FIGURE 15.14 Portion of an image that results from the Bicubic Automatic (effectively Bicubic Smoother) sampling algorithm in Adobe Photoshop shown in Figure 15.21 at 200%. This algorithm results in much less aliasing than Nearest Neighbor, as shown in Figure 15.13, but not as sharp as the 10% method in Figure 15.16.
Credit: Portion of photograph by the author

FIGURE 15.15 Portion of an image that results from a combination of Bicubic Smoother resizing and the 10% percent iterative enlarging method in Adobe Photoshop shown at 200%. This algorithm and method combination exacerbates the softening that comes from Bicubic Smoother sampling and is softer than both one-step resizing in Figure 15.14 and the combination of 10% method and Bicubic sampling algorithm in Figure 15.16.
Credit: Portion of photograph by the author

FIGURE 15.16 Portion of an image that results from a combination of Bicubic resizing and the 10% percent iterative enlarging method in Adobe Photoshop shown in Figure 15-12 at 200%. This algorithm and method combination is sharper than the results from Bicubic Smoother sampling in one-step resizing in Figure 15.14 and the combination of 10% method and Bicubic Smoother sampling algorithm in Figure 15.15.
Credit: Portion of photograph by the author

promoted to improve the amount of detail preserved when up-sampling or enlarging an image was to perform a **Bicubic** enlargement in incremental steps of 10% (or 5%), as shown in Figure 15.12, and resulting in the image portion in Figure 10.16 after nine increments. To help efficiently make the 10% (or 5%) increases until the desired size, it was best to record these **Image Size** settings as an **Action** in Photoshop, which allowed for pressing one key for each incremental 10% enlargement, instead of repetitively launching and resetting the **Image Size** window. Figure 15.15 shows a portion of the image that results from using **Bicubic Smoother** as the sampling algorithm and the 10% increment method, which results in a softer enlargement than one step in Figure 15.14 and the 10% method in conjunction with the **Bicubic** algorithm in Figure 15.16.

Third Party Image Sizing Software

In addition to the **Image Size** window, there are software packages and plug-ins for Adobe Photoshop and Lightroom that specialize in improving the quality of image enlargements over the standard **Image Size** window: **onOne Perfect Resize** (formerly Genuine Fractals) and **Alien Skin Blow Up**. Both software packages promise more advanced sampling algorithms. Figures 15.17 and 15.18 show how to launch **onOne Perfect Resize** and **Alien Skin Blow Up**, respectively, from within Adobe Photoshop. As you can see from Figures 15.19 and 15.20, each plug-in allows you to apply output sharpening and grain patterns (which can

FIGURE 15.17 Launching onOne Perfect Resize (formerly Genuine Fractals) by clicking File > Automate from the menu bar in Adobe Photoshop.
Credit: Portion of photograph by the author

FIGURE 15.18 Launching Alien Skin Blow Up by clicking Filter from the menu bar in Adobe Photoshop.
Credit: Portion of photograph by the author

FIGURE 15.19 onOne Perfect Resize interface in Adobe Photoshop showing the selection of resolutions for different output types and other settings that resulted in the portion of the image shown in Figure 15.21.

Credit: Portion of photograph by the author

FIGURE 15.20 Alien Skin Blow Up interface in Adobe Photoshop showing the sharpening, grain, and other settings that resulted in the portion of the image shown in Figure 15.22.
Credit: Portion of photograph by the author

mask the problems and artifacts of enlargements) to the image simultaneously when up-sampling, which can be a workflow advantage. Finally, Figures 15.21 and 15.22 show portions of the resulting images after up-sampling and applying output sharpening.

Image Enlargement Factors and Considerations

Now that you know different methods for enlarging your images, it is a good point to mention three factors to consider as you are looking how far to go in enlarging your images: the point of failure, viewing distance, and depth of field.

Point of Failure

When enlarging an image, you can get to a point where the image falls apart and shows too much aliasing. This level of enlargement is called the *point of failure* and it will depend on the image, the quality of the image file, the sampling algorithm used in up-sampling, and the quality requirements of the project.

FIGURE 15.21 Portion of an image shown at 200% that results from the up-sampling algorithm in onOne Perfect Resize and the settings used in Figure 15.19.
Credit: Portion of photograph by the author

FIGURE 15.22 Portion of an image shown at 200% that results from the up-sampling algorithm in Alien Skin Blow Up and the settings used in Figure 15.20.
Credit: Portion of photograph by the author

Viewing Distance

One important factor to consider when determining the point of failure for an enlargement is the viewing distance. The *viewing distance* is the distance from the viewer to the print. Although most of us photographers will get a few inches away to view the details of a print, the standard viewing distance is, typically, the same as the diagonal measurement of the print. You can calculate the diagonal of the print with the Pythagorean theorem: $a^2 + b^2 = c^2$. Did you think you'd ever use that again? In this equation, a and b are the width and height of your print and c is the standard viewing distance for that print. As an example, for a 24 x 30-inch print, the equation is $24^2 + 30^2 = c^2$. This would break down to $576 + 900 = c^2$, and then c = square root ($\sqrt{}$) of 1476, which is 38.4 inches. So the standard viewing distance for a 24 x 30-inch print is 38.4 inches.

Depth of Field

Finally, it is important to remember that, as you enlarge your print, you are losing depth of field. *Depth of field* is the perceived range of distances in your scene from your lens that appear to be in focus. Of course we are only able to focus on one point or plane at a time, but

the depth of field includes the closest parts of our scene that appear sharp, to the farthest parts that appear sharp. As our prints are enlarged, the distance from the closest part to the farthest part that appears in focus gets smaller and smaller, eventually just to the single plane that was focused onto. Overall our prints can seem to get softer and have less contrast as we enlarge them. Conversely, smaller prints from the same image appear to have more depth of field, overall sharpness, and contrast. Besides being aware of this effect from enlargements, it also means you will often need to add contrast and additional sharpening to your larger prints.

Types of Sharpening

As mentioned before, our last step, after sizing our images and before making our print, should be to sharpen it. To say it another way, *do not resize the image after sharpening*! That being said, let's start by talking about sharpening generally. Sharpening is the use of different techniques to enhance edge contrast within an image with the goal of bringing out detail and improving the perceived sharpness. An edge is any area of an image where you have a difference in tone from light to dark or from dark to light. There are three main types of sharpening: input, creative effect, and output.

Input sharpening is used to compensate for the degradation of sharpness that can come from lenses, infrared absorbing filters, anti-aliasing filters, and color-filter arrays on digital cameras—or the optics of different print or film-scanning systems. Input sharpening should occur early in the workflow, during the initial processing of the image. Adobe Lightroom and Camera Raw, along with scanner software packages, allow you to introduce sharpening for this purpose.

Creative-effect sharpening is applied to enhance or obscure different elements within an image through selective blurring or sharpening. A common example is to slightly sharpen the eyes in a portrait, which you do in order to help guide and hold the viewer's gaze to this important facet of your subject.

Output sharpening is the final step you take before saving an image to either view on the web or send to your printer or printing-service provider. Output sharpening is used to compensate for the inherent softening of the image that results from resizing, converting, half-toning, dithering, exposing, processing, dot gaining, or any of the other things that happen in the process of translating your image to the final output.

All three types of sharpening can be overdone or underdone. Over-sharpening can be apparent as dark and light lines (on either side of the edge) that are too distinct or exaggerated. At times the light edge on over sharpened images can be described as having a halo effect or artifact. As a general practice, we photographers are timid with sharpening and tend to under-sharpen, whereas pre-press and printing professionals are more aggressive and tend to over-sharpen. The trick is to find the right balance.

Next, we'll discuss different methods for output sharpening in Photoshop and Lightroom and steps to use in determining the optimal amount of output sharpening.

Output Sharpening Methods

There are a number of different methods for sharpening: three standard filters in Photoshop—Unsharp Mask, Smart Sharpen, and High-Pass; two third-party software plug-ins—PixelGenius PhotoKit Output Sharpener, and Nik Software Sharpener Pro; and the sharpening in Adobe Lightroom. These filters and other techniques, we will discuss, find edges (like the light gray/dark gray in the graffiti image in Figures 15.23–15.28) and then lighten an area on the light side of the edge, and darken an area on the dark side of the edge. Photographers, printers, imaging companies, and even painters have known for a long time that this localized increase in edge contrast makes images appear sharper. Figure 15.23 shows the edge and image without any sharpening.

FIGURE 15.23 Image and artificial edge at 200% with shown Adobe Photoshop's Unsharp Mask Filter settings with no sharpening.
Credit: Portion of photograph by the author

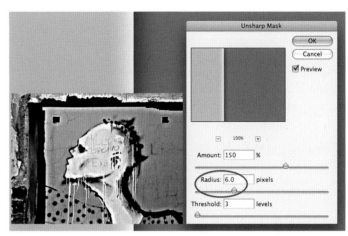

FIGURE 15.25 Image and artificial edge at 200% with shown Photoshop's Unsharp Mask Filter settings with sharpening including a higher radius than Figure 15.24.
Credit: Portion of photograph by the author

FIGURE 15.24 Image and artificial edge at 200% with shown Photoshop's Unsharp Mask Filter settings with sharpening.
Credit: Portion of photograph by the author

Unsharp Mask Filter

The **Unsharp Mask** filter (see Figures 15.23, 15.24, and 15.25) has three controls: *Amount, Radius*, and *Threshold*.

The **Amount** slider controls how light and dark the corresponding sides of the sharpened edges will become. The higher the amount, the more contrast will be created at those edges. The lighter side will have a lighter edge, and the darker side will have a darker edge.

The **Radius** slider controls how far (in pixels) from the edge this lightening and darkening will occur. Figures 15.24 and 15.25 show the effect of sharpening with the same **Amount** and **Threshold**, and a change in the **Radius** setting from 2.0 pixels to 6.0 pixels. The larger the image file, the larger the radius should be.

The **Threshold** slider controls the difference in tone that is required, between the light and dark sides of the edges, to apply the sharpening effect. With a **Threshold** setting of 0, every edge will be sharpened, regardless of the difference between the dark side and light side of the edges. The problem with setting the **Threshold** too low is that you can possibly get unwanted sharpening of noise and grain-like patterns. Some people describe the effect of over-sharpened images as being "crunchy."

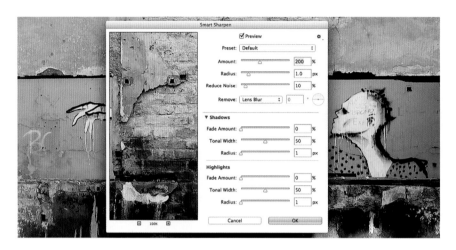

FIGURE 15.26 Image and artificial edge at 200% shown with Photoshop's Smart Sharpen Filter settings.
Credit: Portion of photograph by the author

Smart Sharpen Filter

The **Smart Sharpen** filter, as shown in Figure 15.26, gives somewhat more control than the **Unsharp Mask** filter. It does this by allowing a difference in **Threshold** in sharpening for the shadows and the highlights. This is especially helpful, since digital camera noise is so prevalent in the shadows.

High Pass Filter

The **High Pass** filter is used for finding and accentuating high-frequency edges, while suppressing low-frequency edges. This is the opposite effect of Gaussian Blur filter. The **High Pass** filter is especially useful when sharpening portraits, where you would want to accentuate high-frequency details like the eyes and hair, but not low-frequency details like pores on skin. To sharpen images and accentuate detail using the **High Pass** filter, apply the following steps:

1. Duplicate the main flattened image or background layer.
2. Select this duplicate layer.

3. Launch the **High Pass** filter from the menu bar, **Filter > Other > High Pass**.
4. Select the desired **Radius**, depending on the size of the image (anywhere from 0.3 to 5.0), as in Figure 15.27.
5. Desaturate the layer using the keyboard shortcut **Command-Shift-U** (Windows **Control-Shift-U**) or from the menu bar, **Image > Adjustments > Desaturate**. This will reduce color effects on the edges.
6. Change the **Blend** mode to **Overlay**, **Soft Light,** or **Hard Light**, depending on the image.
7. Reduce the opacity of this layer to fine-tune the effect, if necessary.

PixelGenius PhotoKit Output Sharpener

Since every variation in output type, image resolution, and image size will optimally require different amounts of sharpening for each image, it can be more efficient for you to start with the automated and optimized sharpening in the Photoshop plug-in PhotoKit Output Sharpener by Pixel Genius.

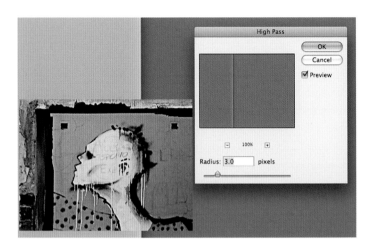

FIGURE 15.27 Image and artificial edge at 200% with the effects from the shown Photoshop High-Pass Filter settings.
Credit: Portion of photograph by the author

Once installed, the plug-in can be selected from the menu bar, **File > Automate > PhotoKit Output Sharpener**. The interface will show a preview, but it will allow you to select the type of output by changing the **Sharpener Set**, which contains the following choices: **Contone** (for photographic or dye sublimation output), **Halftone** (for electrophotographic output or graphic arts printing presses), **Inkjet** (for inkjet prints), and **Web and Multimedia** (for displays).

The Sharpener Effect setting can then be refined for the type of paper and the resolution of the image. In Figure 15.28, the Sharpener Effect is being optimized for an image resolution of 240 pixels per inch with matte paper, which typically requires more sharpening than glossy or luster-type papers. Even photographers who usually shy away from automated techniques often find this tool to be useful, because of the efficiency and intelligence it uses in optimizing the sharpening for the specific type of media.

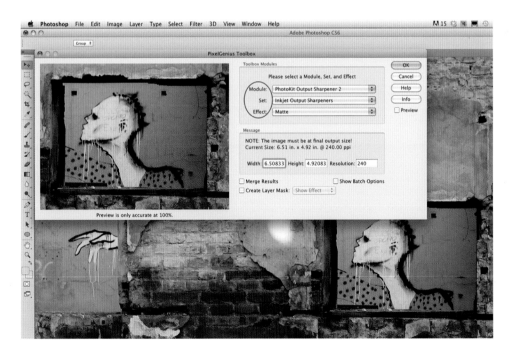

FIGURE 15.28 PixelGenius PhotoKit Output Sharpener plug-in for Photoshop.
Credit: Photograph by the author

Nik Software Sharpener Pro

Like PhotoKit Output Sharpener, Nik Software's Sharpener Pro has an algorithm to calculate the optimal sharpening for the type of output, paper, resolution, and size for the print you are making from your image.

Once installed, the plug-in can be selected from the menu bar in Photoshop by clicking: **Filter > Nik Software > Sharpener Pro: (2) Output Sharpener**. (There is also a Raw Sharpener for input sharpening.) Sharpener Pro's interface will show a preview and, like PhotoKit Sharpener, it will allow you to select the type of output: **Display** (for web and multimedia), **Inkjet**, as shown in Figure 15.29, **Continuous Tone** (for photographic or dye sublimation output), **Halftone** (for electrophotographic output or graphic arts printing presses), and **Hybrid Device** (for output that combines different output methods).

Sharpener Pro setting can then be refined further for the type of paper and the resolution of the printer. In Figure 15.29, the Sharpener Pro is being optimized for a resolution of 1440 x 1440 DPI with a **Textured & Fine Art** paper, which, along with **Canvas**, **Plain Paper**, and **Luster**, in addition to **Glossy** and **Matte**, are the only choices in PhotoKit Output Sharpener. Notice that you are also able to select the assumed viewing distance for your print, which will affect the amount of sharpening you would use. In addition, Sharpener Pro also includes Nik Software's Control Point technology for intelligently adding the sharpening to select areas of your final print.

FIGURE 15.29 Nik Software Sharpener Pro plug-in for Photoshop. (There is also a version for Adobe Lightroom.)
Credit: Photograph by the author

Adobe Photoshop Lightroom

The newest version of Lightroom also offers sharpening customization settings (similar to the ones found in PhotoKit Output Sharpener). You can apply output sharpening when you're sending images to the printer from the **Print** module. Options include: resolution in pixels per inch; standard, high, or low amount of sharpening; and either glossy or matte paper type.

Testing Sharpening

Since fine-tuning the sharpening levels and determining what constitutes over- and under-sharpening is very subjective, we often need to test the level of output sharpening on an actual print. It's best not to depend solely on viewing the sharpening effect on the monitor. For those times when you do judge a sharpening effect on your monitor, it's generally recommended that you view the image at

FIGURE 15.30 Output sharpening print test to help determine the opacity to use for the sharpening layer created with PixelGenius PhotoKit Output Sharpener. The Photoshop layers used to create the test are shown in Figure 15.31.
Credit: Photograph by the author

FIGURE 15.31
Photoshop Layers palette used to create the output sharpening print test in Figure 15.30.

a 100% (Actual Pixel) resolution, but you may still find that the monitor just isn't accurate enough to determine the best level of sharpening. To help you in doing this, you can create a print test for different sharpening levels, which is described below. For those of you who have made prints in the darkroom before, this technique is similar to the test prints you would have made for determining the correct exposure.

To quickly test several different sharpening levels on one print:

1. Add a mask layer to the sharpening effect layer or layer folder.
2. Create a black-to-white gradation from right to left on the mask layer.
3. Launch the **Posterize** adjustment window from menu bar: **Image > Adjustments > Posterize**.
4. Select a level of **5**. This will produce five layers of opacity in the mask layer: 0%, 25%, 50%, 75%, and 100%.
5. Add lines and, possibly, text to make it easier to evaluate the resulting print, as shown in Figure 15.30. (Figure 15.31 shows the layers used to create this test.)
6. Print and evaluate the sharpening test print.
7. Delete the sharpening layer mask and testing layers, change the opacity of the sharpening layer or layer folder to the determined opacity.

Conclusion

In this chapter we have reviewed some of the final steps in making your print: sizing your images using the appropriate sampling algorithm and, finally, sharpening your image for the type of output and print size you are making. Controlling these steps, instead of letting them be done automatically or not at all, should give you higher-quality prints with the sharpness and details you want, without the artifacts you don't.

EXPLORATIONS

There are two things that would be useful to reinforce what we have discussed in this chapter: (1) test the different image sizing algorithms in Photoshop with the same image, so you can see and understand better the differences they produce; and finally, (2) use the different sharpening methods discussed and create your own sharpening test to determine the optimal amount of sharpening for a specific image, printer, paper combination. In the end, you can't find the right amount of output sharpening until you see the effect on your print.

Resources

Image Sizing Software

Alien Skin Blow Up
http://www.alienskin.com/blowup
onOne Software Perfect Resize Pro
http://www.ononesoftware.com/products/perfect-resize/

Sharpening Software

Nik Software Sharpener Pro
http://www.niksoftware.com/sharpenerpro
PixelGenius PhotoKit Sharpener
http://www.pixelgenius.com/sharpener/

Note

1. Cox, Chris, http://forums.adobe.com/message/4314031, April 4, 2012.

Sixteen

COLLABORATION WITH PRINTMAKERS & SERVICE BUREAUS

One of the benefits of working as a photographer or artist is that you can be very independent and produce your work without the involvement of others. Whenever we involve others there can be complications, compromises to our vision, or communication problems. However, the access to tools and expertise we don't have, when working with others, could make our work even better. In the commercial world, working with others is our only option. We need to work closely with clients, assistants, and service providers. In this chapter we will examine collaboration in fine-art digital printmaking, specifically looking at the influence of the collaboration in traditional printmaking techniques. We will also discuss the best communication and color management strategies to use when a service provider is making prints for us.

Collaboration in Fine-Art Digital Printmaking

In this section, we will discuss the historical precedent for collaboration in digital printmaking, especially in terms of traditional printmaking in the United States since the late 1950s, and the benefits of working this way. Finally, we will list some of the current collaborative digital printmaking studios.

Part of the origin of collaboration in fine-art digital printmaking is tied to the formation of the first fine-art digital printmaking studio, Nash Editions. Nash Editions, located in Manhattan Beach, California, was founded in 1991 by Graham Nash and Mac Holbert, but its origins go back two years before that. In 1989, Graham Nash, a musician (of Crosby, Stills and Nash fame) and photographer, was asked by a gallery in Japan to produce an exhibition of 20 x 24-inch black-and-white prints of his work.

Because he did not want to spend the time in the darkroom, Nash looked for alternative methods for producing the prints. Mac Holbert, his road manager and a technology enthusiast, introduced Nash to Steve Boulter—who worked for a company called Iris Graphics that produced a high-end, inkjet-based output device. The main use

of the Iris printer was to produce a preview or proof of the printed page before it went to the production press. They decided to attempt to use this specialized commercial device for printing Nash's exhibition, but it took two additional contributors to make it possible for these prints to be produced: David Coons and Jack Duganne.

David Coons was a color engineer at Disney at the time, and was introduced to Nash by Steve Boulter. It was Coons who scanned Nash's negatives and converted the images to digital data so that black-and-white prints could be produced with the four-color Iris proofing device printing onto Arches fine art paper. Coons has continued this specialty and, not long after working with Nash and Holbert, started ArtScans Studio in Culver City, CA, which specializes in scanning artwork, especially large-scale originals.

Jack Duganne (who, as I mentioned before, coined the term "Giclée") had worked in etching, lithography, and serigraphy; producing mostly fine-art reproductions. He had also been looking for more efficient alternatives for producing his prints. He came along as the prints for Nash's exhibition were being produced. The technology and its potential use in producing fine art intrigued him. Duganne helped to produce the prints for Nash's exhibition and made improvements to the Iris process so it could use thicker fine-art papers with less difficulty. He also helped Nash and Holbert start Nash Editions. He later went back to printing at his own shop, Duganne Ateliers, in Santa Monica, California.

With Jack Duganne's involvement in the beginning of fine-art digital printmaking, it was natural that the use of this new technology would be infused with many of the traditions of printmaking, including: the production of limited editions; the use of chop marks to credit the printer's work; and a collaborative relationship between the artist and the printmaker.

FIGURE 16.1 Aldi by Jonathan Lewis, which is part of his project WalmArt, which consists of limited edition pigment inkjet prints.
Credit: Photograph, © Jonathan Lewis (jgdlewis.com)

How Do We Define an Artistic Collaboration?

Should we only define it as an undertaking in which two artists of comparable stature participate equally in the conception and execution of a work of art? In practice, it is rarely so pure or straightforward for two artists who work together in this way. In fact, the combinations are endless: some of the many formal artistic collaborative conjunctions have been fans and their heroes, friends and acquaintances, teachers and students—even siblings and husbands and wives. Some of these participants have collaborated as painters and writers, sculptors and assistants, photographers and patrons, architects and artisans, and, of course, artists and printers.

In traditional printmaking, there was typically some collaboration between the artist and the printer when using techniques like stone lithography and etching, But in the late 1950s and early 1960s, three institutions and their founders pushed American printmaking in a much more collaborative direction. The institutions were: the Pratt Graphics Center in New York City, United Limited Artists Editions (ULAE) on Long Island, and the Tamarind Lithography Workshop/Tamarind Institute, first in Los Angeles, and founded by Margaret Lowngrund and Fritz Eichenberg, Maurice and Tatyana Grosman, and June Wayne, respectively.

In the late 1950s, June Wayne was trying to start a different kind of workshop in Los Angeles. Frustrated after years of trying to find skilled lithographic printers to work with in the United States, she approached the Ford Foundation with a proposal to establish a lithographic workshop to train a new breed of artist-printmakers and to help revive lithographic fine-art printmaking in America.[1] With the funding she received, Wayne started the Tamarind Lithography Workshop in Los Angeles, which later became the Tamarind Institute when it moved to the University of New Mexico in Albuquerque.

Going against the less collaborative European model, Wayne envisioned that the new breed of artist-printmakers at Tamarind (who were college graduates typically trained as artists themselves) would be full collaborators in the printmaking process. It is a testament to her vision that many master printers who were trained at Tamarind—including the Americans Ken Tyler and Jack Lemon and the Australians Fred Genis and Peter Lancaster—were well taught "in both the technical aspects of making prints and the more subtle issues of collaboration."[2]

Benefits of Collaborative Printmaking

The fact that I am not producing my own art, forming my own imagery, means that when I have an artist in the shop, I live through that artist. I'm obligated to the medium and I want him to do the best he can for the medium, and to help him the best I can.

—Irwin Hollander[3]

Why would the artist want to leave the security of the studio and put up with the possibility of having his or her vision misinterpreted by a mysterious process and an interfering printmaker? And why would a master printer want to deal with the naive requests of a possibly temperamental artist? Why collaborate at all?

The simple reason for all collaborative endeavors is the sheer potential of producing something that one could not have been able to produce alone. Throughout history, both artists and printmakers have had a variety of reasons for working together, ranging from the idealistic to the highly practical.

For the Artist

- *Aesthetic*—By accessing the technical knowledge of a master printer, the artist can get better results more easily than he or she could obtain alone. On a basic level, this helps eliminate the frustrations of trial and error in the proofing process.[4] Taking this further, and paraphrasing Pat Gilmour and John Russell, "master printers are able to show artists undreamed of things by coming up with an end product which is astonishing in its vigor, its assurance and its breadth of resource."[5] Roy Lichtenstein, for example, described one of his collaborations with Ken Tyler this way: "The Entablatures were technical

miracles which were exactly what I wanted, but I never could have done 'em and there would be no way I'd know how to do it."[6]

- *Labor Savings*—The printer carries out the repetitive tasks, which allows the artist to focus on the ideas. For example, when Donald Saff (artist, printmaker, educator who founded the University of Southern Florida's Graphicstudio/Institute for Research in Art in the Art Department) was acting as the artist in a collaboration, he felt that "if someone else undertook the labor he would be more intellectually daring."[7]

- *Catalytic*—The change of environment and the gentle push of the master printer can foster inspiration. As Kathan Brown explained, "One of the uses of printmaking to an artist is to shake him up a little, to take him outside his normal routine, to expand, not constrict ... That is how it should be: an adventure, a pleasure, a way of being outside one's familiar territory."[8] The focused time in the workshop can also lead to increased productivity.

- *Conceptual*—Collaboration can expand the artistic vision. An example of this was Andy Warhol's use of printmakers to produce work in his "factory." He used the fairly commercial silkscreen process "to challenge the uniqueness of individual easel paintings as the mystique of the artist's hand, undermining concepts inherent in Western art since the Renaissance."[9] Robert Hobbs also saw a printmaking collaboration's ability to expand the artist's vision and the conceptual aspects of the work as a direct "opposition to the Romantic work subscribed to by the Abstract Expressionists."[10]

- *Educational*—The artist goes to a printer's workshop to gain experience and learn techniques and "trade secrets" from a master printer. Danny Moynihan, an Australian artist and printmaker, described this as part of his reason for working at the various ateliers in France.[11]

- *Economic*—Printmaking with a master printer is very practical, in that the artist doesn't need to purchase and maintain the expensive equipment. It's also a way for artists who produce a limited number of paintings or sculptures to get more work out,

and to make it more accessible. Such is the case with the American artist Chuck Close, who has only produced 60 or 70 paintings in his career. According to Deborah Wye, "He very much likes the fact that his printed and other editioned works make his art more available."[12] It would be naive to believe that collaborative printmaking is only done for these altruistic reasons. One of the motives for artists and their publishers to 'edition' prints is to make money.

For the Printer

- *Technical Challenges*—By trying to produce the artist's vision— which has not been hampered by the knowledge of limitations to the process—the printer has an opportunity to experiment and learn more about his craft. Japanese woodblock printer Tadashi Toda said of his collaborations with American artists as part of the Crown Point Press exchange, "As I have worked with the artists, I have realized that my understanding of woodblock printing has been completely explored and expanded, and I accept that as a gift."[13] Of course, not all printers will look at these challenges as opportunities let alone as a "gift."

- *Stimulation*—Working with artists can be seen as a break from the repetitive process-oriented world of the printer, which in turn can reinvigorate the printmaker's love of his craft.

- *Acceptance of Technology*—By bringing in established artists from other mediums to produce work in printmaking processes (such as lithography, photography, or digital), the printer can grow to accept these processes in the general art world. For a digital-world example, print publisher Randall Green (of Muse[x] Editions in Los Angeles) has worked to introduce successful mid-career artists to digital options and then to have their prints acquired by established galleries and museums.[14] This has brought about benefits for the artists, the publisher and the digital community overall by furthering acceptance of the technology.

- *Professional Identity*—Elizabeth Jones-Popescu notes that the printer needs the artist more than the artist needs the printer,

because the printer "depends on the artist in a real sense for his [or her] whole professional identity."[15] She further explains that "the printer's self respect depends, first on his own respect for the artist with whom he collaborates and second, on the competence with which he does his job, the assessment of which also depends on the artists' judgment and approval."[16] Although this power relationship is realistic and potentially hazardous to collaborative work, successful master printers seem to have dealt with this problem by being very selective when choosing the artists they invite to produce prints.

- *Financial*—The degree of this benefit can often depend on whether the printer is additionally acting as the publisher or dealer of the artist's work.

Contemporary Collaborative Fine Art Digital Printmakers and Studios

Many contemporary collaborative digital printmaking studios have been influenced by traditional printmaking, and they, as well as their artists, understand the benefits of the collaborative printmaking model. Following are some of the more influential fine-art digital printmaking studios in the United States.

Nash Editions

As mentioned earlier, Nash Editions started in 1991 and is still being run by Graham Nash and Mac Holbert in Long Beach, California. Nash Editions continues to specialize in inkjet output, but has shifted from Iris to Epson printers. Artists they have worked with include Robert Farber, Leonard Nimoy, and David Kennerly.

Adamson Editions Atelier

Adamson Editions Atelier is owned and run by David Adamson, a British lithographer, in Washington, DC. Adamson started making Iris digital prints around the same time as Nash Editions. He has collaborated with many artists and photographers, including Chuck Close, Lee Friedlander, Adam Fuss, Jenny Holzer, Annie Leibovitz, Jack Pierson, Robert Rauschenberg, and William Wegman.

Singer Editions

Started in the late 1990s in Boston by Jonathan Singer, Singer Editions is affiliated with Nash Editions and uses their collaborative printing model. This can be seen via Singer's chop mark, which is the same as Nash Editions—with the addition of his initials, "JS." Singer has worked with Sheila Metzner, Richard Linke, Rosemary Porter, Denny Moers, John Goodman, and David Hilliard.

Cone Editions Press

Cone Editions Press is located in rural East Topsham, Vermont. Like Adamson Editions, Cone was started as a traditional collaborative print workshop. It was founded by Jon Cone, a master screenprint, intaglio, and monoprint printer, in 1980. He started using computers in some of his collaborations in 1984. As he progressed with inkjet digital printmaking technology, Cone also started to develop his Piezography ink-sets, some especially for black-and-white inkjet printing. He sells these inks though his supply and profiling business, InkjetMall.com. Artists and photographers he has worked with include: David Humphrey, Kiki Smith, Barbara Ess, Jesse Orosco, Saul Leiter, and Lynne Davis.

Laumont Photographics

Unlike all of the other collaborative printmaking studios mentioned already, Laumont Photographics in New York City makes both Inkjet and photographic digital output. They are one of the few printmaking

facilities in the word that produces both chromogenic and dye-destruction (Ilfochrome) prints, as well as true fiber-based silver gelatin digital prints. Laumont also has one of the most highly regarded print finishing and framing departments in the business. Philippe Laumont and his staff have worked with Stephen Shore, Greg Crewdson, Alec Soth, and many others.

Ribuoli Digital

Ribuoli Digital was started in 2009 by Andre Ribuoli, the former director of Pamplemousse Press (Figure 16.2). Pamplemousse Press was the digital arm of Pace Editions, which still has woodblock, etching, and relief-printing facilities. Sadly, they closed the digital portion of the business in January of 2009. Andre continues to experiment and produce work with many different types of digital printing, along with standard Iris and Epson inkjet. He works with digital grinders, sewing machines, engraving, vector plotters, oil paint applicators, and other tools and techniques. Through his experiments Andre creatively pushes the definition of the digital print.

Authentic Vision

Finally, outside the USA, a former student of mine named Aaron Chan has opened Authentic Vision with his partners in ShenZhen, China, as seen in Figure 16.3. Aaron is working with established and emerging photographers and artists to interpret their work to digital prints. The studio uses Canon, Epson, and Hewlett Packard printers, as well as one printer with Jon Cone's Piezography K7 ink system for black-and-white printing, which we will discuss in Chapter 14.

All of this being said, over the past ten years there has been a big change in the collaborative fine-art digital printmaking business. Around ten to 15 years ago—when Iris printers were the only printers that could produce large, high-quality digital prints and the cost of those printers was in the high tens of thousands of dollars (and very expensive to maintain)—a photographer or artist would not want to own the printer him/herself.

FIGURE 16.2 Ribuoli Digital in New York City, which was started in 2009 by Andre Ribuoli, the former director of Pamplemousse Press.
Credit: Photograph, © Andre Ribuoli (ribuolidigital.com)

FIGURE 16.3 Authentic Vision in ShenZhen, China. Authentic Vision is a digital printmaking studio started by Aaron Chen and partners.
Credit: Photograph, © Aaron Chan (zhenshiphoto.com)

Now that large-format printers are in the thousands of dollars range (which may still seem expensive, but is a whole order of magnitude cheaper), and require much less knowledge and expense to run and maintain, many more photographers and artists make their own prints in-house. This is often good for the photographer, but has unfortunately also put pressure on the collaborative printmakers to adjust or close their doors.

Communicating with Collaborators, Clients, and Service Bureaus

Whenever we're collaborating in producing images, prints, multimedia, or publications, it's important to communicate as clearly as possible.

FIGURE 16.4 Embedding an ICC color profile when saving an image file for a service bureau in Adobe Photoshop, so that color can more likely be displayed and reproduced accurately.

Good communication techniques are crucial to this process. From the beginning of any project, you should talk with the key people involved, to make sure that questions are answered, expectations are reasonable, and specifications are clear. Is the desired print size too large for the resolution of the image? Does the client understand the limitations of the process? Will the gamut of the printer and paper be able to reproduce the client's product or corporate colors? What color space should the file be in?

This will ensure that you, your collaborators, and clients get the expected results. Color management supports this process. One simple step toward improving communication when handing over our images is to embed the images with the appropriate (working space) profile (Figure 16.4). If their monitors are well calibrated, then when they open the image, their applications will know what the RGB numbers from this file mean, and they should be able to display and reproduce the colors as accurately as possible.

As Chris Murphy—owner of Color Remedies, his color management consultancy, and one of the authors of *Real World Color Management*—said at a seminar a few years ago, "one of the most powerful color management tools is the telephone." It's important that you communicate with everyone involved and that they know how to best reach you. To this end, your contact information should be embedded in the metadata of your images, and included in readme files supplied with your images.

Printing with a Lab or Service Bureau

As we've just discussed, there are many benefits to developing collaborative relationships between artists and printmakers, such as the one found in traditional etching and lithography studios in the United States over the past 50 years. Sadly, this is not the working model that most photographic labs we work with use to make digital chromogenic prints. Most labs work in a more volume-based way and cannot afford the time and knowledgeable employees needed for the collaborative model, at the prices most customers are willing to pay. In some ways, labs are more like black boxes: we send in our files and hope for the best. This being said, there are ways to attain good quality from a lab. But it takes some testing, and, as we will discuss, some question-asking. It is also true that if you want the highest quality, you'll have to pay more for it.

There are lots of reasons for getting our digital color prints or c-prints from a lab. For one, as mentioned before, the prints are made with the same photographic papers and dyes they've been using for generations. Unlike inkjet, digital C-prints are continuous-tone color photographs; they are not made of halftone dots. And, finally, you can't ignore the benefit of having someone else do the printing, since it frees you up to create more images (or to have a life). Of course, the only problem with letting someone else do the printing is that we lose the control we might have when we print at home or in the studio. I, for one, like the control. But how do we get as close a match as possible between the images on our monitors, and the prints from the lab? The answer, as we know, is color management.

As you might guess, color management should include calibrating and profiling your monitor, but it should also include, as mentioned before, a conversation. It's critical to either review the lab or service bureau's website, talk with the customer service agent behind the counter, or contact one of the lab technicians who will actually print your images.

Questions to Ask

Question 1: What White Point, Gamma, and Luminance Should I Select When I Calibrate and Profile my Monitor?

As with all of these questions, the inquiry about white point and gamma for your display could result in a blank stare from the customer service agent behind the counter, as though you were speaking that Vulcan language of extreme Star Trek fans.

Let's start by repeating that if you're making any color adjustments to your digital image, and making those judgments based on what you see on your monitor, you need to calibrate and profile your monitor using a colorimeter or spectrophotometer, and you need to use some sort of digital color management software.

Currently, the leading manufacturers of these systems are DataColor and X-Rite. The colorimeter is an objective measurement device that will help you optimize your monitor's settings, such as contrast and brightness, and help you get as much accuracy and consistency as possible. Remember: one of the big limits to the accuracy and consistency that your monitor is capable of is the quality of the display.

As we discussed in Chapter 4, one of the steps in calibrating and profiling your monitor is choosing a white point, gamma, and luminance, which sets the appearance of your monitor. To help you make these choices, ask your lab what settings they use. Once you calibrate and profile your display to these recommended settings, you will then have the same viewing environment they do.

As we've discussed, when you choose the white point or color temperature, you take control of the color balance or the relative warmth or coolness of your monitor's appearance. The choice typically ranges from 5000 K to 6500 K. Choosing a higher white point results in a cooler or bluer appearance.

Remember that when you choose the Gamma setting, you take control of contrast by dictating how the tonal values of the image are distributed. The choice is typically 2.2 or 1.8. A Gamma setting of

2.2 offers a slightly higher appearance of contrast (as compared to a gamma selection 1.8). A Gamma setting of 2.2 will result in darker darks (shadows) than a setting of 1.8 will, which means that a Gamma setting of 2.2 is probably closer to the way a lab will print your pictures.

The luminance (or brightness) of today's LCD displays is very high, so high that we can't match a print output to them. So, as mentioned before, we want to bring down the luminance of our LCD displays to somewhere in the range from 80–120 cd/m^2, depending on the brightness of the lighting surrounding your display.

The lab might say that these choices or the display conditions don't matter, and that as long as you are calibrating and profiling your monitor at a reasonable luminance, Photoshop will display the color accurately. This is somewhat true, especially as it pertains to white point, since our eyes adjust fairly well to different white point values in a fairly short amount of time (color constancy). Ultimately, though, it depends on them, and you won't really know if the setting is right until you see the prints. The lab might also say that they just don't know. If the lab personnel or website resources are not specific or confused, then a combination of 6500 K, a Gamma of 2.2, and a luminance of 100 cd/m^2 is your best bet.

Question 2: Do You Have a Printer/Paper Profile for Soft Proofing My Images?

Some labs might provide you with ICC profiles for every printer and paper combination that they have. As you've seen before, you could use this profile in Photoshop or Lightroom to simulate or "soft proof" how your image will look once it is printed on different printer and paper combinations.

Once you download or otherwise obtain the printer-paper profile, place it in a specific folder so that Photoshop will recognize it and allow you to select it. In Mac OSX, this folder is **Library/ColorSync/Profiles**. In Windows XP, Vista, and 7 this folder is **C:\Windows\system32\spool\drivers\color**.

Next, open your images in Photoshop and click on **View > Proof Setup > Custom** in the menu bar to launch the **Customize Proof Condition** window. Then select the lab profile from the **Device to Simulate** pull-down menu, as you can see in Figure 16.5.

FIGURE 16.5 Using Adobe Photoshop to soft proof an image using an output profile from a lab for their printer and paper combination.

Note that some labs will not provide the printer-profiles. One reason is that they are constantly updating the profiles and don't want customers to use out-of-date profiles. Other possible reasons are that the lab could be building proprietary profiles, not standard ICC profiles,

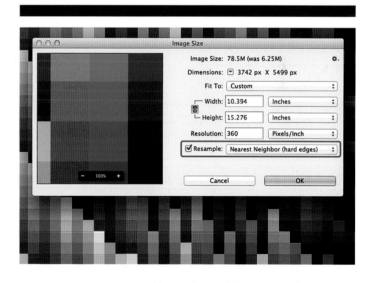

FIGURE 16.6 Resizing output profiling patches in Adobe Photoshop to print at a Lab using their recommended resolution and the 'Nearest Neighbor' algorithm to help maintain hard edges on the printed target.

that are only used by the printer's software (so they can't be used in Photoshop), or that the profiles that get buried too deeply in their printer's software to extract for sharing.

One option for dealing with a lab that doesn't have custom profiles is to send them patches to print, then you can build your own profile for their printer and paper combination. To make this work, it's important to size your profiling patches correctly and then tell the lab not to resize the image file—so that the spectrophotometer will be able to measure the patches. As we discussed in the last chapter, when resizing profiling patches in Photoshop, you should select the **Nearest Neighbor** resampling algorithm to preserve the hard edges of the color patches, which would be softened by using the other resampling algorithms, as seen in Figure 16.6.

Question 3: Into What Color Space Should I Save (Convert) the Images?

Should you save images into a specific working color space or into the lab's printer-paper space? Many printers and labs expect your files to be in specific RGB (red, green, blue) color spaces, such as sRGB or AdobeRGB(1998). If the files you send them are in a different color space, then your prints will not match the way they look on your monitor in Photoshop or Lightroom.

In the scenario in Figure 16.7 the lab's printer expected that all the image files were sent in sRGB. The images in the upper left and the two at the bottom show what would have happened if the image was sent in unexpected color spaces, specifically GenericRGB, AdobeRGB(1998), and ProPhotoRGB. The image on the upper left that was in Generic RGB would result in a print from this sRGB printer that is overly saturated and dark. The image on the lower left that was in AdobeRGB(1998) would result in a print that is unsaturated and

flat print, while the image on the lower right was in ProPhotoRGB and would have resulted in an even more desaturated and dark print. Finally, the image in the upper right was in sRGB and resulted in a print that closely matched to the image in Photoshop.

If the lab says it doesn't matter in which RGB color space you send your images, and you continue to use this service provider, then it's best to convert the image to sRGB. Although this is not necessarily optimal, it is currently the safest bet, since most photographic digital minilab printers expect your images to be in this color space.

If the lab specifies that the image should be in a working color space (like sRGB) and still provides a printer/paper profile for soft proofing, then the best way for using the profile and simulating how the image will look on the final print is to slightly change the settings in Photoshop's **Customize Proof Condition** window from question 2 and Figure 16.5. In this situation (Figure 16.8), you should select the **Preserve RGB Numbers** check box. What does this do? As we've discussed in Chapter 8, the **Preserve RGB Numbers** option simulates what the print would look like if we sent these raw RGB numbers to this printer/paper combination.

Figure 16.9 shows an example of what happened when an image in sRGB was soft proofed using a lab's printer/paper profile. The image on the left shows the image as it should have looked, but the soft proof using Preserve RGB Numbers and the labs profile on the right shows how the image was printed if the sRGB values were sent to the printer. Notice the loss of highlight details. Sadly, I initially made many copies of this print without soft proofing using this method, thinking it was enough to convert the image to the requested color space (sRGB), but they ended up looking like the version on the right. It would have been better to convert the image to the lab's printer/paper profile for this image, as we will discuss next.

Besides having you send images in a standard working color space (like AdobeRGB or sRGB), the lab could give you the option of converting the image files with their printer/paper profile before sending them. This can result in excellent final prints that very closely match what you see on your monitor—as long as you let the

If the service bureau or lab specifies the color space for the image, the file should be converted into that space, *not* assigned. Converting will keep the image looking the same or as close as possible. Assigning the profile could change the image's color drastically and undesirably.

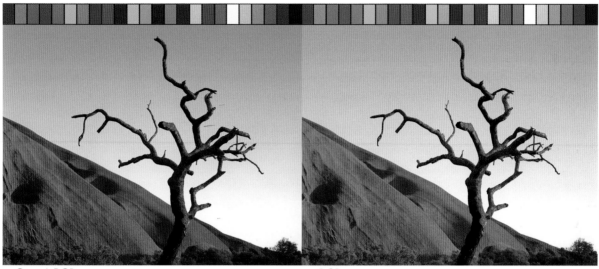

GenericRGB sRGB

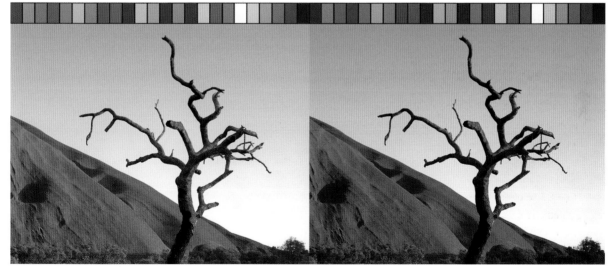

AdobeRGB(1998) ProPhotoRGB

FIGURE 16.7 Four simulated versions of a test print made on a service bureau's digital c-print output device that expects sRGB as the color space. Each shows the colors that would result if the image were in GenericRGB, sRGB, AdobeRGB(1998), and ProPhotoRGB. The sRGB version in the upper right shows the test image, as it should have been reproduced. It is important to ask which color space the service provider wants the image converted to or you will get inaccurate results.
Credit: Photograph by the author

FIGURE 16.8 Using Preserve RGB Numbers in Adobe Photoshop's Custom Proof window to soft proof an image using a printer/paper profile from a lab. The Preserve RGB Numbers option shows what the final print would look like if the RGB values were sent to the printer, as is, without conversion to the printer/paper profile.

FIGURE 16.9 Version of image on the left shows it the way it appeared on the display in AdobePhotoshop. The version on the right simulates how the image looked (with the lack of highlight details) on the print when its sRGB values were sent directly to the printer without conversion to the lab's printer/paper profile. Using the Preserve RGB Numbers in the Custom Proof window, like in Figure 16.8, created this simulation.
Credit: Portion of photograph by the author

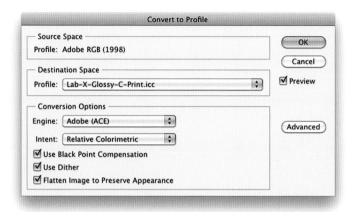

FIGURE 16.11 Selection from a service provider's website that tells the lab not to color correct your order, since you have already color corrected and color managed your images. If this choice is not expressly given, you might need to add a note to your order.

FIGURE 16.10 Using Adobe Photoshop to convert an image using an output profile from a lab for their printer and paper combination.

lab know that you have done this, and tell them *not* to make any adjustments to your image. To perform the conversion in Photoshop, click on **Edit > Convert to Profile** from the menu bar. This will launch the **Convert to Profile** window. Then select the lab profile from the **Destination Space** pull-down menu, as you see in Figure 16.10.

Question 4: In What File Format (TIFF, JPEG) and Resolution Should I Save the Image?

As with the questions about color, color profiles, and color spaces, you are more likely to get an optimal final print from the lab if you clarify their expectations for file format and resolution. When setting the resolution, often the lab will want the image to be an exact number of pixels wide by pixels high. For example, let's say the optimal resolution for a 16 x 20-inch print is requested at 4800 x 6000 pixels at 300 ppi (pixels per inch). The first step will be to crop the image to this aspect ratio and then size it appropriately. We will discuss the methods for sizing your files in the next chapter.

If you find that you are producing lots of prints and preparing many files for sending to the lab, then it's time to look into using automation, which could take the form of **Actions** in Photoshop, to take care of all the repetitive tasks. Automation can save you lots of file-prep time by doing tasks like: resizing the images, converting with profiles, sharpening, flattening the files, saving the images, and embedding profiles. Don't forget to sharpen the images, as we discussed in the last chapter.

Finally, remember that when you color correct your own images, you need to tell the lab not to color correct them. If your lab has a job setup section on their website or uses an order form, then you can tell them not to color correct your images by selecting the **Do not touch images (straight to print)** option, or its equivalent (Figure 16.11).

Once you've had this conversation with your lab and implemented what you learn, you will have improved communication and color management. This will result in lab prints that more closely match your monitor and give you that feeling of control you hopefully have when you're printing yourself.

Remember: part of what you are doing by asking these questions and possibly making test prints with different labs is to audition them. You are really trying to determine if they are a business or professionals you want to work with in the future. This dialog could be the start of great long-term collaboration.

Conclusion

As we have discussed in this chapter, when working with others communication is very important. It doesn't matter if you are sharing files with a client or making prints collaboratively with a master printmaker or a more anonymous lab to make digital C-prints, you always need to ask questions to help insure good color management and more predictable results. In the next chapter we will discuss the specific questions to ask when printing to a CMYK printing press, which adds a few more issues.

EXPLORATIONS

Give yourself the experience of making digital C-prints with different labs. Look at different websites and call the labs to get the answers to the questions we discussed. This will give you a feel for how much the lab knows, their level of customer service, and the best ways to get the resulting prints to match what you see on your display. First print your test page before printing real print jobs. This will give you a good idea of how well the color management workflow and communication between you and the lab are working. Finally remember that you want to have a long-term collaborative relationship with the service provider you choose to make your prints, so take making these test prints as an opportunity for these labs to audition for the role as your printer in the future.

Resources

Fine Art Digital Printmaking Studios

Adamson Editions Atelier, Washington, DC
http://www.adamsoneditions.com

Authentic Vision, ShenZhen, China
http://www.zhenshiphoto.com

Cone Editions, East Topsham, VT
http://www.cone-editions.com/

Gotham Imaging, New York, NY
http://www.gothamimaging.com/

Griffin Editions, New York, NY
http://www.griffineditions.com/

Grundberg, Andy et al., *Atelier Adamson*, Steidl/MEP, Paris, 2005. ISBN-13: 978-3-86521-150-157.

Laumont Studio, New York, NY
http://laumont.com/index.html

Nash Editions, Pasadena, CA
http://www.nasheditions.com/

Ribuoli Digital, New York, NY
http://ribuolidigital.com/

Singer Editions, Boston, MA
http://www.singereditions.com

White, Garrett, ed., *Nash Editions: Photography and the Art of Digital Printing*, New Riders Press, Berkeley, CA, 2006. ISBN-13: 978-0-32131-630-1.

Notes

1. Hansen, Trudy, "Multiple Visions: Printers, Artists, Promoters, and Patrons," in Trudy Hansen et al. (eds.), *Printmaking in America: Collaborative Prints and Presses 1960–1990*. Harry N. Abrams, Inc., New York, 1995, p. 40.

2. Ruzicka, Joseph, *Landfall Press: Twenty-Five Years of Printmaking*. Milwaukee Art Museum, Milwaukee, Wisconsin, 1996, p. 38.

3. Irwin Hollender, master printer, quote from 1968 found in Garo Z. Antreasian, "Some Thoughts About Printmaking and Print Collaborations," *Art Journal*, vol. 39, 1980, p. 184.

4. Antreasian, Garo, and Adams, Clinton, *The Tamarind Book of Lithography: Art & Techniques*, Harry N. Abrams, Inc., New York, 1971, p. 76.

5. Full quote: "John Russell, writing in the *New York Times*, acknowledged that master printers were now able to show artists undreamed of things, come up with 'an end product . . . astonishing in its vigor, its assurance and its breadth of resource'"; Pat Gilmour, *Ken Tyler, Master Printer, and the American Print Renaissance*, Hudson Hills Press, Inc., New York, 1986, p. 32.

6. Jones-Popescu, Elizabeth, "American Lithography and Tamarind Lithography Workshop/Tamarind Institute 1900–1980," Ph.D. dissertation, University of New Mexico, Albuquerque, New Mexico, 1980, pp. 357–372.

7. Fine, Ruth, and Corlett, Mary Lee, *Graphicstudio: Contemporary Art from the Collaborative Workshop at the University of South Florida*, National Gallery of Art, Washington, DC, 1991, pp. 17–18.

8. Brown, Kathan, "Wasting and Wasting Not: How (and Why) Artists Work at Crown Point Press," *Art Journal*, vol. 39, 1980, p. 177.

9. Bernstein, Roberta, "Warhol as Printmaker," in Frayda Feldman and Jörg Schellmann (eds.), *Andy Warhol Print (A Catalogue Raisonné)*, revised edition, Ronald Feldman Fine Arts Inc., New York, 1989, p. 15.

10. Hobbs, Robert C., "Rewriting History: Artistic Collaboration Since 1960," in Cynthia Jaffee McCabe, *Artistic Collaboration in the Twentieth Century*, Smithsonian Institution Press, Washington, DC, 1984, p. 71.

11. Interview with printmaker Danny Moynihan in Melbourne, Australia, September 14, 1999.

12. Wye, Deborah, "Changing Expressions: Printmaking," in Robert Store, *Chuck Close*, Museum of Modern Art, New York, 1998, pp. 80–82.

13. Toda, Todashi, from a Japanese magazine article quoted in Kathan Brown, *Ink, Paper, Metal, Wood: Painters and Sculptors at Crown Point Press*, Chronicle Books, San Francisco, 1996, p. 196.

14. Interview with Randall Green in Los Angeles, CA, June 22, 1999.

15. Jones-Popescu, Elizabeth, "American Lithography and Tamarind Lithography Workshop/Tamarind Institute 1900–1980," Ph.D. dissertation, University of New Mexico, Albuquerque, New Mexico, 1980, pp. 357–372.

16. Ibid.

Seventeen

CMYK OUTPUT: PRINTING PRESSES & SHORT RUN PHOTO BOOKS

In the last chapter we started to discuss the importance of communication and how to prepare files for output to service providers. In this chapter we will continue that discussion by looking at preparing CMYK files for going to printing press. We will also look at printing books and other materials using short run digital (electrophotographic) printing presses.

Converting to CMYK

When work goes to a printing press for output in advertisements, packaging, books, postcards, newspapers, or magazines, at some point your RGB image(s) will need to be converted to CMYK, since, as we discussed in Chapter 2, CMYK is the subtractive method for most print output. That being said, one of the worst requests we as photographers can get is for us to supply images in CMYK. You might be asking yourself, "Why is it such a difficult request?" All you have to do is go to **Image > Mode > CMYK** in the menu bar of Photoshop. It's easy!

Yes, it's deceptively easy—just like making a print—but it is much more difficult to do correctly. There are four reasons why CMYK is a complex request: CMYK conversion in the past was done only by master craftspeople; there is no generic CMYK; the color gamut is limited once the file is converted to CMYK; and the person making the request most likely doesn't know what they're asking for.

CMYK Conversion in the Past

First some history, way back—15 to 20 years ago—there were still craftspeople known as scanner operators. In truth they are not extinct, but digital photography and desktop publishing have greatly squeezed them out and reduced their numbers.

The scanner operator worked on drum scanners that could cost hundreds of thousands of dollars. They would typically go through a long apprenticeship to be trained in using these complex and delicate pieces of equipment. Once trained, the scanner operators scanned photographic transparencies and prints, and then translated the results to halftone film separations, which created the cyan, magenta, and yellow printing plates that would go onto the printing press.

What they did was part art and science. It was no easy task to translate the large gamut of film transparencies so they could be reproduced on the smaller gamut of printing press impressions, and on a variety of papers. For photographers, our job was easier. Once we handed off the client-approved print or transparency, our job was done. If something went wrong after that, then it was someone else's problem. Now, when we produce a CMYK file, the responsibility is ours.

There Is No Generic CMYK

When a client requests an RGB file from you, the next words out of your mouth should be, "Which RGB color space?" You want them to be specific because you know there is *not* just *one* RGB color space, there are many: AdobeRGB(1998), ProPhotoRGB, ColorMatchRGB, and sRGB, as well as BruceRGB, JoeRGB, AppleRGB, or monitor RGB color spaces, digital camera RGB color spaces, scanner color spaces, and RGB printer/paper color spaces. You also know that these RGB color spaces are all different from one another in gamut, white point, and/or gamma. As we learned from Figure 16.7, if you supply the wrong RGB color space, you can get very different results in color and tone than you expected.

The same is true with CMYK files. There is *no one* CMYK space. You require more specific information. You need to ask: "Where in the world is this file going?" "What type of printing press, ink, and paper will be used?" "Is there a standard process or proofing-system profile, or is there a specific press profile I should use to perform the conversion?" "What type of black generation and what ink limits are needed?" (We'll talk about what all these variables mean, and how we can adjust them in the next section.)

FIGURE 17.1 Still life image with printers' crop marks, registration marks, and color bars.
Credit: Photograph, © Katrin Eismann, Dachboden #8, 2013 (katrineismann.com)

Conversion to CMYK Limits the Color Gamut

One of the problems with converting your images from AdobeRGB (1998), ProPhotoRGB—or even sRGB—to any CMYK space is that you will be reducing the gamut of your image to something possibly much smaller. This can be seen in Figure 17.2, which shows the gamut of AdobeRGB(1998) and the gamuts of coated and uncoated versions of U.S. Sheetfed CMYK color spaces in ColorThink Pro.

In many cases, colors will be less saturated and no longer as accurate as before; you can also get some loss of detail. You might think this isn't a big deal and that you could just convert back to a larger space and regain the color gamut—but this is not the case. Once the gamut has been reduced, there's no going back. (It is the same case with bit depth: Once bit depth has been reduced from 16 to 8 bits, going to back to the higher bit-depth will be a waste of file size; nothing is gained.) Also, image quality can be reduced from additional conversions, which might be necessary if the image has been initially converted to the wrong CMYK space.

Client Unfamiliarity with CMYK

Considering these challenges, if the person requesting the CMYK files doesn't give any more specific information, then they probably don't know what they are asking for. This could lead you to converting to the wrong CMYK profile, which could result in poor color reproduction, which—rightly or wrongly—could be considered your responsibility. Converter beware!

CMYK Color Separations

When we convert a file from RGB to CMYK, we go from an additive form of color reproduction to a subtractive form of color reproduction. Another way of describing this is that we are separating out the colors into cyan, magenta, yellow, and black channels, separations, or plates needed for reproduction on printing presses. CMY (cyan, magenta, and

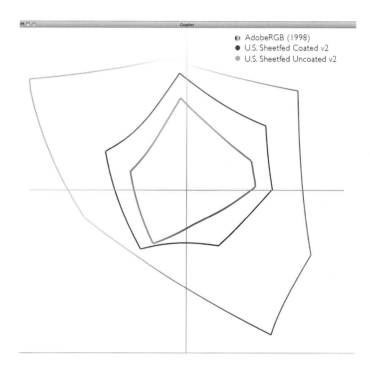

FIGURE 17.2 The gamuts of AdobeRGB (1998) and coated and uncoated versions of U.S. Sheetfed CMYK color spaces in ColorThink Pro, showing that once you convert to a smaller color space, you can not regain the color gamut lost.

yellow) makes sense, but what's with the K (black)? Why do we need black ink? Because of impurities in the cyan, magenta, and yellow inks. In practice, the combination of all three does not produce a true black; it produces a muddy brown or green. We use the black ink to produce a true black.

There are other benefits to having a fourth (black) ink. The black ink allows us to print text using only one ink, instead of trying to get three inks (CMY) in register with one another, which gives us better text quality. Also, wherever there is a neutral in an image, we can use one ink (black) instead of three. This saves money in printing costs, especially if we use a heavier black separation, which you will see later in this section.

As we have discussed, there is not one type of CMYK color separation. There are many different ways of separating an image into cyan, magenta, yellow, and black to reproduce the colors from the RGB color space. The differences depend on the following factors and variables: *paper type, ink type and colors, dot gain, black generation*, and *ink limits*.

Photoshop allows you to adjust these variables and create a custom CMYK separation. To do this, launch the **Color Settings** window by clicking on **Edit > Color Settings** from the menu bar. Then click on the **CMYK working color space** pull-down menu and drag to the top, **Custom CMYK**, as you can see in Figure 17.3. This launches the window seen in Figure 17.4.

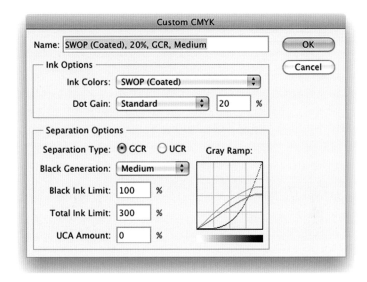

FIGURE 17.4 Custom CMYK window in Adobe Photoshop.

FIGURE 17.3 Selecting Custom CMYK in Color Settings window in Adobe Photoshop.

Paper Type

Although those in the graphic arts industry print on a large variety of paper stocks, the papers are typically divided into two categories: coated and uncoated. As we have seen, paper type has a big impact on the range of colors that can be output. You could end up using either or any type of stock for aesthetic reasons. Some images and printed output will lend themselves better to different types of paper, as we discussed earlier with inkjet output.

Ink Type and Colors

As with paper type, the type and colors of ink affect two things: the gamut (or range) of colors and the dot gain. Figure 17.5 shows the options Photoshop gives for **Ink Colors**. As you can see, the choices are a combination of ink and paper common to different parts of the world.

SWOP stands for "Specifications for Web Offset Publications," which are evolving guidelines created by the North American printing industry (see more information in the Resources section below). Notice that one of the choices of Ink Colors is Custom. Selecting this choice launches the window shown in Figure 17.6, which allows for specifying the measured colors created by different ink combinations on the paper in either CIEYxy or, as shown, in CIE-LAB.

FIGURE 17.6 Ink Colors window in Adobe Photoshop, used to define the color characteristics of the specific CMYK inks.

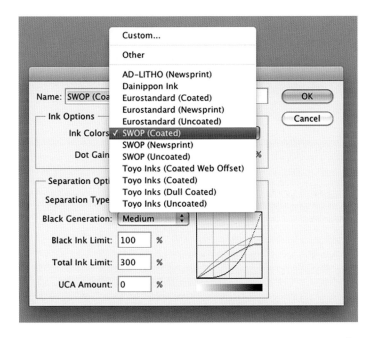

FIGURE 17.5 Standard choices of Ink/Paper combinations in Custom CMYK in Color Settings window in Adobe Photoshop.

Dot Gain

Dot Gain is the measured or expected percentage of increase in halftone dot size—from what the dot size is on the printing plate, to what it ends up being on the paper. The same thing happens with the ink on paper as happens with water on a napkin or paper towel: the liquid is absorbed and spreads. The dot gain is higher when the paper absorbs ink to a greater degree, as is the case with uncoated or newsprint papers. There is less dot gain on coated and glossy papers.

Two elements affect dot gain: the type of paper, and the viscosity (as well as other properties) of the ink. When you correctly understand the dot gain of the ink and paper combination, it's easier to adjust and build the color separation, which results in achieving more accurate color on the press.

Black Generation

As mentioned before, one of the reasons we use black ink is because of impurities in the cyan, magenta, and yellow inks—which result in the combination of all three not producing a true black. The black ink also gives us some real economic and practical benefits, beyond that of the richer, truer black.

On the economic side, in parts of our images that use all three (cyan, magenta, and yellow) inks, we are able to replace the cyan, magenta, and yellow inks with the black ink, which is much cheaper. There are two methods for introducing the black ink to replace the other three inks: *Under Color Removal* (UCR) and *Grey Component Replacement* (GCR).

With UCR separations, black is introduced mainly in the neutrals, especially the dark neutrals. UCR is more common when printing with newsprint. With GCR, black is introduced in the neutrals and in unsaturated colors, replacing the complementary color ink that makes the color appear less saturated—for example, where magenta

FIGURE 17.7 Test page that is separated into different types of CMYK in Figures 17.8, 17.9, 17.10, and 17.11.
Credit: Test page designed by author with photographs by Tom Ashe, Barbara Broder, Jungmin Kim, Brittany Reyna, Christopher Sellas, and Adam Wolpinsky

FIGURES 17.0–17.11 *(top to bottom) (1)* UCR (Under Color Removal) – Medium Black; *(2)* GCR (Gray Component Removal) – Medium Black; *(3)* GCR – Light Black; *(4)* GCR– Dark Black. All CMYK separations from the test page in Figure 17.7.

ink would be added to make greens in the print output appear less saturated, with GCR black ink is used instead of magenta. This then happens with all the other colors—Figures 17.8 and 17.9 show the difference in UCR and GCR separations for the image in Figure 17.7 respectively. A percentage of *Under Color Addition* (UCA) can be added in, when using UCR, to make richer blacks.

Photoshop also lets us increase or decrease the amount of black in the separation. Figures 17.10 and 17.11 show separations that were created with light black and heavy black separations, respectively.

Ink Limits

The highest percent of total ink and the total amount of black ink depends on the printing process, the ink, and the type of paper. With too much ink comes a loss of details, difficulty in drying, ink smearing, and, on the extreme side, ink pooling.

Standard CMYK Spaces and Specifications

Photoshop includes profiles, which are based on different paper, ink, and printing specifications by different organizations. Which standard is used is typically based on where the printing is being done. As long as the printing press is using the specifications set down by the organization, color matching should be reasonably close. Following are some of the specification organizations:

FOGRA—German organization devoted to developing specifications and influencing international standards in the graphic arts industry, which was started in the early 1950s and is mainly followed in Europe.

GRACoL—Stands for "General Requirements and Applications for Commercial Offset Lithography," a task force formed in the mid-1960s, which has created guidelines and recommendations for printing with offset lithography that is meant to help print buyers and designers work more effectively with print suppliers.

SWOP—Stands for "Specifications for Web Offset Printing," a U.S.-based group started in the mid-1970s devoted to developing specifications and influencing international standards in the graphic arts industry.

GRACoL 7—The latest recommendation for quality sheet-fed printing put forward by GRACoL.

G7—This is not the same thing as GRACol7. It's a print calibration process (or methodology) that can be used on presses and digital proofing systems, which takes into account colorimetric and spectrophotometer measurements, especially to help in improving and maintaining neutrality. The G7 gray balance method can be used on presses that are using any press standards, including FOGRA, SWOP, or GRACoL.

Short Run Digital Printing and Publishing

Printing a book on a traditional four-color graphic-arts printing press can be a very expensive investment. The setup costs for offset lithography and other traditional printing press technologies are high, partially because metal plates (and possibly film separations) need to be produced for each page and ink used. Typically, many hundreds or thousands of impressions need to be made to justify the setup costs.

One of the reasons why photographers have needed a publisher to be involved in producing their books is to help absorb the thousands of dollars in upfront investment. Other reasons for having a book publisher include marketing and distribution. For these reasons, publishers have acted as gatekeepers, determining which photography books do and do not get produced.

The availability of short run digital (aka print-on-demand) printing presses has helped change this paradigm, due to their minimal setup costs. While there are still benefits to having a publisher, we photographers can now afford to produce books on our own. In addition to being able to afford to publish books, photographers can now also afford to print marketing collateral materials (like postcards) more

frequently, and at lower volumes. This allows us to create more focused marketing campaigns without producing more prints than we need—just to get discounts and meet minimum-volume requirements. (An environmental benefit?)

The technology used in short run or print-on-demand (PoD) digital presses is electrophotography, which uses either solid or liquid toner. Solid toner is used in Xerox and Kodak Nexpress digital presses, while liquid toner is used in the more offset-like Canon and HP Indigo digital printers and presses.

Working with Short Run Digital Publishers and Printers

As we do with other service providers, we need to work hard to communicate, color manage, and prepare our image files to make sure we can get the best match possible between the images on our monitor and the resulting pages from short run printing and publishing companies.

We'll look at six service providers and attempt to answer the same questions we have asked before:

- Is there an ICC profile for the printing press and paper to use in soft proofing (and possibly converting) our images?
- What color space should the submitted image be in?
- What final image resolution and file format should be submitted to the printing company?

Of the six companies we will review, four are short-run photo book publishers (Blurb, Lulu, HP MagCloud, and Pikto) and two are print-on-demand postcard printers (Modern Postcard and 4over4.com).

Blurb

Blurb is a large self-publishing company based out of San Francisco which makes general books, but also has a strong focus on photo-graphy books. Over the past couple years, they've added better papers and color-managed workflows. The three possible workflows in Blurb are Bookify, BookSmart, and PDF to Book. Bookify is the most basic online bookmaking tool for producing simple photo books. BookSmart is Blurb's proprietary software for formatting and producing a book. And PDF to Book is for designers and more professional users who are designing and formatting their books in Adobe InDesign. Adobe Lightroom now has a Book module, which allows you to design and upload a book directly to Blurb from within the application as seen in Figure 17.12.

- *Profile for Soft Proofing*—Blurb supplies a general CMYK profile, which could be used in soft proofing in Adobe Photoshop, as seen in Figure 17.13. Keep the rendering intent on **Perceptual**, because of the relatively smaller gamut of the Indigo presses used by Blurb. Here's a question for you. Why is **Preserve Numbers** grayed out when using this profile in **Customize Proof Condition**? (Because the document's color space is RGB and the device's color space is in CMYK.) Sadly, you cannot use the Blurb profile for soft proofing in Adobe Lightroom, since Lightroom does not currently support CMYK output profiles.
- *Color Space for Images*—For Bookify and BookSmart workflows, Blurb requests that images be supplied in sRGB. Convert the images into sRGB if they are not already in this space. Do *not* convert to the Blurb profile supplied if you are using the Bookify or BookSmart workflows. Blurb will perform the conversion to CMYK. However, if you are using the PDF to Book workflow, you can either supply the PDF from an Adobe InDesign document with the images converted to sRGB or to the Blurb profile. The benefit to you controlling the conversion is that you would be able to control the rendering intent used and possibly create better black-and-white images.
- *Resolution and File Formats*—Blurb requests a resolution range from 150 PPI (minimum) to 300 PPI (maximum), and they accept either JPEG or PNG formats. PNGs should be 8-bit and non-interlaced.

FIGURE 17.12 Book module in Adobe Lightroom, which allows you to design and upload a book to Blurb for publishing.
Credit: Photographs by the author

FIGURE 17.13 Proof Setup window in Adobe Photoshop with the Blurb CMYK profile set as the device to simulate. As you've seen before, this interface allows you to soft proof images and show how they will look when output, in this case from the Blurb PoD printing press.

Lulu

Lulu is a large self-publishing company with offices in Raleigh, North Carolina, London, Toronto, and Bangalore. It specializes in general books, e-books, cookbooks, calendars, photo books, and poetry books. Although their website and interface is up-to-date and intuitive, of all six of the print-on-demand service providers we are looking at, Lulu gives the least information to help us color manage our images. In some ways they are upfront about this. A few years ago on their website in a section titled "Why Lulu might not be right for you," reason number three is "You're a very picky author. In order to make our publishing system both affordable and scalable, we have to limit choices about things such as paper and book size. We don't offer alternative paper selections or custom-trim books." In a similar vein, I believe they also do not want to get into the business of attempting to match color for very picky photographers.

- *Profile for Soft Proofing*—There is no ICC profile or color space recommended or mentioned for soft proofing your images before incorporating them into a Lulu book.
- *Color Space for Images*—Although some of their support materials on creating and submitting PDFs of book layouts and designs mentions that RGB images should be kept in RGB, and CMYK

FIGURE 17.14 Export PDF settings supplied on Lulu's website shows that ICC profiles are not included with images, so there is no way for Lulu to convert images accurately for the printing press, unless they get lucky.

images should be kept in CMYK, Lulu does not recommend a specific color space for images to be supplied to them. Also, the PDF creation settings supplied from Lulu do not preserve ICC profiles embedded with images, as seen in Figure 17.14. That being said, the templates for their book covers are Portable Network Graphics (PNG), which doesn't have embedded profiles. In the case of Lulu or other similar services, I would convert all images to sRGB and hope for the best.

- *Resolution and File Formats*—As the color space for Lulu books can be implied by the color space of the cover template, the image file resolution can also be implied by the resolution of the template, which is 300 PPI. The file formats Lulu accepts for their books are DOC and DOCX (Word document),

RTF (Rich Text Format), JPG (Joint Photographic Expert Group), GIF (Graphics Interchange Format), and, as mentioned before, PNG and PDF.

HP MagCloud

HP MagCloud was conceived in HP Labs, Hewlett Packard's central research division. As the name suggests, MagCloud is a print-on-demand publishing platform that specializes in making short run magazines of different sizes and formats. They also print and produce flyers, pamphlets, and 12 x 18-inch posters. Not surprisingly, these products are made on HP Indigo PoD printing presses.

- *Profile for Soft Proofing*—There is no ICC profile or color space recommended or mentioned for soft proofing your images before incorporating them into an HP MacCloud publication.
- *Color Space for Images*—Similar to Lulu, MagCloud's instruction materials on creating PDFs mentions that RGB images should be kept in RGB and CMYK images should be kept in CMYK, MagCloud also does not recommend a specific color space for images to be supplied to them. However, unlike Lulu, the PDF creation settings supplied from MagCloud do preserve ICC profiles embedded with images, as seen in Figure 17.15, and they recommend that images be embedded with their original profile. That being said, the Photoshop templates for their publications are in sRGB. So, converting all images to sRGB for MagCloud publications would be a safe choice. Text, on the other hand, should be in CMYK, preferably with black ink only, because of the registration issues we have discussed earlier.
- *Resolution and File Formats*—Although they recommend images to be in 300 DPI (dots per inch), we know they mean 300 PPI (pixels per inch). HP MagCloud is set up mainly for working with PDF files saved or exported from Adobe InDesign, Quark XPress, Microsoft Word, Apple Pages, Microsoft Publisher, Adobe Photoshop, or Apple Aperture.

FIGURE 17.15 Export PDF settings supplied on MacCloud shows that ICC profiles are embedded and saved with images, so they can be converted accurately for CMYK output by the HP Indigo PoD printing press.

Pikto

Pikto is a photographic laboratory based out of Toronto, which also makes print-on-demand fine art photo books. Pikto doesn't offer the free marketing and distribution of Lulu and Blurb, but they do offer many choices and options in materials.

- *Profile for Soft Proofing*—As with Blurb, Pikto has ICC profiles for soft proofing in Photoshop. The added benefit is that they have individual custom profiles for each paper stock they offer. They recommend keeping the rendering intent on **Relative Colorimetric** with **Black Point Compensation** turned on, since this is how they will be performing the conversion to CMYK.

- *Color Space for Images*—As with Blurb, Pikto requests that projects with color and black-and-white images be supplied in sRGB and that black-and-white only project images be supplied in Grayscale Gamma 2.2. Again, do *not* convert to the custom profiles supplied. Pikto will do the conversion to CMYK.
- *Resolution and File Formats*—Pikto requests a resolution of 300 PPI. They accept JPEG files from Adobe Photoshop layouts and PDFs from Adobe InDesign or Apple Aperture.

Modern Postcard

Modern Postcard is a printing and mailing company out of San Diego. Instead of print-on-demand electrophotographic systems, they use Komori Lithrone 40RP and Komori Lithrone S640P offset lithographic printing presses.

- *Profile for Soft Proofing*—Modern Postcard supplies three ICC profiles for soft proofing and converting in Photoshop. One is a CMYK profile for color images, as seen in Figure 17.16. Another is a CMYK profile for black-and-white images and the third is a grayscale black-ink-only profile for their 4/1 option, where one side of the postcard only prints with black ink.
- *Color Space for Images*—Unlike the previous two companies, Modern Postcard does request that images be converted using their supplied CMYK profiles, as shown in Figure 17.16. One benefit of performing the conversion yourself is that you can choose the rendering intent you prefer.
- *Resolution and File Formats*—Modern Postcard requires a resolution of 355 PPI. They accept TIFF or PDF formats from Photoshop.
- *Proofing*—Because you are sending them a CMYK file, you may find that a hard proof can help you obtain better quality. It can allow you to tweak the amount of black ink you use in the dark parts of the image, as well as for type—if you're including any. But be sure to budget some time for this, as it takes a few days for the file-to-proof turnaround.

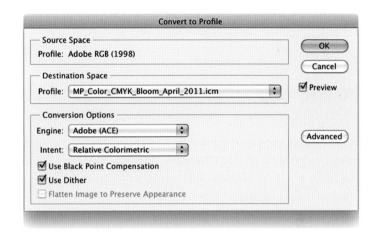

FIGURE 17.16 Convert to Profile window in Adobe Photoshop with the Modern Postcard CMYK profile set as the destination space. This conversion should be done before sending image files to Modern Postcard.

4over4.com

4over4.com is a printing company out of the Astoria section of Queens in New York City. Their name stands for the fact that they offer output with four inks on both sides of the card. Like Modern Postcard, instead of PoD electrophotographic systems, they use offset lithographic printing presses.

- *Profile for Soft Proofing*—4over4 does not supply any custom profiles for their printing press and paper combinations, but they do recommend images be converted to U.S. Web Coated (SWOP) v2, so soft proofing with this standard CMYK profile would be effective.
- *Color Space for Images*—As just mentioned, 4over4 requests that all images be supplied in CMYK, specifically using the standard CMYK U.S. Web Coated (SWOP) v2 color space found in the Adobe applications. One benefit of doing the conversion yourself is that you will get to determine and use the best rendering intent for converting your image to U.S. Web Coated (SWOP) v2.

- *Resolution and File Formats*—4over4 requires a resolution of 300 PPI. They accept TIFF, EPS, or JPEG formats from Photoshop.

Conclusion

In this chapter we have seen the importance of understanding and converting to the specific CMYK required. We have also discussed that our ability with print-on-demand technology to publish a few copies of books of our photographs is really revolutionary. But, although it has gotten much easier to print custom books, magazines, and postcards with these short-run PoD printing presses, it is important to remember to follow instructions to get the best match possible between your monitor and the printed output provided. Also, when producing books and magazines, where you are sequencing images and incorporating text as well, it will be important to consult graphic designers and text editors (at least another set of eyes) to insure our images and ideas are coming through as clearly as possible, without distractions from poor design or typos. In the next chapter we will look at color management in Adobe Illustrator, InDesign, and in creating PDFs.

EXPLORATIONS

There are two things that would be useful to reinforce what we have discussed in this chapter. (1) review the **Custom CMYK** choices in Photoshop's **Color Settings** to give you a better idea of the difference among the standard CMYK color spaces. Remember, there is no one CMYK space; they are all different from each other. (2) It's time to try making a book and/or a postcard! As we have discussed before, give yourself the opportunity to test out different PoD service providers before you are producing your most important project. This way you will have the experience under your belt and understand the optimal workflow for preparing your images and layouts to get the best match possible. Finally, with any book project, give yourself plenty of lead time to get at least one initial run or hard copy proof, before the final version is needed. It can be tough to see some problems on screen, so you really need to print a few working copies on your way to the fine product.

Resources

CMYK Standards

DISC—Digital Image Submission Criteria
> http://www.idealliance.org/downloads/disc-specification-2007

FOGRA—Fogra Forschungsgesellschaft Druck e.V.
> http://www.fogra.org/en

G7 Print Calibration Method
> http://www.idealliance.org/specifications/g7/what-g7

GRACoL—General Requirements and Applications for Commercial Offset Lithography
> http://www.idealliance.org/specifications/gracol/g7-vs-gracol

McCleary, Rick, *CMYK 2.0: A Cooperative Workflow for Photographers, Designers, and Printers*, Peachpit Press, New York, 2009. ISBN: 978–0321573469.

Steve Upton—The Ins and Outs of GRACoL 7 and G7
> http://www.colorwiki.com/wiki/The_Ins_and_Outs_of_GRACoL_7_and_G7

SWOP—Specifications for Web Offset Printing
> http://www.idealliance.org/specifications/swop/certified-proofing-systems

Universal Photographic Digital Imaging Guidelines (UPDIG)
> http://www.updig.org

Short-Run Digital Book Publishers and Printing Services

Blurb
> http://www.blurb.com/

Lulu Publishing
> http://www.lulu.com/

MagCloud
> http://www.magcloud.com/

Pikto
> http://www.pikto.com/

Modern Postcard
> http://www.modernpostcard.com/

4over4.com—Postcards
> http://www.4over4.com/

Self-Publishing

Self Publish, Be Happy
> http://selfpublishbehappy.com/

Himes, Darius D. and Swanson, Mary Virginia, *Publish Your Photography Book*, Princeton Architectural Press, New York, 2011. ISBN-13: 978-1-56898-883-2.

COLOR MANAGING IN ADOBE INDESIGN, ILLUSTRATOR & PDFS

In Chapter 6, we saw how to select and adjust our color settings and how to use ICC profiles in Adobe Photoshop. In this chapter, we will discuss how to set up color and use ICC profiles in other applications within Adobe's Creative Cloud, specifically InDesign and Illustrator. We will also review methods and issues for controlling color in creating ouput to PDF files.

Synchronizing Color in the Adobe Creative Cloud

To help us in setting up Photoshop, Illustrator, and InDesign, Adobe allows users to synchronize color settings across all the applications in its Creative Cloud with the hope of producing more consistent and repeatable color. Synchronizing the applications also should help to keep files, like images and illustrations, looking correct regardless of what application you are using or printing from. Synchronizing color is done from Adobe Bridge (symbolically a good choice of places to do this). To synchronize the Creative Cloud color settings, click on **Edit > Color Settings ...** or use the keyboard shortcut **Shift-Command-K**. This launches the Color Settings window that you see in Figure 18.2.

In Adobe Bridge's Creative Cloud **Color Settings** window, you're able to select some of the common setting options we have in Photoshop's **Color Settings** window, including those for North America General Purpose, Prepress, and Web/Internet applications. If we click on the **Show Expanded List of Color Settings Files** check box, we are given more setting options for Europe and Japan. We can also select custom color settings we have created in Photoshop or any other application by clicking on the **Show Saved Color Settings Files** button. This could include using ProPhotoRGB as your RGB working color space.

In Figure 18.3, we have synchronized our settings across Adobe's Creative Cloud to the **North America Prepress 2** setting options,

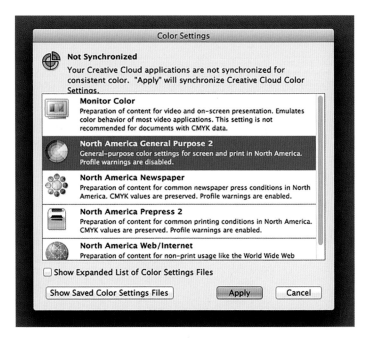

FIGURE 18.2 Adobe Color Settings from Adobe Bridge with the default settings.

which includes AdobeRGB(1998) as the RGB working color space and asks you what to do when opening images that do not have profiles embedded. **North America Prepress 2** is a good general choice for printing press or inkjet printing, but the choice of color setting will depend on the main type of output you are doing. As another example, if you are mainly doing work for the web or video, then you would choose **North American General Purpose 2**, with sRGB as its working color space.

Color in Adobe Illustrator

Like Adobe Photoshop, Adobe Illustrator is an application for producing and adjusting original artwork. But, unlike Photoshop, Illustrator is used mainly for creating vector-based, as opposed to bitmap-based, files.

FIGURE 18.1 Crystal and Fog, Cape Cod, 2009 by Candace Dobro.
Credit: Photograph, © Candace Dobro (cdobrophoto.com)

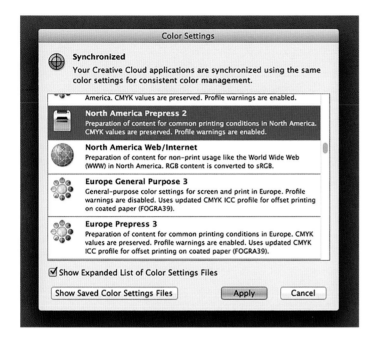

FIGURE 18.3 Adobe Color Settings from Adobe Bridge with the expanded list of color settings, and showing the Adobe suite now synchronized the North American Prepress settings.

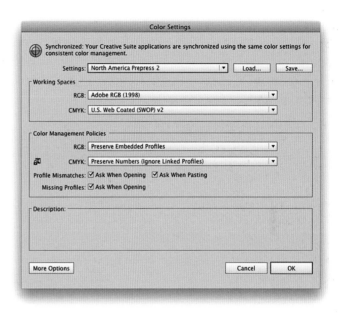

FIGURE 18.4 Color Settings in Adobe Illustrator with synchronized settings from Adobe Bridge in Figure 18.3.

Although Illustrator is similar to Photoshop in the way it handles color, especially if the color settings are synchronized (Figure 18.4), there are some differences in Color Management Policies and the way documents are converted from one color space into another.

Illustrator, for instance, includes an option to **Preserve Numbers (Ignore Linked Profiles)**, in the **Color Management Policies** section of the **Color Settings** window, which is not a choice in Photoshop (Figure 18.4). On the other hand, when opening an RGB or CMYK document, Illustrator, like Photoshop, preserves the embedded profile by default (Figure 18.5). In both cases this results in unchanged RGB or CMYK numbers. But if there's a profile mismatch when pasting an object into a document, then RGB objects and documents are handled differently in Illustrator than CMYK objects and documents are

(Figure 18.6). Illustrator will preserve the color appearance of RGB objects (by performing a conversion when pasting), but will preserve instead the color numbers for CMYK files (by not performing such a conversion).

Why is it more important to preserve the CMYK numbers in Illustrator documents than it is to preserve the color appearance by converting? We first need to remember that typically Illustrator's vector-based documents are mainly made up of lines, shapes, and

This seems like a good point to ask a review question. What is the benefit of vector-based artwork over bitmap-based artwork? Answer: Since vector-based files are only a description of objects, not defined by a specific number of pixels, they can be scaled larger or smaller without any loss of quality.

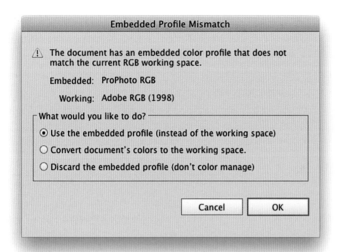

FIGURE 18.5 Embedded Profile Mismatch window in Adobe Illustrator, showing the default choice of how to handle the situation based on the Color Settings in Figure 18.4.

text, with defined CMYK numbers. At the same time, whenever we convert images or objects from one CMYK space to another CMYK space we have to go through Lab, the profile connection space. Because of going through Lab when converting, information about the black separation, and thus the amount of each ink color used in the black elements, including text, lines, and shapes, will be lost. This can be a big problem in both text and fine lines; for example, before conversion text may be defined as C-0%, M-0%, Y-0%, K-100%, but after the conversion through Lab, the text could then have values of C-74%, M-70%, Y-64%, K-78%. When text is reproduced in all four colors on a printing press, there is a good possibility of slight misregistration, which will reduce the readability and quality of the text (as can be seen on the right half of Figure 18.7). To keep the best quality text and fine lines with no misregistrations on printing presses, black is often the only ink used.

This brings us again to *Device link profiles* again. As we mentioned in Chapter 11, when discussing the GMG and EFI RIPs, device link profiles go directly from CMYK to CMYK, without going through Lab. Because of this, they allow a conversion that preserves both the color appearance and the black channel. Device link profiles

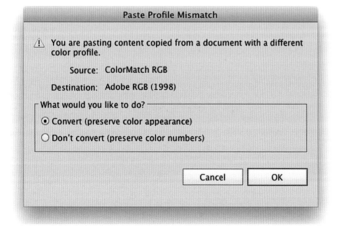

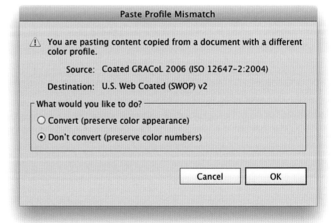

FIGURE 18.6 Adobe Illustrator handles RGB and CMYK objects differently when they are pasted into a document that is in a color space not specified in the Color Settings.

are created by combining the input portion of the source CMYK profile, which goes from CMYK to Lab, with the output portion of the destination profile, which goes from Lab to CMYK. When used properly, device link profiles can help create better quality lines and text on press and in inkjet prints and proofs.

Illustrator has almost the same Assign Profile window as Photoshop (it's only missing the Preview check box), and it is, as in Photoshop, launched by selecting **Edit > Assign Profile** from the menu bar (Figure 18.8).

Illustrator is very different, however, in the way documents and elements within documents are converted. To convert a document from RGB to CMYK, or vice versa, select **File > Document Color Mode** from the menu bar and then either **RGB Color** or **CMYK Color** (Figure 18.9).

Helvetica 8 pt Helvetica 8 pt
Helvetica 10 pt Helvetica 10 pt
Helvetica 12 pt Helvetica 12 pt
Helvetica 14 pt Helvetica 14 pt
Helvetica 18 pt Helvetica 18 pt
Helvetica 24 pt Helvetica 24 pt

FIGURE 18.7 Text on right with 100% black ink only (0% cyan, 0% magenta, and 0% yellow) and text on the left with 74% cyan, 70% magenta, 64% yellow, 77% black ink, which is out of registration.
Credit: Illustration by the author

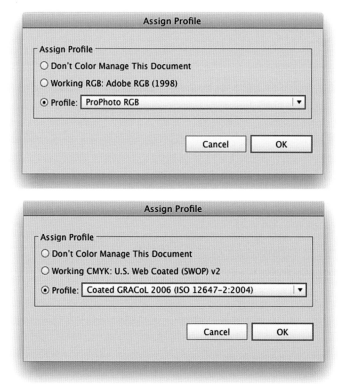

FIGURE 18.8 Assign Profile window in Adobe Illustrator, top version for RGB files and bottom for CMYK files.

FIGURE 18.9 Changing Document Color Mode in Adobe Illustrator.

FIGURE 18.10 Converting an element in an RGB document to the default RGB color space in Adobe Illustrator.

This will convert the document to the RGB or CMYK Working Color Space defined in the color settings. Since different elements in an Illustrator document can be in different color spaces, conversions can be done on specific elements when they are selected (Figure 18.10). As you can see, there are not as many options when converting to profiles in Illustrator as there are in Photoshop. This gives less control, but also gives us fewer opportunities to screw up these documents.

Color in Adobe InDesign

Adobe InDesign is the desktop publishing software where everything comes together for creating output media of many kinds: books, magazines and newspapers, letterheads and business cards, brochures, leave-behinds and postcards, reports, manuals, menus, signs, posters, billboards, and now tablets and smartphones. InDesign incorporates the images and artwork created in Photoshop, Lightroom, and Illustrator and combines it to create all these things and more.

InDesign has both similarities and differences with Illustrator (and more differences than similarities with Photoshop) in the way it handles color management. We will start and end our discussion with the similarities between InDesign and Illustrator beginning with Color Settings in InDesign. Then we will take a look at the Basic Color Structure of InDesign documents with the differences this leads to when assigning and converting profiles, soft proofing in InDesign, and, finally, printing from InDesign and Illustrator.

Color Settings in InDesign

InDesign has the same choices in its **Color Settings** window as Illustrator does (Figure 18.11). Like Illustrator, InDesign is working with text and fine line elements, so the color management policy of **Preserve Numbers (Ignore Linked Profiles)** is also included for dealing with black and text in CMYK files. With the **Color Management Policies** settings shown in Figure 18.11, Illustrator will preserve the embedded profile when it opens an RGB or CMYK document (as shown in the dialog boxes in Figure 18.12). In both cases, this results in unchanged RGB or CMYK numbers in the elements that have been placed in the document.

Basic Color Structure of InDesign Documents

As you can see in Figure 18.12, InDesign (unlike Illustrator) does not offer the ability to convert RGB documents or content to the working color space when opening the file. In fact, as we will discuss, InDesign is not an application for converting content from RGB to CMYK, or vice versa. The basic color structure of InDesign documents is different from Photoshop and Illustrator documents. While both InDesign and Illustrator, but not Photoshop, can have RGB and CMYK content in different color spaces, only InDesign has two document level color

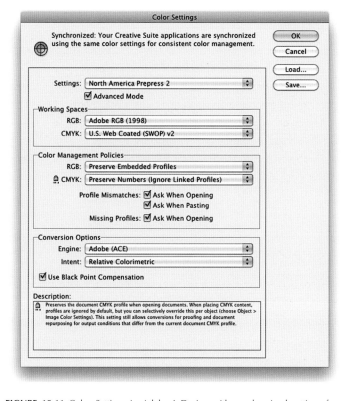

FIGURE 18.11 Color Settings in Adobe InDesign with synchronized settings from Adobe Bridge in Figure 18.3.

spaces (profiles): one RGB and one CMYK. One more time: InDesign has *two* document level color spaces. This means that if the defined RGB and CMYK color spaces do not match the **Working Spaces** in InDesign's **Color Settings** window, you can get both of the **Profile or Policy Mismatch** warning windows in Figure 18.12, one for RGB and one for CMYK, when opening an InDesign document.

InDesign has both **Assign** and **Convert,** those document color profile adjustment functions we got to know so well from Photoshop. (As we saw, Illustrator only has **Assign.**) However, because InDesign documents have two ICC profiles associated with them, **Assign** and **Convert** are different from Photoshop. Both the **Assign Profiles** and **Convert to Profile** windows (Figures 18.13 and 18.14) in InDesign show both document level profiles. (You get a hint by just looking at one of the function names in the **Edit** pull-down menu. The choice is **Assign Profiles** instead of **Assign Profile**. But, for some strange reason the name **Convert to Profile** has not been changed to **Convert to Profiles**, even though, like with **Assign Profiles**, you can adjust both the RGB and CMYK profiles in InDesign.)

FIGURE 18.12 *(below, left and right)* Embedded Profile Mismatch windows in Adobe InDesign, showing the default choice of how to handle the situation based on the Color Settings in Figure 18.11 for RGB images on the left and CMYK images on the right.

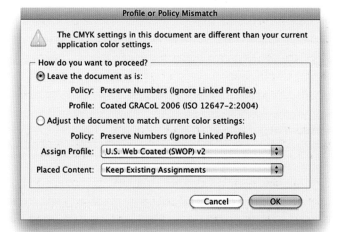

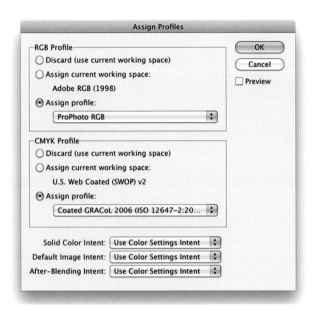

FIGURE 18.13 Assign Profile window in Adobe InDesign, which handles both RGB and CMYK parts of the document at the same time.

FIGURE 18.14 Convert to Profile window in Adobe InDesign, which handles both RGB and CMYK parts of the document at the same time.

Assign Profiles and **Convert to Profile**, however, only affect the documents and elements that are created in InDesign, such as text, lines, and shapes. **Assign Profiles** and **Convert to Profile** are not how the images and artwork placed in the InDesign document layout are managed.

To change the assigned profile for an image that already exists in an InDesign document, select the object and click on **Object > Image Color Settings** from the menu bar (Figure 18.15). This launches the interface shown in Figure 18.16, where you can change the assigned profile and the associated rendering intent, which is typically **Perceptual** for image. You might do this if the colors of the image don't look right, because the wrong profile has been assigned to it.

Soft Proofing in InDesign

The options given when soft proofing documents in InDesign (Figure 18.17), which are launched by clicking on **View > Proof Setup > Custom**, are slightly more limited than the options in Photoshop or Illustrator (Figure 18.18). Missing elements include the choice of rendering intent as well as the **Preview** check box. **Rendering Intent** is not selectable in the **Customize Proof Condition** window in InDesign because, as we saw in Figure 18.16, the rendering intent is defined separately for all the different elements in the document. As the **Description** in Figure 18.17 says, checking the **Preserve RGB** or **CMYK** numbers check box in InDesign makes it so that you are not changing the RGB or CMYK numbers for parts of the document don't have an embedded profile, like lines and text and images with no embedded profile, but parts of the document with embedded profiles will be adjusted and simulated for the profile chosen.

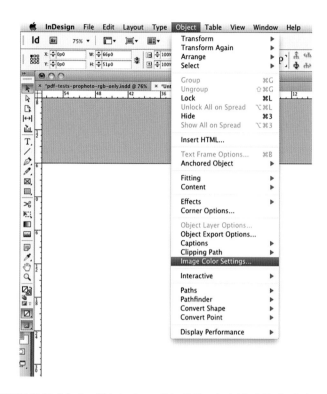

FIGURE 18.15 Selecting Object > Image Color Settings in Adobe InDesign is the way to assign profiles to individual images.

Image Color Settings

Profile: ProPhoto RGB

Rendering Intent: Use Document Image Intent

FIGURE 18.16 Image Color Settings interface in Adobe InDesign, which is launched from the selection in Figure 18.15. This allows you to change the assigned profiles for individual images in the document that might not be displaying correctly because the wrong color space is assigned to them.

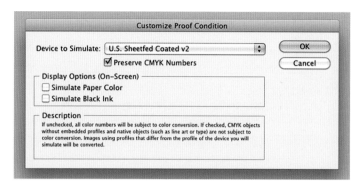

FIGURE 18.17 Customize Proof Condition window in Adobe InDesign, which allows you to soft proof or simulate your documents and the elements in your documents using the chosen profile to get an idea of how the final output will look.

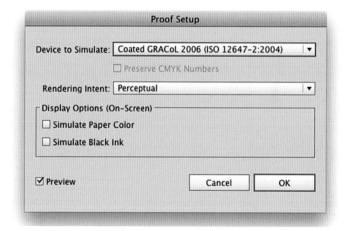

FIGURE 18.18 Proof Setup window in Adobe Illustrator, which is launched by clicking View > Proof Setup > Customize. The interface is similar to Adobe Photoshop and it allows you to soft proof or simulate your artwork using the chosen profile to get an idea of how the final output will look.

Printing from InDesign and Illustrator

Finally, the color management options for printing from both Illustrator and InDesign are very similar, since they both may have content in different color spaces. From InDesign, if you select an RGB printer, like the Epson 3880 using the standard Epson driver, as in Figure 18.19, then the **Document Profile** source space will be the defined document RGB profile, in this case AdobeRGB(1998). Everything in the document that is untagged will be assumed to be in the Documents Profile space. Everything in the document that has a profile embedded will be converted to the printer paper profile from the embedded profile

The problem with printing an InDesign document to an RGB printer is that we will lose the CMYK information, including the ability to print text with just black ink, so text and vector-based fine line quality will typically be reduced. One method to avoid this is to use a CMYK RIP, like ColorBurst, as shown in Figure 18.20, By sending CMYK directly to the printer without conversion for text and fine lines (by selecting the **Preserve CMYK Numbers** check box), the text and fine lines will be printed with black ink only and give much better results.

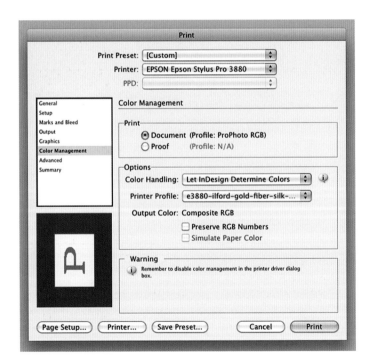

FIGURE 18.19 Printing an RGB document to a standard RGB driver for the Epson 3880 from Adobe InDesign. With these settings everything will be converted to the printer/paper profile selected. As mentioned in the dialog box, it is important to turn off color management in the driver, since InDesign will do the conversion.

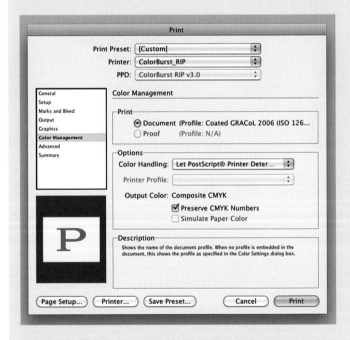

FIGURE 18.20 Printing a CMYK document to the (CMYK) ColorBurst RIP from Adobe InDesign. With these settings Color Burst and not InDesign will color manage the document and the individual elements, instead of InDesign.

using the corresponding rendering intent. Of course, we still need to select the correct color settings in the Epson driver, including turning off color management.

Portable Document Format (PDF)

You've spent months on the layout for your book in InDesign; the next step is to gather all the items used in the document—images, fonts, and artwork, along with the InDesign document itself—and send everything to the printer. The first phone call from the printer is to say that they don't use InDesign. They only use QuarkXPress. Trust me, it happens or, at least, it used to happen.

The *portable document format* (PDF) format was created by Adobe in the early 1990s to help deal with situations like this. *PDF, along with the free PDF reader, Adobe Acrobat, have made the sharing of documents of all kinds much easier.* In 2007, Adobe released the full PDF 1.7 specification to the Association for Information and Image Management (AIIM) to allow it to become an open standard by the International Standards Organization (ISO). In 2008, the ISO approved and published PDF 1.7 as ISO 32000.

Major Benefits of PDF

- *Freedom for Content Creators*—Content creators can use any application to produce the content.

- *Convenience for Content Users*—Users of the content (like clients and service providers) don't need the same (possibly expensive) application or version of the software used to create the content.

- *Consistent Format*—The format of the documents is set by the creator and is not changed by the users or software.

- *Text Security*—Text is not easily changed and can be protected from copying or altering.

- *Portability*—Fonts, images, and artwork are incorporated (and possibly compressed) in the document and do not need to be on the users' or the service providers' computer.

Standard PDF Formats

Over the past ten years, different standard PDF formats have been developed and agreed upon by the document archiving (PDF/A), printing and graphic arts (PDF/X), and engineering (PDF/E) industries. They include:

- *PDF/A-1a (2005)*—ISO standard electronic document format for long-term preservation, which includes embedded fonts and certain metadata. Based on PDF 1.4. Supported by Acrobat 5 and up.
- *PDF/A-1b (2005)*—Higher compliance level, which includes embedded color profiles for preserving document appearance. Based on PDF 1.4. Supported by Acrobat 5 and up.

- *PDF/X-1a (2001)*—Standard format for graphic arts printing. Supports CMYK files only. Based on PDF 1.3. Supported by Acrobat 4 and up.
- *PDF/X-3 (2002)*—Standard format for graphic arts printing. Supports ICC compliant CMYK, RGB, and Lab color spaces. Based on PDF 1.3. Supported by Acrobat 4 and up.
- *PDF/X-4 (2008)*—Same as PDF/X-3, but additionally supports live transparency and layers in artwork. Based on PDF 1.6. Supported by Acrobat 7 and up.
- *PDF/E-1 (2007)*—Standard format for engineering workflows, collaborations, and documentation. Based on PDF 1.6. Supported by Acrobat 7 and up.

Creating PDF Files

We'll begin by discussing the many ways to create PDF files in Mac OS X and in the Adobe applications. Later, we'll discuss ways of improving image and color quality when creating PDFs from these applications and utilities.

Apple Macintosh OS X

One of the simplest ways to produce a PDF from a document in Mac OS X is to launch the print driver window and select **PDF > Save as PDF** in the lower left-hand corner, as seen in Figure 18.21. If you are coming from Photoshop, be sure to select **Let Printer Determine Colors**

under **Color Handling** in the **Print** window. If you leave this option set to **Let Photoshop Manage Colors**, then you risk applying a profile twice, and this is not a good thing. The only thing I don't like about this method is the lack of control over file size and the fact that a **Generic RGB** profile is always added to the actual profiles in a document, which can confuse some applications and cause poor color reproduction.

Adobe PDF Driver

The Adobe PDF driver, currently comes with Adobe Acrobat Pro or Pro Extended, but only for Windows. When installed, you're able to select the Adobe PDF driver in the same place as you would select a printer in the **Print** window. This gives you more options than the **Save as**

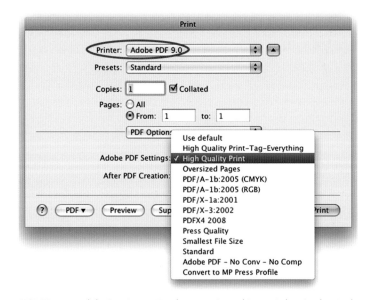

FIGURE 18.21 *(left)* Creating a PDF from a printer driver window in the Apple Macintosh OSX operating system.
Credit: Test page designed by author with photographs by Tom Ashe, Barbara Broder, Jungmin Kim, Brittany Reyna, Christopher Sellas, and Adam Wolpinsky.

FIGURE 18.22 *(above)* Selecting settings for creating a PDF from an Adobe PDF driver, which is not available with the latest version of Adobe Acrobat Pro for the Mac, but is still available in Windows.

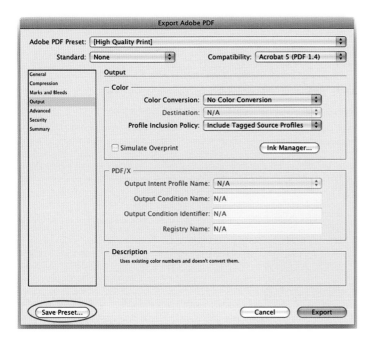

FIGURE 18.23 Saving settings, including color settings, for PDF generation from a variety of applications. Color settings here will preserve any profiles in a document and embedded those profiles, so they are understood by PDF readers, and colors can be displayed accurately.

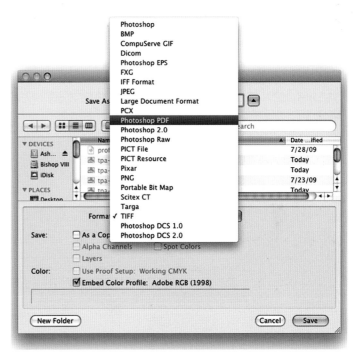

FIGURE 18.24 Saving a file from Adobe Photoshop as a PDF in the Save As window.

PDF option above. As you see in Figure 18.22, showing the last version for the Apple OS X operating system, the driver gives you a variety of options and settings to use when creating the PDF, including ISO standard PDF-A and PDF-X formats. You can also add preset customized color settings to this list in Adobe Acrobat Distiller, Photoshop, InDesign (Figure 18.23), and Illustrator. As before, if you are coming from Photoshop, be sure to select **Let Printer Determine Colors** under **Color Handling** before leaving Photoshop's **Print** window.

Adobe Photoshop and Illustrator

Both Adobe Photoshop and Illustrator allow you to save files in their own specific PDF formats (Figure 18.24). These formats preserve full editing capabilities in the PDF file with some, but not all, PDF preset settings, such as **High Quality Print**.

Adobe InDesign

Although you don't save InDesign documents as PDF files, you can efficiently export PDFs from InDesign right from the menu bar, as shown in Figure 18.25. As mentioned before, you can also add more presets to the list by clicking on **Define** at the top of the list. This will launch the window in Figure 18.23.

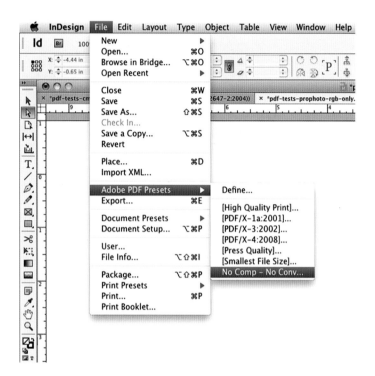

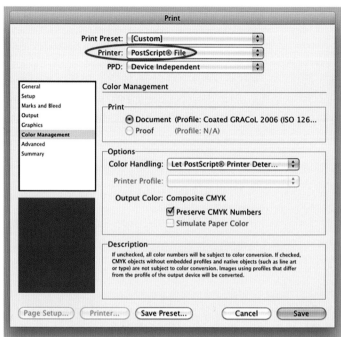

FIGURE 18.25 Selecting a custom PDF Export Preset in Adobe InDesign as a PDF, which uses the settings saved in Figure 18.23.

FIGURE 18.26 *(top right)* Saving a PostScript File in Adobe InDesign's Print window, which will later be used for building different PDF files in the Adobe Acrobat Distiller. It is important to use the 'Let PostScript Printer Determine Colors' Color Handling setting to get accurate results.

FIGURE 18.27 *(right)* Creating different types of PDF documents from the same Post-Script file in Adobe Acrobat Distiller, notice the differences in file size.

Adobe PostScript and Acrobat Distiller

Another way to produce PDFs from InDesign and other applications is to save a PostScript version of your document. PostScript is a proprietary Adobe file format, which came before PDF. PostScript is the computer language which describes documents, vector graphics, and images in a way that many printers, drivers, and RIPs understand and translate into ink or toner on paper. You can produce a PostScript version of your document from the **Print** window of some applications, like InDesign (Figure 18.26). This one PostScript file can then be used to quickly produce different types of PDFs using Adobe's Acrobat Distiller, which also comes with Adobe Acrobat 9 Standard, Pro, or Pro Extended. When a PostScript document is dropped onto the Acrobat Distiller window (Figure 18.27) or into a designated "hot folder," a PDF is instantly created with the current preset settings.

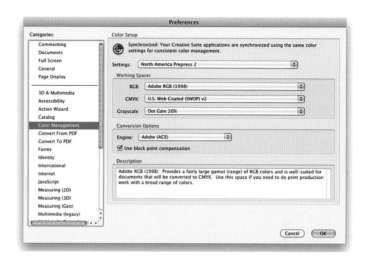

FIGURE 18.28 Synchronized Color Management Color Setup Preferences in Adobe Acrobat Pro.

Analyzing PDF Settings and Files

The chart in Figure 18.31 compares the files resulting from different methods and preset settings that we have discussed for producing PDFs. Most are self-explanatory; by the setting labeled "No Comp & No Conv" means that when building the PDF images were not compressed or converted to any other color space. The file size of the PDF files was recorded from the file browser. The original file size of the TIFF document in ProPhoto RGB was 25.3 MB. The image was then opened in Adobe Acrobat Pro, which had the synchronized color management **Preferences** (Figure 18.28). To show which profiles and color spaces were embedded with the PDF, the **Convert Colors** window was launched from the menu bar (Figure 18.29) and the color spaces were revealed by clicking on the blue button in the upper right of the **Convert Colors** window (Figure 18.30) under where it says **Document Colors**.

FIGURE 18.29 Selecting Tools > Print Production > Convert Colors in Adobe Acrobat Pro to examine the profiles associated with a PDF document.
Credit: Test page designed by author with photographs by Tom Ashe, Barbara Broder, Jungmin Kim, Brittany Reyna, Christopher Sellas, and Adam Wolpinsky.

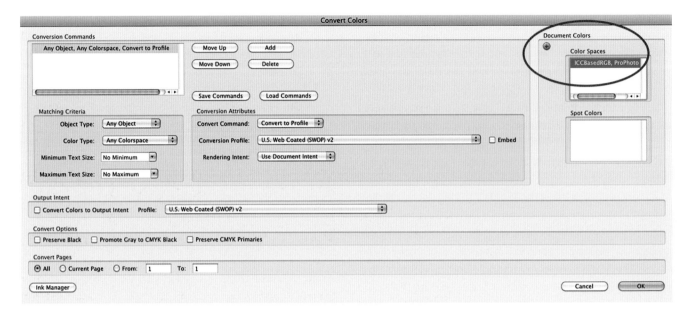

FIGURE 18.30 Convert Colors window in Adobe Acrobat Pro, showing where to inspect the PDF document colors.

PDF Generator	Settings	File Size	Color Space
Adobe InDesign Export	High Quality Print	1.7 MB	ICC-Based–ProPhotoRGB
Adobe Photoshop Save	High Quality Print	13.9 MB	ICC-Based–ProPhotoRGB
PostScript to Distiller	High Quality Print	2.0 MB	ICC-Based–ProPhotoRGB
Adobe Photoshop Save	No Comp & No Conv	33.7 MB	ICC-Based–ProPhotoRGB
PostScript to Distiller	No Comp & No Conv	25.3 MB	ICC-Based–ProPhotoRGB
PostScript to Distiller (Let InDesign Manage Color)	No Comp & No Conv	25.3 MB	Device RGB
PostScript to Distiller	PDF/A-1b (CMYK)	4.2 MB	Device CMYK
Adobe InDesign Export	PDF/X-1a	3.6 MB	Device CMYK
Adobe InDesign Export	PDF/X-3	2.5 MB	ICC-Based–ProPhotoRGB
Adobe InDesign Export	PDF/X-4	2.1 MB	ICC-Based–ProPhotoRGB
Adobe InDesign Export	Press Quality	3.3 MB	Device CMYK
OSX	Save as PDF	9.1 MB	ICC-Based–ProPhotoRGB ICC-Based–sRGB 1EC61966-2.1
Adobe InDesign Export	Smallest	86 KB	ICC-Based–sRGB 1EC61966-2.1
PostScript to Distiller	Smallest	90 KB	ICC-Based–sRGB 1EC61966-2.1
PostScript to Distiller	Standard	209 KB	ICC-Based–sRGB 1EC61966-2.1

FIGURE 18.31 Chart comparing different results in file size and color space from different PDF generation techniques and standards.

Figures 18.32, 18.33, 18.34, and 18.35 show four examples of the resulting images through different settings used in building PDFs. With the images and the chart (Figure 18.31), we can make some observations about these different methods for building PDFs.

- The **High Quality Print** setting will give us a reasonable result in terms of image and color quality, considering the compression used to give us a much smaller size than the files with no compression, as seen when comparing Figures 18.33 and 18.34.
- PDFs created using Photoshop consistently produce a larger file than though InDesign or Postscript/Acrobat Distiller.
- Although not shown, the image produced by using the Let InDesign **Determine Colors Color Handling** when producing the PDF, instead of using **Let Postscript Printer Determine Colors**, as seen in Figure 18.26, results in a less accurate PDF.
- PDF settings that convert to CMYK limit the gamut of the output and give a result that is lower in saturation than the original, as seen in Figure 18.34. Therefore, these settings should definitely only be used for specific applications where they are requested and required.

EXPLORATIONS

There are three things that would be useful to reinforce what we have discussed in this chapter. (1) Synch your color settings in the Adobe applications using Bridge. (2) Test assigning profiles to documents, and images within your InDesign documents. Use your test page to make sure you are seeing both the subtle and more radical changes in color and tone. Finally, (3) test the different PDF building techniques for yourself, so you have a feeling for which ones will be best for your applications.

- Saving as a PDF from the print driver window in Mac OS X results in a document containing two color spaces: sRGB and the color space of the image in the document, ProPhotoRGB in our case.
- The settings to produce the smallest file size destroy images with heavy size reduction and compression, as seen in Figure 18.35.

Producing PDF Files for Electrophotographic Short Run Books and Offset Postcards

As we discussed in the last chapter, for us as photographers one of the main reasons we will be using Adobe InDesign and a PDF workflow will be for creating books on short run digital printing press with a service like Blurb or Lulu. When doing this, it is important to do three things: use their templates for InDesign, which will have many of their formatting and color requirements; prepare your images before bringing them into your InDesign layout by converting them to the requested (RGB or CMYK) color space, resizing to the desired size, and sharpening for the type of output; and export the files using the PDF settings the service provider requests.

Conclusion

In this chapter we have reviewed how color is handled in the Adobe Color Cloud, and specifically in Illustrator and InDesign. Hopefully, if you are using these applications, you will feel more confident about what you will need to do to get color synced and working well across the applications. We have also reviewed the benefits of using documents in Adobe's PDF format and how color works in generating, viewing, and printing with PDFs.

Resources

Color in the Adobe Creative Cloud

Color Workflows for Adobe Creative Suite 3 (I know this is CS3 and you are using CS6 or CC, but the color information is the same.)
http://www.adobe.com/designcenter-archive/creativesuite/articles/cs3ap_colorworkflows_02.html

Adobe Illustrator
http://www.adobe.com/products/illustrator.html

Adobe InDesign
http://www.adobe.com/products/indesign.html

Portable Document Format

Adobe and PDF
http://www.adobe.com/products/acrobat/adobepdf.html

PDF Zone
http://www.pdfzone.com/

Planet PDF
http://www.planetpdf.com/

Adobe Acrobat Reader Download
http://get.adobe.com/reader/

Troubleshooting Adobe Acrobat
http://helpx.adobe.com/reader.html

FIGURE 18.32 *(facing page, top left)* Portion of test page image that was processed as a PDF by producing a PostScript file from InDesign's print window and then generating the PDF in Adobe Acrobat Distiller using no compression and no conversion of color space. The result looks very much like the original.

FIGURE 18.33 *(facing page, top right)* Portion of test page image that was exported as a PDF from Adobe InDesign using the High Quality Print setting. The result looks very much like the original, even though the file size is much smaller.

FIGURE 18.34 *(facing page, bottom left)* Portion of test page image that was exported as a PDF from Adobe InDesign using the print standard PDF/X-1a setting. The result is desaturated compared with the original and in CMYK (a smaller gamut space).

FIGURE 18.35 *(facing page, bottom right)* Portion of test page image that was exported as a PDF from Adobe InDesign using the Smallest File Size setting. The result is more desaturated than the original and in CMYK.
Credit for all figures 18.32–18.35: Portion of test page designed by author with photographs by Barbara Broder, Jungmin Kim, and Christopher Sellas

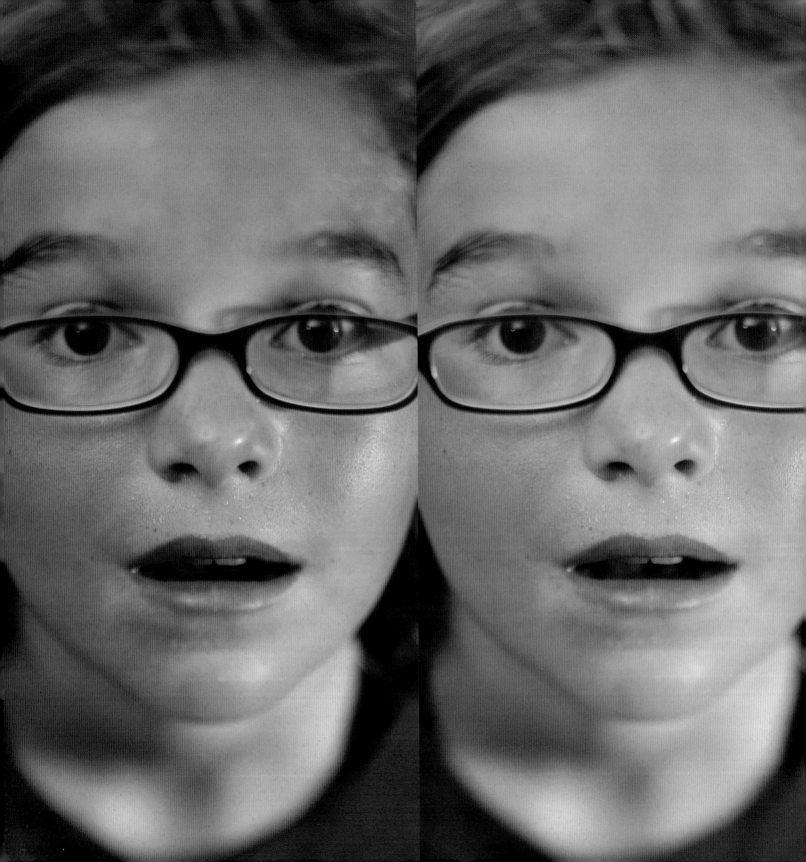

PREPARING FILES FOR THE WEB & TABLETS

In the previous chapters we have discussed how to prepare our files for output to different types of prints. Now we need to look at preparing our files for soft output on the web, tablets, and projected from presentation applications. After spending so much time and energy calibrating and profiling our own displays, one of the most frustrating things can be the fact that when we post or share images on the web, we have no control over how the images are being viewed on everyone else's monitors. It's difficult, since we don't know what type or quality of display, let alone the operating system or web browser the viewers are using. We don't know if their displays have been calibrated and profiled, and, if they have, we don't know what white point, gamma, or luminance they are using. Enough factors are out of our control to make us feel like it's better to not bother worrying and to just accept that the situation is impossible to control. In some ways this is true, but you still need to prepare your files for the web—so what is the best way to approach this dilemma?

In this chapter we will start by looking at a specific case of an image looking strange through an internet browser, which will lead to a discussion of how different browsers handle color management and the best practices to use when preparing your files for viewing on the greatest variety of browsers and displays. Finally, we will specifically examine the color characteristics of computer tablets like the Apple iPad, and presentation applications like Apple Keynote and Microsoft PowerPoint, and best methods for preparing files for viewing on them.

Why is Adrienne's Face so Red?

The left side of Figure 19.1 shows how the portrait of my niece Adrienne looked on a calibrated and profiled LaCie 321 display when viewed in Apple Safari. Why is her face so red and saturated on the left, when it should look like the version on the right? Although we can rule out embarrassment, there were many factors involved in causing this robust red, including: Adrienne's genetic background and the fact that she had just gotten home from soccer practice on a hot July day; the rendering of the camera used; the display's gamut; the color space of the image (GenericRGB); the fact that no profile was embedded; and the surprising way color was, and is, handled in the web browser (Apple Safari) and most browsers.

Let's cut to the chase. I recommend two basic steps to prepare images for the web so that they look (as much as is possible) the same as they do in Adobe's Photoshop and Lightroom when the monitor is calibrated and profiled.

Two Basic Steps to Prepare Images for the Web

1. Convert the image to sRGB.
2. Embed the sRGB profile with the image.

The version of the portrait on the right in Figure 19.1 does neither of the above, which is the reason it looked so wrong.

Why am I making these recommendations? The conclusion comes down to testing and observing how color is handled in four web browsers: Safari (Apple Mac OS X), Chrome (Apple Mac OS X), Explorer (Microsoft Windows 7), and Firefox (Apple Mac OS X). As indicated, three of the browsers tested were versions for the Apple OS X operating system, specifically OS 10.6 (Snow Leopard), and one for the Microsoft Windows 7 operating system. After discussing how it could be useful for browsers to manage color, we will review the way color is handled in these four browsers.

FIGURE 19.1 Portrait of Adrienne that is too red and saturated on the left, because the image was in GenericRGB color space without an embedded profile when viewed in the Apple Safari web browser. On the right, the image as intended.
Credit: Photograph by the author

How Browsers Should Work

In an ideal world, as far as color handling is concerned, the browser would be color managed and do two specific things:

1. If there *is* an embedded ICC profile in an image, the browser should recognize the profile and use it along with the monitor profile to display colors accurately, the same way that Photoshop and Lightroom do; or
2. If there is *no* embedded profile, the software should assume some standard RGB working color space. I vote for sRGB. That's what it's there for.

Currently, all four browsers will recognize and use embedded ICC profiles (as described in recommendation 1, above), if set up properly. But none of the four assume sRGB when there is no embedded profile (that's where the importance of assigning the profile to the image comes in). What the browsers seem to do, when no profile is embedded, is to assume the image is in the system level display color space. This is a problem.

Figures 19.3, 19.4, 19.5, 19.6, and 19.7 show how four versions of a test image (the original is shown in Figure 19.2) looked on my monitor in each browser. The two images on the left had no ICC profile embedded and the two on the right did have profiles embedded. The images on top are in sRGB, and the images on the bottom are in ProPhotoRGB.

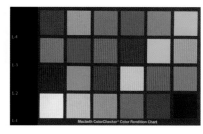

sRGB - EMBEDDED

FIGURE 19.2 Test image for evaluating how color is handled in web browsers, consisting of a portrait by Brittany K. Reyna, X-Rite ColorChecker, and highlight/shadow detail patches.
Credit: Portion of test page designed by the author with photograph by Brittany K. Reyna

Apple Safari

Figure 19.3 shows how the four versions of the test image appeared in Apple Safari. The right half of the Safari chart shows that, as long as there is a profile embedded with the image—regardless of whether it is in sRGB or ProPhotoRGB—the images look the same and that they also look the same as they do in Photoshop and Lightroom. We can conclude that Apple's Safari recognizes and uses embedded ICC profiles.

The left side of the chart shows what happens if no profile is embedded. The sRGB image on the top illustrates the same situation I saw with the image of Adrienne at the beginning of the chapter—and many other images as well. Obviously, Safari does not assume sRGB when there is no profile embedded. Safari assumes that the image is in the default monitor space, whether that's from a custom or generic monitor profile. That is why the image looks more saturated, especially on the LaCie 321.

The problem with assuming that the image is in the monitor's color space is that not only do images in different color spaces not match, but also that the image will look different on every different

Apple Safari

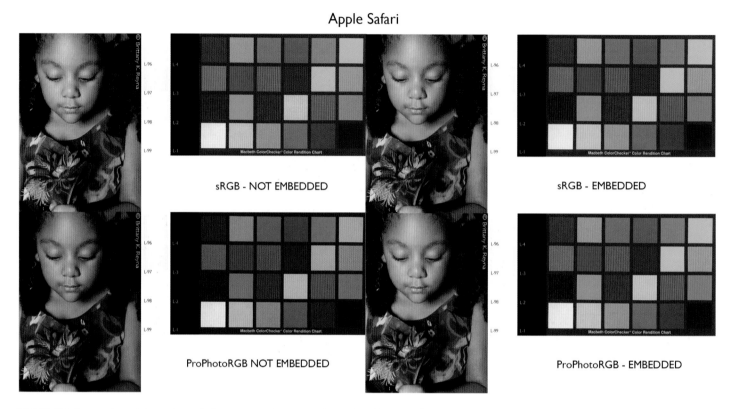

sRGB - NOT EMBEDDED

sRGB - EMBEDDED

ProPhotoRGB NOT EMBEDDED

ProPhotoRGB - EMBEDDED

FIGURE 19.3 Four versions of the test image in Figure 19.2 as they appeared in Apple Safari on a calibrated and profiled LaCie 321 and Apple OS X operating system. Credit: Portion of test page designed by the author with photograph by Brittany K. Reyna

monitor, even ones that are calibrated and profiled. In the case of the ProPhotoRGB image with no embedded profile, the image looks desaturated, since, as we said, Safari assumes that the image is in the default monitor space.

The good news for PC users is that Safari is also available for Windows. The even better news is that, not only does it color manage images with embedded profiles, but it also assumes that untagged images are in sRGB.

Google Chrome

Figure 19.4 shows how the four versions of the test image appeared in Google Chrome on the same LaCie 321 display. As you can see, both of the sRGB images are the same, regardless of whether there is an embedded profile or not. The sRGB images are oversaturated, compared with how they looked in Photoshop (Figure 19.2). On the other hand, the ProPhotoRGB image is desaturated with no embedded profile, as expected. But the strange thing is that the version with a ProPhotoRGB profile embedded looks the same as the sRGB images:

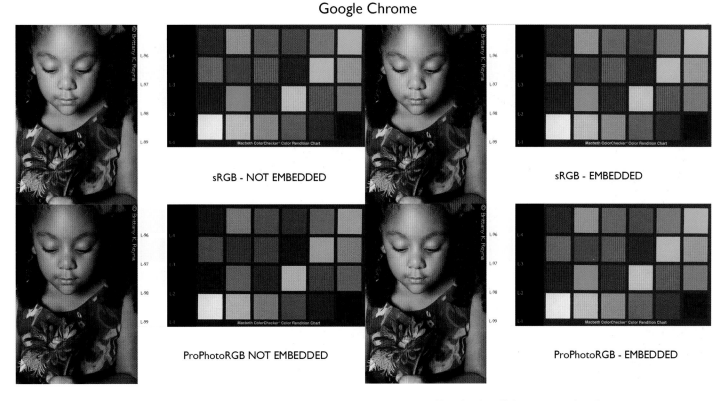

FIGURE 19.4 Four versions of the test image in Figure 19.2 as they appeared in Google Chrome on a calibrated and profiled LaCie 321 and Apple OS X operating system. Credit: Portion of test page designed by the author with photograph by Brittany K. Reyna

slightly saturated. Google Chrome, as the chart shows, is not fully color managed, even though the embedded ProPhotoRGB profile has some sort of effect. In the end, regardless of whether the profile is embedded or not, Google Chrome assume that the image is in the default monitor space. Sadly, there's no exact color matching with Google Chrome.

Microsoft Windows Internet Explorer

Figure 19.5 shows how the four versions of the test image appeared in Microsoft Windows Internet Explorer on a Dell laptop display. Like in Google Chrome, both of the sRGB images are the same, regardless of whether there is an embedded profile or not. The sRGB images are oversaturated, compared with how they looked in Photoshop (Figure 19.2), but not as saturated as they looked in Google Chrome on the LaCie 321. This is because the Dell laptop display has a smaller gamut than the LaCie 321. Also, as before, the ProPhotoRGB image is

Microsoft Windows Internet Explorer

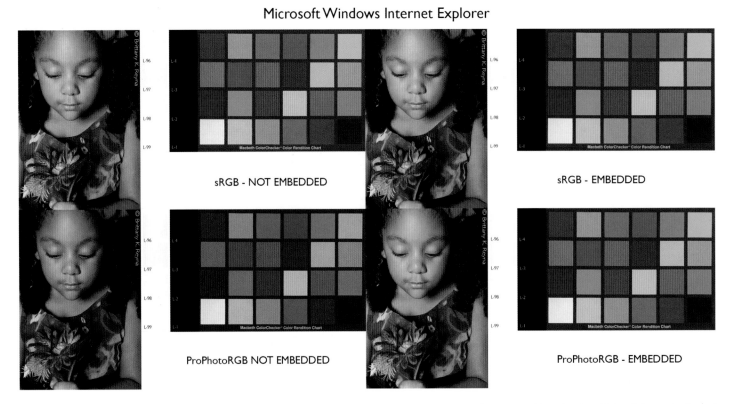

sRGB - NOT EMBEDDED

sRGB - EMBEDDED

ProPhotoRGB NOT EMBEDDED

ProPhotoRGB - EMBEDDED

FIGURE 19.5 Four versions of the test image in Figure 19.2 as they appeared in Microsoft Windows Internet Explorer on a calibrated and profiled Dell laptop display and Windows 7 operating system.
Credit: Portion of test page designed by the author with photograph by Brittany K. Reyna

desaturated with no embedded profile, while the version with a ProPhotoRGB profile embedded looks the same as the sRGB images: slightly saturated. Microsoft Windows Internet Explorer, as the chart shows, is not fully color managed, even though, as with Google Chrome, the embedded ProPhotoRGB profile has some sort of effect. In the end, regardless of whether the profile is embedded or not, Explorer assumes that the image is in the default monitor space. Sadly, there's no exact color matching with Explorer.

Mozilla Firefox

The Mozilla Firefox browser has two different possible configurations: Color Management Off or Color Management Enabled (or On). Figure 19.6 shows how the four versions of the test image appeared in Mozilla Firefox with color management off on the LaCie 321 display. Like in Chrome and Explorer, both of the sRGB images are the same, regardless of whether there is an embedded profile or not. The sRGB images are oversaturated, compared with how they looked in Photoshop (Figure 19.2). Also, as before, the ProPhotoRGB image is desaturated

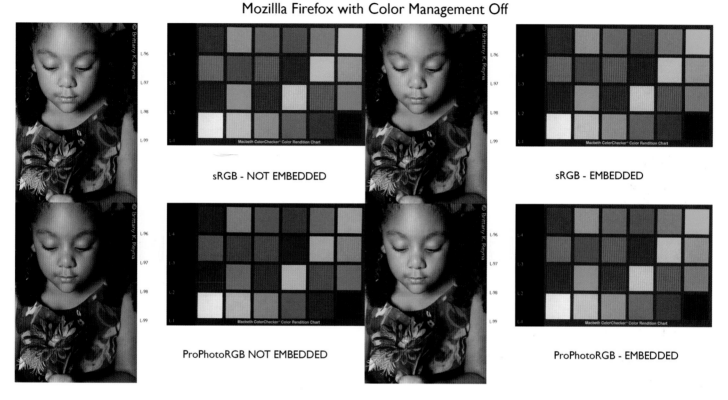

FIGURE 19.6 Four versions of the test image in Figure 19.2 as they appeared in Mozilla Firefox with color management turned OFF on a calibrated and profiled LaCie 321 and Apple OS X operating system.
Credit: Portion of test page designed by the author with photograph by Brittany K. Reyna

As mentioned, Mozilla's Firefox is capable of allowing you to obtain the same color management behavior as you would in Safari on the Mac, as we see in Figure 19.7. To enable or turn color management on in Firefox's configuration settings use the following steps:

1. Enter **about:config** in Firefox's address bar, as you would a URL.
2. Promise to be careful.
3. Enter the word **color** in the filter bar.
4. Find the line with **gfx.color_managment.enabled** toward the bottom of the list.
5. Double click the **false** value given, which changes it to **true**.
6. Quit Firefox and restart.

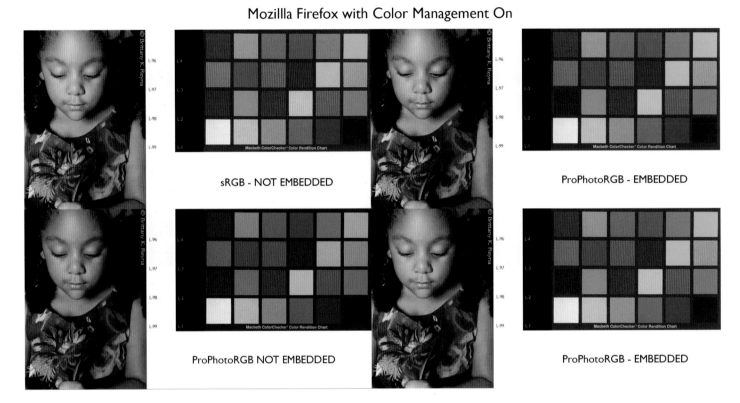

FIGURE 19.7 Four versions of the test image in Figure 19.2 as they appeared in Mozilla Firefox with color management ENABLED on a calibrated and profiled LaCie 321 and Apple OS X operating system.
Credit: Portion of test page designed by the author with photograph by Brittany K. Reyna

with no embedded profile, while the version with a ProPhotoRGB profile embedded looks the same as the sRGB images: slightly saturated.

Figure 19.7 shows how the four versions of the test image appeared in Mozilla's Firefox with color management enabled or turned on. As in Safari, the right half of the chart shows that, as long as there is a profile embedded with the image—regardless of whether it is in sRGB or ProPhotoRGB—the images look the same, and they look the same as they do in Photoshop and Lightroom.

As long as the version of Firefox is at least a 3.0 version and is configured correctly, it will recognize and use embedded ICC profiles.

Again, the same as with Safari, the left half of the chart shows what happens if no profile is embedded. Firefox assumes that the image is in the default monitor space, which is why the sRGB image looks more saturated and the ProPhotoRGB image with no embedded profile looks desaturated.

Another option is to use an add-on for Firefox that allows you to set some preferences, including sRGB to be assumed for untagged images. This add-on can be found at: https://addons.mozilla.org/en-US/firefox/addon/color-management/.

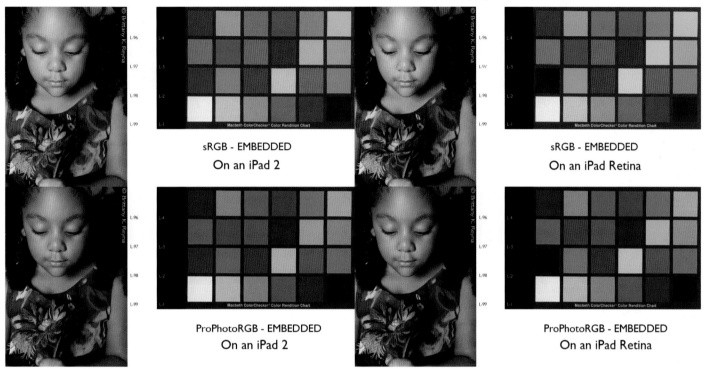

FIGURE 19.8 Four versions of the test image in Figure 19.2, shown as they appeared on two different iPads: iPad 2 on the left and iPad Retina on the right. The top images were in sRGB with profile embedded and the bottom images were in ProPhotoRGB with profile embedded.
Credit: Portion of test page designed by the author with photograph by Brittany K. Reyna.

Color on Apple iPads

Whether professionals or amateurs, many of us now share our portfolios or images on tablet computers. The bad news for preparing your files for viewing on an iPad or iPhone is that iOS (the Apple operating system for iPads and iPhones) is not color managed. It does not recognize or use embedded profiles, as you can see in Figure 19.8. We can tell this because, even though all the images have embedded profiles, they do not all look like the original image.

The good news is that the new Apple Retina displays on these devices have a gamut that is very close to sRGB, which you can see in Figure 19.9. You can confirm this by looking at the test image on the upper right of Figure 19.8, which is in sRGB and looks similar to the original image in Photoshop or Lightroom. So, for preparing images for display on an Apple device with a Retina display, the best thing to do is to convert the image to sRGB.

What we can also see in Figure 19.9 is that the gamuts of the iPad 2 and the iPad Mini are similar and smaller than the gamut of the iPad Retina display. We can also see this in the image in the

upper left of Figure 19.8, which shows that an image in sRGB on the iPad 2 looks slightly more saturated in the skin tones, the reds and yellows are more orange, and the yellow-green are desaturated and warmer than the original image. If you want to prepare files for optimal viewing on the iPad 2 or iPad Mini, than you could either use DataColor's Spyder Gallery App, which is free for all Spyder 4 or 3 users, or convert the images to a profile for the device, which you can create using the method below.

As mentioned before, you do not need to build a profile for Apple tablets or phones with their Retina display, since its gamut is very close to sRGB. When preparing color critical files for display on the Retina displays, it is best to convert the images to sRGB.

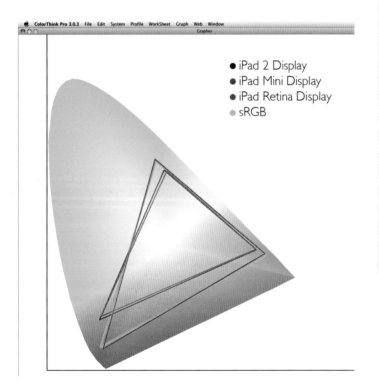

FIGURE 19.9 Gamuts of three different iPads (iPad 2, iPad Mini, and iPad Retina) and sRGB, shown in ColorThink Pro's Yxy gamut viewer.

Building a Profile for iPads and Other Tablet Computers

To get more accurate color from images viewed on a tablet computer that doesn't have a gamut that is the same as sRGB, like the iPad 2 or the iPad mini, you can convert your images to a profile made with the following steps:

1. Create the following four image files in Adobe Photoshop with the requested RGB code values and upload them to your tablet computer:

 a) White (R-255, G-255, B-255)
 b) Red (R-255, G-0, B-0)
 c) Green (R-0, G-255, B-0)
 d) Blue (R-0, G-0, B-255)

2. Display these colors on your tablet and measure their xy values with a colorimeter or spectrophotometer, as shown with X-Rite i1Profiler and an i1Display Pro colorimeter in Figure 19.10.

3. Launch the **Color Settings** window in Adobe Photoshop.

4. Click on the **RGB Working Spaces** pull-down menu and select **Custom RGB**.

5. Enter the xy values measured in step 2.

6. Name and save this color space (Figure 19.11).

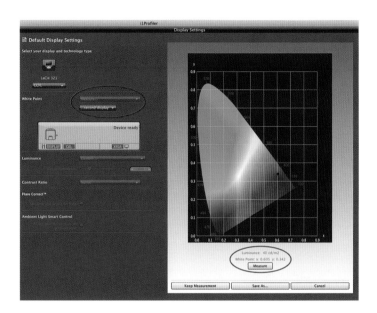

FIGURE 19.10 Measuring xy values for the red primary of an iPad 2 with an i1 Display Pro colorimeter in i1Profiler software.

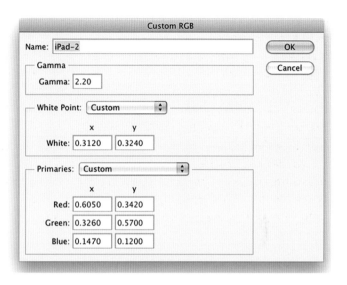

FIGURE 19.11 Creating a Custom RGB color space for the iPad 2 in Adobe Photoshop's Color Settings window.

Color from Presentation Applications

Finally, let's discuss one more type of soft output we might be producing with our images: Adobe Keynote or Microsoft PowerPoint presentations. If you are preparing images for either of these applications you will want to convert the images to sRGB and embed the profile. As you've seen with browsers, the most important of these two steps to getting accurate color is embedding the profile. Of course, profiling your projector will also help you, as we discussed in Chapter 4.

Conclusion

So, for the moment, we're not going to avoid the problem of our images on the web looking different on some browsers, computers, tablets, and projected in presentations. I won't even get into the fact that images in Adobe Flash files are not color managed. I think you get the message. As mentioned many times, the best we can do to get consistency across the widest number of screens (and especially on those that are color managed) is to: (1) convert images to sRGB and (2) embed the profile with the image. This does add 4 KB (that's kilobytes) to the file size, which will possibly slow things down a little, but it's worth it. Happy sharing!

EXPLORATIONS

Now it's your turn to test your browsers and tablets. Convert one version of your test page to sRGB with the profile embedded and save another with the profile *not* embedded. Open these versions and the original version of your test page and observe the differences. This will hopefully confirm the workflow suggested throughout the chapter.

Resources

Color in the Web Browsers

Gary Ballard—Web Browser Color Management Tutorial
 http://www.gballard.net/psd/go_live_page_profile/embeddedJPEG
 profiles.html

Color in Tablets

DataColor Spyder Gallery
 http://spyder.datacolor.com/portfolio-view/spyder-gallery/

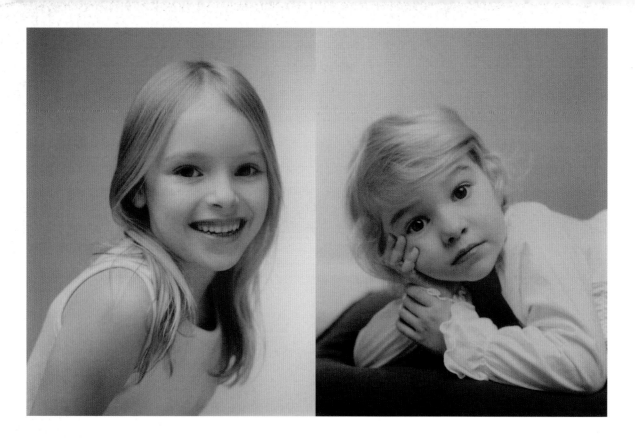

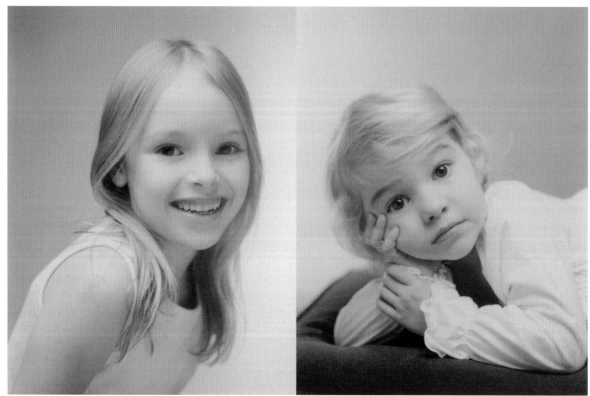

DIGITAL PRINT PERMANENCE & LONGEVITY

One of the major stumbling blocks that prevented the original digital Iris prints (created by Nash Editions and others) from being easily accepted by collectors, galleries, and museums was the poor longevity of these prints. What do we mean by "poor longevity"? Basically, over a short period of time (months to a few years) the look of the prints would change from the way they looked when they were originally printed. The color of the (mainly) dye-based inks would fade as the prints were on display, and the rate of fading was unique for the dyes in each ink, so that, for example, if the magenta dye faded faster than other dyes (cyan, yellow, or black), then the print would get lighter and produce a very undesirable green cast, as seen in the prints of the portraits in Figure 20.1.

Fading was not introduced with the invention of Iris and inkjet prints. If you go to the Metropolitan Museum of Art in New York, you will see that rooms for Edgar Degas's pastels are kept in considerably darker rooms than rooms in which oil paintings are hung. This is because pastels, like watercolors, are usually much more susceptible to fading from exposure to light.

With color photographic materials, except for Kodachrome slides and the traditional dye transfer prints mentioned in Chapter 12, all other color photographic materials, most popularly RA-4 processed chromogenic prints and E-6 processed slides, are known to be more prone to fading over time, even short periods of time. I'm guessing you've all seen this happen with your own family photographs as they've faded over the years, particularly the prints displayed openly and which have therefore been subjected to sunlight. In addition to the fading of the photographic dyes, the white or minimum density (d-min) of the paper the prints are on can get darker or yellower over time.

Although everything (even art!) changes over time, the rapid changes that occur over time with photographic and inkjet prints are of concern, especially in the fine-art market. These changes didn't

FIGURE 20.1 Prints of portraits of the author's nieces Hannah and Adrienne from 2002. The dye based inkjet print as it looked originally and on the bottom as it looked after it had been on a refrigerator in a brightly lit kitchen for three years. Credit: Photograph by the author

matter in terms of the proofing market, for which the Iris printer was originally built. The proofs of how pages will look on a printing press only needed to last a few months without changing and are typically discarded after that.

But art is meant to represent a civilization long after it is gone. Fine-art prints made by traditional techniques, like etching and lithography, are expected to last for centuries with minimal changes. In the world of photographs, fiber-based silver gelatin photographic prints, which have been processed and washed properly, can last for 100 to 200 years without changing—and even longer if the prints go through a chemical toning process. The limiting factor for longevity in these prints is the degradation of the paper support, not typically the silver gelatin emulsion.

In this chapter we will discuss some of the factors that can affect the longevity of our prints and also how our print materials are tested for longevity. This review is meant to help you to understand the resources and information that is available, so you can make decisions about which materials to use and how to handle and store your final prints.

Factors that Affect Print Longevity

Many factors can affect the longevity of our digital prints and should be considered when printing, displaying and storing them. These factors include: the materials used, ultraviolet radiation, temperature, humidity and moisture, and pollutants in the atmosphere.

Materials

In general, as discussed in Chapters 12 and 13, pigment-based prints have much more longevity and fade resistance than dye-based prints. Dyes are used in all photographic prints and in the original inkjet prints. Of course, not all dyes are the same—some will fade after months; others, after years or decades. Kodak and Fuji have both improved the longevity characteristics of their chromogenic color

papers, with their Endura and Crystal Archive materials, respectively. Epson, HP, and Canon all make pigment-based inkjet printers and inks for the photographic and fine-art markets.

The other major material to consider for your prints is the paper. Many inkjet papers contain UV or optical brighteners to make the paper appear brighter and whiter. The problem is that, like the dyes in the ink, these brightening additives can change with exposure to ultraviolet radiation from light exposure over time. The result: as the brighteners fade, the paper becomes darker and typically more yellow. If you want your prints to last longer without the paper yellowing, it is better to start with paper that has no UV or optical brighteners. The paper will start off yellower and darker, but it will be less likely to change over time. Also remember that longevity is not affected by the ink and paper separately, but that each combination of ink and paper will have different characteristics.

Ultraviolet Radiation

There are two ways to look at longevity of a fine art print: consider how long the print will last without changing when displayed on the wall under light and how long it will last in the dark of a drawer.

Most materials will last longer if they are not exposed to the ultraviolet radiation inherent to being displayed. Dye-destruction (Ilfochrome) prints have especially good dark-storage stability. You can help the longevity of prints by changing their display and storage conditions. Lots of testing has been done regarding the best ways to store and display different types of fine art prints. Framing the print with glass helps the longevity, but using UV-absorbing glass helps even more, which we will discuss more in the final chapter.

Temperature

Keeping prints at a higher temperature will typically result in faster fading and less longevity than keeping them at a lower temperature. It's recommended that color photographic prints (C-prints) and negatives, for example, should be stored in a freezer (less than 0° C) to help slow down the fading of their dyes.

Humidity/Moisture Sensitivity

The dyes in dye-based inkjet prints are water-soluble, so they are especially susceptible to damage from spills, sprays, and spit. On the other hand, the dyes in photographic prints are somewhat protected from physical damage because the dyes are suspended in gelatin. Higher humidity conditions will exacerbate the fading of all prints, but especially dye-based prints. Pigments, on the other hand, are not water-soluble, so they are more water-resistant and less sensitive to humidity-induced fading.

Pollutants

Higher concentrations of pollutants (such as ozone) in the atmosphere can attack the dyes or pigments on a print and reduce its longevity and increase fading. In general, one of the best things you can do to protect a print is to frame it behind glass—real glass (even better, UV-absorbing glass)—not Plexiglas(r). Plexiglas(r), acrylic glazing, and plastics do not protect as well as real glass, and they allow pollutants through to the print. Glass is not always practical. We'll discuss this more in the next chapter, when we discuss different print-finishing techniques.

Testing and Measuring Materials for Print Longevity

How do we know how long different printer/ink/paper combinations will last without noticeably fading under different storage and display conditions? We get longevity information from accelerated testing and results reporting by manufacturers and independent testing labs on our digital print materials.

When we see results that say "more than 250 years without fading" under a certain condition, we have to remember that no time machine was involved to verify the results! Since it's not practical to test a print under standard viewing conditions for 250 years, we use accelerated testing for light fastness. With this method, a print is put

under more intense light energy (than standard viewing conditions) for a shorter period of time (than 200 years). This method is meant to expose a print to the equivalent amount of light energy it would be subjected to over a longer period of time under standard viewing conditions.

Watch out, though: because the tests are often conducted differently from one another, the data from different tests can be difficult to compare. In addition, not everyone agrees on what is an acceptable or imperceptible amount of fading. Accelerated aging tests are best for relative comparisons when two or more tests are done in the same way.

There are two main independent photographic print-longevity testing organizations: Wilhelm Imaging Research and the Image Permanence Institute at Rochester Institute of Technology.

Henry Wilhelm of Wilhelm Imaging Research has been pushing the photographic industry (mainly Kodak) for years to implement improvements in photographic color print longevity. He has been measuring, documenting, and writing about the failings of these materials for decades. He has also been instrumental in testing and pushing for improvements in the longevity of inkjet materials. Many manufacturers now hire him to perform longevity and other types of testing on their materials.

Along with B&H's website for checking prices and the *DP Review* website for camera-testing comparisons, the Wilhelm Imaging Research website (http://www.wilhelm-research.com) is one of the most fundamental resources for digital photographers.

Whether you agree with the longevity predictions or not, you should know what Henry Wilhelm and Wilhelm Imaging Research are saying. Figure 20.2 shows the first two pages of Wilhelm Imaging Research's testing of prints from the Hewlett-Packard Designjet Z3200 printer and 12-color HP Vivera 70 pigment inks on various Ilford papers. This data is particularly helpful for seeing the effect of the different print-longevity factors discussed above, such as display conditions, dark storage, and the presence of optical brighteners.

As you read any of the Wilhelm Imaging Research test-result PDFs, you will see they include information about Wilhelm's testing methodology, as shown in the second page of Figure 20.2. Here you can see that Wilhelm believes he and the rest of the imaging community are in agreement about how to conduct longevity testing, and that only Eastman Kodak has disagreed, specifically when it comes to testing chromogenic materials.

Kodak's counterargument in the past revolved around the fact that testing with a higher light level to illuminate test prints in the accelerated testing can result in a side effect of adding more heat to the test conditions than would be typical in gallery or home viewing environments, which can potentially make the results less accurate.

As mentioned earlier, the best way for us to use accelerated testing data is to compare relative differences from testing done by the same method. We do this *not* for 100% accurate predictions of longevity for your printer and paper combinations, but to give us understanding of which digital printing methods and materials, finishing techniques, and display and storage conditions will provide our prints with improved longevity.

Conclusion

In this chapter we have reviewed the factors that affect the longevity of our digital prints. Whether they are fine-art prints or family photographs, our images are precious, so we do not want them to fade away. By using the resources and research at our disposal, we can better understand our materials and the best ways to store and display our prints. In the next chapter, we will look more specifically at the options for finishing and protecting our prints, so they will continue to be around for future generations.

ILFORD Inkjet Papers with HP Inks – Print Permanence Ratings[1]

The image permanence data presented here are based on test samples printed with a Hewlett-Packard Designjet Z3200 printer and 12-color HP Vivera 70 pigment inks. ILFORD inkjet photo and fine art papers are manufactured by ILFORD Imaging Switzerland GmbH, Case Postale 160, CH 1723 Marly 1, Switzerland (telephone: +41 (0)26 435 71 11; fax: +41 (0)26 435 72 12). ILFORD papers are available from suppliers and dealers around the world.

www.ilford.com
www.facebook.com/ilfordimaging

Display Permanence Ratings and Album/Dark Storage Permanence Ratings (Years Before Noticeable Fading and/or Changes in Color Balance Occur)[2]

Paper, Canvas, or Fine Art Media Printed With HP Vivera 70 Pigment Inks	Displayed Prints Framed Under Glass[3]	Displayed Prints Framed With UV Filter[4]	Displayed Prints Not Framed (Bare-Bulb)[5]	Album/Dark Storage Rating at 73°F & 50% RH (incl. Paper Yellowing)[6]	Unprotected Resistance to Ozone[7]	Resistance to High Humidity[8]	Resistance to Water[9]	Are UV Brighteners Present?[10]
ILFORD Galerie Gold Fibre Silk Paper	>200 years	>250 years	70 years	>250 years	>100 years	very high	moderate[11]	no
ILFORD Galerie Smooth Pearl Paper	>200 years	>250 years	78 years	>250 years	>100 years	very high	high	no
ILFORD Galerie Smooth Gloss Paper	>200 years	>250 years	70 years	>250 years	>100 years	very high	high	no

FIGURE 20.2 *(above and overleaf)* Wilhelm Imaging Research longevity test results for prints from the Hewlett-Packard Designjet Z3200 printer and 12-color HP Vivera 70 pigment inks on various Ilford papers.

Credit: © Wilhelm Imaging Research (wilhelm-research.com)

ILFORD Inkjet Papers with HP Inks – Print Permanence Ratings[1]

Notes on These Tests:

1) The image permanence data presented here are based on tests done with samples printed with a Hewlett-Packard Designjet Z3200 printer and 12-color HP Vivera 70 pigment inks. ILFORD inkjet photo and fine art papers are manufactured by ILFORD Imaging Switzerland GmbH, Case Postale 160, CH 1723 Marly 1, Switzerland (telephone: +41 (0)26 435 71 11; fax: +41 (0)26 435 72 12). ILFORD papers are available from suppliers and dealers around the world. www.ilford.com

2) There are currently no ISO or ANSI standards which provide a means of evaluating the permanence of inkjet or other digitally-printed photographs. As a member of ISO WG-5/TG-3 permanence standards group, WIR is actively involved in the development of a new series of ISO standards for testing digital prints. However, as of January 2010, no dates have been announced for the completion and publication of these new ISO standards. The WIR Display Permanence Ratings (DPR) given here are based on accelerated light stability tests conducted at 35 klux with glass-filtered cool white fluorescent illumination with the sample plane air temperature maintained at 24°C and 60% relative humidity. Data were extrapolated to a display condition of 450 lux for 12 hours per day using the Wilhelm Imaging Research, Inc. "Visually-Weighted Endpoint Criteria Set v3.0." and represent the years of display for easily noticeable fading, changes in color balance, and/or staining to occur. See: Henry Wilhelm, "How Long Will They Last? An Overview of the Light-Fading Stability of Inkjet Prints and Traditional Color Photographs," *IS&T's 12th International Symposium on Photofinishing Technologies,* sponsored by the Society for Imaging Science and Technology, Orlando, Florida, February 2002. This paper may be downloaded in PDF form at no charge from: *<http://www.wilhelm-research.com/pdf/is_t/WIR_ISTpaper_2002_02_HW.pdf>*.

For a study of endpoint criteria correlation with human observers, see: Yoshihiko Shibahara, Makoto Machida, Hideyasu Ishibashi, and Hiroshi Ishizuka, "Endpoint Criteria for Print Life Estimation," *Final Program and Proceedings: IS&T's NIP20 International Conference on Digital Printing Technologies,* pp. 673–679, sponsored by the Society for Imaging Science and Technology, Salt Lake City, Utah, November 2004.

See also: Henry Wilhelm, "A Review of Accelerated Test Methods for Predicting the Image Life of Digitally-Printed Photographs – Part II," *Final Program and Proceedings: IS&T's NIP20 International Conference on Digital Printing Technologies,* pp. 664–669, sponsored by the Society for Imaging Science and Technology, Salt Lake City, Utah, November 2004. Also available, with *color illustrations: <www.wilhelm-research.com> <WIR_IST_2004_11_HW.pdf>*. High-intensity light fading reciprocity failures in these tests are assumed to be zero. Illumination conditions in homes, offices, museums, and galleries do vary, however, and color images will last longer when displayed under lower light levels; likewise, the life

Table 1. "Standard" Home Display Illumination Levels Used by Printer, Ink, and Photo Paper Manufacturers

120 lux/12 hrs/day	450 lux or 500 lux/10 hrs/day or 12 hrs/day
	Hewlett-Packard
	Epson
	Canon
	Lexmark
	Fuji
	Ilford
	Canson
	DNP Konica
Kodak (for Kodak silver-halide papers and Kodak dye-sub prints)	Kodak (for Kodak consumer inkjet prints)
	Ferrania
	InteliCoat
	Somerset
	Harman
	LexJet
	Lyson
	Luminos
	Hahnemuhle
	Premier Imaging Products
	American Inkjet
	MediaStreet

of prints will be shortened when displayed under illumination that is more intense than 450 lux. Ink and paper combinations that have not reached a fading or color balance failure point after the equivalent of 100 years of display are given a rating of "more than 100 years" until such time as meaningful dark stability data are available (see discussion in No. 5 below).

Eastman Kodak has licensed WIR image permanence data for the Kodak line of consumer inkjet printers, and WIR data for these printers are posted on the WIR website (see, for example, *<http://www.wilhelm-research.com/kodak/esp9.html>* WIR's tests with the Kodak consumer inkjet printers are performed using the exact same methodologies employed for all other inkjet printers and other print products posted on the WIR website.

Kodak's internally-developed print permanence test methodologies have been used by the company for many years and the company continues to base its

. . . . continues next page

FIGURE 20.2 continued Second page of Wilhelm Imaging Research document for the Hewlett-Packard Designjet Z3200 printer and 12-color HP Vivera 70 pigment inks on various Ilford papers with notes on the methodology used, especially for the intensity of light and average daily duration simulated.
Credit: © Wilhelm Imaging Research (wilhelm-research.com)

EXPLORATIONS

Based on what we've discussed in this chapter, it is time for you to review the expected longevity of your printer and paper combinations. Look for information from the manufacturers, as well as independent testing firms like Wilhelm Imaging Research. Questions you should be able to answer include: (1) Does my paper include optical brighteners that could fade over time and yellow my paper? (2) How much is the longevity of my printer/paper combination extended by framing it behind regular glass or UV glass? (3) Are there specific recommendations on the best conditions to store my prints?

Resources

Print Longevity

Wilhelm Imaging Research
http://wilhelm-research.com/

Image Permanence Institute
https://www.imagepermanenceinstitute.org/

Hahnemühle on Optical Brighteners
http://www.hahnemuehle.com/news/en/239/122/hahnemuehle-fineart-on-the-subject-of-oba-s.html

Storage and Care of Kodak Photographic Materials—Technical Reference E-30
http://www.kodak.com/global/en/consumer/products/techInfo/e30/e30.pdf

PRINT TREATMENTS, EDITIONS & DOCUMENTATION

In this chapter we are looking at the final steps of the process of making our high-quality output. First we will examine our options for finishing, mounting, and framing our prints, which will protect them and possibly enhance their aesthetic appearance. Next we will review reasons and strategies for editioning our prints. Finally, we will review the ways to document our prints, so that they can be maintained and conserved for generations.

Print Finishing Treatments

Over the history of photography, there have been many ways to finish photographs for display or storage. These methods have come in and out of fashion over time, for technical and aesthetic reasons. The popularity of some finishing techniques is also specific to certain countries and parts of the world. This could be seen early in the history of photography. The standard method for finishing daguerreotypes in the mid-19th century in the United States was to use an elaborate case—which could include a decorative outer shell, an interior of red velvet, glass, and a *passe-partout*, which is a paper or cardboard mat, or a brass mat.

Figure 20.1 and 20.2 show contemporary daguerreotypes and cases by Alan Bekhuis. This finishing technique served (and still serves) two purposes: to protect the photograph and to add an aesthetic element. Photographers continue to have the same two reasons for using different finishing techniques with their prints.

Protection of the Photograph

The main reasons to finish the photographic print is to protect the image from the fading properties of light, the ravages of pollutants in the environment, the destructive oils in our hands, and our inadvertent spills and sprays of spit.

FIGURE 21.1 Mourner diptych, 2007, a daguerreotype by Alan Bekhuis, who also produced the case.
Credit: Image, daguerreotype, and case by Alan Bekhuis (casedimage.com)

FIGURE 21.2 Horse's Head, 2009, a daguerreotype by Alan Bekhuis, who also produced the case.
Credit: Image, daguerreotype, and case by Alan Bekhuis (casedimage.com)

Light and UV Radiation

As we discussed in the last chapter, some of our print materials are more susceptible than others to fading over time. One factor affecting this fading is exposure to visible and ultraviolet (UV) radiation. If we can protect the print from being exposed to the ultraviolet radiation, then we should be able to prevent or minimize some of this fading.

As Wilhelm Imaging Research test data has shown (as in Figure 20.3, for the Epson 7900), by blocking or protecting the print from UV radiation while it is under display longevity can be extended. For example, the accelerated testing data shows that, by displaying a print

Epson Stylus Pro 7900 – Print Permanence Ratings (preliminary[1])

Ink System: Eleven pigmented inks are provided in the printer with ten inks used at any given time, as determined by the paper type and print mode selected. Eleven pressurized 350 ml or 700 ml ink cartridges. The 1-inch wide piezo inkjet heads are a permanent part of the printer. The new Epson UltraChrome HDR Inks include pigmented Cyan, Light Cyan, Vivid Magenta, Vivid Light Magenta, Yellow, Orange, Green, Photo Black (for glossy photo papers) or Matte Black (for matte photo papers), Light Black, and Light, Light Black. The three-level black inks are used over the complete tonal scale to improve the printer's gray balance and eliminate color casts in neutrals and near-neutrals. Auto black ink switching mode saves ink and eliminates the need to change black ink cartridges. Maximum resolution: up to 2880 x 1440 dpi; ink drop size as small as 3.5 picoliters with variable drop size technology.

Maximum Paper Width: 24 inches (61 cm). Handles roll or cut sheet media from U.S. Letter size (8.5" x 11") up to 24 inches (61 cm). Cut sheet paper thickness up to 500 gsm and 1.5 mm poster board can be accommodated. All media types and sizes are front loaded. Border-free printing provided.

Operating Systems: Windows XP and 7 (both 32 and 64-bit supported); Mac OSX Leopard 10.5 or higher (16bit); Hi-Speed USB 2.0 and 10/100 BaseT Ethernet connectivity. Supported by most major third-party RIPs and workflows.

Special Features: Epson "Advanced Black and White Print Mode." Automatic nozzle verification and cleaning. Built-in rotary cutter for roll papers and canvas. The optional Epson SpectroProofer, a spectrophotometer developed with X-Rite, provides advanced measurement, linearization, and certification automatically.

Price: $3,995 (USA) Epson Stylus Pro 7900 (24-inch). A wider, 44-inch version of the printer, the Epson Stylus Pro 9900, is available for $5,995. The printers started shipping in November 2008. In Japan the printers are known as the PX-H800/10000 and in China and in Hong Kong, the 7910/9910.

The 7900 and 9900 printers are the first Epson printers to use the new eleven-ink UltraChrome HDR pigmented inkset. Orange and green inks have been added to the cyan, magenta, and yellow inks to expand the printer's color gamut.

Jeff Schewe, an internationally-known photographer, author, color management and profiling expert, software architect, and digital imaging instructor making prints with an Epson 7900 in his Chicago, Illinois studio. Schewe serves as an alpha tester for Adobe Photoshop and Lightroom. <www.schewephotography.com>

©2008 Henry Wilhelm

This document originated at <www.wilhelm-research.com> File name: <WIR_Ep7900_2010_04_25.pdf>

Display Permanence Ratings and Album/Dark Storage Permanence Ratings (Years Before Noticeable Fading and/or Changes in Color Balance Occur)[2]

Paper, Canvas, or Fine Art Media Printed With UltraChrome HDR Pigment Inks	Displayed Prints Framed Under Glass[3]	Displayed Prints Framed With UV Filter[4]	Displayed Prints Not Framed (Bare-Bulb)[5]	Album/Dark Storage Rating at 73°F & 50% RH (incl. Paper Yellowing)[6]	Unprotected Resistance to Ozone[7]	Resistance to High Humidity[8]	Resistance to Water[9]	Are UV Brighteners Present?[10]
Epson Premium Glossy Photo Paper (250)	**85 years**	98 years	60 years	>300 years	>100 years	very high	high	no
Epson Premium Luster Photo Paper (260)	**83 years**	>200 years	45 years	>200 years	>100 years	very high	high	yes
Epson Premium Semimatte Photo Paper (260)	**83 years**	>200 years	45 years	>200 years	>100 years	very high	high	yes
Epson Exhibition Fiber Paper (Epson Traditional Photo Paper outside USA)	**90 years**	150 years	44 years	>200 years	>100 years	very high	moderate[11]	yes
Epson UltraSmooth Fine Art Paper	**108 years**	175 years	57 years	>300 years	>100 years	very high	moderate[11]	no
Epson Hot Press Natural Paper	now in test	now in test	now in test	>200 years	>100 years	very high	moderate[11]	no

. . . . continues next page

FIGURE 21.3 Wilhelm Imaging Research longevity test results for prints for the Epson 7900 printer and the 11-ink UltraChrome HDR pigment ink set on various Epson media and finishing conditions.

Credit: © Wilhelm Imaging Research (wilhelm-research.com)

behind a UV-absorbing filter, the number of years it would last without noticeable fading would jump from 44 to over 150 (for an image that was printed on Epson Exhibition Fiber Paper).

Pollutants

Finishing a print can also help protect it from the pollutants in the environment, which, like UV radiation, can lead to the fading of the image over time. One such pollutant, ozone, affects our health as well as the stability of our prints. Ozone especially affects dye-based prints. A simple way to protect a print from ozone and other pollutants is to frame it behind glass. Glass keeps out the majority of pollutants, while plastic lamination and face-mounting to a sheet of clear (polymethyl methacrylate, PMMA) such as Plexiglas(r), do not protect against pollutants. Of course, another option is to move the print to a place where there is less air pollution—but it might be simpler to put the print behind glass.

Handling

The other variable our prints need protecting from is . . . us. By touching and handling prints, we can potentially damage them physically. Although the damage is mostly inadvertent and accidental, the moisture and oils in our skin detrimentally affect prints and the paper they're on. Also, inkjet prints on matte—and many of the fiber-based—papers have very delicate surfaces that are easily scuffed. If unprotected, these prints must be handled very carefully.

Humidity and Moisture

As we discussed before, pigment-based inkjet prints are less susceptible to the effects of moisture and humidity than dye-based prints, which use water-soluble dyes. But all prints are likely to fade faster in high-humidity environments. This could also be because ozone

levels are higher in areas with higher humidity. (Ah, overlapping effects!) Regardless of the technology, finishing the print can protect the image from water and other liquids that can stain or damage the print.

Print Finishing Techniques

Each print-finishing technique will, of course, give different protective and aesthetic effects. The optimal finishing technique for a specific digital print depends on the type of printing technology used and the way the print will be utilized and/or displayed. Next, we will cover the benefits, detriments, materials, and procedures involved in the five main finishing techniques for digital prints: applying lacquers and fixatives, mounting, matting and framing, lamination, and face-mounting.

Before Print Finishing

It's important to note that, before treating or finishing any inkjet print, you must wait at least 12–24 hours after the print has been made. This gives time for the print to completely *off-gas*. Off-gassing is the release of residual solvents from the ink as the print is drying. Although the print may be dry to the touch during this time, it is still changing chemically. These continued changes, especially in color, are why we often wait before measuring printer/paper-profiling color patches. If we don't wait until the print has finished off-gassing, then they can end up with physical defects like bubbles and areas of delamination. Other defects include discoloration and accelerated fading from trapped gases that react with the paper and the colorants in the pigments or dyes.

Lacquers and Fixatives

The main benefit of adding a clear varnish or lacquer to the top of an inkjet print is to protect it from fading, pollutants, handling, moisture,

and humidity. Aesthetically, the addition of the lacquer can give the print additional depth, add a whole new texture—or produce little effect. The finishes or surfaces produced from the lacquer can be anything from matte to high gloss.

Although it's mostly useful on matte papers, lacquer, when applied onto pigment-based inkjet prints on glossy or luster type papers, can minimize the gloss differential (which is where the difference in gloss of the ink and paper is noticeable at certain angles).

On a practical level, a benefit of this finishing technique is its cost and accessibility. You don't need expensive equipment, and aerosol cans of print lacquer sprays are available from a cost of ten to twenty dollars. Also, of all the methods we will discuss, the addition of a lacquer to the top of a print adds the least amount of weight or rigidity to it.

Applications that would benefit most from applying lacquer are ones where the print surface will not be protected by anything else and/or the print will receive lots of handling, like inkjet prints on canvas or prints in a portfolio or handmade book.

One detriment of this technique is that since you're applying the lacquer or varnish directly to the surface of the print, there can be some unexpected chemical interactions, which can result in defects, discoloration, or color fading. It's best to use materials that have been tested with the ink and paper combination you're using. Figure 20.4 shows Wilhelm Image Research results from testing with and without Premier Art Spray. If you can't manage to test all varnished or lacquered prints in this way, then you should at least make preliminary tests before using the material on a large print. Be aware when applying lacquer or varnish that it can be easy to permanently impregnate foreign matter into your print if you're not working in a fairly dust- and debris-free area.

The most common way of applying lacquers and fixatives to inkjet prints is by aerosol spray can or a high-volume, low-pressure (HVLP) spray-gun system. For a thicker, more coarse effect, print lacquers can also be applied by roller or brush. Alternately, to ensure a very even coat of any thickness—or in selective areas of the print for a spot varnish—you can apply the lacquer by silkscreen.

If you're applying lacquer to your prints on a regular basis, it might be worth building a custom profile that includes this aspect of the process. This will help with the accuracy of your final print, since the color and tone of the print can be slightly altered by this finishing technique. Of course, such a custom profile will only be useful if you are consistent in the way you spray or apply the lacquer.

Because of the solvents used in some of the lacquers, it's important to read their safety instructions. When spraying prints with these materials, make sure to work in a well-ventilated environment. You should also wear respiratory protection (like a filter mask) or, better yet, a respirator that filters both particles and solvents. Some print lacquers use safer solvents, which can be slightly more expensive; they are worth it. When using the safer solvents, be sure to still read the instructions to be certain you understand how to handle the materials.

Mounting

The basic benefits of mounting any print to a rigid surface are practical and aesthetic. Mounting the print makes it flat and adds structural strength.

The detriment of mounting a print is that an adhesive must be used, which means it can react with the print (immediately or over time) and result in defects, deformation, discoloration, or poor longevity. The one exception to this is the use of a windowed mat with archival corners that keep adhesive off the print (see below).

It's important that the mounting adhesive materials and methods you use are archival and compatible with the print material you are using. For example, you don't want to use any thermal mounting techniques with inkjet or electrophotographic prints, especially ones with wax-based inks like Xerox Tektronix Phaser prints.

Epson Stylus Pro 7900 – Print Permanence Ratings (preliminary[1])

(. . . . continued from previous page)

Display Permanence Ratings and Album/Dark Storage Permanence Ratings (Years Before Noticeable Fading and/or Changes in Color Balance Occur)[2]

Paper, Canvas, or Fine Art Media Printed With UltraChrome HDR Pigment Inks	Displayed Prints Framed Under Glass[3]	Displayed Prints Framed With UV Filter[4]	Displayed Prints Not Framed (Bare-Bulb)[5]	Album/Dark Storage Rating at 73°F & 50% RH (incl. Paper Yellowing)[6]	Unprotected Resistance to Ozone[7]	Resistance to High Humidity[8]	Resistance to Water[9]	Are UV Brighteners Present?[10]
Epson Hot Press Bright Paper	now in test	now in test	now in test	>200 years	>100 years	very high	moderate[11]	yes
Epson Cold Press Natural Paper	now in test	now in test	now in test	>200 years	>100 years	very high	moderate[11]	no
Epson Cold Press Bright Paper	now in test	now in test	now in test	>200 years	>100 years	very high	moderate[11]	yes
Somerset Velvet for Epson	62 years	128 years	37 years	>200 years	now in test	very high	moderate[11]	some
Somerset Velvet for Epson w/PremierArt™ Spray[12]	166 years	>200 years	75 years	>200 years	now in test	very high	moderate[11]	some
Epson Velvet Fine Art Paper	61 years	125 years	34 years	>200 years	>100 years	very high	moderate[11]	some
Epson Velvet Fine Art Paper w/PremierArt™ Spray[12]	82 years	168 years	55 years	>200 years	>100 years	very high	moderate[11]	some
Epson Textured Fine Art Paper	118 years	236 years	68 years	>200 years	now in test	very high	moderate[11]	no
Epson Enhanced Matte Paper [13]	82 years	110 years	48 years	110 years	now in test	very high	moderate[11]	yes
Epson Premium Canvas – Satin	75 years	132 years	46 years	>200 years	now in test	very high	moderate[11]	no
Epson Premium Canvas – Satin w/PremierArt™ Print Shield Spray[12]	85 years	142 years	60 years	>200 years	now in test	very high	moderate[11]	no
Epson Premium Canvas – Satin w/PremierArt™ Eco Print Shield Coating[12]	>100 years	>100 years	>100 years	now in test	now in test	very high	moderate[11]	no
Epson Premium Canvas – Matte	to be tested	to be tested	to be tested	to be tested	to be tested	to be tested	to be tested	–

. . . . continues next page

This document originated at <www.wilhelm-research.com> File name: <WIR_Ep7900_2010_04_25.pdf>

FIGURE 21.4 Wilhelm Imaging Research longevity test results for prints for the Epson 7900 printer and the 11-ink UltraChrome HDR pigment ink set on various Epson media and finishing conditions, highlighting the effect on longevity with the use of different lacquer spray coatings.
Credit: © Wilhelm Imaging Research (wilhelm-research.com)

TABLE 21.1

Material	Description	Benefits	Detriments	Price
Museum Board 4-ply and 8-ply	Made from 100% cotton and buffered with calcium carbonate	Acid free. Preferred by conservators and museums	Less surface strength and rigidity	$ 58.00 $ 87.00
Foam Core	Foam core with paper on front and back	Least expensive, smooth, and lightweight	Non-archival, least durable	$ 41.00
Gator Board	Polystyrene core bonded to a wood fiber veneer facing infused with resins	Lightweight, durable, for indoor and outdoor use	Non-archival	$ 48.00
Masonite	Compressed wood, brown color	Physically durable	Non-archival, heavy	$ 48.00
Dibond or Alucobond	Two thin sheets of aluminum bonded with a thermoplastic core	Rigid, flat, light, thin, strong, heat resistant, and archival		$180.00
Sintra	Expanded polyvinyl chloride (PVC) 3 mm and 6 mm	Lightweight, rigid, dent- and scratch-resistant	Surface texture, non-archival	$ 73.00 $ 85.00
Aluminum	Anodized aluminum	Smooth, flat, archival, thinner and lighter than Plexiglas® (better for larger prints)	Not as rigid as Dibond or Plexiglas®	$190.00
Poly(methyl methacrylate) (PMMA) or Plexiglas®	Transparent plastic Black plastic 1/8" Thick	Flat, smooth, rigid, archival	Heavy, less crack- and heat-resistant than Dibond	$ 96.00 $120.00

Note: This chart is a synopsis of the information from the website for Laumont Photographics in New York City (http://laumont.com), which also contains some great example images. All of the prices were for mounting and materials only, for a 24 x 30-inch print.

Table 21.1 lists the most common backing materials for mounting a 24 x 30-inch print with descriptions, benefits, detriments, and approximate prices.

Matting and Framing

The goal of framing our photographs is to create a protective housing, which incorporates a molding around the print and can include glazing in front of the print. The glazing can either be glass or PMMA (Plexiglas**(r)**). To protect our prints from the effects of UV radiation and pollutants for print longevity, it's best to use UV filtering glass and not PMMA, which allows some pollutants through to the print.

Additionally, for museum and conservation purposes, the optimal method for framing is to attach the print to museum board, using archival corners and holding down the edges of the print with a window mat. This mat serves two purposes: to hold the print in place and to create a gap between the print surface and the glass, which (depending on the paper) can cause print transfer and/or Newton Rings, which are iridescent patterns that can result when two smooth objects are in contact, like glass and glossy photo paper, over time. Aesthetically it can be beneficial to use non-reflective glass, such as museum glass, to minimize or eliminate distracting reflections.

Although the method mentioned above is the most archival one, it does have its detriments. One trade-off is the weight of the glass

in comparison with PMMA. For much larger prints, which have recently been more in fashion in contemporary photography, glass can be too heavy. Also, standard glass is not shatterproof like PMMA. Additionally, corner mounting does not leave the print as securely positioned or as flat as mounting the entire print to museum board or another archival substrate.

Another issue with the framing method described above is aesthetic. Window mats, while classic and very archival, can be considered somewhat old-fashioned in contemporary framing. Floating the mounted print in the frame is also common. In float mounting a spacer is used so that the print does not touch the glass (Figure 21.5). An even more common contemporary framing method is the shadow box, where the print is mounted to one of the substrates mentioned above, surrounded by a square molding, and separated from the glazing by a spacer.

FIGURE 21.5 Framed float mounted print, which uses spacers to keep print surface from touching the glass or glazing. Image also shows edition number and the chop mark for the digital printmaker, Jonathan Singer of Singer Editions.
Credit: Photograph by the author

Lamination

As with adding a varnish or lacquer to a print, the main benefit of adding a laminate to the top of a photograph is to protect the print from fading, pollutants, handling, moisture, and humidity. This is a very common way to protect prints that are going to be mounted and displayed directly without a frame. With lamination the mounted print includes a wooden or aluminum brace on the back, which allows the mounted print to attach to the wall with a slight gap. The effect makes it appear as if the print is floating from the wall.

Lamination allows the print to have some protection along with an aesthetically minimal presentation. The finishes or surfaces produced from the lamination can include matte, luster, and glossy. In comparison with face-mounting to PMMA, lamination allows for a much lighter aesthetic effect and a smaller difference from the look of the original print.

As with adding a varnish or lacquer, one detriment of this technique is that, since you're adhering the laminate directly to the surface of the print, there can be some unexpected interactions, which can result in defects or discoloration. It's best to use materials that have been tested with the ink and paper combination you're using.

Also, over time, laminates can shrink and change differently than the original print does, which can lead to delamination or peeling. Not all laminating technologies work for all types of digital prints. As Sylvie Pénichon and Martin Jürgens mention in their 2001 article entitled "Two Finishing Techniques for Contemporary Photographs":

Standard thermal laminates are much cheaper than the pressure-sensitive films and are appropriate for a wide variety of media (photographs, electrostatic prints, xerographic prints, etc.), but cannot be used with heat-sensitive materials such as wax-based ink jet prints or coated media. Polyethylene adhesives do not show extensive penetration. In some instances, when used with certain types of ink jet

prints, the adhesive will bond to the top layer of the deposited ink instead of bonding to the paper substrate. As a result, the laminate may peel away from the paper, thereby also removing the ink. Polyethylene may also not adhere to ink jet inks with incorporated glycerin. [1]

As this shows, you need to be aware of these limitations and choose the appropriate laminating technique for your type of print if you are considering having a print laminated as part of your finishing process. In general, standard thermal laminates adhere much better to the smooth surface of the gelatin emulsions of glossy chromogenic prints, which are all on resin-coated or RC-based paper. They don't work as well on textured papers or inkjet prints, where the ink sits on the surface of the print.

Face-Mounting

Mounting the image side of a print to PMMA (Plexiglas®) with either a pressure-sensitive adhesive or silicone rubber, as with the Diasec proprietary mounting system, has been popular with photographers for the past 15 to 20 years, especially in Europe. This system has the benefit of protecting the image from handling, moisture, humidity, and potentially from ultraviolet radiation, if the sheet of PMMA used includes UV-absorbing filtrations. Aesthetically, this finishing method has been popular because it has the effect of adding an optical dimensionality, a highly glossy wet look and an almost polished jewel-like appearance, which can be stunning.

Despite these benefits, face-mounting also has drawbacks. As mentioned before, PMMA, unlike glass, does not protect against the effects of airborne pollutants. Also, while PMMA is not as susceptible to shattering as glass is, it's very prone to scratches, which still makes it a somewhat delicate surface for handling. Surprisingly, accelerated testing has shown that face-mounting prints can improve dark stability, but also that it makes prints more light-sensitive than unmounted prints. Like laminated prints, face-mounted prints have shown a propensity to delaminate over time. Finally, one of the toughest issues with these

objects is that, once the object is face-mounted, it is next to impossible to reverse the process, which is a tremendous difficulty for photograph conservators.

As with laminating, Diasec face-mounting with silicone rubber requires you to have prints that have a smooth surface, such as the emulsion of chromogenic prints. It does not work well with textured and some inkjet prints.

Aesthetic Enhancement

Besides the very practical reasons and methods listed above, finishing our prints can also change or improve the presentation or appearance of the image. The choice of how to treat and finish the print should complement, and not distract from, the goals you have for the work as the photographic artist.

Editioning in Fine-Art Digital and Photographic Printmaking

After you have completed all of your corrections, edits, and testing (for sharpening, etc.) and have finally created a final version of your print(s), you need to make a decision. How many prints are you going to create from this image or series of images?

In traditional fine-art printmaking methods, such as stone lithography, the number of prints you can make of a certain image is often naturally limited by the physical deterioration of the matrix with each impression. The matrix refers to the material or surface used for creating the image. In traditional printmaking, the matrix often holds the ink. As an example, if you are an etcher, your matrix is possibly a copper plate that the image has been carved into by hand or chemicals. If you are an artist working in traditional lithography, your matrix is the image that was drawn onto the lithographic stone.

With these traditional processes, there are only a certain number of impressions it is possible to make. The natural limit helps set the number of prints in each edition. Depending on the process, the first

prints could be somewhat different than the last ones that are made in the progression. When these traditional printmaking methods are used, the image is wiped from the stone (or the matrix or plate is destroyed or struck) after the last impression is made.

Photography and digital printmaking are different than these traditional printmaking methods. Setting an edition limit is typically an artificial choice that is made primarily for business reasons—to help the dealer and the collector set prices for the work. In photographic and inkjet printing, there is no natural reason for you to set a limit to the number of prints you output from a version or size of an image.

That being said, setting the edition limit can depend on the size version of the image you are making. Let's say you have three versions of your image: 11 x 14-inch, 16 x 20-inch, and 20 x 30-inch prints. You could decide to have different edition limits for each size, i.e., 20 prints of the 11 x 14-inch version, ten prints of the 16 x 20-inch version, and five of the 20 x 30-inch version. Or you could make your life easy and set the same number of prints for all of your editions. This choice is arbitrary, but you need to make a conscious decision and then stick to it.

With digital printmaking, as much as possible, each print should be the same at the beginning and end of the edition; however, if the edition is made over a long period of time (which is often the case with digital printmaking), then things can change. Possible reasons for such changes include: the printer, the paper, the ink, the profiling software, the computer, the operating system, the printer driver, etc. You need to watch and document all of these variables (and others) when creating an edition, to insure that things remain the same. Depending on how exacting your standards and the duration of time in creating the edition, sometimes this can mean maintaining older computers, operating systems, and software.

Documenting Prints

In the fine-art printmaking process, the *bon à tirer* or *right-to-print* (BAT or RTP) proof is the first print that is determined to be acceptable by both the artist and the printer; in your case, this will be the same person. The BAT print will later be compared to the final proofs and edition prints for quality. It is the first proof you will sign.

Proofs that precede the *bon à tirer*—sometimes called the *working proofs*, *state proofs*, or *trial proofs*—are rarely signed. Besides the actual edition prints, the other images you will make after the *bon á tirer* are the *artist proof* (AP) and the *printer proofs* (PP), which typically don't exceed ten prints, or 10% of the edition, whichever is smaller.[2]

One of the final steps in the collaborative process between and artist and printmaker, which we discussed in Chapter 16, is to produce a document that includes all of the important information about the print. The artist, and possibly the printer, will sign this document. According to educators and master printmakers Donald Saff and Deli Sacilotto, the documentation can indicate exactly: how many prints and proofs were produced; the techniques employed in printing; the type and colors of ink; the kind of paper; and any other materials that were used—and possibly a reproduction of the print.[3] In addition to these technical details, all of the other collaborators in the project can also be listed. In this way, the documentation also acts as a list of credits, giving recognition to everyone involved—such as with Asian and Eskimo prints, where even the ink maker could be listed.[4] Figure 20.6 shows an example of documentation for inkjet prints that were made for Portland-based photographer Andy Batt, as part of the project "Six Degrees of Collaboration."

Besides just giving credit to all those involved with the process of creating your prints, documentation will also be important to the people who are charged with caring for our photographic prints once they enter private or institutional collections. These professionals are called *photograph conservators*. To help photograph conservators make decisions of how to store and, possibly, repair a damaged print, it is imperative that they understand the materials that make up your print. For this purpose, a writeable PDF form, called the Photograph

FIGURE 21.6 Documentation for a series of inkjet prints by photographer Andy Batt. Credit: Photographs by Andy Batt (andybatt.com)

Andy BATT (b.1969, USA)

Ink jet prints from a digital files produced with a Roland Hi-fi Color Printer using pigmented inks on Somerset Velvet Enhanced Paper

NYC Sheet 1
2000

Sheet: 57.8 x 85.6 cm
Image: 49.4 x 70.0 cm
Edition: 5, plus 1 AP

NYC Sheet 2
2000

Sheet: 57.8 x 85.6 cm
Image: 49.4 x 70.0 cm
Edition: 5, plus 1 AP

BC-OR Sheet 1
2000

Sheet: 57.8 x 85.6 cm
Image: 49.4 x 70.0 cm
Edition: 5, plus 1AP

Inscriptions: Titled, signed, and dated at the bottom of the sheet on the lower right and numbered on the left in pencil, and TPA five hole mark on lower right.

Collaboration:
Scanner Operator: Andy Batt
Location: All Points Bulletin Productions, Portland, Oregon, USA
Printer and ICC Colour Management: Tom P. Ashe
Location: RMIT University Media Arts Department, Melbourne, Victoria, Australia
Printing Date(s): 19-20 October 2000

These Prints could not have been made without the support of RMIT's Media Arts Department, specifically John Billan and Les Walkling.

Photograph Information Record

This questionnaire is used internationally to obtain essential information detailing the materials and techniques used in the creation of photographic works and their history. This allows institutions and individuals to better catalogue, interpret, and care for their photographs. Please provide as many details as you can. Extra space is provided at the end for responses that exceed the space allotted.

Contact information for the person completing this form:

Name Date

Address

Email Telephone

Please complete or verify the following information.

Artist name

Nationality Birth date or life dates

1.1 Title of work

1.2 Image date **1.3** Print date

1.4 Is the work editioned? ○ Yes ○ No If yes, this print is number from an edition of plus artist's proofs.

1.5 Is this work editioned in any other size or format? If so, provide details.

1.6 If not editioned, are there other known prints of this image?

1.7 Is the work part of a series or portfolio? If so, please describe.

2.1 History of ownership, including dates:

2.2 Exhibition history **for this print** (indicate length of time and light levels if possible):

2.3 Publication or reproduction history **for this image** (including other prints):

2.4 Conservation history **for this print**. Has the work been examined or received treatment? ○ Yes ○ No

Is documentation or information available? ○ Yes ○ No ○ Attached

3.1 This image derives from ○ film ○ digital capture ○ scanned film ○ other (e.g., paper negative, glass negative)

Provide film type and size, camera type, digital file specifications, or other information as applicable.

3.2 Describe any image manipulation prior to printing.

continued on other side

FIGURE 21.7 *(Above and opposite)* Photograph Information Record, which is recommended as a complete record of prints acquired by galleries, collectors, archives, libraries, and museums so photograph conservators know the best method for displaying and preserving prints over time.

3.3 This print is a ○ gelatin silver print ○ chromogenic print (C-print, Ektacolor, etc.) ○ ink jet print (Iris, Gyclée, Epson, etc.)
○ silver dye bleach print (Cibachrome, Ilfochrome) ○ other

3.4 If the support/paper is commercially produced, please identify the manufacturer and product name. If produced by hand, please describe the materials and techniques used.

3.5 If this is an ink jet print, please provide ink set information (for example: Epson UltraChrome K3 ink). If the inks are altered or mixed by the artist or printer, please describe.

3.6 This work was printed by ○ the artist ○ the artist's studio ○ a commercial printer ○ other
Provide printer's name and contact information if applicable.

3.7 Please provide any available information regarding printing equipment such as model, chemistry type, etc. (e.g. Light Jet, Lambda, RA4, Epson, Fuji, etc.).

4.1 Once printed, this work has been ○ toned ○ spotted ○ retouched ○ coated ○ treated with other applied media
○ framed ○ laminated (with plastic film) ○ face-mounted (to glazing material)
○ back-mounted (adhered to solid support) ○ lined (adhered to flexible paper or textile support)
○ other
For each procedure checked above, please specify materials, application techniques, mounter's name and contact information as appropriate.

4.2 Are there aspects of presentation (framing, installation details) that are considered integral to the work?

5.1 Are there aspects of the work that are particularly vulnerable and in need of special care?

5.2 If appropriate, please provide contact information for a conservator, assistant, or other individual who is familiar with the work and can be consulted on preservation matters.

5.3 Any other comments or information that you would like to offer regarding the creation and preservation of this work of art would be greatly appreciated.

Additional space for answers to questions above

This form is endorsed by The American Institute for Conservation and its Photographic Materials Group. It is used by The Art Institute of Chicago; Atelier de Restauration et de Conservation des Photographies de la Ville de Paris; George Eastman House, Rochester, New York; High Museum of Art, Atlanta; J. Paul Getty Museum, Los Angeles; Los Angeles County Museum of Art; The Metropolitan Museum of Art, New York; Milwaukee Art Museum; Museum of Fine Arts, Boston; The Museum of Fine Arts, Houston; The Museum of Modern Art, New York; National Gallery of Art, Washington, D.C.; National Gallery of Australia, Canberra; The National Gallery of Canada, Ottawa; The New York Public Library; Philadelphia Museum of Art; Rijksmuseum, Amsterdam; San Francisco Museum of Modern Art; (list in formation).

This form is not copyrighted. It may be reproduced, translated, and used freely by artists, galleries, and collecting institutions without requesting further permission. A writable pdf version of this document may be found at: **www.conservation-us.org/PIR**. This version produced June 2009.

Information Record, shown in Figure 20.7, was launched in July 2009. It's been accepted officially by the American Institute for Conservation and the Photographic Materials Group, and therefore by most collectors, galleries, and museums.

Conclusion

After we have spent so much time on color managing our systems, adjusting our images, possibly finding the most experienced labs and collaborators, and choosing the optimal output type and materials, it is important we complete the process as well as possible. As mentioned, we do this so that our photographic prints are protected and preserved, so they can be viewed as we intended for many decades (or centuries) to come. Why is this important? Art and images are one of the most important ways we as a people will all be remembered and represented for posterity. Let's give them as clear and faithful a representation as we can.

EXPLORATIONS

There are three things that would be useful to reinforce what we have discussed in this final chapter. (1) Look at prints at gallery and museum exhibitions. Observe how they have been finished. Identify the techniques and materials used, if possible. How do the techniques affect the aesthetic nature of the piece and viewing experience? (2) Start talking with framers and print finishers near you. Investigate what options they offer. Ask if they have worked with the type of prints you are making? Do they have suggestions for how the prints should be produced and handled? Finally, (3) get into the habit of documenting your prints and supplying the Photograph Information Record with the prints you supply to collectors (even in your family), galleries, and institutions.

Resources

Print Finishing and Treatments

Laumont Studio—Services—Technical Specs
 http://laumont.com/services/mounting-lamination.html
 http://laumont.com/services/framing.html

Hahnemühle Varnish
 http://www.hahnemuehle.com/site/en/1263/hahnemuehle-varnish.html

Krylon UV Archival Varnish
 http://www.krylon.com/products/uv_archival_varnish/

Lacquer-Mat
 http://www.lacquer-mat.com/

Premier Imaging Print Shield
 http://www.premierimagingproducts.com/pc_printshield.php

Photograph Conservation

McCabe, Constance (ed.), *Coatings on Photographs: Materials, Techniques, and Conservation*, AIC, The Photographic Materials Group, 2006.

The Photographic Materials Group (PMG) of The American Institute for Conservation of Historic and Artistic Works (AIC)
 http://www.conservation-us.org/index.cfm?fuseaction=Page.view
 Page&pageId=485&parentID=476

Preservation of Inkjet Hardcopies: An Investigation by Martin C. Jürgens
http://www.ica.org/?lid=5711&bid=744

George Eastman House—Certificate in Photographic Preservation and Collections Management
http://www.eastmanhouse.org/education/gradcert.php

Fine Art Photographic Print Documentation

Photograph Information Record
http://www.conservation-us.org/index.cfm?fuseaction=page.view
 page&pageid=949

Notes

1. Pénichon, Sylvie, and Jürgens, Martin, "Two Finishing Techniques for Contemporary Photographs," in Sarah S. Wagner (comp.), *Topics in Photographic Preservation*, vol. 9, American Institute for Conservation, Washington, DC, 2001, pp. 85–96.

2. For rules of designating different proofs, see either Kathan Brown, *Ink, Paper, Metal, Wood: Painters and Sculptors at Crown Point Press*, Chronicle Books, San Francisco, 1996, p. 19 or Garo Antreasian and Clinton Adams, *The Tamarind Book of Lithography: Art & Techniques*, Harry N. Abrams, Inc., New York, 1971, p. 114.

3. Saff, Donald, and Sacilotto, Deli, *Printmaking: History and Process*, Holt, Rinehart and Winston, New York, 1978, p. 398.

4. Gilmour, Pat, and Tyler, Ken, *Master Printer, and the American Print Renaissance*, Hudson Hills Press, Inc., New York, 1986, p. 31.

Index